THE WHOLE MYSTERY
OF ART

THE WHOLE
MYSTERY
OF ART

Pattern into Poetry
in the Work of W. B. Yeats

by
GIORGIO MELCHIORI

GREENWOOD PRESS, PUBLISHERS
WESTPORT, CONNECTICUT

Library of Congress Cataloging in Publication Data

Melchiori, Giorgio.
 The whole mystery of art.

 Reprint of the 1961 ed. published by Macmillan,
New York.
 Bibliography: p.
 Includes index.
 1. Yeats, William Butler, 1865-1939—Criticism and
interpretation. 2. Creation (Literary, artistic, etc.)
I. Title.
[PR5907.M4 1979] 821'.9'12 72-12553
ISBN 0-8371-6719-1

FOR GIULIANO

First published in the United States of America 1961

Reprinted with the permission of Routledge & Kegan
Paul Ltd.

Reprinted in 1979 by Greenwood Press, Inc.,
51 Riverside Avenue, Westport, CT 06880

Printed in the United States of America

10 9 8 7 6 5 4 3 2 1

Acknowledgements

PARTS of this book, generally in a very different and shorter form, appeared as articles or were delivered as lectures. I wish to thank the following for granting me permission to use such material: *English Miscellany* (Rome) and its Editor, Professor Mario Praz; *Lo Spettatore Italiano* (Rome) and its Editor, Signora Elena Croce; *The Durham University Journal* and its Editor, Mr. J. C. Maxwell; The International Association of University Professors of English for a paper I read at their second Conference, and the B.B.C. Third Programme, for which I broadcast a shortened version of the same paper.

My greatest debt is perhaps to the books of a large host of Yeats scholars; since a list would run practically to the same length as the bibliography appended at the end of this book, I must refer the reader to it, expressing my gratitude to the different authors, and apologizing to them if, at times, I may inadvertently have appropriated their thought or used their findings without direct acknowledgement in the notes.

Generous permission to quote extended passages from copyrighted works has been granted in the first place by Mrs. W. B. Yeats, to whose kindness I am particularly grateful, and by the publishers of Yeats's works or their successors: Macmillan & Co. Ltd., London; The Cuala Press, Dublin; A. H. Bullen; Routledge & Kegan Paul; T. Fisher Unwin; Werner Laurie;

v

Acknowledgements

Rupert Hart-Davis; Quaritch; Jarrolds; T. O. & E. C. Jack, Edinburgh. Mrs. Yeats and authors and publishers have also allowed me to reproduce passages they had printed for the first time from Yeats's manuscripts: acknowledgements are due for this to Messrs. Macmillan & Co. and Professor R. Ellmann for *Yeats: the Man and the Masks* and *The Identity of Yeats*; to the same publishers and the heirs of the late J. M. Hone for *W. B. Yeats, 1865–1939*; and to the Cornell University Press and Professor H. Adams for *Blake and Yeats: the Contrary Vision*.

My thanks are extended to the following for permission to quote from their works: The Princeton University Press and Professor E. Baldwin Smith for *The Dome*; Faber & Faber Ltd. and Sir Herbert Read for *Icon and Idea*; Methuen & Co. Ltd. and Mr. T. R. Henn for *The Lonely Tower*; John Lane Ltd. and Mr. E. Pound for *Gaudier-Brzeska, A Memoir*; The Cuala Press and the copyright holders for *An Offering of Swans,* by O. St. John Gogarty; The Oxford University Press and the copyright holders for *Letters on Poetry from W. B. Yeats to Dorothy Wellesley*; Rider Ltd. and Mr. Israel Regardie for *The Tree of Life*; Macmillan & Co. Ltd. and the heirs of G. W. Russell for *Song and Its Fountains,* by A. E.; The Medici Society and the copyright holders for S. MacKenna's translation of *The Enneads* of Plotinus; The Theosophical Publishing Soc. and the copyright holders for *The Secret Doctrine,* by H. P. Blavatsky. Full details of the sources of all quotations are to be found in the footnotes. Acknowledgements for the pictures here reproduced are recorded in the list of illustrations.

My work has been helped at all stages by the suggestions, discussions and criticism of scholars and friends. I owe a very special debt to Professor A. N. Jeffares, who read and criticized the typescript and helped with the loan of books and with personal encouragement; I enjoyed the advantage of the kind interest of Mr. Alan Bowness, Mr. Ian Fletcher, Professor D. J. Gordon, Sir Herbert Read, Professor Leo Spitzer, Professor Rudolf Stamm, Mr. Peter Ure, Mr. F. A. C. Wilson, who assisted my work in different ways. It is a

Acknowledgements

pleasure to recall the generous support I received from my Italian friends, Professors Nemi D'Agostino, Vittorio Gabrieli, Claudio Gorlier, Carlo Izzo, Agostino Lombardo, Giorgio Manganelli, Mario Praz and Elémire Zolla, all of whom went to the trouble of finding and securing for me books, articles and illustrations which I needed; for the most friendly hospitality I repeatedly received in London from the Italian Cultural Institute I am very grateful to its Directors Count Umberto Morra di Lavriano and Professor Gabriele Baldini, and to all their staff. But without the help of my wife, who endlessly copied and re-copied my manuscript and made my life happy and comfortable in these years, I could never have completed this book.

Contents

ix

Illustrations

Illustrations

xi

XVI. William Blake: *The Whirlwind of Lovers* (*Inferno*, canto V). From *The Savoy*, n. 3, July 1896, illustrating Yeats's article on 'William Blake and His Illustrations to the Divine Comedy' *page* 267

N.B. I am grateful to Mrs. Yeats and to the publishers (Routledge & Kegan Paul, Werner Laurie, Macmillan, and Quaritch respectively) for permission to reproduce the illustrations in the text, numbers 3, 4, 8 and 11. I am indebted to the British Museum for reproduction of material in the Museum, and for permission to publish them.

It is pleasant to see great works in their seminal state pregnant with latent possibilities of excellence; nor could there be any more delightful entertainment than to trace their gradual growth and expansion and to observe how they are sometimes suddenly advanced by accidental hints, and sometimes slowly improved by steady meditation.

SAMUEL JOHNSON

Metaphysics of Magicians

These metaphysics of magicians
And necromantic books are heavenly;
Lines, circles, scenes, letters, and characters;
Ay, these are those that Faustus most desires.

YEATS'S work has been for a number of years a favourite
quarry for interpreters, explicators and source-hunters. The
present book may be considered as a further exercise in this
field—and since the ultimate usefulness of such investigations
has frequently been questioned, I feel that I must state at the
outset the guiding principles of my enquiry.

In the first place my aim is not so much to point out the
sources of different poems and to explain their meaning, as to
discover and trace, as far as this is possible, the mental process
by which they have come into being. At the root of each poem
there is the intuition of a whole world of images, thoughts,
echoes, sensuous experiences (whether auditory or visual or
tactile) and stylistic conceptions, which have sunk very deeply
into the poet's consciousness during the course of his life—a
world which has been slowly forming through the years and is
suddenly apprehended in a unified whole, and seeks expression.
The synthesis which is the poem, can, therefore, be analysed
into its components, and this has in fact been done for many of

Yeats's works. But the analysis in most cases has been only partial: Mr. Hough and Professor Lombardo see the derivation from the Symbolists and Aesthetes, Mr. Henn sees the visual influences, Mr. F. A. C. Wilson picks up the gnostic, neo-Platonic esoteric strand, Mr. Adams subtly interprets the influence of Blake, Mr. Bjersby traces the legendary Irish strand, and so on. The very fact that the same poem at times can be seen from each of these different angles shows the exceptional diversity and variety of the elements which went into its making. Each analysis is valid in its own way. Yeats's faculty for association was developed to an extraordinary extent, and his range of interests was extremely wide, so that he could immediately catch unexpected correspondences between, for instance, the Symbolist doctrine and the Upanishads, or a painting by Moreau and an Irish legend. My first purpose in this book is to show how all these things are brought together in his mind and in his poetry.

My second purpose is to identify, at least tentatively, the principle by which Yeats succeeded in ordering the various experiences I mentioned before into the single structure of a poem. Poetry, or art in general, is essentially order. The aesthetic achievement is the ability to order and harmonize the sparse and heterogeneous materials which a sudden intuition has gathered together from the recesses of the poet's mind. Many potential works of art never get beyond this stage: the materials which went into their making are not ordered and organized into a whole—the work has no pattern. It is actually the pattern that makes a work of art out of materials which, in themselves, have no aesthetic value. It could be said of a poem that it is the expression of the inner world of the poet within a certain mental pattern. And the pattern itself is not superimposed afterwards, is not a metrical scheme or a technical device: it is a form of mental organization developed by the poet at the same time as he was gathering, more or less unconsciously, the materials from which the poem is born. I propose to enquire into the mental pattern upon which Yeats's poetry is built. And

2

I may as well state that I suspect that this mental pattern had, in Yeats's case, a strong visual basis: that it approached a geometrical scheme. The characteristics of this pattern, however, should emerge in the following chapters. By way of introduction I wish in the next few pages, to dwell on the definition of 'pattern': a scheme of organization both of thought and of form.

I prefer 'pattern' to 'scheme' because of its associations with sensuous impressions rather than with thought impressions. Poetry and art appeal to the mind through the senses (or to the senses only). The creator of poetry and art in his turn, even when his work expresses serious philosophical conceptions, operates through the senses, and his intuition is essentially sensorial. Impressions which would be merely physical for the average man affect the artist so deeply as to become for him the very essence of thought. His thought will therefore organize itself according to a mental pattern which is not only of the mind but of all the senses.[1] So, for instance, a visual pattern (a certain arrangement of lines and planes, a pictorial or plastic motif) may so impress a poet's mind as to become transformed there into a philosophical or metaphysical system.

That Yeats realized this transference of patterns from the sensory to the mental plane at a late stage of his development, appears clearly from the final passage of the introduction to the 1937 edition of *A Vision*.[2] He is referring here to his complicated and abstruse schemes of lunar phases and interpenetrating spirals through which the whole history of mankind was represented:

Some will ask whether I believe in the actual existence of my circuits of sun and moon. Those that include, now all recorded

[1] In his essay of April 1916, on 'Certain Noble Plays of Japan', Yeats himself wrote: 'We only believe in those thoughts which have been conceived not in the brain but in the whole body.' Not long afterwards T. S. Eliot wrote his famous pages on poetry as 'a direct sensuous apprehension of thought' and on the necessity of feeling 'thought as immediately as the odour of a rose'.

[2] This passage was apparently a last moment addition, since it did not appear when the new prefatory matter to *A Vision* was published separately in 1929 under the title *A Packet for Ezra Pound*.

time in one circuit, now what Blake called 'the pulsaters of an artery', are plainly symbolical, but what of those that fixed like a butterfly upon a pin, to our central date, the first day of our Era, divide actual history into periods of equal length? To such a question I can but answer that if sometimes, overwhelmed by miracle as all men must be when in the midst of it, I have taken such periods literally, my reason has soon recovered; and now that the system stands out clearly in my imagination I regard them as stylistic arrangements of experience comparable to the cubes in the drawing of Wyndham Lewis and to the ovoids in the sculpture of Brancusi. They have helped me to hold in a single thought reality and justice.

(Vis. B, 24)

This statement is revealing of Yeats's most extraordinary quality: his intuitive power, which could penetrate with sudden clear-sightedness the thick esoteric fog in which he seemed to have become more and more wrapped since the beginning of his metapsychical experiments. The cosmological system which he had been so patiently piecing together over a number of years with the help of his ghostly 'communicators', appeared to him for what it really was: 'a stylistic arrangement of experience', a geometrical, physical pattern like those most clearly and obviously revealed by cubist and abstract art,[1] which had impressed itself on his thought, had become philosophy and metaphysics.

Indeed, in the early 'twenties, when Yeats was loth to admit that his system was suggested by spirits evoked through the mediumship of his wife, he had devised the fantastic oriental tale told in the maddeningly confusing introduction to the first edition of *A Vision*, of the dancers who trace with their feet on the desert sand the pattern that underlies the system;[2] and the

[1] See Excursus I: Yeats and Abstract Art.

[2] The story (later suppressed) came at the beginning of Book I, 'What the Caliph Partly Learned', and bore the signature of Owen Aherne and the title 'The Dance of the four Royal Persons'. The expression *Royal Persons* is commonly found in occult treatises with reference to alchemical symbols; see *post* the account of the *Chymical Marriage of Christian Rosencreutz*.

other oriental tale in the Browningesque poem 'The Gift of Harun Al-Rashid' (1923)[1] according to which the somnambulist wife of Kusta ben Luka, the Arab sage, runs in her sleep to

> the first ridge of the desert
> And there marked out those emblems on the sand
> That day by day I study and marvel at,
> With her white finger . . .
> All, all those gyres and cubes and midnight things . . .
> <div align="right">(CP., 518–19)</div>

Also here, in these deliberately obscure allusions to his system of thought, Yeats has recourse to a visual pattern, traced in the sand, and again in a note to the first edition of his play *The Cat and the Moon* (1924) when he still refused to speak openly of his system but wanted to make the symbolism of the play which was based on it clear, he wrote:

> I have amused myself by imagining incidents and metaphors that are related to certain beliefs of mine as are the patterns upon a Persian carpet to some ancient faith or philosophy.
> <div align="right">(C. & M., 35)</div>

We are reminded of Henry James's splendid metaphor for art 'the figure in the carpet', and of how the signs traced in the desert sand were suggested by Shelley's *Revolt of Islam*. We can agree then with Donald Stauffer when he says that

> [Yeats's] natural instincts were toward pattern, toward revelation through visual evocation. He is a descendant of the Pre-Raphaelite poet-painters, who wrote pictures and painted

[1] The poem, after publication in periodicals, was included in *The Cat and the Moon and Certain Poems* (Cuala Press, 1924), and became part of the first *Vision*, where it occupied a prominent place at the beginning of Book II, 'What the Caliph Refused to Learn', and bore the title 'Desert Geometry, or the Gift of Harun Al-Rashid'.

sonnets. Art for Yeats is a vision; at times, it is almost geometry.[1]

I should add that also his thought is visual pattern, since this is at the basis of all his creative life. It is worth while to look at a passage from one of his early prose works, *John Sherman*, which was written in 1888 and appeared in 1891, together with another tale of Yeats, in the Pseudonym Library, under the pen-name Ganconagh. The figure of the twenty-three year old author is so thinly disguised under the literary trappings of the hero of the story, that *John Sherman* preserves a keen biographical or rather psychological interest. His attitude to women, whom he loves, but rejects or loses, his curious and shy pride, make one think of what Yeats in later years said of his youth: 'My isolation from ordinary men and women was increased by an asceticism destructive of mind and body, combined with an adoration of physical beauty that made it meaningless';[2] or more straightforwardly: 'In those days I was a convinced ascetic, yet I envied Dowson his dissipated life.'[3] In the story the sensitive young Irishman, John Sherman, is thinking over some personal sentimental problem:

A few days ago he had found an old sketch-book for children among some forgotten papers, which taught how to draw a horse by making three ovals for the basis of his body, one lying down in the middle, two standing up at each end for flank and chest, and how to draw a cow by basing its body on a square. He kept trying to fit squares into the cows. He was half inclined to take them out of their frames and retouch on this new principle. Then he began somehow to remember the child with the swollen face who threw a stone at the dog the day he resolved to leave home first. Then some other image came. His problem moved before him in a disjointed way. He was dropping asleep. Through his reverie came the click, click of his

[1] D. Stauffer, *The Golden Nightingale*, N.Y., 1949; 47.
[2] Preface to *Letters to the New Island*, ed. H. Reynolds, Harvard U.P., 1937.
[3] In the broadcast 'Modern Poetry', Oct. 1936, included in *Essays 1931 to 1936*, Cuala Press, 1937; 7.

mother's needles. She had found some London children to knit for. He was at that marchland between waking and dreaming where our thoughts begin to have a life of their own—the region where art is nurtured and inspiration born.

<div align="right">(J.Sh., 105–6)</div>

The passage may seem irrelevant; but its peculiar minutiae give it the ring of truth, of a personal experience. Probably Yeats is here more or less deliberately relating some of his metapsychical experiments. By 1890 he was already absorbed in such experiences: especially in inducing trance-like states by observing symbols drawn on cards. The symbols (most frequently geometrical patterns) induced visions. Here the ovals and the squares from the sketch-book have the same effect: the result is not just abstract vision but artistic inspiration. It is clear that, even at that early stage, Yeats conceived of patterns (geometrical patterns—ovals and squares) as the basis of artistic expression as well as of thought. It little matters that he considered patterns to be important not in themselves, but as symbols: what counts is the fact that they—as is very plain from this quotation where they are not magical patterns but just odd patterns in a children's book—had become associated in his mind with inspiration and aesthetic expression.

This idea, only intuitively and momentarily realized in Yeats's last years in the passage from *A Vision* that I have quoted, had been unconsciously present in his mind for a long time. It underlies a very significant comment on Blake's conception of art, made by Yeats in that monumental edition of Blake's work with which he and E. J. Ellis had been occupied in the early 'nineties, and which appeared in 1893:

This process of the separation of a portion of matter by 'circumcizing' away the indefinite is Blake's definition of drawing. We make an outline upon paper and so give a portion of the paper a mental existence, and by means of this mental existence we forget the paper. It is then 'cast out', and a last judgement 'has passed over it' . . . All experience is obtained in the same way, and all arts, whether they be painting,

poetry, music, architecture or merely one of the arts of life, are contained within this definition.[1]

In the outline, in the basic pattern drawn on the paper, is all art and all arts, and life itself: Yeats, like all critics, has fathered on Blake a principle which he had unconsciously found in his own experience. A linear pattern is already transferred here from the visual to the mental plane.

In insisting on the linear or visual character of the pattern, which is at the basis of Yeats's thought and poetry, I do not mean to imply that the poet had any pictorial tendency (in spite of his early training as a painter and the presence of painters in his family and among his closest friends). We shall look in vain in Yeats's poems for the romantic Irish landscapes or detailed three-dimensional representations of human figures, which were by no means rare in the poetry of his time. 'The Wild Swans at Coole', for example (to take a poem which seems to have a local habitation and a name), is no landscape with swans: the picture which it leaves in our mind is that of a vast flurry of wings and feathers.[2] All that Yeats gives us in his

[1] *The Works of William Blake . . . edited with . . . a memoir and interpretation by Edwin John Ellis and William Butler Yeats,* London, Quaritch, 1893; I, 306–7. According to a manuscript note in Yeats's own copy, apart from the biographical 'Memoir', most of the first volume of the edition, dealing with 'The Symbolic System', was written by Yeats himself. Compare with the passage quoted the following lines, from Yeats's preface to his selections of *Poems of William Blake* (Lawrence & Bullen, 1893; later Routledge, 1905; p. xxxiii): 'We must take some portion of the Kingdom of darkness, of the void in which we live, and by "circumcising away the indefinite" with a "firm and determinate outline", make of that portion a "tent of God", for we must always remember that God lives alone, "in minute particulars" in life made beautiful and graceful and vital by imaginative significance, and that all worthy things, all worthy deeds, and worthy thoughts, are works of art or of imagination. In so far as we do such works we drive the mortality, the infection out of the things we touch and see, and make them exist for our spiritual senses.'

[2] Compare the similar remarks on this poem in John Press, *The Fire and the Fountain,* O.U.P., 1955, 41 ff.; 'All that we know about Coole is that there are wild swans drifting on the darkening flood, great trees, pure clouds, and woods where one can wander at peace. Yeats was more concerned with the total sense

poems, by way of pictorial representation, is a colour ('The honey-pale moon') or a vague tonality ('Under the October twilight the water / Mirrors a still sky'), a single feature, a striking detail ('a bird's round eye' or 'these red lips, with all their mournful pride'). This induced even people who knew him well, like Dorothy Wellesley, to fail to realize how open he was to visual impressions. Commenting on his letters to her, she writes:

> I have come to the conclusion that this lack of 'visualness', this lack of interest in natural beauty for its own sake, may originate in the fact that most of the Celtic poets are not concerned with nature at all. Yeats did not himself draw much inspiration from Nature, certainly from no details; only sometimes massed effects, such as a painter sees, influenced his verse. Referring to a poem of mine Yeats once said to me in an outburst of irritability: 'Why can't you English poets keep flowers out of your poetry?'[1]

The misunderstanding is due to her identification of 'visualness' with 'natural beauty'. Yeats's visual faculty was of a different kind. His aim was not the description of landscapes, but rather, in Donald Stauffer's words, 'revelation through visual evocation'. He was a descendant of the Pre-Raphaelite poet-painters, but was too good and instinctive a poet to be really one of them, to 'write pictures' himself. One early example will be sufficient. Here is a landscape described in the remarkably unemphatic prose of the long story *John Sherman*:

> It made him remember an old day-dream of his. The source

of richness and beauty arising from a scene than with constituent parts.' Mr. Press rightly remarks that 'a study of Yeats's poetry should dispel the notion that a poet is an inspired bird-watcher who celebrates in ecstatic language the rural beauties of innocent nature.' But he too, in defending Yeats with the argument that 'dull or defective vision is not a fundamental defect in a poet', conveys the impression that the visual element in poetry can be expressed only through detailed descriptions of Nature.

[1] *Letters on Poetry from William Butler Yeats to Dorothy Wellesley*, O.U.P., 1940, p. 190.

of the river that passed his garden at home was a certain wood-bordered and islanded lake, whither in childhood he had often gone blackberry-gathering. At the further end was a little islet called Inniscrewin. Its rocky centre, covered with many bushes, rose some forty feet above the lake. Often, when life and its difficulties had seemed to him like the lessons of some elder boy given to a younger by mistake, it had seemed good to dream of going away to that islet and building a wooden hut there and burning a few years out, rowing to and fro, fishing, or lying on the island slopes by day, and listening at night to the ripple of the water and the quivering of the bushes—full always of unknown creatures—and going out at morning to see the island's edge marked by the feet of birds.

(J.Sh., 122–3)

This day-dream makes a pretty picture, a sort of Boecklin landscape diluted into an English nineteenth century water-colour. And of this picture the most famous of Yeats's early poems, 'The Lake Isle of Innisfree', was born:[1]

I will arise and go now, and go to Innisfree,
And a small cabin build there, of clay and wattles made:
Nine bean rows will I have there, a hive for the honey-bee,
And live alone in the bee-loud glade.

And I shall have some peace there, for peace comes dropping
 slow,
Dropping from the veils of the morning to where the cricket
 sings;

[1] There is a direct reference to the origin of the poem and its connection with the story in a letter of Yeats to Katharine Tynan of 21 Dec. 1888: 'Here are two verses I made the other day: There is a beautiful Island of Innisfree in Lough Gill, Sligo. A little rocky Island with a legended past. In my story I make one of the characters whenever he is in trouble long to go away and live alone on that Island—an old daydream of my own. Thinking over his feelings I made these verses about them . . .' There follows an earlier version of the first two stanzas of the poem (*L.*, 99–100). For another account of its inception see *Aut.*, 153.

There midnight's all a glimmer, and noon a purple glow,
And evening full of the linnet's wings.

I will arise and go now, for always night and day
I hear lake water lapping with low sounds by the shore;
While I stand on the roadway or on the pavements grey,
I hear it in the deep heart's core.

<div align="right">(C.P., 44)</div>

Here the word 'isle' is mentioned only in the title. The land-
scape is only hinted at; or rather it has been translated from
visual into auditory terms: the buzzing of the bees, the song of
the cricket, the lapping of the lake water. He does not *see* the
island and himself in it: he 'hears it in the deep heart's core'.
At twenty-three Yeats, in spite of his pre-Raphaelite schooling,
knew better: he knew that poetry is sound, is the art of creating
images through sound. He knew it so well that, with character-
istic enthusiasm, he developed a few years later his method of
reciting poetry to the accompaniment of a psaltery; he went so
far, in spite of being tone-deaf, as to have a special instrument,
'half psaltery half lyre' made for him by Dolmetsch.[1] This is
typical of Yeats: when he had an idea or a theory he would try
to work it out to the end, to ride it to the death, as it frequently
turned out. It is significant that, though borrowing ideas and
beliefs from any quarter, he never really belonged to any party
or church or society: he founded many of the latter, occultist,
or nationalist, or literary, but never completely shared in the
convictions of his fellow-members or even of his followers. His
individuality would always affirm itself, by making him take a
different road from the one intended and understood by his
companions. This is why his political attitude appears so
irritatingly elusive and at times suspect; and his philosophy
could make no disciples. But in this individuality lies also the
strength of his poetry, and especially of his late poetry.

Yeats's poetry, therefore, is in no sense pictorial (only some

[1] Cp. 'Speaking to the Psaltery', in *I.G. & E.*, 22.

youthful compositions are conventionally 'picturesque'). The visual pattern I shall try to identify in it has nothing to do with 'writing a picture'. It is rather a certain characteristic arrangement of lines, or, better still, the adoption of a certain outline which, to paraphrase what Yeats said of Blake, 'circumcizes away the indefinite and gives the poem a mental existence'.

Mention has already been made of some of the reasons why the pattern which underlies Yeats's poetry and thought was so intensely visual. These reasons are to be traced in the very nature of his artistic formation. First of all there was the fact that his father was a painter and—at least for a certain time—a fervent admirer of the pre-Raphaelites. We know that Yeats himself remained devoted to Rossetti[1] and violently hostile to the Impressionists even when his father turned towards the latter with a certain admiration. Yeats attended an art school where he learned little, and he never became a good painter. Nevertheless this early training must have made him aware of the importance of pattern, the disposition of lines on paper. In 1922, comparing himself to the other Rhymers, Yeats wrote:

I was full of thought, often very abstract thought, longing all the while to be full of images, because I had gone to the art schools instead of a university.

(*Aut.*, 166)

He did not like over-faithful naturalistic painting, the pictorial *tranche de vie*; his conception of art was already visionary, rich, noble and mythical, as befitted an admirer of Spenser, Shelley and Morris. And certainly his acquaintance at school with the visionary George Russell must have strengthened this anti-naturalistic tendency. On the other side he despised the Impressionists' preoccupation with masses and tones and surfaces, and what he considered their geometrical and angular mathematical abstraction. Neither tendency attracted the

[1] In an essay of 1913, 'Art and Ideas' (*C. of A.*), Yeats listed Millais' *Ophelia*, Rossetti's *Mary Magdalene* and *Mary of Galilee* as the paintings that moved him most.

worshipper of physical (meaning corporeal) beauty, of beauty intended as 'the body as it can be imagined as existing in ideal conditions'.[1] What remained was a third way, the way of Rossetti: physical beauty transposed on to a visionary plane, and therefore stylized. What is stylization but the enclosing of the figures in a certain ideal line-scheme, in a certain pattern? This is the element of painting that Yeats was able to appreciate: neither tone nor mass nor the minute observation of reality, but the disposition of the outlines, the enclosed pattern.

Many years later, writing in 1932 the introduction to the book *An Indian Monk* by his Oriental friend, the Shri Purohit Swami, Yeats saw clearly what his youthful preferences in art had been:

Being most impressed by arts that I have myself practised, I remember our selection for admiration of old masterpieces where 'tonal values' or the sense of weight and bulk that is the particular discovery of Europe are the least apparent.

<div align="right">(Ess. '31 to '36, 81–2)</div>

[1] This definition is actually Sturge Moore's, and was suggested at a much later date. Yeats approved of it very warmly and wrote to Moore on 9 March 1929: 'Your definition of beauty was "the body as it can be imagined as existing in ideal conditions" or some such phrase. I understand it as including all the natural expressions of such a body, its instincts, emotions, etc. Its value is in part that it excludes all that larger modern use of the word and compels us to find another word for the beauty of a mathematic problem or Cubist picture or of *Mr. Prufrock*' (*W.B.Y. & T.S.M.*, 144). I feel that Yeats would have subscribed to Moore's definition of beauty even thirty or forty years earlier. Compare the following from an essay of 1906 ('Discoveries'): 'Art bids us touch and taste and hear and see the world, and shrinks from what Blake calls mathematic form, from every abstract thing, from all that is of the brain only, from all that is not a fountain jetting from the entire hopes, memories, and sensations of the body' (*Ess.*, 362). In *The Trembling of the Veil* (1922–3) Yeats gives the following definition of his doctrine of Unity of Being (meaning the perfect harmony of all arts at a certain period): 'I delighted in every age where poet and artist confined themselves gladly to some inherited subject–matter known to the whole people, for I thought that in man and race alike there is something called "Unity of Being", using that term as Dante used it when he compared beauty in the *Convito* to a perfectly proportioned human body' (*Aut.*, 190).

From the beginning his preference went to the works which showed the linear, stylized characteristics of oriental art.[1] He saw a strict connection between Oriental art (as expressed in the Japanese Nô plays) and the European 'symbolist' art and literature of the second half of the nineteenth century. 'Some among them [the Japanese] would have understood the prose of Walter Pater, the painting of Puvis de Chavannes, the poetry of Mallarmé.'[2] Mr. Ellmann notes that one of Yeats's favourite early metaphors was that of tapestry, and weaving.[3] It might indeed have come from his acquaintance with the apostle of the applied arts, William Morris, who was a friend, though an older friend, of Yeats. And Morris was certainly to Yeats's taste,[4] spreading into household furnishings the decorative motifs of pre-Raphaelite art, emphasizing in the process their ornamental and highly stylized elements, reducing them to patterns. We saw how, in later life, in the notes to *The Cat and the Moon* Yeats used the image of the pattern in the carpet to indicate the web of metaphors which he had cast over his beliefs. The same image he had used in 1900 speaking of the recurrent symbol of the cave in Shelley's poetry; after suggesting several meanings for it he concludes:

or it may have as little meaning as some ancient religious symbol enwoven from the habit of centuries with the pattern of a carpet or a tapestry.

(*I.G. & E.,* 125–6)

Though this last sentence, read out of context, may suggest that Yeats dismissed the figure in the carpet too lightly, yet if we take into account Yeats's convictions in the matter of religious, philosophical or poetic symbolism we see that this is far from being so.

Symbolism was a fashionable word in literary circles at the

[1] Cp. Yeats's remarks on Japanese painting in his letter of 1916 quoted *post*, Excursus I.

[2] 'Certain Noble Plays of Japan' (1916), *Ess.*, 294.

[3] R. Ellmann, *The Identity of Yeats*, London, Macmillan, 1954; 20–1.

[4] Yeats's sisters were apprenticed in Morris' tapestry workshop.

end of last century, but for Yeats the term had a special and complex meaning which we should now examine.

A symbol is indeed the only possible expression of some invisible essence, a transparent lamp about a spiritual flame; while allegory is one of many possible representations of an embodied thing, or familiar principle, and belongs to fancy and not to imagination: the one is a revelation, the other an amusement.

<div align="right">(I.G. & E., 176)</div>

This definition of symbolism in art appeared in an article that Yeats published in *The Savoy* for July 1896.[1] A symbol in art is an image which is the only possible expression of either a simple or a complex feeling or emotion; not a metaphor for an accepted idea, for a single and definable object, with one specific meaning, but the image which summarizes in itself a number of possible meanings. The overall meaning of a symbol is therefore of itself undefinable: separate facets of it can perhaps be logically explored; but the symbol in its complex unity can be apprehended only through the emotion it communicates, through the feeling it awakens, acting on our senses. It is not so much the sensuous representation of an abstract idea, as the immediate blending of sensuous impression, feeling and thought: it is the intuition of a complex idea through our physical senses. As such it cannot be logically analysed to get to the idea 'behind' it. There is nothing behind it, as there is behind allegory or behind commonplace metaphors: it *is* the idea, and as such has an independent life of its own, independent of any logical structure of thought, or philosophical or religious system. The symbol may be a whole system, born and manifested in a single image. If we call this undefinable content 'invisible essence', or a 'spiritual essence',

[1] In *I.G. & E.* this essay ('William Blake and His Illustrations to *The Divine Comedy*: I. His Opinions upon Art') is erroneously dated 1897; for a perceptive treatment of Yeats's aesthetic ideas and poetry in the 'nineties, see A. Lombardo, *La poesia inglese dall'estetismo al simbolismo*, Roma, Edizioni di Storia e Letteratura, 1950; especially pp. 97–100 and 249–88.

we can say with Yeats that the symbol is its 'only possible expression', the 'transparent lamp' which lets us see the flame and impresses our senses with its light.

This is one of those intuitions of Yeats's which I mentioned earlier: he has reached in a flash the very core of the symbolist doctrine which was spreading from France to England in the 'nineties. Arthur Symons (the editor of *The Savoy*, the magazine where this definition first appeared) was quite right in considering Yeats the first English symbolist and in dedicating to him in 1899 his influential book, *The Symbolist Movement in Literature.*[1] Symons, in fact, realized the importance of the visual element in symbolism (deeply felt but consciously perceived only vaguely by Yeats) so that he could write that 'the modern ideal in matters of artistic expression' was the ballet, because it had 'the intellectual as well as sensuous appeal of a living symbol, which can but reach the brain through the eyes, in the visual, concrete imaginative way'.[2] If we run through Yeats's collection of essays written between 1895 and 1903, *Ideas of Good and Evil,* in which he discusses symbolism at length (as was inevitable in those years), we shall find that the quotation given above is only *one* of many definitions: there was an extra-aesthetic influence at work on him which induced him to extend the meaning of the term Symbolism to certain special connotations.

[1] The dedication shows that Symons was also aware of the esoteric connotations of Symbolism, in which Yeats was an expert; Symons wrote: 'I speak often in this book of Mysticism, and that I, of all people, should venture to speak, not quite as an outsider, of such things, will probably be a surprise to many. It will be no surprise to you, for you have seen me gradually finding my way, uncertainly but inevitably, in that direction which has always been to you your natural direction.'

[2] A. Symons, 'Ballet, Pantomime and Poetic Drama', in *The Dome*, n.s., I, Oct.–Dec. 1898, pp. 65–71; see the penetrating comments on this essay in connection with Yeats's image of the dancer in F. Kermode, *Romantic Image,* London, Routledge, 1957; 72 ff. Cp. D. J. Gordon and Ian Fletcher, *I, the Poet William Yeats* (Descriptive Guide to the University of Reading, 1957, Yeats's photographic Exhibition), pp. 30–1.

There is a much-quoted statement in the essay 'Symbolism in Painting', which had already appeared before, in 1898, as an introduction to the visionary and esoteric drawings of the painter and mystic, W. T. Horton:

> Symbolism said things which could not be said so perfectly in any other way, and needed but a right instinct for its understanding.
>
> <div align="right">(<i>I.G. & E.</i>, 227)</div>

The definition, attributed by Yeats to a German Symbolist painter to whom he sat for his portrait in Paris,[1] is excellent. The painter went on to say, as Yeats tells us, that he:

> would not put even a lily, or a rose, or a poppy into a picture to express purity, or love, or sleep, because he thought such emblems were allegorical, and had their meaning by a traditional and not by a natural right.

Yeats, however, disagreed with this, arguing somewhat inconclusively:

> I said that the rose, and the lily, and the poppy were so married, by their colour and their odour, and their use, to love and purity and sleep, or to other symbols of love and purity and sleep, and had been so long a part of the imagination of the world, that a symbolist might use them to help out his meaning without becoming an allegorist.
>
> <div align="right">(<i>I.G. & E.</i>, 228–9)</div>

His justification for upholding such obviously standardized

[1] The German Symbolist painter was probably Paul Herrmann, born in Munich in 1864, established in Paris from 1895, and a friend of Oscar Wilde, E. Munch and A. Strindberg; when the essay was first printed as an introduction to *A Book of Images* drawn by W. T. Horton and introduced by W. B. Yeats, London, at the Unicorn Press, 1898, it listed as examples of symbolism (together with the works of Wagner, Keats, Blake, Calvert, Rossetti, Villiers De l'Isle Adam, Shannon, Whistler, Maeterlinck and Verlaine) 'the black-and-white art of M. Herrmann, Mr. Beardsley, Mr. Ricketts and Mr. Horton'. All mention of Herrmann and Horton disappeared from the reprint of the essay in *I.G. & E.* (1902).

metaphors is to be looked for in a supposed 'imagination of the world', a sort of universal repository of emblems able to evoke this or that idea. Presently I shall look more closely into this repository, as illustrated in Yeats's essays. It is enough here to say that his reason for salvaging the rose, the lily and the poppy was mainly sentimental: he was fond of these simple emblems, partly because they were consistently used by his favourite pre-Raphaelite painters (he mentions in this context two paintings by Rossetti in which the lily appears), but mainly because he attributed to single emblematic patterns specific powers which have nothing to do with literary and artistic symbolism. They are the kind of 'elemental shapes' to which he refers in another essay of the same book, on 'The Philosophy of Shelley's Poetry' (1900). Here is the opening sentence of the section of the essay dedicated to Shelley's 'ruling symbols':

At a comparatively early time Shelley made his imprisoned Cythna become wise in all human wisdom through the contemplation of her own mind, and write out this wisdom upon the sand in 'signs' that were 'clear elemental shapes whose smallest change' made 'a subtler language within language' and were 'the key of truths, which once were dimly taught in old Crotona'.

<div align="right">(<i>I.G. & E.</i>, 111–12)</div>

Incidentally we learn in this way that the 'emblems on the sand' traced by the wife of Kusta ben Luka in the much later poem 'The Gift of Harun Al-Rashid', quoted earlier in this chapter, were suggested by Shelley's *Revolt of Islam*. But what interests us now is the significance Yeats attributed to such emblems. The essay goes on:

His early romances and much throughout his poetry show how strong a fascination the traditions of magic and of the magical philosophy had cast over his mind, and one can hardly suppose that he had not brooded over their doctrine of symbols or signatures, though I do not find anything to show that he gave it any deep study.

<div align="right">(<i>I.G. & E.</i>, <i>loc. cit.</i>)</div>

Magic is the key to Yeats's acceptation of the word 'symbolism' in painting or in poetry. All biographers and critics of Yeats's work have dealt at length with his very early interest in magic, as well as in theosophy and in spiritualism. He deserted drawing classes when at the arts school in order to spend his time in a library over Sinnett's *Esoteric Buddhism*, a rather confused exposition of esoteric doctrine, including a wild cosmology, which, as we shall see, left its mark on the system expounded by Yeats in *A Vision*, forty years later. And in 1885, when he was only twenty years old, Yeats was a co-founder of the Hermetic Society, devoted to the study of what, in the longest of the essays included in *Ideas of Good and Evil*, he frankly calls 'Magic'. The whole book, actually, runs on a single theme, recurring in essay after essay: the identification of magic symbols with poetic and artistic symbols. One sees how Yeats must have been impressed by a statement like this, in Madame Blavatsky's *The Secret Doctrine*:

... such is the mysterious power of Occult symbolism, that the facts which have actually occupied countless generations of initiated seers and prophets to marshal, set down and explain, in the bewildering series of evolutionary progress, are all recorded in a few pages of geometrical signs and glyphs. The flashing gaze of those seers has penetrated into the very kernel of matter, and recorded the soul of things there, where an ordinary profane observer, however learned, would have perceived but the external work of form.[1]

In the 'eighties Yeats had been a follower of Madame Blavatsky. But if she could call the *Secret Doctrine* 'the Synthesis of Science, Religion, and Philosophy', how could Yeats, an artist by nature, leave art out of this all-embracing synthesis? Madame Blavatsky saw' the soul of things' in what appeared only as 'the external work of form'; Yeats was born to art at a time when,

[1] H. P. Blavatsky, *The Secret Doctrine: the Synthesis of Science, Religion, and Philosophy*; the first edition was published in 1888; I am quoting from the posthumous third revised edition, with preface by A. Besant and G. R. S. Mead, London, Theosophical Publishing Soc., 1893; vol. I, 293.

owing mainly to Pater's teaching, 'the external work of form' was all-important, and there was a risk of reaching an art of pure, and completely empty, form. The esoteric doctrines showed him the way in which pure forms, even 'geometrical signs and glyphs', could be found extremely meaningful. In this way, art would not only be included in the universal doctrine, but it would actually include it. We should not forget that in Marlowe, Shakespeare, Donne and in much of seventeenth century English the word 'art' was used very frequently in the sense of 'magic art' and not of figurative art.

Yeats began experimenting with symbols. Many years later he described his experiences:

There is a form of meditation which permits an image or symbol to generate itself, and the images and symbols so generated build themselves up into coherent structures often beautiful and startling. When a young man I made an exhaustive study of this condition in myself and in others, choosing as a rule for the initiatory symbol a name or form associated with the Cabbalistic Sephiroth, or with one of the five traditional elements. Sometimes, though not in my own case, trance intervened and the structure attained a seeming physical solidity . . . [1]

(Ess. '31 to '36, 58-9)

[1] This practice is amply illustrated by Yeats's fellow-occultist in the Society of the Golden Dawn, Israel Regardie, *The Tree of Life,* London, 1932; here is an example (p. 245): 'When assailed by undesirable thoughts and hateful emotions, relief from their pressure, even spiritual assistance and strength, may be gained by assuming the form of this God [Harpocrates]. By this assumption one's being is transmuted to the shape of the God, and the mind is elevated beyond worldly pettiness by assimilation into the character and nature of divinity. It implies, certainly, a strength of imagination and will, but pictorial images are more easy for most people to retain in the mind than an abstract idea, and any individual with a little practice may be trained to visualize so simple and beautiful a form as the babe on the lotus.' Prof. L. L. Martz in *The Poetry of Meditation* (Yale U.P., 1954; especially pp. 321-30) has noticed how this practice of evocation in Yeats is 'uncannily akin to the orthodox method of meditation' originating in the Jesuitic Spiritual Exercises which deeply influenced the poetry of Southwell, Donne, Herbert, Crashaw, Vaughan and even G. M. Hopkins.

This he wrote when in 1933 he went back once again to Shelley (the first poet who had made a deep impression on him) and re-appraised *Prometheus Unbound*. The very word symbol was associated in his mind both with art and with magic: the evocative power of art was the evocative power of those 'names or forms', those patterns fixed by a long secret tradition, frequently with a geometrical and therefore graphic basis (those geometrical patterns in a children's sketch-book which we saw in the tale of *John Sherman*). One characteristic of such patterns was their repetitiveness: they were few in number and established by an immemorial tradition, like the rose or the lily occurring in the work of certain painters. This enables us to understand better Yeats's defence of them against the 'German painter in Paris' who professed a more rigidly aesthetic doctrine of symbolism. We understand it still more upon reading the last part of Yeats's introduction to Horton's *Book of Images*, which was suppressed as too personal when the introduction was reprinted as 'Symbolism in Painting' in *The Ideas of Good and Evil*:

. . . he who is content to copy common life need never repeat an image, because his eyes show him always changing scenes, and none that cannot be copied; but there must always be a certain monotony in the work of the Symbolist, who can only make symbols out of the things that he loves. Rossetti and Botticelli have put the same face into a number of pictures; M. Maeterlinck has put a mysterious comer, and a lighthouse and a well in a wood into several plays; and Mr. Horton has repeated again and again the woman of *Rosa Mystica*, and the man-at-arms of *Be Strong*; and has put the crooked way of *The Path to the Moon*, 'the straight and narrow way' into *St. George*, and an old drawing in *The Savoy* . . .[1]

I have quoted this passage at some length because the exemplification is significant: Rossetti once again, the sinuous figures of Botticelli, the enchanted silences of Maeterlinck, and

[1] *A Book of Images, cit.,* 15–16.

finally the rather inexperienced drawings of Horton, an un-
happy compromise between the heavy and vigorous contours
of Blake and the elegant linear developments of Beardsley; all
artists in which a linear schematization prevails. Though later
Yeats recognized the poor quality of Horton's art, those draw-
ings made a lasting impression on him: they may or may not
have come from the repository of emblems which was the
'imagination of the world', but they certainly found a place in
that universal repository which was Yeats's mind. They welled
up again in his work, as we shall see; but for the time being it
will be sufficient to say that Horton was one of the three
presiding spirits that he invoked in 'All Souls' Night', the
epilogue to his major philosophical work, *A Vision*: 'Horton's
the first I call . . .' [1]

It is little wonder that with this conception of symbolism
Yeats should have considered as his most sacred book (among
the far too many books which he, at some time or other,
defined as 'sacred') Villiers de l'Isle Adam's play, *Axel*, that
futile attempt at dramatizing in an extremely stylized verbal
form, some chaotic Rosicrucian doctrines. Yeats saw the play
in Paris without having read the text, and without understand-
ing the long speeches, since he knew little French. The first
impact of *Axel* was, once again, visual. This still appears
clearly thirty-five years later, when he wrote the preface to
Finberg's translation of the play:

The most important things are the symbols: the forest castle,
the treasure, the lamp that had burned before Solomon . . . I
can see how those symbols became a part of me, and for years
to come dominated my imagination . . . It is only because I

[1] Another tribute, perhaps unconscious, to Horton is that Yeats in the intro-
duction to the first edition of *A Vision* called one of the imaginary books on
which he pretended to have based his philosophical treatise *The Way of the Soul
Between the Sun and the Moon,* by Kusta ben Luka; Horton had published in
1910 a book of esoteric emblems accompanied by poems with the title *The Way
of the Soul, A Legend in Line and Verse.* On Horton's influence on Yeats see
Gordon and Fletcher, *op. cit.,* 23.

opened the book [he read this laboriously some time after seeing the performance] for the first time when I had the vivid senses of youth that I must see that tower room always, and hear always that thunder.[1]

It is clear that, even so many years later, what Yeats remembered were not the words of the play, but the noise of thunder, and the settings and stage properties: a tower room, a castle in the forest, a treasure hoard, a lamp . . . Once again, the visual character of symbols is underlined. In Paris he went to see *Axel* with the Rosicrucian occultist MacGregor Mathers, whose guest he was at the time. Yeats met Mathers in the British Museum while he was engaged on his edition of Blake. Mathers in his turn was preparing from British Museum MSS. his edition and translation of *The Key of Solomon* (published in 1889), the basic handbook of Cabbalistic magic, reproducing in fifteen plates and 93 figures the 'signs'—mainly geometrical patterns and stylized emblems—for the evocation of spirits, with careful instructions on how to use them.[2] Mathers, at about the same time (1888), had published another handbook, the contents of which are sufficiently explained by its title: *Fortune-Telling Cards. The Tarot, Its Occult Signification, Use in Fortune-Telling, and Method of Play, etc.*; there are in it carefully detailed descriptions and explanations of the twenty-two trumps of the Tarot pack, which are, according to Mathers, 'the hiero-glyphic symbols of the occult meanings of the 22 letters of the Hebrew alphabet'. The signs of Solomon's Key and the Tarot cards are in fact those 'forms associated with the Cabbalistic Sephiroth' which Yeats used in his experiments with magic. The deep impression that they made on him is revealed by a comparison between the diagrams illustrating Mathers' translation of

[1] J. M. Villiers de L'Isle Adam, *Axel,* translated into English by H. P. R. Finberg; preface by W. B. Yeats; illustrations by T. Sturge Moore, London, Jarrolds, 1925; 7–8.

[2] *The Key of Solomon the King* (*Clavicula Salomonis*), now first translated and edited from Ancient MSS. in the British Museum by S. Liddell MacGregor Mathers, London, Redway, 1889.

Solomon's Key, and the diagrams in Yeats's *Vision*. The similarity between these two sets of diagrams, which are mainly made of geometrical patterns enclosed in circles, is striking. And the more so since the meaning attached to them in the two books is completely different. In *A Vision* they are not emblems of magic, but serve only to illustrate the perennial cycles followed by all life, that of individuals as well as that of civilizations. By the time he wrote *A Vision* Yeats did not remember the doctrine of Solomon's Key, but only its figurative emblems, which he adapted to his own purposes.

He was right to consider Mathers, with Horton, as among the presiding spirits of *A Vision* in the already mentioned epilogue to this book:

> And I call up MacGregor from the grave,
> For in my first hard springtime we were friends,
> Although of late estranged.

Mathers did not inspire the system, but provided him with all-important visual and graphic stimuli, both through Solomon's signs and through the Tarot cards: the clumsy but emblem-packed pictures on the latter, with moons and towers and pentacles, etc., obviously influenced Yeats's imagery and his conception of symbolism.

The influence of MacGregor Mathers went even further than this, for it was through him that Yeats became associated in 1890 with the Rosicrucian order of the Hermetic Students of the Golden Dawn. Yeats remained a member of his esoteric society for nearly thirty years, and together with Mathers he devised some of the rituals used by the adepts. The story of the Golden Dawn is very complicated, and has already been told by others,[1] but it made a tremendous impact on Yeats's

[1] The fullest study of Yeats's affiliations to occult societies is Virginia Moore, *The Unicorn; William Butler Yeats' Search for Reality*, N.Y., Macmillan, 1954; for accounts of the Society of the Golden Dawn see I. Regardie, *The Golden Dawn: An Account of the Teachings, Rites and Ceremonies of the Order*, 4 vols.,

imagination, providing him with much occult knowledge and setting him to the study of esoteric texts of different ages and civilizations—books of alchemy, Rosicrucian symbolism and oriental cults.

For the present purpose I want to give only one example of the influence which this had on Yeats: the reference in the passage of his essay on *Prometheus Unbound* quoted above to the symbols of the five traditional elements shows Yeats's acquaintance at this stage with the Hindu doctrine of the Tattvas, according to which, beyond the basic elements of fire, water, air and earth, there is a fifth element, Akasa, which is the Quintessence, or spirit, or ether. In the ritual hierarchy of the Golden Dawn the four lower grades corresponded to the four basic elements, after which an elaborate initiation ritual, known as the Portal ritual, gave access to the inner order, in which the fifth element, Akasa or spirit, was reached. Yeats went through the Portal ritual in 1893. Each of the elements was represented by geometrical symbols, the contemplation and combination of which could be used to induce trance states. As one member of the Golden Dawn wrote: 'The combinations of any two symbols seem in a most singular way to stand out from the dark background of the inner vision and to stimulate all the powers of the imagination.'[1] Yeats followed this practice and meditated at length on the Tattvas symbols (which he mentions even in his commentary to the Yeats and Ellis edition of Blake).

The Tattvas are as follows:

Element	Name	Colour	Figure
Earth	Prithivi	Yellow	Square
Air	Vayu	Blue	Circle

Chicago, Aries Press, 1937–40; I. Regardie, *My Rosicrucian Adventure,* Chicago, Aries Press, 1936; and the more concise articles by Pierre Victor, 'Magie et sociétés secrètes: l'Ordre Hermétique de la Golden Dawn', in *La Tour Saint-Jacques,* nn. 2–3, Janvier–Avril 1956.

[1] I. Regardie, *The Tree of Life, cit.,* 124. Also the following account of the Tattvas symbols is based on Regardie's book; see too I. Regardie, *The Philosopher's Stone,* London, 1938, especially pp. 151 ff.

Element	Name	Colour	Figure
Water	Apas	Silver	Crescent
Fire	Tejas	Red	Triangle
	Akasa	Black	Ovoid (egg)

It is clear that, besides the symbols of the Sephiroth and Tarot cards, these purely geometric patterns of the Tattvas dominated his imagination for the rest of his life.

There are many reasons, then, why a graphic pattern underlies Yeats's thought, and why also his symbolism has a visual and highly stylized basis: firstly, that his father was a painter; secondly, that Yeats's taste was formed on the stylized pre-Raphaelite painting so strictly associated with poetry and literature; thirdly, that he studied at an art school; and fourthly, that his early interest in magic, partly due to his Celtic background, and developed through his association with George Russell, Madame Blavatsky and MacGregor Mathers, stressed the relevance of stylized pattern and visual symbolism.

A further reason, which I have only hinted at above, was the influence of Blake. Yeats, together with Ellis, had been working long and devotedly on the monumental edition of Blake's work. While on the one hand Blake fascinated Yeats with his inextricable esoteric inventions, on the other he was the palpable expression of the link between poetry and visual images. Yeats found on each page of the manuscripts and etchings he was editing the word indivisibly joined with unrealistic powerful images charged with mystical or occult meanings. Blake is in fact for Yeats the archsymbolist: he is the real hero and inspirer of *Ideas of Good and Evil*—the very title of the collection of essays is quoted from Blake; his name recurs in essay after essay, whether Yeats is speaking of magic or of Shelley's poetry. Blake, according to Yeats, 'announced the religion of art'.[1]

Here we touch another basic early belief of Yeats, which was strictly connected with his conception of the ambivalence of

[1] 'William Blake and the Imagination', in *I.G. & E.*, 168.

symbols on the artistic and esoteric planes: the belief that art, through its magic symbolism, is the heir to religion:

> The arts are, I believe, about to take upon their shoulders the burdens that have fallen from the shoulders of priests, and to lead us back upon our journey by filling our thoughts with the essences of things, and not with things. We are about to substitute once more the distillation of alchemy for the analyses of chemistry.
>
> ('*The Autumn of the Body*', *I.G. & E.*, 303)

The essences of things are the symbols, and symbols belong, as we saw, not only to art, but to magic. Significantly enough, in the essay on 'Magic', magic is seen as the root of art:

> Have not poetry and music arisen, as it seems, out of the sounds the enchanters made to help their imagination to enchant, to charm, to bind with a spell themselves, and the passers-by? These very words, a chief part of all praises of music or poetry, still cry to us their origin.
>
> (*I.G. & E.*, 54–5)

or again:

> I cannot now think symbols less than the greatest of all powers whether they are used consciously by the masters of magic, or half unconsciously by their successors, the poet, the musician and the artist.
>
> (*I.G. & E.*, 64)

More statements of this kind could be quoted. But what matters is the fact that this belief of Yeats goes back to his very early youth, and has an essentially aesthetic origin. When he was twenty, in 1885, at the first meeting of the Hermetic Society, of which he was co-founder, Yeats proposed that 'whatever the great poets had affirmed in their finest moments was the nearest we could come to an authoritative religion' (*Aut.*, 90). Here we get to the motivation of Yeats's interest in esoteric doctrines. The starting point was aesthetic: Yeats— a born poet—was conscious of the extraordinary power of works of art, an emotional and intellectual power, a power of

evocation which could not be accounted for through logical and rational means. It was this very unaccountability, the way in which a work of art defies the analysis of reason, that suggested the existence in it of some secret force. For a boy brought up in the wild legends of fairies and dhouls still current in the Irish countryside, it was natural to associate the secret power of art with that of magic. The scientific bent of nineteenth-century thought, whether philosophical or religious, contradicted all visionary intuition, in folk-beliefs as well as in art. Yeats was naturally on the side of art, and therefore on the side of the irrational and anti-scientific. He rebelled against science and against accepted religion, and embraced the wildest forms of belief. But when we come to assess it, his fundamental belief was one: his belief in art.

That is why, though he experimented in a variety of occult practices, though he was fascinated by Oriental religions and philosophies, which he studied to the end of his life, he never embraced any, he was never an orthodox occultist, he never even remained in those esoteric movements which he had helped to found. In the end he reached the point of regarding his own system, as laboriously expounded in *A Vision*, as no other than a mere 'stylistic arrangement of experience'. Though convinced that he was looking for—and finding—a new philosophy and a new religion, his search was always a search not for thought but for art. The opening passage of the already quoted essay on Shelley—in which Yeats refers to the foundation of the Hermetic Society—is in itself revealing:

When I was a boy in Dublin I was one of a group who rented a room in a mean street to discuss philosophy. My fellow-students got more and more interested in certain modern schools of mystical belief, and I never found anybody to share my one unshakeable belief. I thought that whatever of philosophy has been made poetry is alone permanent, and that one should begin to arrange it in some regular order, rejecting nothing as the make-belief of the poets.

(*I.G. & E.*, 90)

Philosophy and religion are for him the formal ordering, the patterning of the visionary images expressed in poetry and in the arts. Such images, Yeats's symbols, which are expressed through poetry, well up from unknown depths. And Yeats, as we learn from his report of the discussion he had with the German Symbolist painter, identified the unknown depths where the images waited to be expressed, with the 'imagination of the world', and developed that conception of a Great Mind and a Great Memory which is one of the mainstays of his personal doctrine of symbolism (the other being his identification of art with magic, philosophy and religion). The page at the beginning of the essay on 'Magic' where this principle is expressed has been quoted by all students of Yeats:

I believe in the practice and philosophy of what we have agreed to call magic, in what I must call the evocation of spirits, though I do not know what they are, in the power of creating magical illusions, in the visions of truth in the depths of the mind when the eyes are closed; and I believe in three doctrines, which have, as I think, been handed down from early times, and been the foundations of nearly all magical practices. These doctrines are—

(1) That the borders of our minds are ever shifting, and that many minds can flow into one another, as it were, and create or reveal a single mind, a single energy.

(2) That the borders of our memories are as shifting, and that our memories are a part of one great memory, the memory of Nature herself.

(3) That this great mind and great memory can be evoked by symbols.

<div align="right">(I.G. & E., 29)</div>

Later Yeats found a confirmation of this doctrine in Henry More's book *Anima Mundi*, which he read in 1914,[1] and he gave this title to one of the two parts of *Per Amica Silentia Lunae*, an important work since it contains the basic ideas

[1] See the letter to his father of 12 Sept. 1914 (*L.*, 588): 'Henry More, the seventeenth-century platonist whom I have been reading all summer . . .'

which he was to elaborate so fantastically in the system of *A Vision*. His medianic 'communicators', he stated, began their teaching of the system by taking as a starting point some of his statements in *Per Amica Silentia Lunae*. And he must certainly have found further support for the idea of a great collective memory in Jung's theory of the collective unconscious: when freed from their magical trappings, Yeats's symbols from the great memory are none other than the archetypal patterns from the collective unconscious which Miss Bodkin has traced in English literature.[1] But Yeats in 1900 was not a psychologist, and magic appealed to his poetic fancy. Even in 1917, in *Anima Mundi*, he was trying to express his conception of the great memory with images borrowed from the poetry of Edmund Spenser, who, as he says more than once in his *Autobiographies*, had presided, with Shelley, over his earliest poetical efforts:

I think of *Anima Mundi* as a great pool or garden where it [a logical process or a series of related images] spreads through allotted growth like a great water plant or branches more fragrantly in the air. Indeed, as Spenser's Garden of Adonis:
 There is the first seminary
Of all things that are born to live and die
According to their kynds.

(*P.A.S.L.,* 63)

Yeats set out to reveal this secret garden.[2] He thought that such was the task of all poetry and art. A further influence may have come into this: the two 'esoteric' novels of Balzac, *Séraphita* and *Louis Lambert*, which Yeats repeatedly mentioned among the books which had a fundamental importance in

[1] Besides her *Archetypal Patterns in Poetry* (O.U.P., 1934), Maud Bodkin carried her Jungian interpretation of literary images beyond the bounds of esoteric mysticism in her *Studies of Type-Images in Poetry, Religion, and Philosophy* (O.U.P., 1951), which contains an analysis of Yeats's 'Second Coming'. The relation between Jungian and Yeatsian ideas is suggested more soberly and convincingly by George Whalley, *Poetic Process,* London, Routledge, 1953.

[2] See Excursus II: The Enchanted Garden.

shaping his thought. As late as 1933 he wrote an essay re-assessing *Louis Lambert*, and drawing attention once again to its value.[1] We can see how Yeats must have been struck by a sentence like the following, in *Louis Lambert*, which I quote from G. Saintsbury's edition of *La Comédie Humaine* (published in 1897, this is probably the edition Yeats knew):

Ideas are a complete system within us, resembling a natural kingdom, a sort of flora, of which the iconography will one day be outlined by some man who will perhaps be accounted a madman.[2]

Once again there is that natural kingdom of ideas, that garden which is the world imagination, the great mind and great memory. And the seer who tries to outline it is accounted a madman. This explains the defiant tone of Yeats's essay on Magic, and the 'risk' of which he speaks in the impetuous last sentences of that essay:

And surely, at whatever risk, we must cry out that imagination is always seeking to remake the world according to the impulses and the patterns in that great Mind, and that great Memory? Can there be anything so important as to cry out that what we call romance, poetry, intellectual beauty, is the only signal that the supreme Enchanter, or some one in His councils, is speaking of what has been, and shall be again, in the consummation of time?

<div align="right">(I.G. & E., 68–9)</div>

[1] 'Louis Lambert', first published in *The Spectator,* is included in *Ess. '31 to '36.* An assessment of the influence of the novel on Yeats was attempted in: Carl Benson, 'Yeats and Balzac's *Louis Lambert*', in *Mod. Philol.*, XLIX, 4, May 1952, 242–7; a more thorough and penetrating treatment of the connections between the two authors is to be found in F. A. C. Wilson, *W. B. Yeats and the Tradition*, London, Gollancz, 1958.

[2] Balzac, *La Comédie Humaine,* ed. G. Saintsbury, London, 1897; vol. 34, p. 209; in this edition *Séraphita* and *Louis Lambert* are printed in one volume. In 1905 Yeats bought a forty-volume English edition of Balzac, in 1908 he was reading it systematically and by December he had reached the 12th or 13th volume, but stated that he had read 'some of the remainder' years before (*L.*, 449; 513).

Poetry and art, as expressed in symbolism, he claims, are magic and religion (the only signal from the supreme Enchanter); the great Memory is the repository of all symbols, is the secret garden of ideas located in the great Mind; and the great Mind in turn is the only superhuman entity, the only divinity.

Such is the essence of Yeats's personal doctrine of symbolism, as distinct from the more generalized acceptation of the word in the literary field. We saw most of the elements which went to shape that doctrine in Yeats's mind: from the pre-Raphaelites and Morris to the occultist teachings of Madame Blavatsky and MacGregor Mathers; from the poetry of Spenser and Shelley to Yeats's own artistic training; from the visionary world of William Blake and of that other William, so much his inferior, William T. Horton, to the stage properties of *Axel* and the esoteric novels of Balzac. But there is a further influence which I have only hinted at, though it was amply acknowledged by Yeats himself in his *Autobiographies*, and has been rightly emphasized by different critics, especially by Mr. Hough and Professor Lombardo.[1] This is the influence of the aesthetic movement, which reached its peak, perhaps, at the time when Yeats was a contributor to *The Savoy* (1896), belonged to the Rhymers' Club, and was a friend of Arthur Symons, Aubrey Beardsley, Oscar Wilde, Dowson, Johnson and other poets and artists so movingly evoked in his *The Trembling of the Veil*. From them he had learnt to pay that attention to form and pattern, which plays such a part in his theory of symbolism. It is enough to look at the passages quoted above to see how strongly he felt the need for form: the images and symbols evoked in magical practices 'build themselves up into coherent structures': he wanted to 'arrange in some regular order' whatever of philosophy has been made poetry; finally, imagination is seeking to remake the world according to 'the patterns in that great Mind'.

[1] G. Hough, *The Last Romantics,* London, Duckworth, 1949; A. Lombardo, *op. cit.*

Pater and his followers had founded the cult of form and of formal arrangement, both in the figurative arts and in literature. It was just this precise and precious formal arrangement of verbal and figurative elements which they called style. Yeats, as in other cases, transferred this conception from the merely aesthetic onto the philosophic and magical plane: like Pater he wanted to arrange the elements of a composition in the most beautiful order possible, but for Yeats the elements were symbols with a mysterious magical content.

The cult of beauty as an end in itself (art for art's sake), suggested a curious apologue in Yeats's story 'The Eaters of Precious Stones', published in *The Celtic Twilight* (1902), and its presentation in the form of a waking dream further connects it with Yeats's addiction to dream-states induced by 'magic' practices:

One day I saw faintly [in a waking dream] an immense pit of blackness, round which went a circular parapet, and on this parapet sat innumerable apes eating precious stones out of the palms of their hands. The stones glittered green and crimson, and the apes devoured them with an insatiable hunger. I knew that I saw my own Hell there, the Hell of the artist, and that all who sought after beautiful and wonderful things with too avid a thirst, lost peace and form and became shapeless and common.

<div align="right">(E.P. & S., 263)</div>

It is the Hell of the aesthete. The fate of becoming shapeless and common befell too many fin-de-siècle collectors of beautiful things, who lacked the strength to carry out the basic tenet of aestheticism: to order them, to subject them to a form. At the same time the precious stones eaten by the apes can be those symbols of which Yeats was so fond, symbols that glittered, as he said, 'as a sword-blade may flicker with the light of burning towers'.[1] Symbols, then, must be strictly connected with

[1] 'The Symbolism of Poetry', *I.G. & E.*, 243.

pattern, with style; Yeats identifies them with it, writing in his essay on 'The Symbolism of Poetry' (1900):

In 'Symbolism in Painting' I tried to describe the element of symbolism that is in pictures and sculpture, and described a little the symbolism in poetry, but did not describe at all the continuous indefinable symbolism which is the substance of all style.

(I.G. & E., 241)

Symbolism, then, when it is true symbolism with all its magical overtones, has a kind of internal and occult organization which makes it style, which gives it form. Yeats quotes the example of Blake, remarking that, even when ungrammatical or obscure, his poetry has form, 'the form of sincere poetry'. Yeats, by giving this twist to the meaning of form and style, and by excluding from the definition what is merely outer polish, avoids one of the major pitfalls of the aesthetic doctrine: the frequent confusion between form and formalism. This is a further example of his intuitive power: while he seemed to have taken the wrong turning, complicating the meaning of symbolism with extremely dubious magic lore, this same false step set him on the right road to an understanding of the true essence of style. By endowing symbols with a super-human and therefore intangible quality, he realized that form and style were not a question of a-posteriori external finish, but of their instinctive and unaccountable arrangement in the mind.

I

The Beast and the Unicorn

═══════════════════════════════════════

The Second Coming! Hardly are those words out
When a vast image out of *Spiritus Mundi*
Troubles my sight: somewhere in sands of the desert
A shape with lion body and the head of a man,
A gaze blank and pitiless as the sun,
Is moving its slow thighs, while all about it
Reel shadows of the indignant desert birds.
The darkness drops again; but now I know
That twenty centuries of stony sleep
Were vexed to nightmare by a rocking cradle,
And what rough beast, its hour come round at last,
Slouches towards Bethlehem to be born?

THESE are not only some of Yeats's most impressive lines, but
also some of the most significant from the point of view of his
symbolism. In this passage from 'The Second Coming' (1919)
Yeats's symbolism had come to maturity. The 'rough beast'
represents the Second Coming, the advent of a new historical
cycle which is going to completely reverse all the values
cherished by the Christian era. It is known that Yeats, though
representing this new advent with terrifying images, thought of
it as necessary and inescapable, and looked forward to it with
passionate intensity.

W.M.A.—D 35

One of the elements contributing to the emotional impact that the poem (even when not perfectly or rationally understood) has on the reader, is the vagueness of the description of the beast slouching towards Bethlehem: it instinctively conveys the terror of the unknown, the indefinably monstrous. Vagueness is a virtue, in this case, because it is suggestive, and if an illustrator were to draw a detailed picture of the prodigious beast he would only diminish the power of the poetry, by over-defining the visionary figuration. Nevertheless, I propose to examine this image and its origin in Yeats's mind in detail, because it is particularly revealing in two respects. In the first place, in relation to the nature of Yeats's imaginative process, his treatment of symbols and the way in which they were transformed in his mind; in the second place in relation to the origin, development and significance of another image recurring in Yeats's plays and poems, that of the unicorn.

The rough beast is described as having a 'lion body and the head of a man' and a blank gaze. This is all we are told in the poem. The most obvious interpretation seems to be the sphinx, a recurrent motif for Yeats from an early stage.[1] Mr. Henn suggests several other possible visual sources for this mythical creature, the most likely of which seems to be Blake's illustration to the *Divine Comedy* representing a winged lion with an eagle's head drawing Beatrice's chariot. Yeats speaks of a man's and not an eagle's head, but we must take its vagueness into account, and the fact that this is obviously a composite image, the details of which must have been blurred and shifting in

[1] See especially the Sphinx in 'The Double Vision of Michael Robartes' (1919) and perhaps 'Rocky Face' in 'The Gyres'; Gordon and Fletcher (*op. cit.*) stress the suggestiveness of the Sphinxes in works of art well known to Yeats: Moreau's paintings and Ricketts' precious illustrations for Oscar Wilde's *The Sphinx* (1894). More relevant perhaps are the male bearded Sphinxes drawn by T. Sturge Moore to decorate Finberg's translation of *Axel* (*cit.*), though this appeared only in 1925: they are emblems of occult wisdom and prophecy, the 'Magi'. The next reference is to T. R. Henn, *The Lonely Tower*, London, Methuen, 1950, 136. Another interesting suggestion of Mr. Henn's is that the beast 'may be no more than a memory of the Lion of St. Mark at Venice'.

Yeats's mind. The man's head may well have come from another drawing of Blake's, in which an aged man, Nebuchadnezzar, is slouching on all fours along the ground. The body of the old king, in Blake's powerful drawing, is more like that of the beast he had become, than of a man. Whether or not these pictures by Blake were before Yeats's mind's eye while writing 'The Second Coming', the mysterious animal form he was thinking of had been long in his imagination, and its features were continually changing. Mr. Peter Ure[1] has traced it back to the black Titan emerging from a heap of ruins in a desert, seen by Yeats in vision during his spiritualistic experiences with MacGregor Mathers in 1887. Certainly the disturbing apparition had been with him for a long time, as appears from a very significant passage in the introduction to the play *The Resurrection*, written in 1934:

Had I begun *On Baile's Strand* or not when I began to imagine, as always at my left side just out of the range of the sight, a brazen winged beast that I associated with laughing, ecstatic destruction?

(*W. & B.*, 103)

Furthermore, to the words 'a brazen winged beast' Yeats himself appended the footnote: '*Afterwards described in my poem "The Second Coming".*'

The associations become in this way more complex. The description in the poem itself does not suggest brass, or wings, or laughter, which—in Yeats's recollection—characterized his early visionary intuition of the Apocalyptic animal. For confirmation we must turn to the works he wrote at the beginning of this century (*On Baile's Strand* was begun in 1901, completed

[1] P. Ure, *Towards a Mythology*, Liverpool Univ. Press, 1946, 46. I rather suspect that the vision of the Titan was suggested to Yeats by Blake's illustrations to Canto XXXI of Dante's *Inferno*, representing 'Nimrod' and 'Ephialtes and Two Other Titans'. Horton too, of whom Yeats said that he had the same kind of visions as he had himself, represents giant figures emerging in landscapes from the waist up: see e.g. 'Mammon' in Horton's *Book of Images, cit.,* for which Yeats wrote the preface in 1898.

in 1903). At the time his main interest was not so much poetry as the theatre. Apart from *On Baile's Strand* he wrote in those three years *Kathleen ni Houlihan*, the prose version of *The Hour Glass, A Pot o' Broth, Where There Is Nothing*, and *The King's Threshold*. It is in *Where There Is Nothing*, the least known of these plays, that we find allusions to the 'brazen winged beast'.

Where There Is Nothing has been rather overlooked by Yeatsian scholars, and for very good reasons: from a literary point of view it is not distinguished, its most peculiar feature being a new Nietzschian strain in some of the speeches; since 1908 it disappeared from Yeats's collected plays because it was completely re-written, reduced from five to three acts, the names of the characters and most of the situations were changed, and the title became *The Unicorn from the Stars*; finally, both *Where There Is Nothing* and *The Unicorn from the Stars* are plays written in collaboration, and therefore considered unrepresentative of Yeats's personality. A letter addressed by the poet to his publisher, A. H. Bullen, in 1908 tells the story:

> Though *The Unicorn* is almost altogether Lady Gregory's writing it has far more of my spirit in it than *Where There Is Nothing* which she and I and Douglas Hyde wrote in a fortnight to keep George Moore from stealing the plot . . . There is certainly much more of my own actual writing in *Where There Is Nothing*, but I feel that this new play [*The Unicorn from the Stars*] belongs to my world and that it [*Where There Is Nothing*] does not . . . I planned out *The Unicorn* to carry to a more complete realization the central idea of the stories in *The Secret Rose* and I believe it has more natural affinities with those stories than has *Where There Is Nothing* . . .
>
> (*L.*, 503)

It is for the sake of that 'central idea' that *Where There Is Nothing*, as well as *The Unicorn* and the stories of *The Secret Rose*, are worth examining afresh. It must be kept in mind that, up to that time, Yeats tended to keep ideas out of his poems, and to express them instead in his essays, stories and plays—that is why many of the apparently obscure conceptions

expressed in his later poems are clarified if one turns to the stories and plays written in the 'nineties or at the beginning of this century.

The central idea behind the stories and the plays just mentioned is the prophetic intuition of the advent of a new cycle of civilization, which is to destroy all the work done during the previous cycle and to subvert all established principles. Such an event could only be expressed by way of parable, symbol or myth. The stories 'Rosa Alchemica', 'The Tables of the Law' and 'The Adoration of the Magi' (1896, included in 1908 in *The Secret Rose* volume of the collected edition of Yeats's works) are such parables, and so are 'The Second Coming' (1919) or the sonnet 'Leda and the Swan' (1923). It is rewarding to see how Yeats developed the same theme in *Where There Is Nothing* (1902).

The hero of the play is an Irish visionary from an aristocratic family, Paul Ruttledge, who, impelled by some superhuman call, deserts his kin to join a company of tramps together with whom he intends to subvert and destroy the established social order. Later he enters a monastery and there too, under the impulse of his visions, he preaches the subversion of the established religion, the advent of a new dispensation, till he and his followers are expelled, and he dies at the hands of a superstitious crowd, like Michael Robartes in 'Rosa Alchemica'.[1] *The Unicorn from the Stars* is very much along the same lines: the visionary is called Martin Hearne, his visions induce him to take the lead of a crowd of tramps who set fire to the land, and in the end he is killed by mistake during a struggle with the constables.

But what interests us at this stage is the kind of images through which Yeats's visionary conception of the forces of subversion is expressed in *Where There Is Nothing*. It can be

[1] Michael Robartes and Owen Aherne are the heroes of the esoteric tales written by Yeats in the 'nineties. He 'revived' Robartes in 1918 (see note to 'The Phases of the Moon' in *C.P.*, 532) and attributed to these fictitious characters the finding of the doctrines he was to develop in *A Vision*.

gathered from the words of Paul Ruttledge in Act II of the play:

Paul: I have taken to the roads because there is a wild beast I would overtake, and these people are good snarers of beasts. They can help me.

Charlie Ward: What kind of a wild beast is it you want?

Paul: Oh! it's a very terrible wild beast, with iron teeth and brazen claws that can root up spires and towers.

* * *

My wild beast is Laughter, the mightiest of the enemies of God.

* * *

I think they have seen my wild beast, Laughter. They could tell me if he has a face smoky from the eternal fires, and wings of brass and claws of brass (*Holds out his hands and moves them like claws*). Sabina, would you like to see a beast with eyes hard and cold and blue, like sapphires?

(*W.T. Is N.,* 45, 46, 50)

Here, seventeen years earlier, is the 'brazen winged beast, associated with laughing ecstatic destruction', with the blank gaze which we find in 'The Second Coming'. In the play it is made quite clear that the fabulous beast stands for 'a terrible joy', sent to 'overturn governments and all settled order' and to 'bring back the old joyful, dangerous, individual life'. The symbolic, or even emblematic, quality of the image is stressed in the last scene of the play, when it is seen as the figure painted on the banner of the army marching against the Church and the World, against all settled order:

We will have one great banner that will go in front, it will take two men to carry it, and on it we will have Laughter, with his iron claws and his wings of brass and his eyes like sapphires.

(*W.T. Is N.,* 121)

A moment later the physical representation of the revolu-

40

tionary forces is transposed onto a merely mental plane (as was to happen also in *The Unicorn from the Stars*) and Paul Ruttledge exclaims:

> We cannot destroy the world with armies, it is inside our minds that it must be destroyed, it must be consumed in a moment inside our minds.
>
> (*W.T. Is N.,* 121–2)

But the basic idea remains: that of a revolutionary movement inspired from above, from a vision. It is an idea partly derived from Blake; but the choice of Laughter as its manifestation shows the influence of another author who had, just at this time, fascinated Yeats: in 1902 he had been reading Nietzsche intensively. A letter to Lady Gregory of September 1902 is very significant:

> I have written to you little and badly of late I am afraid, for the truth is you have a rival in Nietzsche, that strong enchanter. I have read him so much that I have made my eyes bad again . . . Nietzsche completes Blake and has the same roots—I have not read anything with so much excitement since I got to love Morris's stories which have the same curious astringent joy.
>
> Paul is at last finished, sermon and all, and is going to press. I have written in a good deal here and there—sermon gave me most trouble but it is right now. It is as simple as it was and no longer impersonal but altogether a personal dream . . .

The 'Paul' to which Yeats refers in the last sentence quoted is Paul Ruttledge, the hero of *Where There Is Nothing*. The letter provides final proof that he gave the finishing touches to the play while under the strong influence of Nietzsche, whom he considered as an ideal complement of Blake. No wonder that Yeats should have adopted in it the Nietzschian conception of Laughter announcing the advent of the superman; and then, when trying to find an emblematic figuration for Laughter, he

may have remembered some monstrous human or animal
figure out of Blake.

This was the origin of the 'brazen winged beast' which was
to figure so impressively in 'The Second Coming', and which
was to undergo a number of transformations in the later poems.
It was an emblem of the future era, an era of terror and joy, of
destruction and rebirth; it was to be represented by such
shadowy and shifting images as the Sphinx in 'The Double
Vision of Michael Robartes' (1919) or finally as Old Rocky
Face in one of Yeats's last poems, 'The Gyres':[1]

The gyres! the gyres! Old Rocky Face, look forth;

* * *

Irrational streams of blood are staining earth;
Empedocles has thrown all things about;
Hector is dead and there's a light in Troy;
We that look on but laugh in tragic joy.

What matter though numb nightmare ride on top,
And blood and mire the sensitive body stain?
What matter? Heave no sigh, let no tear drop,
A greater, a more gracious time has gone;

* * *

What matter? Out of cavern comes a voice,
And all it knows is that one word 'Rejoice!'

(*C.P.*, 337)

In 'The Second Coming' and 'The Gyres' the 'wild beast,
Laughter', awkwardly described by Paul Ruttledge in *Where
There Is Nothing*, reaches full poetic expression. It is prophecy

[1] For the connection between 'The Gyres', 'The Second Coming' and 'The
Double Vision of Michael Robartes', see Henn, *op. cit.*, 303; cp. D. Stauffer,
op. cit., 43. Professor Jeffares in 'Yeats's "The Gyres": Sources and Symbolism',
The Huntington Library Quarterly, XV, 1, Nov. 1951, 87–97, identifies 'Old
Rocky Face' with Ahasuerus the Wandering Jew in Shelley's *Hellas*.

and tragic joy, terror and laughter, a feeling more than a symbol. Yeats is no longer bound by his own personal nightmare of the 'brazen winged beast', and does not try to describe in detail his imagined symbolic animal. By being more indefinite he succeeds in communicating the sense of universal nightmare.

There is more in *Where There Is Nothing* which is of interest: there is a surprising shift of image in mid-career. While in the first two and in the fifth acts Paul Ruttledge speaks of a wild beast with brazen wings and hard, cold, blue eyes as a personification of his dreams of destruction, in the fourth act, relating one of his visions, he uses a very different symbol for the same conception. During the first part of the act Paul (now Brother Paul, since he has become a monk) is seen lying in a trance on the stage. When he wakes up he relates his dream. He thought he was being trampled on, pecked, bitten and clawed by all sorts of birds and beasts, symbolizing 'the part of mankind that is not human, the part that builds up the things that keep the soul from God'; he goes on:

Then suddenly there came a bright light, and all in a minute the beasts were gone, and I saw a great many angels riding upon unicorns, white angels on white unicorns. They stood all round me, and they cried out, 'Brother Paul, go and preach; get up and preach, Brother Paul.' And then they laughed aloud, and the unicorns trampled the ground as though the world were already falling in pieces.

<div align="right">(W.T. Is N., 87–8)</div>

Two things should be noticed at this point: this is the first time that Yeats mentions unicorns in his published writings, and the destructive angels riding unicorns are the exact equivalent of the fabulous indefinite beast mentioned before and after in the play. In view of the subsequent development of this image in Yeats's work it seems probable that it was introduced here by Yeats, rather than Hyde or Lady Gregory. And two questions could be asked: why in the middle of the play did he decide to introduce this new distracting symbol he had

never used before? What suggested the unicorn to him as a suitable image?

The first question is harder to answer. Perhaps we could refer to Yeats's own words in the quoted letter to Lady Gregory: he wanted to give the character of Paul a 'personal dream', a dream belonging to him as a character, not to its author. Besides he may have felt that his 'brazen winged beast' was too much of a private symbol, which a theatre audience could not easily understand and visualize; he wanted to represent the new destructive and freedom-giving force in an animal shape to underline the fact that such a universal change could be brought about only by the united impact of Godhead and sheer animality, the superhuman and the brute at once. An unreal animal from the fabulous medieval bestiary would therefore serve his purpose: the unicorn was such, and had the advantage of being familiar to his audience, who would grasp the supernatural and savage quality of the symbol. The unicorn has also a certain nobility and spirituality, deriving from its traditional association with the idea of chastity; and to emphasize the spiritual element Yeats made his hero speak of angels riding unicorns. While from the unknown image of the brazen winged beast the audience would have received only an obscure impression of terror, from the much more familiar one of the unicorn they would get a sense of superhuman glory and spiritual triumph as well: and it was charged at the same time with a strong visual appeal.

As for the origin of the image of the unicorn in Yeats's mind, it can be stated with certainty that this was double, both visual and esoteric. It has been proved that Yeats was particularly sensitive to visual stimuli, to the suggestions of pictures and works of art.[1] He certainly saw a number of pictures of unicorns before 1902. One of them, a painting by Gustave Moreau (a favourite artist with Yeats) which he must have seen during one of his visits to Paris in the 'nineties, impressed him so much

[1] See especially T. R. Henn, *op. cit.*, Gordon and Fletcher, *op. cit.*, and the later chapters of the present book.

through its vague and complex symbolism, that as late as 1936 the poet kept a reproduction of it in his room: the painting was *Ladies and Unicorns* (*L.*, 865). But the particular connotations of the vision described in *Where There Is Nothing*, white unicorns ridden by bright angels, are to be found in another picture that Yeats had certainly seen shortly before. This picture decorated the end-papers of a periodical to which he contributed regularly from 1897 to July 1900, when it ceased publication. The magazine was called *The Dome*, described in the first issue (for Lady Day 1897) as 'A Quarterly containing Examples of All the Arts', and was published by the Unicorn Press. The emblem of the publishers is a vignette drawn by W. L. Bruckman (used in the end-papers in the first issue and on the back cover in the later ones) representing a unicorn, rampant, on a mosaic background, its head encircled by the solar disc. That must have been attractive enough for Yeats, as suggesting the heavenly nature of the symbol.[1] But the end-papers used from the second issue of the periodical onwards are still more remarkable: they represent two prancing white unicorns facing each other, ridden by naked youths with wide-spread wings, armed with spears and shields. It seems more than probable that this was the picture that appeared in Yeats's mind when he was describing Paul Ruttledge's vision: the winged youths as the bright fighting angels.

The particular visual image of the unicorn would not probably have impressed itself on Yeats's mind so firmly if, at the time, the unicorn had not had for him a deep symbolic meaning. The period when Yeats was most deeply involved in

[1] The supernatural beings in Yeats's symbolical mythology had their origin in the sun, as it appears from the words of Cuchulain in *On Baile's Strand* (1903): 'He that's in the sun begot this body / Upon a mortal woman.' In a later version of the same play this divine being is identified as a hawk: 'that clean hawk out of the air / That, as men say, begot this body of mine / Upon a mortal woman.' The union of woman and supernatural beast, adumbrated here, can be followed through the Unicorn legend in *The Player Queen* and the Leda myth in 'Leda and the Swan', to Yeats's very personal myth of the Great Herne (heron and hawk in one) in *The Herne's Egg*.

1. End-papers of *The Dome* in the years 1898–9.

the activities of the Golden Dawn was at the turn of the century, when the Hermetic Society was going through a crisis. On this occasion, in 1901, Yeats wrote and published (privately and anonymously) a pamphlet dealing with some contingent problems, as the title shows: *Is the Order of R.R. & A.C. to remain a Magical Order?* (the initials mean 'Rosa Rubea et Aurea Crux', the Red Rose and the Golden Cross, the name of the Second or Inner Order of the Golden Dawn, into which Yeats had been admitted). He was fascinated by the ritual and by the magic lore of the Order. The title for the third grade, which Yeats held for some time in the early 'nineties, was that of *Monocris* (or *Monoceros*) *de Astris*, the Unicorn from the Stars.[1]

This title was certainly connected with the symbolism to be found in a sixteenth century text which was considered a sacred book by the Golden Dawn. This book was *The Chymical Marriage of Christian Rosencreutz*, the Latin original of which is generally attributed to Johann Valentin Andreas, but which exists in English in a delightful seventeenth century translation. This translation had been included by A. E. Waite, himself a prominent member of the Golden Dawn, in his *Real History of the Rosicrucians* (1887).[2] Yeats was certainly familiar with this book, and himself wrote an essay 'The Body of the Father Christian Rosencrux'.[3] The unicorn figures prominently in the extraordinary bestiary of the *Chymical Marriage*, and appears also in *The Book of Lambspring*, one of the alchemical treatises included in the seventeenth century

[1] Reference should be made to the books listed in the notes to pp. 24 and 25, *supra*.

[2] A. E. Waite, *The Real History of the Rosicrucians, Founded on Their Manifestoes, and on the Facts and Documents Collected from the Writings of Initiated Brethren*, London, Redway, 1887; 99–196.

[3] See *I.G. & E.*, 308–11; the essay, which is dated 1895, uses the legend of the finding of the body of Father Rosencreutz, well known to Golden Dawn initiates, as a rather commonplace allegory of the state of contemporary art: the sacred body of Rosencreutz is 'imagination' which for two hundred years 'has been laid in a great tomb of criticism'; the re-discovery of the 'body' means that 'this age of criticism is about to pass, and an age of imagination, of emotion, of moods, of revelation, about to come in its place.'

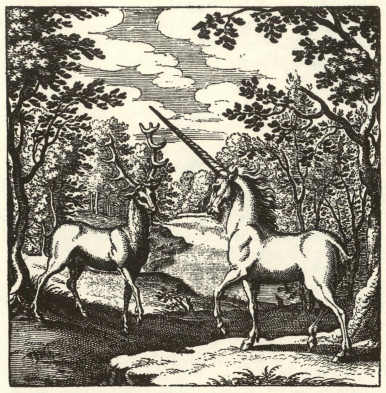

2. Illustration to 'The Book of Lambspring', in *The Hermetic Museum* (1893).

collection *Musaeum Hermeticum*, which had been translated into
English by Waite in 1893.[1]

This book, 'concerning the philosophical stone', is a series of

[1] *Musaeum Hermeticum*, Frankfurt, 1678. The English edition, in two vols.,
bears the title *The Hermetic Museum restored and enlarged: Most faithfully instructing
all Disciples of the Sopho-Spagyric Art how that Greatest and Truest Medicine of The
Philosopher's Stone may be found and held.* Now first done into English from the
Latin Original . . . Containing Twenty-two most celebrated Chemical Tracts,
London, Elliott and Co., 1893. *The Book of Lambspring, A Noble Ancient Philo-
sopher, concerning the Philosophical Stone; rendered into Latin verse by Nicholas Barnaud
Delphino*, is in vol. I, pp. 271 ff. of this edition. On the tradition of alchemical
emblem books, which may have influenced Blake's *The Gates of Paradise*, see
G. W. Digby, *Symbol and Image in William Blake*, O.U.P., 1957, 5–7.

alchemical emblems with commentaries, originally in Latin verse. The third picture in the book, representing a deer and a unicorn in a forest, is emblematic of the maxim that 'In the Body there is Soul and Spirit'. In view of Yeats's use of the Unicorn symbol I think it relevant to quote the commentary to this emblem in full:

> The Sages say truly
> That two animals are in this forest;
> One glorious, beautiful, and swift
> A great and strong deer;
> The other an unicorn.
> They are concealed in the forest,
> But happy shall that man be called
> Who shall snare and capture them.[1]
> The masters show you here clearly
> That in all places
> These two animals wander about in forests
> (But know that the forest is but one)
> If we apply the parable to our Art,
> We shall call the forest the Body.
> That will be rightly and truly said.
> The Unicorn will be the spirit at all times.[2]
> The deer desires no other name
> But that of the Soul; which name no man shall take
> away from it.
> He that knows how to tame and master them by Art,
> To couple them together,
> And to lead them in and out of the forest,
> May justly be called a Master.
> For we rightly judge
> That he has attained the golden flesh,

[1] Compare the passages from Yeats's *Where There Is Nothing* quoted *supra*: '. . . these people are good snarers of beasts . . .'

[2] Compare Yeats's definition of the symbolism of the Unicorn in the letter to his sister quoted *post*.

And may triumph everywhere;
Nay, he may bear rule over great Augustus.[1]

The choice of the unicorn as a visionary beast in Yeats's play was prompted by all these magical associations. This is typical of the way in which Yeats treated his esoteric beliefs, whether those learnt from Madame Blavatsky, or MacGregor Mathers and the Golden Dawn, or later through his wife's medianic powers. The original significance of the symbols was transformed in his mind, where they remained above all as fantastic stimuli of a visionary imagination, to reappear later as poetic images in his works, upon which he put a different symbolic construction from their earlier limited esoteric meaning. Significantly enough, the symbols that he chose most frequently were those which had the strongest visual appeal, which could be visualized, or actually seen in pictures or statues. We find again and again, and Mr. Henn's book is illuminating on this point, the combination, in Yeats's favourite symbols, of intellectual and visual impulses. Inspiration seems to come to him under the double and contemporary impact of abstract (even abstruse) thought and visual sense. And this, I think, is the nature of the visionary, since vision is indeed an inner *sight*, something, to use an expression of Yeats's, actually '*seen* under one's closed eyelids'.[2] It should however be taken into account that into the vision, as into the dream, there enter reminiscences of things seen in waking life (however transformed and mixed together). When we try to identify the pictures the poet saw during his life, we are looking not so much for the sources of the images used in his poetry, as for the origin of his visions, which in turn suggested those images.

In *Where There Is Nothing* the esoteric symbol of the 'Unicorn from the Stars' is suddenly equated with a visionary brazen winged beast, and at the same time is represented in images reminiscent of the pictures in the end-papers of *The Dome*. From this time onward, for a good many years, the unicorn was

[1] *The Hermetic Museum, cit.*, I, 280; illustration, I, 281. [2] *Vis. A,* 191.

to remain one of Yeats's most cherished and most private symbols, though it figures in only one poem. In the plays it is mentioned several times, but at first only in passing, as a poetic exotic. In *The King's Threshold* (written about 1903) we are told that poets should guard their 'images' as 'the pale, righteous horse' guards 'the jewel that is underneath his horn'.[1] In *Deirdre* (completed in 1906) 'the ivory of the fierce unicorn' is mentioned.[2] The allusions are irrelevant to the symbolic meaning which Yeats had attributed to the unicorn, and testify only to the permanence of the image in his mind. Meanwhile *Where There Is Nothing* was being completely rewritten, to reappear five years later in the collected edition of 1908 as *The Unicorn from the Stars*. With such a title there is no risk of missing the central symbol of the play. It is interesting to notice that now all allusions to 'Laughter, with his iron claws and his wings of brass' have disappeared. When Martin Hearne,[3] who has taken the place of Paul Ruttledge of the earlier play, wakes up from his trance in the first act, he says:[4]

There were horses—white horses rushing by, with white shining riders—there was a horse without a rider, and some one caught me up and put me upon him and we rode away, with the wind, like the wind— . . .

We went on, on, on. We came to a sweet-smelling garden with a gate to it, and there were wheatfields in full ear around, and there were vineyards like I saw in France, and the grapes in bunches. I thought it to be one of the townlands of Heaven. Then I saw the horses we were on had changed to unicorns, and they began trampling the grapes and breaking them. I tried to stop them, but I could not.

[1] *C.Pl.,* 112 (lines unaltered from first edition, 1904).

[2] *C.Pl.,* 175 (lines unaltered from first edition, 1907).

[3] As Miss Virginia Moore hints (*op. cit.,* 402), Owen Aherne of the early esoteric tales, Martin Hearne, and the Great Herne of the later play *The Herne's Egg* seem to express the affinity of their nature in that of their names; they could in fact be considered as three stages in the development of a superhuman figure.

[4] The passages of *The Unicorn from the Stars* I quote remained unaltered from the first edition of the play (1908) to the last.

Father John: That is strange, that is strange. What is it that brings to mind? I heard it in some place, *monoceros de astris*, the unicorn from the stars.

<div align="right">(*C.Pl.*, 337)</div>

Here the very title which Yeats bore in the Golden Dawn is mentioned, though the members of the Order were not supposed to reveal anything connected with it and its rituals. Yeats takes the precaution of putting the words into the mouth of a priest, so that the uninitiated reader would tend to connect them with some Biblical reference; Martin's words which I have quoted are compact with images out of the Book of the Revelation—the horsemen of the Apocalypse, and the winepress of the wrath of God, of which it is said that 'blood came out of it even unto the horses bridles' (Rev. xiv. 20); and in Isaiah xxxiv. unicorns are mentioned in connection with the terrible vengeance of the Lord, who will destroy all nations. *The Unicorn from the Stars* is, among the works of Yeats, the fullest of Biblical imagery. We may account for this uncommon feature of the play by the fact that, as Yeats repeatedly acknowledged, most of the actual writing was Lady Gregory's,[1] though the 'spirit' was his own. Having to put Yeats's visions into words she—an observing Protestant—thought in terms of the visionary and prophetic texts with which she was most familiar, those of the Bible,[2] rather than of the esoteric literature Yeats knew.

This Biblical tone is kept up in the rest of the play. There is the golden bowl of the last chapter of Ecclesiastes in the description of the last part of Martin's vision:

I saw a bright many-changing figure; it was holding up a

[1] See the letter to Bullen quoted *supra,* and the introductions to the volumes in which the play was included, e.g. the first edition of *C.Pl.* (1934): 'I have explained my indebtedness to Lady Gregory. If I could have persuaded her, she would have signed *The Unicorn from the Stars,* her share in it is so great.'

[2] Yeats remarked of Lady Gregory: 'She hates all clergy though she never misses church and is a great reader of her bible and, as she believes, very orthodox' (*L.*, 706).

shining vessel; then the vessel fell and was broken with a great crash; then I saw the unicorns trampling it. They were breaking the world to pieces—when I saw the cracks coming I shouted for joy! And I heard the command, 'Destroy, destroy, destruction is the life-giver! destroy.'

<div align="right">(C.Pl., 345-6)</div>

And in the second act Martin paints on the banner of his army of destruction the figure of the Unicorn. This time there is no mistaking the symbol: the divine nature of the unicorn, a scourge from above which will bring renewal, through ruin —irresistible spiritual force announcing a Second Coming, a new dispensation. We understand also the announcement of Septimus in that strange play of Yeats, *The Player Queen*, which took him over ten years to write (from 1908 to 1919):[1]

Gather about me, for I announce the end of the Christian Era, the coming of a New Dispensation, that of the New Adam, that of the Unicorn . . .

<div align="right">(Pl., 398; Pl.Q., 42)</div>

Before discussing *The Player Queen* I wish to draw some conclusions from what has been said up to this point. The unicorn struck Yeats's imagination in the 'nineties, but established itself as one of his symbols only at the beginning of this century, when he was looking for a fabulous animal to represent the brazen winged beast that haunted his visions. He went back to the indefinite beast in some of his later poems which were a direct expression of his feelings. But in his plays he preferred the more familiar symbol of the unicorn. It stood

[1] All quotations from *The Player Queen* in this chapter are not from *C.Pl.* since the text printed there is extensively revised. I quote from the first printing in the 1922 *Plays in Prose and Verse* (second volume of the Macmillan collected edition) and from the separate volume edition of *The Player Queen* published in the same year and which is practically an off-print of the 1922 *Plays*, save for page numbering.

for a conception which he had tried to put across several times before: that he and his contemporaries were living on the brink of chaos, in the last phase of a dying civilization. It is this feeling of danger, of an imminent end, that confers tragic depth on so much of his work. At the same time what distinguished him from the decadents, who consciously let themselves be carried downstream towards catastrophe, was his conviction that the destruction of one world would bring about its opposite, an era of 'joyful, dangerous, individual life'. This idea gave his poetry its vigour and zest for life, its unique sense of tragic joy.

When he tried to put across these conceptions in his stories of 1895–6, in 'Rosa Alchemica', 'The Tables of the Law' and 'The Adoration of the Magi', he failed, because he had not found a single, powerful image to contain them: the poetical symbol which would communicate them in a flash. In the first decade of this century he thought that this image could well be the unicorn.

The great (and private) value he set by it is shown by his commission to Sturge Moore for an ornament representing a unicorn descending from a starry heaven, with the motto MONOCEROS DE ASTRIS. It was meant to decorate the frontispiece of the books by Yeats published by the Cuala Press, the printing press run by his sister Elizabeth, and it appeared for the first time in *Reveries over Childhood and Youth* (1915). By this time Yeats considered the unicorn as a distinguishing personal symbol, a sort of private seal, a hall-mark on his work. Curious readers noticed the recurrence of the decoration and enquired at the Cuala Press about its meaning. In her turn Elizabeth Yeats asked her brother. His reply, for the date of which Allan Wade suggests Autumn 1920, shows some embarrassment:

I forgot to tell you about *Unicorn from the Stars*. You must just tell your correspondents that it is the name of a play of mine and refer them to me and when they write to me I will forget to answer. The truth is that it is a private symbol

belonging to my mystical order and nobody knows what it comes from. It is the soul.[1]

(*L.,* 662)

The explanation is, to say the least, only partial. It merely demonstrates that Yeats attributed a transcendental meaning to the image. The historical origin of the symbol did not matter: it represented the power of the soul, a mysterious power which would not bear definition (that is perhaps why in 1936 he wrote to Dorothy Wellesley that Moreau's painting, *Ladies and Unicorns,* represented 'mystery'). Judging from the previous contexts in which he used the image, it was the power of the soul to create within itself—in the moment of inspiration, of vision, in which all the past is destroyed and all the future generated: violent destruction and violent creation which will go on for ever. I have already quoted Paul Ruttledge's words in *Where There Is Nothing*: 'The world must be consumed in a moment inside our minds'. The idea is developed in the last speeches of Martin Hearne in *The Unicorn from the Stars*:

I was mistaken when I set out to destroy Church and Law. The battle we have to fight is fought out in our own mind. There is a fiery moment, perhaps once in a lifetime, and in that moment we see the only thing that matters. It is in that moment the great battles are lost and won, for in that moment we are a part of the host of Heaven.

. . . Heaven is not what we have believed it to be. It is not quiet, it is not singing and making music, and all strife at an end. I have seen it, I have been there. The lover still loves, but with a greater passion; and the rider still rides, but the horse[2] goes like the wind and leaps the ridges, and the battle goes on always, always. That is the joy of Heaven, continual battle.

(*C.Pl.,* 378, 381)

[1] This contradiction is typical of Yeats; in *The Book of Lambspring* the soul is symbolized by the deer, while the unicorn is 'spirit'.

[2] The 'host of heaven' and 'the horse' are of course to be taken in connection with the 'army of Unicorns' seen by Martin in his vision.

We are reminded of Blake (*Milton*, Book II):

As the breath of the Almighty such are the words of man
 to man
In the great Wars of Eternity, in fury of Poetic Inspira-
 tion,
To build the Universe stupendous, Mental forms Creating.

Yeats's cyclic conception of history, elaborately expounded in *A Vision*—history conceived as a series of two-thousand year periods, in contrast with each other, the eternal struggle of primary and antithetical, shot through with sudden violent crises, violent destruction and violent birth—is but a projection onto a cosmic plane of his intuition of what happens in the soul and mind of man; of what is the essence, in fact, of the creative process: whether what is created is history, or poetry, or art. There is a truth which is seldom sufficiently realized: in most cases the poet's faculties centre round the creation of poetry. When he works out a theory of politics or history, of magic or metaphysics, he is but trying to unravel the mystery and wonder of man's existence and of man's mind. Now, the mystery and wonder of the poet's nature and mind is his ability to write poetry. His search (whatever his subject) will unconsciously be, all the time, for the nature of poetry and the mode of its creation. The value, therefore, of the 'philosophical', or 'cosmological', or 'political' systems devised by poets is in that they may give us the key to their poetics. They may be wild as cosmology, ridiculous as philosophy, or positively criminal as politics: but if we consider them as statements about the nature of the poetic process we shall find them substantially true. True of course for the poetry of the particular poet who made them.

So it is with Yeats's 'system', and still more with the idea which we have seen symbolized in the 'brazen winged beast' and in the Unicorn: raging violence and new-born joy, tragedy and laughter in instantaneous synthesis, are the very

3. T. Sturge Moore: Bookplate for Mrs. Yeats (1918).

essence of all his greatest poetry, are actually the things that make that poetry great.

'Destruction is the life-giver!', was the command heard by Martin Hearne in his vision. And in 1918 Yeats had this very idea graphically represented in a bookplate for his wife George, that he commissioned from Sturge Moore. The bookplate

represents a tower falling to the ground, hit by lightning. Out of the ruin there springs, as though born of it, a young white unicorn. The symbolism is obvious: the old civilization, the old order is suddenly disrupted, in a flash, and a new irresistible force springs to life.

In his correspondence with Sturge Moore over a number of years Yeats shows a constant and sincere admiration for this bookplate.[1] In June 1924 he thought of commissioning the same artist to design another bookplate, this time for his daughter Anne, and wrote to him:

> I think also that my wife wants to get a bookplate for our daughter Anne; this sounds premature as Anne is not yet six, but my wife wants to have it ready for the first sign of interest in books. Are you doing such things now? and at what rate? The bookplate you did for my wife was a masterpiece and it is possible that she may want to send you some suggestions as to its subject.
>
> <div align="right">(W.B.Y. & T.S.M., 54)</div>

The project did not progress very quickly. After a year Sturge Moore advanced a suggestion (letter to Yeats of 14 Dec. 1925):

> I sometimes see visions of possible dancers for Anne's book-plate—one on a tiny island dancing between the moon and its reflection in a lake.
>
> <div align="right">(W.B.Y. & T.S.M., 60)</div>

Yeats was rather taken with the idea of the dancing girl: perhaps she recalled to him the girl dancing in 'The Double Vision of Michael Robartes', under the eyes of the representatives of the two immemorial Oriental religions, Buddha and the Sphinx:

> O, little did they care who danced between
> And little she by whom her dance was seen
> So she had outdanced thought.
>
> <div align="right">(C.P., 193)</div>

[1] See *W.B.Y. & T.S.M.*, 33–4, 54, 91.

The girl is the new-born, the new civilization superseding the past ones—she is the future which has 'outdanced thought'.[1] But the most interesting phase of the negotiations about the bookplate is represented by the letter written by Yeats on 27 May 1926, after seeing the first sketch of the bookplate itself:

Make the dancing girl about eighteen. I want my daughter Anne to think of this bookplate as a 'grown-up' bookplate while she is a child and to continue to use it when she is grown-up. The design will be very fine if you keep it severe like my wife's bookplate, which is magnificent. My wife asks me to say that Anne is going to be tall and slight, which no doubt means that she wants the dancing girl to look as much as possible like that admirable faun or stag springing from the broken tower.

<div align="right">(W.B.Y. & T.S.M., 91)</div>

Faun (meaning fawn) or stag: Yeats had forgotten that the creature springing out of the broken tower was (and is) recognizably a unicorn. The dancing girl was its exact equivalent, the symbol of the same idea—which alone mattered —not the actual symbolic form that the idea had assumed in the other bookplate. This lapse of memory was only temporary: sixteen months later, in September 1927, when Sturge Moore

[1] This is only one way of looking at the poem. For T. R. Henn (*op. cit.,* 179–80), the Sphinx and Buddha are respectively West and East, the dancing girl is Iseult Gonne, and Helen (mentioned later in the poem) is Maud Gonne; Mr. Ellmann (*The Identity etc., cit.,* 255–6) takes the Sphinx to be intellect, Buddha heart, and the dancing girl art; Mr. Kermode (*op. cit.,* 59), basing his interpretation on Yeats's own statements in *Vis. B.,* 207–8, identifies the Sphinx as the 'introspective knowledge of the mind's self-begotten unity' (subjectivity, or, in Yeats's words, the 'Antithetical'), Buddha as 'the outward-looking mind' (objectivity or the 'Primary'), and the girl as what Yeats called 'the Fifteenth Phase' in his 'system', that is to say the achieved Unity of Being (complete subjectivity), the miraculous moment of perfection beyond nature, revelation. In this way the girl and the Sphinx are cognate images, both connected with subjectivity; that, I think, would account for their both assuming, at different times, the same meaning as the image of the unicorn (the Sphinx in 'The Second Coming' and the dancing girl in the bookplate).

sent him what should have been the final drawing for Anne's bookplate, Yeats saw again the dancing girl as a unicorn:

No, I am sorry but I don't like that young woman. The right leg seems thick and clumsy and the head looks immense and is without charm. I sometimes like your figures, but I always like your beasts and your decoration. I like the landscape in this greatly, and am convinced if the dancer were a unicorn or such I would like all.

<div align="center">(W.B.Y. & T.S.M., 113)</div>

We need not follow the negotiations further.[1] What these letters demonstrate is the instability of symbols even when the underlying idea is the same. This instability, united with the bewildering pluri-significance of each symbolic image, makes it hard to find logical consistency in the works of poets like Blake or Yeats.

The unicorn, in Mrs. Yeats's bookplate, is still connected with the idea of ruin and renewal, but instead of being the life-giving destroyer as in *The Unicorn from the Stars*, is the new life itself. It is a change of stress rather than of meaning, a change deeply involving Yeats's own attitude and personality. The idea of the end of an era was, as we have seen, an old one for him, and he shared it with his contemporaries, the decadents; but, unlike them, he always linked it with the idea of 'something' that would replace the old civilization. He could not define this 'something'. Was it the return of an older type of civilization? or of the ancient barbarism? He was unable to decide, so that the stress in his poems, until about 1916, remained constantly on the destruction rather than on the renewal. The images of ruin stood out clearly—the fall of Troy, the trampling unicorns, the raging fires—while those of renewal were unstable and hazy.

A striking example of this is represented by the story 'The

[1] The bookplate was never completed. When a year later Yeats candidly asked: 'How about the bookplate?', Sturge Moore icily replied (letter of 31 May 1928): 'I know nothing about any bookplate' (*W.B.Y. & T.S.M.*, 129).

Adoration of the Magi' [1] in which Yeats, in 1896, attempted to express this conception. Three old men are called by a mysterious 'voice' to the bedside of a dying prostitute in Paris (personifying the present age of decadence) to hear from her lips a supernatural message: the annunciation of a new age. Here is how Yeats put the injunction to the three old men in the original version of the story:

Bow down before her from whose lips the secret names of the immortals, and of the things near their hearts, are about to come, that the immortals may come again into the world. Bow down, and understand that when the immortals are about to overthrow the things that are to-day and bring the things that were yesterday, they have no one to help them, but one whom the things that are to-day have cast out. Bow down and very low, for they have chosen for their priestess this woman in whose heart all follies have gathered, and in whose body all desires have awaked; this woman who has been driven out of Time and has lain upon the bosom of Eternity. After you have bowed down the old things shall be again, and another Argo shall carry heroes over the deep, and another Achilles beleaguer another Troy.

(T. of L. 1897, 42–4)

[1] 'The Adoration of the Magi' was obviously meant for publication in *The Savoy*, in which its two companion tales appeared ('Rosa Alchemica' in n. 2, April 1896, and 'The Tables of the Law' in n. 7, Nov. 1896), but the periodical ceased publication in the same year, before printing the tale. It should then have been included in the collection *The Secret Rose* (London, Bullen, 1897), but the publisher rejected both 'The Tables' and 'The Adoration', and preferred to print them separately and privately. The story was then included in the following volumes: (1) *The Tables of the Law and The Adoration of the Magi*, priv. printed in 110 copies by Bullen, 1897; (2) a larger reprint of the same in 1902; (3) with slight alterations in a volume of the same title, London, E. Mathews, 1904; (4) with further but not substantial changes in vol. VII of *The Collected Works of W.B.Y.*, Stratford-on-Avon, 1908; (5) *The Tables of the Law and the Adoration of the Magi* (from n. 4), Stratford-on-Avon, 1914; (6) with substantial alterations in *E.P. & S.*, 1925. See A. Wade, *A Bibliography of the Writings of W. B. Yeats,* 2nd edition, London, Hart-Davis, 1957. The story has been included since in the volume *Mythologies,* London, Macmillan, 1959.

The last sentence is an open quotation from the fourth eclogue of Virgil, 'Pollio', a text that was considered prophetic by occultists of different ages:

> Alter erit tum Tiphys, et altera quae vehat Argo
> Delectos heroas: erunt etiam altera bella:
> Atque iterum ad Trojam magnus mittetur Achilles.

The Eclogue prophesies a birth which will usher in a new cycle in human history. Some believed that Virgil was announcing in it the birth of Christ, hence the idea of a Christian Virgil. Yeats referred to 'Pollio' in several later works,[1] including *A Vision*, and mentions it earlier in the present story, though mistakenly referring to it as the V and not the IV Eclogue. The prophecy that Yeats wanted to convey in 'The Adoration of the Magi' is of a return to an older civilization violent and pagan. When nearly thirty years later, in 1925, he revised[2] the story for inclusion in the Macmillan collected edition, the passage underwent significant changes:

> The woman who lies there has given birth, and that which she bore has the likeness of a unicorn and is most unlike man of all living things, being cold, hard and virginal. It seemed to be born dancing; and was gone from the room wellnigh upon the instant for it is of the nature of the unicorn to understand the shortness of life. She does not know it has gone for she fell into a stupor while it danced, but bend down your ears that

[1] For a list and discussion of such references see R. Ellmann, *The Identity, etc., cit.*, 261. A particularly close echo of the lines quoted is to be found in Yeats's late play, *The Resurrection* (1926–31): 'Another Argo seeks another fleece, another Troy is sacked.' Yeats remembered Virgil's passage concurrently with Shelley's imitation of it in *Hellas,* another poem well known to him.

[2] He had been thinking of revising it for a long time. R. Ellmann, *Yeats: The Man and the Masks,* London, Macmillan, 1949, 190, quotes from an unpublished diary of 1909 where Yeats examines the possibility of making the story fit in with his new theory of Self and Mask, which he was to develop especially in *The Player Queen*; Mr. Ellmann erroneously states that the diary entry refers to 'The Tables of the Law' instead of 'The Adoration of the Magi'.

you may learn the names that it must obey . . . When the
Immortals would overthrow the things that are to-day and
bring the things that were yesterday, they have no one to help
them, but one whom the things that are to-day have cast out.
Bow down and very low, for they have chosen this woman in
whose heart all follies have gathered, and in whose body all
desires have awaked; this woman who has been driven out
of Time and has lain upon the bosom of Eternity.

(*E.P. & S.*, 522)

The return of the pagan cycle of civilization is prophesied
here also, but there is a new element: the woman is no longer
sterile, she gives birth to a symbolic figure, a personification of
the new age. As in Mrs. Yeats's bookplate, a unicorn is born
out of ruin and decay, in a moment, in a flash.

What I wish to underline is the new certainty of Yeats's
tone: what matters is not the return of the old, but the fact that
this old will be new, springing out of the womb of destruction.
All the stress is now on *birth*, presented in physical terms, while
before it was on *return*, *renewal*, *recurrence*—a new turn of the
wheel, not a new birth. I think that this shift of stress, so im-
portant for Yeats's later poetry, came about in the second decade
of this century. The world seemed to be slowly decaying
around him: the first world war was not the concern of an
Irish nationalist—it was only another proof of the general
disintegration.[1] The Easter Rising of 1916 came as a surprise
to Yeats, a great shock: that *did* concern him, something new
and unexpected, a revelation and a transformation of the world
he knew. It was of course only his Irish world, but that again
is typical: for Yeats the only things that mattered were his
things: the universe at large of which he was always speaking
was only a projection of his personal universe. The Easter
Rising was for him the token of a New Birth, it revealed to him

[1] Yeats's tepid attitude towards the first world war is clearly expressed in such
poems as 'An Irish Airman Foresees His Death' and 'On Being Asked for a
War Poem', in full contrast with the obvious passion and participation of his
many poems on the Easter Rising and the Civil War.

that what he had been expecting all the time was not really the return of an ancient civilization, but the birth of a new, violent one:

> All changed, changed utterly
> A terrible beauty is born.
> (*C.P.*, 203)

Violent birth: a new assurance enters his poetry from this moment, he has found a theme. Even his visionary 'brazen winged beast' representing 'laughing, ecstatic destruction', is now associated with birth, is 'slouching towards Bethlehem *to be born*'.

Yeats felt his images and his poetry with physical intensity (the same could be said of Blake, and is perhaps true of the nature of all visionaries). The new theme of birth entering his poetry suggested to him, from this moment on, with ever-greater insistence, the idea of the act of generation. His youthful poems had been singularly chaste; his approach to physical passion had sounded half-hearted. From the *Wild Swans at Coole* volume (1917) onward, there is instead an extraordinary frankness and vigour in his poems, culminating in the 'Leda' sonnet (1923), the 'Woman Young and Old' group (1926–9), and the 'Three Bushes' (1936). It is illuminating to follow the same change of attitude also in his treatment of the unicorn symbol.

The advent of the Unicorn was greeted as 'the end of the Christian Era, the coming of a New Dispensation', in that curious play, *The Player Queen*. Yeats had begun it in 1907 or 1908, but it was completed only in 1919, and it took three more years before it was published for the first time, with further revisions, in the Macmillan collected edition (1922). *The Player Queen* deserves careful study because it contains, in a cryptic form, the ideas and beliefs that Yeats had (or with which he toyed) over a number of the most important years of his poetic life, and the seeds of the ideas which he was to

develop in the last phase of his activity. His account of the writing of the play is well known:

I began in, I think, 1907, a verse tragedy, but at that time the thought I have set forth in *Per Amica Silentia Lunae* was coming into my head, and I found examples of it everywhere. I wasted the best working months of several years in an attempt to write a poetical play where every character became an example of the finding of what I have called the Antithetical Self; and because passion and not thought makes tragedy, what I made was neither simplicity nor life. I knew exactly what was wrong and yet could neither escape from thought nor give up my play. At last it came into my head all of a sudden that I could get rid of the play if I turned it into a farce; and never did I do anything so easily, for I think that I wrote the present play in about a month.[1]

(Pl., 428–9)

It is said that the change from tragedy to farce was suggested by Ezra Pound.[2] The change certainly made for a greater freedom in the treatment of rather complex ideas, and the new ironical turn in the presentation of them is a welcome relief from the awkward solemnity of some of Yeats's other 'abstract' plays. A vein of irony runs through most of his best work, giving it the detachment characteristic of art and saving it from the pathos which often mars his youthful poems. The main trouble with *The Player Queen* is an overcrowding of ideas. The theory of self and anti-self or mask, though dominant, is at the basis of only one of what Mr. Becker has rightly identified as the two plots of the play.[3] It is expressed in the story of Decima,

[1] In the published letters the play is first mentioned in Sept. 1908, and it appears that the change from comedy to farce was effected in 1914; but two years later Yeats was still working at it, and in May 1917 he was revising it (see *L.*, 511, 512, 513, 532, 588, 614, 625).

[2] See R. Ellmann, *Yeats, etc., cit.*, 215.

[3] W. Becker, 'The Mask Mocked: or, Farce and the Dialectic of Self', *Sewanee Review*, LXI, 1, Winter 1953, 82–108. For a more general survey of the play see N. Newton, 'Yeats as Dramatist: *The Player Queen*', *Essays in Criticism*, VIII, 3, July 1958, 269–84.

the actress, so fond of playing the part of queen, who in the end becomes queen herself, becoming her own mask. The second plot centres round Septimus, the poet and actor, and the rumoured coupling of the saintly queen with the unicorn. This imaginary union, presented as an invention of the populace suspicious of the secluded life of their queen, is meant as a new myth: the end of an era and the beginning of a new one symbolized in the conjunction of a woman and a fabulous animal,[1] which is all the more prodigious on account of the traditional association of the unicorn with chastity. Yeats is using again his old image of the unicorn to express his conception of decadence and renewal, but for the first time he mentions, and insists on, the act of generation as its necessary cause. The stress has shifted once again, and in the direction I have already pointed out: from birth to the act of generation.

Septimus, who is at one and the same time an aristocratic poet, a drunkard and a seer, harps at length on this theme. After announcing 'the end of the Christian Era, the coming of a New Dispensation, that of the New Adam, that of the Unicorn', he adds:

but alas, he is chaste, he hesitates, he hesitates.
. . . I will rail upon the Unicorn for his chastity. I will bid him trample mankind to death [an image out of *The Unicorn from the Stars*] and beget a new race.

(*Pl.*, 398–9; *Pl.Q.*, 42–3)

This seems to me an extreme application of the theory of the Antithetical Self, or Mask, based on the principle that every-

[1] In this respect the play is full of seminal ideas for the treatment of the same conception in Yeats's later work. Particularly significant are the allusions to the Leda myth (to which I shall refer in the next chapter) and to a seer who brays like an ass when a monarch is succeeded by another, a theme which was to be developed in *The Herne's Egg*. Yeats was fully aware that *The Herne's Egg* developed out of *The Player Queen*; he wrote to Dorothy Wellesley in Nov. 1935: 'I have a three act tragi-comedy in my head . . . as wild a play as *Player Queen*, as amusing but more tragedy and philosophical depth' (*L., cit.*, 843).

thing aspires to its own opposite.[1] The Unicorn is chastity itself. Copulation and begetting is its opposite, its Mask. Now, the consummation by the Unicorn of an act of lust would mean reaching its own opposite, its Mask; and this is outside the range of natural possibilities, it is miracle (I am using the word in the sense Yeats uses it, for instance, in 'Byzantium'). Only miracle can produce the end of an era and the advent of a New Dispensation. That is why the copulation of the Unicorn is the event that, in Septimus' clairvoyant expectation, is to accomplish this work of destruction and generation.

But there is another strand in the symbol, which is explored later in the play. The Unicorn is an animal, but it is at the same time a creation of the mind, an image (a 'Mental form', as Blake would have said). Like the beast of 'The Second Coming' (we actually know that it is the equivalent of the beast) it comes out of *Spiritus Mundi*, the world's Great Memory. As such it has an independent and everlasting life, it is extra-temporal, and participates in a sort of divine nature. The great events in time, the destruction and rebirth of the world, are generated at the point of union of the temporal and the extra-temporal, of man, divinity *and* the animal faculties (the beast). That is why the Unicorn seems particularly fit for the work to which Septimus sees it as destined:

Man is nothing till he is united to an image. Now the Unicorn is both an image and beast; that is why he alone can be the new Adam. When we have put all in safety we will

[1] There are some perceptive remarks in George Russell (A.E.), *Song and Its Fountains* (London, 1932, 9-10) on Yeats's consciousness of duality: 'I can see today the central idea I surmised forty-five years ago in the young Yeats grown to full self-consciousness. I remember as a boy showing the poet some drawings I had made and wondering why he was interested most of all in a drawing of a man on a hill-top, a man amazed at his own shadow cast gigantically on a mountain mist, for this drawing had not seemed to me the best. But I soon found his imagination was dominated by his own myth of a duality in self, of being and shadow. I think somewhere in his boyhood at the first contact of inner and outer he became aware of a duality in his being.'

go to the high tablelands of Africa and find where the Unicorn is stabled and sing a marriage song. I will stand before the terrible blue eye.

(*Pl.*, 402; *Pl. Q.*, 46)

Here a fundamental principle of Yeats's later thought is set down. Creation, rebirth for mankind (or, for that matter, inspiration for the poet) comes at a moment in which nature (man) is one with the symbol, the 'vast image out of *Spiritus Mundi*', the sudden manifestation of that mystery (there are many names for it: God, the supernatural, the eternal, the extratemporal . . .) which surrounds our existence. The symbol, or image, is preserved and lives forever in the Great Memory of the World, a reservoir which only the poet, the magician and the seer can tap. This moment of miraculous unity, of oneness between man and image, in which all senses (the 'beast') participate, is revelation—we should remember Martin Hearne's words in *The Unicorn from the Stars*: 'My business is not reformation but revelation.' And the act of revelation is an experience of such intensity that the poet feels it as a mental and physical rape. The only metaphor fit to express it is that of a rape from above, of a sudden and violent sexual conjunction. Hence Yeats's insistence in his later poetry on the Leda myth and on similar images: the emphasis on the sexual act which Miss Koch has pointed out—and Mr. Henn has largely discounted[1]—in Yeats's last poems, is due to this conception of the act of revelation, which he developed round 1920.

By following the different stages through which the image of the unicorn passed in Yeats's writings up to this point, we have been able to trace the development of his thought and poetic feeling. An image, for him, was not a static, but a dynamic nucleus, not a stand-in for one particular concept, but a sort of living organism and force-centre. It was continually

[1] V. Koch, *W. B. Yeats: The Tragic Phase*, London, Routledge, 1951; T. R. Henn, 'The Accent of Yeats' "Last Poems" ', *ESEA*, IX, 1956, 56–72.

modified, or rather enriched, by his developing thought, and in its turn modified and enriched his thought.

After *The Player Queen* the unicorn, as far as I know, is mentioned only once in Yeats's work, and in a very different context. His fondness for it as a personal emblem is shown by his use of it as a decoration for his books. In 1922 he got Charles Ricketts to do for him a picture for the end-papers of the volumes of the Macmillan collected edition; this is best described in Ricketts' own words:

I have combined most of [the symbols suggested by Yeats] in a sort of book-plate design which is placed inside the cover . . . On this I have represented a Unicorn couching on pearls before a fountain, backed by a cave full of stars. On the crest of the cave is what I believe to be a hawk contemplating the moon.[1]

Yeats was most appreciative of the picture and wrote to the artist:

The little design of the unicorn is a masterpiece in that difficult kind. You have given my work a decoration of which one will never tire . . . It is a pleasure to me to think that many young men here and elsewhere will never know my work except in this form.[2]

(*L.*, 691)

He commissioned another unicorn from Edmund Dulac as one of the only three illustrations to the first edition of *A Vision* (1925); the other two were a diagram of the 'Great Wheel' and a portrait of himself in the guise of 'Giraldus Cambrensis', the fictitious author of Yeats's esoteric system.[3] Also in this

[1] *Self-Portrait taken from the Letters and Journals of Charles Ricketts, R.A.,* compiled by T. Sturge Moore, ed. C. Lewis, London, 1939, 341.

[2] In view of Yeats's fondness for this decoration it is the more regrettable that in the Macmillan volumes of *Collected Poems* and *Collected Plays* it should have disappeared, replaced by a much reduced gold decoration on the cover, based on Ricketts' picture, but with many of the original symbols left out.

[3] Dulac's Unicorn, a woodcut, is pasted at the bottom of p. 8 of *Vis. A.*

4. E. Dulac: Decoration in *A Vision* (1925).

case the unicorn has nothing to do with the text of the book: it is only a kind of hall-mark of Yeats's work.

The single poetic context in which the unicorn figures is part VII of 'Meditations in Time of Civil War' (1921–2):

> Their legs long, delicate and slender, aquamarine their eyes,
> Magical unicorns bear ladies on their backs.
> The ladies close their musing eyes. No prophecies,
> Remembered out of Babylonian almanacs,
> Have closed the ladies' eyes, their minds are but a pool
> Where even longing drowns under its own excess;
> Nothing but stillness can remain when hearts are full
> Of their own sweetness, bodies of their loveliness.
>
> <div align="right">(C.P., 231–2)</div>

Here a subtitle Yeats has prefixed to this section of the poem openly states the significance of the image, inspired, as Mr. Henn has pointed out,[1] by Moreau's painting *Ladies and*

[1] T. R. Henn, *op. cit.*, 242.

Unicorns which I have already mentioned: the unicorns and the
ladies are 'Phantoms of the Heart's Fullness', in contrast with
'the Coming Emptiness', represented by 'brazen hawks',
symbolic in their turn, as Yeats explains in a note, of logic as
opposed to intuition. In other words, the unicorn here is an
even more inclusive image: intuition, the faculty to see into the
mystery, the gift of the seer and of the poet. Not the violent
birth, revelation, but the revealing power, poetry itself. The
esoteric symbol of the Soul has become the symbol of his own
art.

This last transformation of the symbol was final. Its meaning
could not be further extended. For the previous, more limited,
significance of violent birth (which was still a very important
conception for Yeats) he had to find more earthy symbols. By
1931 the mounting stallion had taken the place of the trampling
unicorn:[1]

> On Cruachan's plain slept he
> That must sing in a rhyme
> What most could shake his soul:
> 'The stallion Eternity
> Mounted the mare of Time,
> 'Gat the foal of the world.'
> (*C.P.*, 306)

The unicorn, instead, as we saw in the lines from the
'Meditations', had found again, after so many years, the delicate
outlines, the precious colours, with which the young William
Butler Yeats must have seen it first in the pictures and book

[1] The poem is 'Tom at Cruachan', dated by Mr. Ellmann (*The Identity, etc.,
cit.*, 292) 29 July 1931. Miss Moore has some interesting remarks on horse-
symbolism in Yeats, which she interprets along Jungian lines ('. . . Jung calls
the horse a symbol of the libido that "covers all the unknown and countless
manifestations of the will"; a symbol of the wind, which in turn is a symbol of
the spirit; . . .'), and finally identifies it with Unicorn symbolism (see V. Moore,
op. cit., 446–7).

illustrations of the refined artists of the end of the last century.[1] That is the image to which he returned, and which remained in the end. But it would not have been so valuable and important for him if it had not first passed through these transformations.

[1] One recalls as well Aubrey Beardsley's delightful verbal picture of Helen's pet unicorn, 'a delicate and dainty beast', in the last sentences of his unfinished novel *Under the Hill* (*The Savoy*, II, April 1896, 195–6).

II

The Birth of Leda

A sudden blow: the great wings beating still
Above the staggering girl, her thighs caressed
By the dark webs, her nape caught in his bill,
He holds her helpless breast upon his breast.

How can those terrified vague fingers push
The feathered glory from her loosening thighs?
And how can body, laid in that white rush,
But feel the strange heart beating where it lies?

A shudder in the loins engenders there
The broken wall, the burning roof and tower
And Agamemnon dead.
 Being so caught up,
So mastered by the brute blood of the air,
Did she put on his knowledge with his power
Before the indifferent beak could let her drop?
 (*C.P.*, 241)

THIS is the final version of the sonnet 'Leda and the Swan' as it
appears in Yeats's *Collected Poems*. In the early part of this book
I have shown that Yeats had an extraordinary variety of interests.
Every poem is the result of a complexity of experience. This is

73

borne out by even so short a unit as this sonnet, which is much
more than a single idea—it is an idea made up of hundreds of
others. A mass of varied experience went into the formation of
this sonnet unit, and in the next three chapters I shall show
the process by which this complexity came together.

In the *Collected Poems* the Leda sonnet bears the date of
1923. From the drafts found, it appears that it was first written
on 18 September 1923, but Yeats was perpetually revising
his own work, and the first draft is by no means identical with
the final version. It has been published by Mr. Richard
Ellmann:[1]

> Now can the swooping godhead have his will
> Yet hovers, though her helpless thighs are pressed
> By the webbed toes; and that all powerful bill
> Has suddenly bowed her face upon his breast.
> How can those terrified vague fingers push
> The feathered glory from her loosening thighs?
> All the stretched body's laid in that white rush
> And feels the strange heart beating where it lies.
> A shudder in the loins engenders there
> The broken wall, the burning roof and Tower
> And Agamemnon dead . . .
> Being so caught up
> Did nothing pass before her in the air?
> Did she put on his knowledge with his power
> Before the indifferent beak could let her drop?

The main variants are in the first quatrain and in line 12.
Mr. Ellmann actually shows six different stages in the develop-
ment of the poem, the first four of which were preserved only in
manuscript. Let us indicate them, for expediency, with the
first six letters of the alphabet, Version A being the one dated
18 September 1923 which I have just reproduced, and Version
F the one printed in the *Collected Poems*. Of the intermediate

[1] For all the MS. drafts I rely on R. Ellmann, *The Identity, etc., cit.*, 176–9.

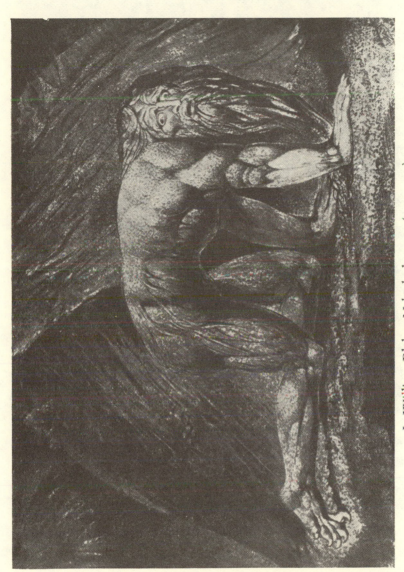

I. William Blake: *Nebuchadnezzar* (see p. 37).

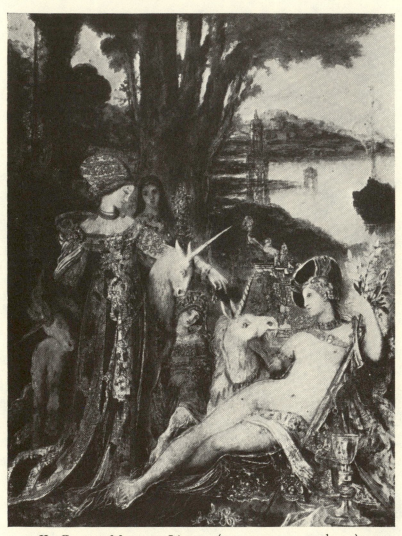

II. Gustave Moreau: *Licornes* (see pp. 45, 70 and 157).

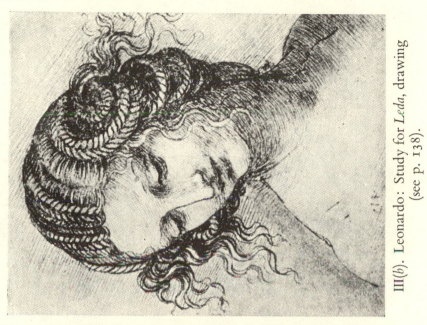

III(b). Leonardo: Study for *Leda*, drawing (see p. 138).

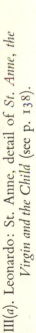

III(a). Leonardo: St. Anne, detail of *St. Anne, the Virgin and the Child* (see p. 138).

IV(a). William Blake: *Jerusalem*, page 11 (see p. 143).

IV(b). William Blake: *The Marriage of Heaven and Hell*, page 3 (see p. 144).

texts, Version B is a refashioning of the first quatrain, Version C a rewriting of the complete poem, in which the powerfully imaginative twelfth line appears for the first time ('So mastered by the brute blood of the air,') as well as some unhappy modifications in the tercets (line 11: 'Being mounted so' instead of 'Being so caught up'; line 14: '. . . go?' instead of 'drop?') which were later rejected in order to revert to the diction of Version A; Version D is a further redrafting of the first two lines. Finally, Version E was the first that Yeats had printed in the Cuala Press volume *The Cat and the Moon and Certain Poems* (Colophon date 1 May 1924) and at the same time in the review *To-Morrow* for August 1924 and in the American periodical *Dial* for June 1924.[1] In this version the first quatrain represents another intermediate stage between Version A and Version F:

> A rush, a sudden wheel, and hovering still
> The bird descends, and her frail thighs are pressed[2]
> By the webbed toes, and that all-powerful bill
> Has laid her helpless face upon his breast.

Lines 7–8 are still those of Version A, while the tercets are already in the form they have in Version F. The final version appeared first in the 1925 edition of *A Vision*.[3]

[1] For a recension of the printed versions of this and all other poems of Yeats see *The Variorum Edition of the Poems of W. B. Yeats,* edited by Peter Allt and Russell K. Alspach, N.Y., Macmillan, 1957. Mr. Ellmann (*loc. cit.*) refers only to the printing in *To-Morrow*.

[2] This second line was already in Version D.

[3] The only differences between the text in *A Vision* (1925) and Version F are the use of a comma instead of a question mark in line 6, and of a semicolon instead of a question mark in line 8, and the absence of a wider spacing between the octave and the sestet (*Vis. A,* 179). Mr. Ellmann (*loc. cit.*) introduces the final version with the words: 'But by 1928, in *The Tower,* [Yeats] had at last brought the octave to the same perfection as the sestet'; and does not mention *A Vision*. The statement gives the false impression that 'Leda' had not been published between 1924 and 1928, and that Yeats waited four years before giving it those final touches which make of it a perfect work of art.

The poem had already reached its definitive form before the middle of 1925, as appears from a letter addressed by Yeats to L. A. G. Strong on June 25th of that year:

> Certainly you may use my 'Leda' . . . but I don't want you to use it in the form it had in *To-morrow*. I have re-written it since. The worst of it is, I don't [know] where my new version is at the moment. I shall, however, receive it very shortly in the proof sheets of *A Vision*. I open a section with it. In fact there are 40 pages of commentary, for I look upon it as a classic enunciation [*sic*].[1]
>
> (*L.*, 709)

The poem occupies an important place in *A Vision*. It is printed at the opening of Book III which was completed, as Yeats states, in Capri in February 1925, and which gives an outline of universal history based on his cyclical conception. The Book, which bears the significant title 'Dove or Swan', maintains that the union of Leda and the swan, with their fated offspring (Helen, the Dioscuri and Clytemnestra), symbolizes the opening of one of the great cycles of civilization, a cycle of two thousand years, which came to an end with the birth of Christ, a birth which marked in its turn the opening of another two-thousand-year cycle, now nearly spent, and to be superseded by a third cycle.

The letter to Strong makes it clear that Yeats conceived the Leda myth as 'a classic Annunciation' ('enunciation' is typical of the vagaries of his spelling): a pagan counterpart to the Christian Annunciation.[2] This is further confirmed by the

[1] The letter carries the following PS.: 'Proofs of *A Vision* has just come—I enclose it but ask you to return proof when you have copied the poem . . . there is no typist here I would ask to copy it—one a few days ago wept because put to type a speech in favour of divorce I was to deliver in the Senate.' This must be the origin of Hone's statement that Yeats's 'typist refused in tears to copy' the 'Leda' poem (J. M. Hone, *W. B. Yeats, 1865–1939*, London, 1942, 361).

[2] Though it has been recently maintained that Yeats was at first unconscious of such symbolism. See H. Trowbridge, 'Leda and the Swan: A Longinian Analysis', *Mod. Phil.*, LI, 2, Nov. 1953, 118–29: 'As far as I can see, Yeats has not written into the poem the idea he expresses elsewhere . . . of the rape of

note on the circumstances of composition of the sonnet appended by Yeats to the first printing of 'Leda and the Swan' (still in version E) in the volume *The Cat and the Moon and Certain Poems* (1924):

I wrote Leda and the Swan because the editor of a political review asked me for a poem. I thought 'After the individualist, demagogic movement, founded by Hobbes and popularized by the Encyclopaedists and the French Revolution, we have a soil so exhausted that it cannot grow that crop again for centuries'. Then I thought 'Nothing is now possible but some movement, or birth from above, preceded by some violent annunciation'. My fancy began to play with Leda and the Swan for metaphor, and I began this poem; but as I wrote, bird and lady took such possession of the scene that all politics went out of it, and my friend tells me that 'his conservative readers would misunderstand the poem'.

(*C. & M.*, 37)

As an example of political and philosophical thinking this is, to say the least, disconcerting—and it makes us understand why Yeats should candidly have got involved, at about this time, in para-Fascist movements.

The editor referred to in the note was George W. Russell and the political review his *Irish Statesman*, which eventually rejected Yeats's poem. It had been offered by the author under the significant title 'Annunciation'.

Leda as an Annunciation, beginning a new cycle of civilization.' Mr. Trow-bridge's lifeless application of Longinian standards has been most effectively criticized by Professor Leo Spitzer, 'On Yeats's Poem "Leda and the Swan"', *Mod. Phil.*, LI, 4, May 1954, 271–6. Professor Spitzer's aesthetic analysis of the poem is unlikely to be surpassed; in his interpretation, though, he has been mis-led at one point by Mr. Trowbridge's sentence quoted above. Mr. Louis Mac-neice, *The Poetry of W. B. Yeats*, O.U.P., 1941, 144, has put the case clearly, remarking that the Leda sonnet signifies Yeats's belief that 'the eternal (Zeus) requires the temporal (Leda), further (for the myth is complex) that the human being (Leda) requires the animal (the swan), that God and Nature in fact re-quire each other and that the world will only make sense in terms of an incarna-tion'.

Yeats's confused and arbitrary cosmological theories began to take their final shape, as is well known, round the year 1917, when he thought that the mysterious 'communicators' evoked by the mediumistic powers of his wife were confirming some intuitions of the pattern of human and universal life which he had already had. By January 1919 the existence of a two thousand year cycle which had begun with the birth of Christ (and therefore with the Annunciation to Mary) and was soon to end with some kind of new annunciation and new mysterious birth, was already clear in his mind. I need only recall 'The Second Coming' and the treatment of the image of the unicorn: the bookplate for Mrs. Yeats is striking in this respect.

The new annunciation for Yeats had taken the form of a mysterious bird or animal. For some hidden reason (possibly a confused recollection of the 'beasts' in the Book of Revelation) Yeats saw the crucial events, the most important moments in universal and personal history, as produced by the conjunction and the conflict of human and animal forms. The animal symbolizes not only the lowest physical impulses uncontrolled by reason (the 'beastly', 'rough', 'brute' side of life), but also the superhuman, transcendental powers, the miraculous and the prodigious which cannot be accounted for in rational terms. An earlier poem of Yeats goes to prove that he saw or felt an 'animal' element also in the Christian Nativity: in 'The Magi' (1913) the poet described the Nativity as

The uncontrollable mystery on the bestial floor.[1]

(*C.P.*, 141)

In 'The Second Coming' and in other works of the same

[1] The imagery of this short poem is curiously reminiscent of 'Rosa Alchemica', while it looks forward to 'Byzantium' (1930). Still more significantly this is the line Yeats quoted at the opening of Book I of *A Vision* (1925), where he described the first phase of his 'system', the beginning of each new cycle of universal life: 'When the old *primary* becomes the new *antithetical*, the old realization of an objective moral law is changed into a subconscious turbulent instinct. The world of rigid custom and law is broken up by "the uncontrollable mystery upon the bestial floor" ' (*Vis. A*, 38; *Vis. B*, 105).

period, he had referred to two supernatural 'births': that of a future cycle of civilization symbolized in a mysterious 'brazen winged beast', a sphinx, or a unicorn, and that of the Christian cycle which is on the wane. What he needed at this stage was a third symbolic annunciation to usher in his first cycle of civilization, the classical one. The myth of Leda provided it. Once the conception of revolutionary annunciations fusing the animal, the human and the superhuman had crystallized in Yeats's imagination, it was logical that the Dove of the Christian annunciation should be seen by the poet in the same light as the Beast of 'The Second Coming' and the Swan in 'Leda'. This he stated, though not in so many words, at the beginning of the 'Dove or Swan' Book of the 1925 *Vision*; and he further emphasized the parallel by writing the short poem 'The Mother of God' (dated 3 September 1931) on the Christian Annunciation, obviously intended as a counterpart to 'Leda and the Swan' and based on the same imagery of fire, wings, sky, terror and love:

> The threefold terror of love; a fallen flare
> Through the hollow of an ear;
> Wings beating about the room;
> The terror of all terrors that I bore
> The Heavens in my womb.
>
> (*C.P.*, 281)

The symbolic meaning that the myth of Leda had for Yeats when he wrote the sonnet, is clear. What is important is to find the moment when he chose just this myth to express it. In his authoritative book, *Yeats: The Man and the Masks*, Mr. Richard Ellmann states (p. 245):

This myth [of Leda and the swan] had held his mind since his first use of it in 'The Adoration of the Magi' in 1896, where he had prophesied that 'another Leda would open her knees to the swan' and begin a new age.

The important fact overlooked here is that Yeats did not write

the sentence quoted or use the myth in 1896, but introduced it in the story mentioned only when he included 'The Adoration of the Magi' in volume V of the collected edition of his works, *Early Poems and Stories*, published by Macmillan in 1925, that is to say at a time when the significance of the myth was very clear in his mind. It is well known that Yeats was an indefatigable reviser of his early works, and was frequently taken to task by his friends for modifying his poems at each reprinting. In the case of his stories, Yeats himself had given fair warning to the readers in a note at the end of the 1925 volume:

In these as in most of the other stories I have left out or re-written a passage here and there.

(E.P. & S., 528)

A collation of all previous printings of 'The Adoration of the Magi' shows that the reference to Leda appears only in 1925. But while this suggests that the Leda myth had *not* held Yeats's mind since 1896, we must not completely overlook his early story, since there is something to be learnt in it about the working of his mind. 'Rosa Alchemica', 'The Tables of the Law' and 'The Adoration of the Magi' were all written in 1896, at a time when the author was feeling most strongly the influence of his wide reading and experience in occultism and magic, the interpretation of the prophetic books of William Blake, and the study of the nature of symbolism. In these three stories Yeats created the characters of Michael Robartes and Owen Aherne, the occultists, which are obvious projections of his own personality. Theirs is the task of unveiling elusive and eternal truths and of giving prophetic hints on the future of our civilization and of the world. At the beginning of this century the two figures disappeared from Yeats's work; but as soon as, at the end of 1917, he started piecing together his metaphysical system, to be fully set out in *A Vision*, he immediately reverted to them. The poem 'The Phases of the Moon' written in 1918 in order to present 'officially' for the first time his cyclical theory of the universe is in the form of a dialogue between Aherne and

Robartes.[1] And the ascendancy of these two characters became stronger throughout the period during which the poet worked at his 'system': they appear in several poems, and in the notes to others. When for the first time Yeats collected 'The Second Coming' in the Cuala Press volume *Michael Robartes and the Dancer* (1920), he appended to the poem a six-page note in which he put into Robartes' mouth the best summary he ever provided of his 'system' and of the principles governing it.[2] Finally the Introduction and the allegorical story of 'The Dance of the Four Royal Persons' in the 1925 edition of *A Vision* are supposed to have been written by Owen Aherne, who relates the teachings of Robartes.

The connection established through these two figures between Yeats's later philosophical conceptions and his early fantastic stories is relevant: the fact is that his 'system', suggested by spiritualistic practices in the years after 1917, was only the re-emergence of principles and intuitions he had had in the 'nineties, complicated of course by many new elements absorbed in the intervening years. The poet himself has stated his aim in writing the three stories of 1896:

... presently Oisin and his islands faded and the sort of

[1] In a note of 1922 to this poem (now in *C.P.*, 532) Yeats wrote: 'Years ago I wrote three stories in which occur the names of Michael Robartes and Owen Aherne. I now consider that I used the actual names of two friends, and that one of these friends, Michael Robartes, has but lately returned from Mesopotamia, where he has partly found and partly thought out much philosophy. I consider that Aherne and Robartes, men to whose namesakes I had attributed a turbulent life or death, have quarrelled with me. They take their place in a phantasmagoria in which I endeavour to explain my philosophy of life and death.' Compare the note written in 1899 for the collection *The Wind Among the Reeds* (1899, 73–4) where Yeats says that the names appearing in the titles of the poems (abolished in later editions), including Robartes, are used 'more as principles of mind than as actual personages', and Michael Robartes 'is the pride of imagination brooding upon the greatness of its possessions, or the adoration of the Magi'.

[2] Professor A. Norman Jeffares was apparently unaware of this publication since in his *W. B. Yeats: Man and Poet* (London, 1949, 197–8) he defines this note, which he reproduces in full, as an 'unpublished' summary of the doctrines of *A Vision* written in 1919 and found only in manuscript.

images that come into *Rosa Alchemica* and *The Adoration of the Magi* took their place. Our civilization was about to reverse itself, or some new civilization was about to be born from all that our age had rejected, from all that my stories symbolized as a harlot, and take after its mother; because we had worshipped a single god it would worship many . . .[1]

(*W. & B.*, 102)

Though these remarks were written thirty-five years later, a reading of the three stories in their original form will show their accuracy. 'Rosa Alchemica' and 'The Tables of the Law' are obscure because of their overloading with magic lore and the luscious style derived from the Pater school. 'The Adoration of the Magi' is altogether plainer, and looks like a straightforward allegory in which Yeats tries to make use of Christian symbolic patterns in order to express his feeling that 'our civilization is about to reverse itself', that 'some new civilization was to be born', that, as he put it later in 'The Second Coming', 'Surely some revelation is at hand.' So he imagines a new set of 'Magi' to whom this revelation should be given. This story, which has no literary value, I have already summarized in the chapter on the Unicorn. It is only a psychological document— with all the naiveté and the absurdity of most documents of this kind—but it interests us as a further proof that the conception of the decay and birth of civilizations was already in Yeats's mind at this time, and two of its poles, or points of crisis (the Christian Nativity and the present century) were as clear to him then as they were to be at the time of writing 'The Second Coming'.

How the Leda myth crept into 'The Adoration of the Magi' thirty-nine years after it was written, can be seen by comparing the same passage from the story as it was in the early versions and as it appears in the 1925 edition. The passage, fairly near the beginning of the story, refers to the mysterious

[1] Introduction to *The Resurrection*, in *W. & B.*, 102.

communication received by the Magi mourning the death of Robartes:[1]

Early version (1897, pp. 38–9; 1904, pp. 47–8; 1908, p. 170):

While they were still mourning, the next oldest of the old men fell asleep whilst he was reading[2] out the Fifth Eclogue of Virgil, and a strange voice spoke through him, and bid them set out for Paris, where a woman lay dying, who would reveal to them the[3] names of the immortals,[4] which can be perfectly spoken only when the mind is steeped in certain colours and certain sounds and certain odours; but at whose perfect speaking the immortals cease to be cries and shadows, and walk and talk with one like men and women.

Version of 1925 (pp. 519–20):

While they were still mourning, the next oldest of the old men fell asleep whilst he was reading out the Fifth Eclogue of Virgil, and a strange voice spoke through him, and bid them set out for Paris, where a dying woman would give them the secret names and thereby so transform the world that another Leda would open her knees to the swan, another Achilles beleaguer Troy.

What has happened is clear: in 1896 Yeats was thinking of the practices to induce trance states (colours, sounds, odours) as the only possible way to induce some sort of a revelation like the prophecy of re-birth in Virgil's IV Eclogue, but was not very sure of what this revelation would be about; what mattered was to communicate with extra-human powers. By 1925 he thought he knew clearly what to expect: a transformation of the world announced and ushered in by the union of the human with the non-human; since this idea was symbolized in the rape of Leda by the swan, he did not hesitate to mention the

[1] For bibliographical references see note on p. 61.

[2] In the 1908 edition the first lines read: 'They were still mourning, when the next oldest of the old men fell asleep while reading . . .'

[3] 1908 inserts here the adjective 'secret'.

[4] 1908 substitutes for 'immortals' the word 'gods'.

myth at this point, and together with it the fall of Troy, referred to in Virgil's IV Eclogue. The words 'another Achilles beleaguer Troy' were removed from a later passage in 'The Adoration of the Magi' which I have quoted in the previous chapter. They have been transferred here because the new mention of Leda called up in Yeats's mind the fateful event resulting from the union of Leda and the swan. The connecting link between the Leda myth and the fall of Troy is Helen, the offspring of the union of bird and woman. Though mentioned neither in this story nor in the sonnet, Helen, a typically decadent myth, had figured in several other works of Yeats. Even in 'The Adoration of the Magi' the decadent Helen prototype may be felt behind Yeats's description of the dying prostitute in Paris:

This woman in whose heart all follies have gathered, and in whose body all desires have awaked.

Yeats, in working out his allegory of present decay and future rebirth wanted, in his story, to keep a parallelism with Christian tradition, or rather, an inverted parallelism, since he proposed to show that the new age would be the reversal of the Christian one. He looked, therefore, for the type of woman who would be the exact opposite of the Christian Virgin. As Mr. Ian Fletcher pointed out to me,[1] William Blake described Mary as just such a harlot in his poem 'Was Jesus humble or did he . . .'. But Yeats, living in the *fin de siècle*, chose the fatal woman of the period, the eternal prostitute, the type of Helen-Ennoia described by Flaubert in *La tentation de Saint Antoine*:

Elle a été l'Hélène des Troyens ... Elle s'est prostituée à tous les peuples. Elle a chanté dans tous les carrefours. Elle a baisé tous les visages... Innocent comme le Christ... Elle est Minerve! elle est le Saint-Esprit!

The woman in 'The Adoration of the Magi' announcing a new cycle of civilization is indeed Helen (had not Flaubert

[1] In a private communication.

84

said of her 'Elle est le Saint-Esprit'?) and is therefore logically connected with the fall of Troy mentioned by Virgil.[1]

From what has been said we can draw the following conclusions: (1) By 1896 Yeats had already some inkling of the cyclical theory of history which he was later to develop and expound in *A Vision*; (2) The Trojan war, the birth of Christ, and an indefinite event due to happen in our century were already considered by him as three fundamental crises in world history, each of which reversed the established order and ushered in a new cycle of civilization; (3) With the Trojan war he had already associated the figure of Helen, still linked with the decadent conception of the fatal woman, but susceptible of acquiring a more central symbolic significance as the emblem of the first major crisis in civilization (a significance that by 1925 was transferred to the figure of Helen's mother, Leda); (4) The Leda myth, instead, had not particularly impressed Yeats, and became important for him only much later.

At this point, in order to ascertain whether the Leda myth had acquired any significance for Yeats before the composition of the sonnet, we must look for references to it in his work before 1923. One such reference is in the poem which has now the title 'His Phoenix' and which, according to Mr. Ellmann's valuable chronology of the composition of Yeats's poems, was written in January 1915.[2] The poem is an evocation of a beautiful woman whom Yeats had known as a young man: 'I knew a phoenix in my youth'. The allusion is undoubtedly to Maud Gonne, who had been compared by Yeats to a phoenix in an unpublished diary of 1909[3] (she appears in other poems by Yeats as a kind of reincarnation of Helen of Troy). The tone is

[1] For a fuller treatment of the Helen figure in Yeats, see the next chapter of the present book.

[2] R. Ellmann, *The Identity*, etc., cit., 287–94.

[3] Quoted by R. Ellmann, *Yeats, etc., cit.*, 192: 'She is my innocence & I her wisdom. Of old she was a phoenix & I feared her, but now she is my child more than my sweetheart . . .'

one of passionate recollection and vague melancholy, closer to the dreaminess of his earlier, rather than to the sensuality of his later poetry. The poem was printed in the magazine *Poetry* for February 1916 and in *Form* in April of the same year under the title 'There is a Queen in China', and then, with alterations and under its present title, in the Cuala Press volume *The Wild Swans at Coole* (1917), in the Macmillan enlarged edition of the same collection (1919), in *Later Poems* (1922), and finally, in its present form, in the *Collected Poems* (1933).[1] In this and later editions the poem begins:

> There is a queen in China, or maybe it's in Spain,
> And birthdays and holidays such praises can be heard
> Of her unblemished lineaments, a whiteness with no stain
> That she might be that sprightly girl trodden by a bird.
>
> <div align="right">(C.P., 170)</div>

But the line referring to Leda was different when it first appeared in *Poetry*:

> That she might be that sprightly girl who had married with
> a bird.

Clearly, Leda here is by no means meant as a symbol; she is in case an emblem: the paragon of whiteness, according to a very old tradition, which Yeats may have found in a poet who deeply influenced him as a young man: Edmund Spenser. The lines of the *Prothalamion* are well known (stanza 3, ll. 39-45).

> Two fairer Birds I yet did neuer see:
> The snow which doth the top of *Pindus* strew,
> Did neuer whiter shew,

[1] On 'His Phoenix' and its variant readings see the excellent essay by Marion Witt, 'A Competition for Eternity: Yeats's Revision of his Later Poems', *PMLA*, LXIV, 1, March 1949, 40-58; the essay discusses also the *Dial* version of 'Leda and the Swan'.

Nor *Ioue* himselfe when he a Swan would be
For loue of *Leda*, whiter did appeare:
Yet *Leda* was they say as white as he,
Yet not so white as these, nor nothing neare;[1]

The first appearance of Leda in Yeats's poetry, then, does not go beyond the conventional. The myth suits the fabulous tone of the opening of the poem: the queen of China or Spain, her birthdays and holidays, all words and images reminiscent of nursery rhymes; the 'sprightly girl who had married with a bird' seems to come out of a fairy-tale rather than from the classical past. The myth of Leda struck Yeats at first as just another pretty picture of an idyllic and fantastic nature.

But by the time Yeats thought of reprinting the poem in the Cuala Press volume *The Wild Swans at Coole* (the printing of which was completed, according to the colophon, on 10 October 1917) he had changed his mind about the idyllic quality of the 'marriage' between woman and swan. In that edition (and the same is true of the 1919 and 1922 publications) the line runs:

That she might be that sprightly girl who was trodden by a
 bird.

Though Leda is still there not as a symbol but only to provide a paragon for whiteness, Yeats has chosen to underline the sexual and violent aspects of the mating of bird and woman —rather incongruously with the general tone of the poem. This sudden, and not very happy (in view of the context) shift of emphasis can be re-connected with a deeper change in Yeats's feelings and psychological attitude which took place at this time. We have seen how 1916–17 were fateful years for him. A man of over fifty, he was suddenly transported by a wave of

[1] For some interesting remarks on the relation of Yeats to Spenser, based largely on the same quotations, see M. C. Bradbrook, *Shakespeare and Elizabethan Poetry*, London, Chatto & Windus, 1951, 28–31, 245–6.

restlessness. The portentous outbreak of violence which he had been obscurely prophesying since the 'nineties seemed now to be really at hand. A new sense of miracle seemed to take hold of him, and together with it a new vigour, both physical and sentimental. The story is well known: in rapid succession he proposed first to Maud Gonne, now a widow since Major MacBride, her husband, had been executed for having taken part in the Easter Rising; then to Iseult, Maud's daughter; having been rejected a second time, he turned to Georgie Hyde-Lees and married her after a very short engagement, on 21 October 1917. A few days later he realized the medianic powers of his wife, and his work on his esoteric 'system' began.

The reflection of these changes in his life brought new vitality to his poetry: the language is more concrete and even harsh, in spite of the frequently obscure and abstract conceptions he wanted to express; the images of sexual violence are more and more frequent. The word-change in the fourth line of 'His Phoenix' must therefore be seen in the light of this crisis in Yeats's own character and consequently of his poetic style.

It must be seen as well in connection with the development of his play *The Player Queen*, the importance of which, as a seminal work, I have already emphasized. The play harps on the theme of the coming of a new dispensation after the end of the Christian era and is strictly connected with the conceptions expressed in such works as 'The Second Coming' or 'The Adoration of the Magi'. The theme, as we saw, is expressed through the fabled union of the Queen with the Unicorn, a new myth of Yeats's invention. Later in the play the myth is ironically mirrored in a farcical scene: not the queen but the player-queen, her mask, decides to choose a lover among her fellow players who are dressed as different animals and birds (bull, turkey, swan, etc.). This mime of the conjunction of woman and beast acquires mythological overtones, and is danced to the tune of the player-queen's song:

Shall I fancy beast or fowl,
Queen Pasiphae chose a bull,
While a passion for a swan
Made Queen Leda stretch and yawn,
Wherefore spin ye, whirl ye, dance ye,
Till Queen Decima's found her fancy.

Spring and straddle, stride and strut,
Shall I choose a bird or brute?
Name the feather or the fur
For my single comforter?

<div align="center">(Pl., 397; Pl. Q., 41)</div>

·The allusion to Leda in this context is clearly an anticipation
of the meaning the myth was to assume in the Leda sonnet—
especially if it is taken in conjunction with the allusion, shortly
after, by another character, to 'the old play of the Burning of
Troy'. Furthermore Septimus, the hero of *The Player Queen*,
for a moment sees himself as a divine swan: 'My breast feathers
thrust out and my white wings buoyed up with divinity'. But
in the play the myth of Leda, the idea of a New Dispensation,
and the burning of Troy are not yet fused into a single symbolic
cluster as in 'Leda and the Swan'. Troy stands for destruction
by fire, the Unicorn for the advent of a new cycle of civiliza-
tion, while the union of Leda with the swan, like that of
Pasiphae with the bull, is merely an ironical variation on the
theme, not the central theme itself. The elements for the new
interpretation of the myth were there, but had not yet fused.

What brought this fusion about? Why in 1923 did Yeats's
'fancy begin to play with Leda and the swan for metaphor'?
The birth of a poem is a sort of sudden and inexplicable
release, and the reason why a poem is *poetry* will probably never
be satisfactorily explained. But if it is a release, it must be a
release of something which already existed in the mind, or if
we prefer, in the consciousness, of the creator, the poet. It is the
outcome of an immemorial preparatory work, an accumulation

of 'materials' which started from the beginning of consciousness (not only individual consciousness, but the consciousness that the individual inherits from the world's past, his culture and his instincts). In other words, each poem has its sources in the poet's past experiences, in his reading, in the things he has seen and heard.

But before considering the literary or figurative sources which went into the making of 'Leda and the Swan', there is another point of more immediate importance.

If a poem is a momentary release, in a form which has mysterious laws of its own, of the materials (or of some of the materials) which had been accumulating in the author's consciousness, there must be an external reason, a contingent cause, that produces the release just at that time, in this case in September 1923; and which produces the release of just *those* materials, here the rape of Leda and the fall of Troy. In other words there must be an event (possibly of a merely intellectual nature, something the poet reads or sees) that in a particular moment acts as a catalyst for a particular group of images and ideas (the 'materials') which had accumulated in his mind. It is frequently impossible to find this 'catalyst', since it may be a very private event that no biographer can discover, or a particular mental state lasting materially for only a few moments (this may well be the case with those poems allegedly written in trance states, or automatically).[1] But it seems to me that it is always worth enquiring at least into the known circumstances of the composition, and into the external events in the period during which the poem was composed.

Yeats, as we saw, wrote the sonnet in reply to a request by George Russell, to express the idea that 'nothing is now possible but some movement, or birth from above, preceded by some violent annunciation'. The interesting question is why an idea which he had expressed earlier through the symbols of the

[1] For a discussion of automatic poetry, with many examples, see Robin Skelton, *The Poetic Pattern,* London, Routledge, 1956, especially 134–64.

unicorn or of the beast of 'The Second Coming', reappeared in September 1923 in terms of the Leda myth.

Yeats spent the second half of 1923 (except for the visit to Stockholm in December, to collect his Nobel Prize), and most of 1924, till he left for his second visit to Italy in November that year, at his house at 82, Merrion Square, Dublin, with occasional visits to his fantastic country residence, the tower he had bought and restored at Gort, in County Galway. The tower (Thoor Ballylee) was by no means a comfortable residence, and he went there only for short periods in the good season; the pleasure he took from its possession was of a purely intellectual kind: the tower, as he was never tired of repeating, was a symbol, perhaps his main symbol, and a good many of his poems are witnesses to this. It is significant that in the first draft of 'Leda and the Swan' the word Tower in line 11 is spelt with a capital, though its symbolic value in the context is not immediately apparent.

A long stay at Thoor Ballylee in 1923 was in any case not advisable also in view of the political situation, and of the violent agitations in the country. We have a fairly accurate report on Yeats's movements at the time from a letter addressed to T. Sturge Moore on 18 August 1923. He says that he

had first a most crowded week in Dublin, and then Ballylee and a cold, followed by a return to Dublin, and after that more Ballylee . . .

I am at Ballylee but get back to Dublin by August 24th. Little harm has been done here, despite rumours in the press, . . . except the windows and doors burst in and various traces of occupation by Irregulars, stray bullets, signs that a bed has been slept in and so on.

After some more talk about the situation at Ballylee, and a reference to the writing of *A Vision* ('my philosophy'), Yeats adds:

Have you heard that as a result of my sister's illness my wife

91

has taken charge of the Cuala embroidery and that the whole industry is moving into 82, Merrion Square?

(W.B.Y. & T.S.M., 48–9)

The Cuala embroidery was the embroidery workshop set up by Yeats's sister Lily (Susan Mary), who had been a pupil and a fervent admirer of William Morris and of his crusade in favour of applied arts. But when Yeats speaks of the transfer to Merrion Square, that is to his Dublin house, of 'the whole industry', he is referring presumably not only to the embroidery workshop, but also to the Cuala (ex-Dun Emer) Press, which the poet's sisters Lily and Lolly (Elizabeth) had been running since 1903 in Dundrum and Churchtown. The Cuala Press printed only very limited editions of hand-set small books by Yeats and his friends. They published a maximum of two or three books a year, since the printing process was very slow and done with great care from the aesthetic point of view, in a type patterned on that inaugurated by William Morris at his Kelmscott Press in the 'nineties.[1] Up to 1923 the Cuala Press had been in Dundrum, and Dundrum is indicated as the place of printing of J. B. Yeats's (the poet's father's) *Early Memories,* which came out in July that year. But the next volume carried the following colophon:

Here ends 'An Offering of Swans', by Oliver Gogarty: the first book of Elizabeth Yeats' Cuala Press printed at Merrion Square. Finished on the twentieth day of October nineteen hundred & twenty three.

During the summer of 1923 not only the embroidery workshop, but also the Cuala printing press had been transferred to Yeats's house in Dublin, where it had taken possession of the dining room.[2] It is reasonable to surmise that in those months

[1] The accuracy did not extend to spelling and punctuation: no member of the Yeats family seems to have been a good speller, and the Cuala Press books are marred by wayward orthography and very frequent misprints.

[2] See letter to John Quinn of 29 Jan. 1924 *(L.,* 704). Only one other book was printed at Merrion Square, Yeats's own *The Cat and the Moon and Certain Poems,* which includes the 'Leda' sonnet. From 1925 the address of the Cuala Press is 133 Lower Baggot St., Dublin.

between August and October (just the time when he wrote
'Leda and the Swan'), Yeats must have seen and heard a good
deal about the book which was being printed in his house,
especially in view of the fact that Lily, who together with her
sister should have looked after the printing, was ill. In a letter
of January 1924 he writes that the Press was taking away
most of his time. The book was a collection of 23 poems by
Oliver St. John Gogarty, the man who had shared the Martello
Tower with Joyce (the Buck Mulligan of *Ulysses*), a writer,
surgeon and member with Yeats of the first Irish Senate. The
reason for the title of the collection, *An Offering of Swans*, is
explained by Yeats himself in his preface to the book. Gogarty
rang him up one day to enquire about the possibility of buying
two swans; he had narrowly escaped killing at the hands of
Irish Republicans, and the river Liffey had been his means of
escape. In the moment of danger he had made a vow offering
a brace of swans to the river if he survived his adventure—and
the vow was kept. Such is the story told by Yeats in the preface,
which is dated 30 August 1923. Swans had always exercised
a strong fascination on Yeats's mind. We shall see later the
development of swan imagery in his poetry up to this date. He
must therefore have been particularly struck by Gogarty's
'offering' to the Liffey, which was commemorated in the little
volume. But in the poems he read in August 1923 (which
must have come more than once under his eye during Septem-
ber and October, while the book was being printed) he
found other elements which are of basic importance for our
research.

In themselves Gogarty's poems are of indifferent literary
merit, though Yeats in his preface mentions the names of
Herrick and Fletcher as possible terms of comparison. He
selects for special praise Gogarty's poems 'Non Dolet', 'Begone
Sweet Ghost' and 'Good Luck'. But it is reasonable to think
that he was struck first of all by some images which seem directly
derived from Yeats's own poems. His 'Rose of the World'
begins:

Who dreamed that beauty passes like a dream?
For these red lips, with all their mournful pride,
Mournful that no new wonder may betide,
Troy passed away in one high funeral gleam, . . .

(*C.P.*, 41)

Yeats is obviously referring to a beauty of his own time ('*these
red lips*') who has the same power as the mythical figure of
Helen (later, in poems written between 1908 and 1910, he
identified Helen with Maud Gonne). Gogarty does something
of the same kind in his poem 'Tell Me Now':[1]

(ll. 2–6): Beauty as elect and rare
 As when towns are trampled on
 Lives to-day and takes the air,
 Yet no amorous Truimvir (*sic*)
 Throws the world and Rome away;

(ll. 11–13): Love's as strong to-day as when
 Walls could not endure his brunt
 And he broke the Trojan men;

As we shall see later when discussing the Helen figure in
Yeats's work in greater detail, up to 1923 every mention of the
fall of Troy was associated with fire images rather than with
the breaking of walls. Only in 'Leda and the Swan' (and from
its very first version) Yeats speaks of:

The broken wall, the burning roof and tower.

Speaking once again of Troy, he has been put in mind this
time not only of the 'burning' but also of the 'broken wall', and
it seems logical to conclude that this was suggested by the
words 'walls' and 'broke' which he found just then in a very
similar context in Gogarty's poem. But Yeats's debt to his
fellow-Senator and poet does not end here. The legend of

[1] O. Gogarty, *An Offering of Swans, cit.*, 3.

94

Troy is treated in another poem of the same collection, 'The History Examination':[1]

> I know how Love maltreated Troy;
> (I know how Love besets us all)
> The Eagle, the Idaean boy . . .
> —But that's not History at all.

The mention in one quatrain of the fall of Troy and of the Ganymede myth may be an indirect confirmation of a theory advanced by G. P. D. Allt and adopted by Henn in *The Lonely Tower*,[2] according to which the description of Leda in Yeats's sonnet owes something not only to the Michelangelesque painting of 'Leda and the Swan' but also to the drawing of 'Ganymede and the Eagle' attributed to Michelangelo. I shall discuss at greater length this suggestion when dealing with the figurative sources of the poem; for the time being I need only say that Gogarty's quatrain referring to the fall of Troy, running in Yeats's mind while he was composing his sonnet and while he was looking for figurative representations of the Leda myth to be rendered into verse, may have awoken the memory of Michelangelo's other work, producing the composite picture to which Allt and Henn refer.

But the most striking poem in Gogarty's collection is the last one, referring directly to his votive offering to the Liffey:[3]

> TO THE LIFFEY WITH THE SWANS
> Keep you these calm and lovely things,
> And float them on your clearest water;
> For one would not disgrace a King's
> Transformed beloved and buoyant daughter.
>
> And with her goes this sprightly swan,
> A bird of more than royal feather

[1] O. Gogarty, *op. cit.*, 21. [2] T. R. Henn, *op. cit.*, 243.
[3] O. Gogarty, *op. cit.*, 25.

The Birth of Leda

With alban beauty clothed upon:
O keep them fair and well together!

As fair as was that doubled Bird
By love of Leda so besotten,
That she was all with wonder stirred:
And the Twin Sportsmen were begotten.

The short poem opens with a reference to an old Irish legend of which Yeats had been particularly fond: the story of a mythological Irish king, Lir, whose children had been transformed into swans by Oifa, their jealous stepmother. They were two pairs of twins, Fiachra and Conn, both sons, and Oodh and Fianoula, son and daughter. The story had been told in verse by John Todhunter and included in his volume *The Banshee and Other Poems*, which Yeats reviewed for the American paper *Providence Sunday Journal* for 10 February 1889. The review, under the title 'The Children of Lir', is full of praise for Todhunter, who was a friend of Yeats. He states that the legend (already treated in poems by Katharine Tynan and Aubrey de Vere) was

so famous . . . that down to this day an old-fashioned peasant would think it most unlucky to injure a swan. In Dr. Todhunter's version it may again grow into a national epopee. There is not a more beautiful story anywhere extant; it is like a breath of morning air.[1]

(*L. to N.I.,* 186)

[1] In his contributions in the years 1889–91 to *The Boston Pilot* and the *Providence Sunday Journal* (collected by H. Reynolds in this book) Yeats spoke repeatedly and admiringly of Todhunter's most ambitious work, the verse play *Helena in Troas*. In the very review quoted Yeats established for the first time a relation by contrast between the Helen myth and a legend involving swans, by comparing the play with 'The Children of Lir'. Todhunter had adopted the version of the Helen myth found in William Morris' *The Earthly Paradise* (part III, 'September: the Death of Paris'), another early favourite of Yeats's. In later years the poet changed his mind about the literary merits of Todhunter's play (though not of Morris' poem) and in *The Trembling of the Veil* he speaks of

It was just after writing this review that swans began to appear in Yeats's poetry, to become later one of his most important symbols. Gogarty's poem was dealing with images which had already a powerful hold on Yeats's imagination. The 'sprightly' in the fifth line may even have reminded Yeats of his reference to Leda 'that she might be that sprightly girl who was trodden by a bird' ('His Phoenix') making him fully receptive to the last quatrain, where Gogarty mentions directly the story of Leda and the begetting of the Dioscuri from her union with the swan. Moreover, the analogy with the legend of Lir, evoked in the first quatrain of Gogarty's poem, reminded Yeats that also in the case of Leda there were not one, but two pairs of twins, not only the Dioscuri, but also Helen and Clytemnestra.[1]

The reading of Gogarty's *Offering of Swans*, coming at a time when Yeats was looking for a new 'metaphor' on which to build a poem, and by appealing to him with images with which he was already familiar (Helen, the Fall of Troy, and the swan symbol), suggested the possibility of concentrating them in a single myth: that of Leda and the Swan.[2] And

Helena of [sic] *Troas* as 'an oratorical Swinburnian play which I had thought as unactable as it was unreadable' (*Aut.*, 120).

[1] Yeats, as he showed later (*St. of M.R.*, 20), chose among the many contradictory versions of the Leda myth the one according to which the two pairs of twins were respectively Castor-Clytemnestra and Pollux-Helen: 'He then spoke of the two eggs . . . , how Castor and Clytemnestra broke the one shell, Helen and Pollux the other . . .' The presence of male and female in one shell allowed Yeats, in his poem 'Among School Children', to connect the Leda myth with Aristophanes' parable of the sexes in Plato's *Symposium*. On these matters see *post*, chapter V of the present book.

[2] While Gogarty's *An Offering of Swans* was the catalyst for the images that went into Yeats's 'Leda and the Swan', the debt was amply repaid, for the myth of Leda recurs with obsessive insistence in Gogarty's later poetry, and Gogarty's own long ironical poem 'Leda and the Swan' borrowed heavily from Yeats's sonnet, as can be seen from its last stanzas: 'How could she protect her / From the wingéd air? // Why is it effects are / Greater than their causes? / Why should causes often / Differ from effects? / Why should what is lovely / Fill the world with harness? / And the most deceived be / She who least

it suggested also the portentous consequences of the union of woman and bird. That is why, in August–September 1923, Yeats's fancy 'began to play with Leda and the Swan for metaphor'.

The mental process did not stop at this point. *An Offering of Swans* was only the catalyst. Its mere presence set in motion a whole chain of unconscious reactions, of mental associations, fusing together and bringing to light a wealth of literary and visual reminiscences, into which we are now going to enquire. To impose some order on this weltering chaos of imaginative association, I propose to deal separately (at the cost of some repetition) with the Swan symbol, the Helen figure, the Tower and the Leda myth.

suspects? // When the hyacinthine / Eggs were in the basket— / Blue as at the whiteness / Where a cloud begins; / Who would dream there lay there / All that Trojan brightness; / Agamemnon murdered; / And the mighty Twins?' 'Hyacinthine' recalls the description of the egg in Yeats's *St. of M.R.*, 1931. Gogarty's poem was first published in *The Atlantic Monthly* for March 1932, 325–6; it was later included in his collections: *Others to Adorn*, 1938, 156–61; *Perennial*, 1946, 44 ff.; *Collected Poems*, 1951, 144–8.

III

The Swan, Helen and the Tower

⚹⚹⚹⚹⚹⚹⚹⚹⚹⚹⚹⚹⚹⚹⚹⚹⚹⚹⚹⚹⚹⚹⚹⚹⚹⚹⚹⚹⚹⚹

YEATS had been impressed by the old Irish legend of the children of Lir transformed into swans. At that time (1889) he was passionately endeavouring to revive, or even to create, an indigenous mythology for Ireland. In the review of Todhunter's poem he relates at length the story of the four swans, telling, among other things, how

one winter night the sea was frozen round them, and in the midst of that frozen sea they sang a new song—a hymn to God—and while they sang the North 'budded with phantom fire'. Christianity was drawing westward; the old Gods were flying before it.

<div align="right">(L. to N.I., 183)</div>

There is already here a vague association between the swan image and the idea of the annunciation of a new cult, or a new civilization. But what remained in Yeats's early poetry was only the image of the singing swans, which comes into 'The Wanderings of Oisin' completed in the same year, 1889:

<div align="center">. . . swans with their exultant throats.</div>
<div align="center">(C.P., 415)</div>

When the swans reappear in 'Baile and Aillinn' (1903) they

are still strictly connected with Yeats's imaginative interpreta-
tion of Irish folklore. Baile and Aillinn, as Yeats tells us, 'were
lovers, but Aengus, the Master of Love, wishing them to be
happy in his own land among the dead, told to each a story
of the other's death, so that their hearts were broken and they
died'. Here they are in Aengus' land of the dead:

> Two swans came flying up to him,
> Linked by a gold chain each to each,
> And with low murmuring laughing speech
> Alighted on the windy grass.
>
> (*C.P.*, 463)

The same pair of swans, in the same atmosphere of Irish twi-
light, reappear in another poem written at about the same time,
'The Withering of the Boughs':

> I know of the sleepy country, where swans fly round
> Coupled with golden chains and sing as they fly.
>
> (*C.P.*, 88)

In spite of the more rarefied atmosphere, these swans are not
yet symbols. They were to become so only many years later,
and through a very interesting process. It started with some-
thing that Yeats had actually seen: the wild swans at Coole.
They are still reminiscent of the transformed Baile and Aillinn:

> Unwearied still, lover by lover,
> They paddle in the cold
> Companionable streams or climb the air;

and they may carry some recollection of the swans descending
the current of the Thames in the already quoted passage of
Spenser's *Prothalamion*:

> But now they drift on the still water,
> Mysterious, beautiful,
>
> (*C.P.*, 147–8)

but they represent at the same time eternal youth, immutability, perhaps immortality ('their hearts have not grown old'). 'The Wild Swans at Coole' was written in October 1916, and although it still expresses a typically decadent feeling of self-pity, it represents an attempt at finding a deeper meaning in a scene that the poet has actually witnessed. Yeats is no longer dealing with abstractions: he starts from concrete images to discover in them some abstract significance.

The full symbolic transformation of the swan, however, only came about at a time when Yeats was already deeply involved in the construction of his 'system'. The poet was still engaged in giving a personal symbolic interpretation to the Christian tradition, in making it subservient to his system by giving it a personal twist. The short 'play for dancers', *Calvary*, was written in 1920 for this purpose. The lovely songs in the play are all based on intense bird imagery, and the birds referred to most frequently are the heron, the eagle, the gull and the swan.[1] The last lines of the closing song deal more particularly with the swan:

First Musician But where have last year's cygnets gone?
The lake is empty; why do they fling
White wing out beside white wing?
What can a swan need but a swan?
Second Musician God has not appeared to the birds.
(*C.Pl.*, 457)

The echoes from 'The Wild Swans at Coole' are obvious in the interrogatives that are nothing but an intensification of the questions asked in the last stanza of the 1916 poem, in the repetitions 'wing . . . wing' and 'swan . . . swan', which recall

[1] For a *catalogue raisonné* of Yeats's bird imagery see G. Brandon Saul, 'The Winged Image: a Note on Birds in Yeats's Poems', in *Bulletin of the New York Public Library*, LVIII, 6, June 1954, 267–73. There are interesting and amusing remarks on the subject in A. Ussher, *Three Great Irishmen*, London, Gollancz, 1952, 77–8.

the 'lover by lover' in the 'Wild Swans' (which in turn sends us back to the Baile and Aillinn legend). But the symbolic implications of the present context, as Yeats himself explains in a long note appended to the first edition of *Calvary*, are quite different. The note (part of which appears in the form of a letter full of esoteric lore supposed to have been written by Michael Robartes to Owen Aherne in the spring of 1917) makes it clear that in *Calvary* Yeats wanted to try out one of his new 'philosophical' principles: utter subjectivity and utter objectivity as the two poles of human nature and universal history. According to Robartes' letter, each human being has a 'Daimon' or 'Angel', representing his nature in beast-form if it is objective or in bird form if it is subjective:[1]

. . . Certain birds, especially as I see things, such lonely birds as the heron, hawk, eagle and swan, are the natural symbols of subjectivity, especially when floating upon the wind alone or alighting upon some pool or river, while the beasts that run upon the ground, especially those that run in packs, are the natural symbols of objective man. Objective men, however personally alone, are never alone in their thought, which is always developed in agreement or in conflict with the thought of others and always seeks the welfare of some cause or institution, while subjective men are the more lonely the more they are true to type, seeking always that which is unique and personal.

Here Robartes' letter ends, and Yeats goes on to explain his aims in *Calvary*:

I have used my bird-symbolism in these songs to increase the objective loneliness of Christ, by contrasting it with a loneliness, opposite in kind, that unlike His can be, whether joyous or

[1] The note, in *Four Plays for Dancers* (1921), where *Calvary* was first printed, was repeated without changes in *Plays and Controversies* (III vol. of Macmillan's Collected edition, 1923). Mr. Henn (*op. cit.*, 194–5, 268) connects the birds in *Calvary* with the two white herons watching indifferently Christ's *Agony in the Garden* in the Mantegna painting of that title which Yeats might have seen in the National Gallery, London.

sorrowful, sufficient to itself. I have surrounded Him with the images of those He cannot save, . . . the birds, who have served neither God nor Caesar, and await for none or for a different saviour . . .

<div align="center">(F.Pl. for D., 135–7; Pl. & C., 458–60)</div>

Christ is then, for Yeats, the type of objective nature. The heron, the eagle, the swan are his opposite 'Daimons'. But another basic tenet of Yeats was the inescapable attraction of the contraries, so that each man had his mask, his opposite in which he projected himself. Therefore the birds, symbols of subjectivity, are strictly associated in his mind with the figure of Christ, the paragon of objectivity.[1] It is this conception, which had been maturing in Yeats's consciousness since his youth, that makes his poetry such a fascinating 'series of interwoven paradoxes', as F. O. Matthiessen put it.[2] It can be shown that the association of the Christ figure with swans and other bird images had already taken place unconsciously in Yeats's mind as early as 1899, through the Irish love-god, Aengus. From the 'nineties onward Aengus appears frequently in Yeats's poems, and he is traditionally associated with birds which fly continuously round his person. In a letter addressed to George Russell on 27 August 1899, Yeats discusses at length 'Aengus and his birds', remarking:

Aengus is the most curious of all the gods. He seems both Hermes and Dionysus. He has some part perhaps in all enthusiasm . . . Christ must himself have been one of the followers of Aengus. Has not somebody identified him with Hermes?

<div align="center">(L., 324)</div>

What is relevant in this typically muddled statement is the

[1] It is interesting to notice that, in *Vis. B*, 208, Yeats said that also in 'The Double Vision of Michael Robartes' he 'should have put Christ' instead of Buddha to represent 'the outward-looking mind'.

[2] F. O. Matthiessen, 'The Crooked Road' (1942), in *The Responsibilities of the Critic*, N.Y., O.U.P., 1952, 25.

relation established between Aengus and Christ. Not long afterwards 'Baile and Aillinn' introduced, as we saw, the image of the two swans as Aengus' birds. Some twenty years later, in *Calvary*, Aengus has disappeared, but Christ and the swans associated with him are there.[1] This reminiscence accounts also for a certain incongruity between the image presented in the last lines of the play, and the idea of loneliness it is meant to symbolize: instead of a 'lonely bird' (as Yeats says in his note), we see the swans flying side by side 'white wing beside white wing', like those of Coole, or like Baile and Aillinn, coupled by the golden chain. The fact is that, while in the case of the gull ('Lonely the sea-bird lies at her rest') or of the ger-eagle ('He is content with his savage heart') Yeats could visualize solitary birds, the mention of swans evoked the scene witnessed at Coole, and Aengus' lovers. The poet is still bound by his old contexts, and his image contradicts his symbolic conception.

But the new significance attributed by Yeats to the swan image in his note to *Calvary* was working on his imagination. When the swan next reappears in a poem of his it is transformed into that symbol which in *Calvary* was merely described *a posteriori* and not effectively presented in the lines. The new poem is 'Nineteen Hundred and Nineteen', completed only in 1922. When it was published in the Cuala Press volume *Seven Poems and a Fragment* (1922) it bore the title 'Thoughts upon the Present State of the World'. The opening of its third section is a deliberate restatement of what Yeats had said in the note to *Calvary*:

> Some moralist or mythological poet
> Compares the solitary soul to a swan;

[1] Dionysus, mentioned in the letter of 1899, becomes associated with Christ in the play *The Resurrection* (1931); Aengus' birds were already mentioned in 'The Wanderings of Oisin' (1889) and can be identified with 'The White Birds' of the poem of that title (1892), a poem the imagery of which closely anticipates that of 'The Withering of the Boughs'.

But here the image has acquired a completely new vigour:

> I am content with that,
> Contented that a troubled mirror show it
> Before that brief gleam of its life be gone,
> An image of its state;
> The wings half spread for flight,
> The breast thrust out in pride[1]
> Whether to play or to ride
> Those winds that clamour of approaching night.

* * *

> The swan has leaped into the desolate heaven.
> That image can bring wildness, bring a rage
> To end all things, to end
> What my laborious life imagined, even
> The half imagined, the half written page.
>
> (*S.P. & F.*)

How did this new and powerful figuration of the solitary flight of the swan emerge in Yeats's mind? It is possible, at least in part, to retrace the process. Yeats wanted to stress the idea of solitude. It is only natural that his mind should instinctively turn to a poem which had made a tremendous impression on him as a boy, Shelley's *Alastor, or the Spirit of Solitude.*[2] In his *Reveries over Childhood and Youth* (1915) he had written of his boyish dreams:

I had many idols, and as I climbed along the narrow ledge I was now Manfred on his glacier, and now Prince Athanase with his solitary lamp, but I soon chose Alastor for my chief of men and longed to share his melancholy, and maybe at last

[1] The feathery pride of the swan was very much in Yeats's mind at the time, as shown by Septimus' words in *The Player Queen*, where the divinity of the swan image is further emphasized: 'My breast feathers thrust out and my white wings buoyed up with divinity.'

[2] Cp. A. N. Jeffares, *op. cit.*, 223.

to disappear from everybody's sight as he disappeared drifting
in a boat along some slow moving river between great trees.

(*Aut.*, 64)

It is well known that Yeats was extremely faithful to his early
conceptions and fantasies, and we shall find frequent evidence
of this in discussing the sources of 'Leda'.[1] His early enthusiasm
for Shelley never flagged: in him Yeats found a repository of
those ancient symbols from the world's Great Memory, which
he believed to be the substance of all poetry: the tower was one
of them, derived directly from Shelley, and we know how it
must have been uppermost in Yeats's mind in the years round
1920, when he had just acquired Thoor Ballylee as a sort of
materialization of the symbolic tower which he had discovered
in the lines of the Romantic poet.[2]

It is not surprising, then, that while Yeats was looking for a
bird symbol of solitude, he should have remembered Alastor's
swan (ll. 275–9):

> . . . A swan was there,
> Beside a sluggish stream among the reeds.
> It rose as he approached, and with strong wings
> Scaling the upward sky, bent its bright course
> High over the immeasurable main.

[1] Yeats himself seems to have been aware of this when he wrote in *The
Trembling of the Veil* (1922): 'I am persuaded that our intellects at twenty contain
all the truths we shall ever find' (*Aut.*, 189).

[2] For Yeats's conception of symbolism see the Introduction to the present
book. Immediately after his discussion of the tower symbol in Shelley, in 'The
Philosophy of Shelley's Poetry', Yeats remarks: 'It is only by ancient symbols,
by symbols that have numberless meanings beside the one or two the writer lays
an emphasis upon, or the half-score he knows of, that any highly subjective art
can escape from the barrenness and shallowness of a too conscious arrangement,
into the abundance and depth of nature. The poet of essences and pure ideas
must seek in the half-lights that glimmer from symbol to symbol as if to the ends
of the earth, all that the epic and dramatic poet finds of mystery and shadow in
the accidental circumstance of life' (*I.G. & E.*, 127–8).

It should be noticed that in Shelley the image of the swan is far less powerful than in Yeats, and there are no close verbal similarities. Besides, Shelley's swan is not an emblem of solitude, but provides a contrast with it. In fact, Alastor says, while looking at it:

> . . . Thou hast a home,
> Beautiful bird; thou voyagest to thine home,
> Where thy sweet mate will twine her downy neck
> With thine . . .

recalling the previous treatment by Yeats of swans as eminently 'companionable' birds.

It is at this point that I would suggest that another poetical swan presented itself to Yeats's imagination. In the Irish poet's autobiographical reminiscences Shelley is frequently associated with another author by whom he was deeply influenced in his early youth: Edmund Spenser. Among the essays which he was most anxious to see reprinted in different collected editions, there was one on Edmund Spenser, originally written as an introduction to his selection of Spenser's poems, which appeared only in 1906;[1] we have seen how the *Prothalamion* may have played a part in suggesting not only the reference to Leda in 'His Phoenix', but also the idea of the Swans swimming or flying side by side in 'Baile and Aillinn' and in later poems. It is Spenser who provides the most beautiful picture of the solitary flight of a swan in English poetry. It occurs towards the end of *The Ruines of Time* (ll. 589–602):

> Upon that famous Riuers further shore,
> There stood a snowie Swan of heauenly hiew,
> And gentle kinde, as euer Fowle afore;
> A fairer one in all the goodlie criew

[1] *Poems of Spenser selected and with an Introduction by W. B. Yeats,* Edinburgh, T. O. & E. C. Jack, 1906. The introduction was ready in 1902.

Of white *Strimonian* brood might no man view:
There he most sweetly sung the prophecie
Of his owne death in dolefull Elegie.

At last, when all his mourning melodie
He ended had, that both the shores resounded,
Feeling the fit that him forewarnd to die,
With loftie flight aboue the earth he bounded,
And out of sight to highest heauen mounted:
Where now he is become an heauenly signe;
There now the ioy is his, here sorrow mine.

The passage is deliberately and avowedly emblematic, and
it is included in that kind of gallery of emblems[1] with which
Spenser's poem closes. But the description of a sudden flight
in lines four and five of the second stanza conveys a sense of
mystery which seems to transcend the emblem and to give this
swan an independent life as an indefinite symbol. These are the
lines which impressed Yeats most deeply, and are echoed in his
'The swan has leaped into the desolate heaven': where 'leaped'
recalls Spenser's 'bounded', while 'desolate heaven' is nearer
Spenser's 'highest heauen' than Shelley's 'upward sky'. A con-
firmation of the presence of Spenser's passage in Yeats's mind is
found in Yeats's later use of the image, for instance in 'Coole
Park and Ballylee, 1931', where the line occurs: 'At sudden
thunder of the *mounting* swan', and the poet exclaims: 'Another
emblem there!' [2] Spenser's swan was an emblem, but rather
symbolical than allegorical, and as such was acceptable to Yeats
who, in the preface to his selections from Spenser, had written:

I find that though I love symbolism, which is often the only

[1] See Excursus III: The Swan Emblem.

[2] Italics mine; *C.P.*, 275. In a letter to Mrs. Yeats the poet stated that the swan
here was 'a symbol of inspiration' (A. N. Jeffares, *op. cit.*, 223, 337). The dying
swan appears also in the poem 'The Tower', but in this case Yeats stated in a
note that he was influenced by T. Sturge Moore's poem of the same title, 'The
Dying Swan'.

fitting speech for some mystery of disembodied life, I am for the most part bored by allegory, which is made, as Blake says, 'by the daughters of memory' and coldly, with no wizard frenzy.

In Spenser's poetry he had looked therefore for those passages that have enough ancient mythology, always an implicit symbolism, or . . . enough sheer passion to make one forget or forgive their allegory, or else . . . are . . . so visionary, so full of a sort of ghostly midnight animation, that one is persuaded that they had some strange purpose . . .[1]

Such is the passage quoted from *The Ruines of Time*, though Yeats had not included it in his selection. It is very significant of the way in which his imaginative process worked, that at first he should not have recognized the power of certain symbols or images. They lay smouldering for years in the recesses of his mind, till they were evoked by a process of association. We can understand why a man, whose mind was such a storehouse of past experiences, should be so taken with the idea of a Great Memory, in which all symbols would be contained from eternity to eternity, and from which a poet would, at times, draw some of them for his own purposes. The conception of the Great Memory was a transference onto a universal plane of a mental process which Yeats continually accomplished when writing his poems. The Great Memory was his own mind, and the 'ancient symbols' lying in it were the recollections of his own past experiences (and reading was a major experience for him) which provided images for his poetry.

We have seen now how the image of the swan was mainly of Spenserian origin. After 'Nineteen Hundred and Nineteen' the swan symbol reappears, in Yeats's poetry, in the sonnet 'Leda and the Swan'. We know how, in this case, Gogarty's *An Offering of Swans* provided the necessary spark at the right moment, helping to close the mental circuit, by joining together the ideas of Helen and the fall of Troy, of the swan, and of

[1] *Poems of Spenser, cit.*, xlv; now in *Ess.*, 474.

Leda. But the sonnet would probably never have been written, or at least it would not have had its present form, if the swan symbol had not by this time reached the stage which I have tried to point out in Yeats's imagination. I would not agree with Donald Stauffer who excludes 'Leda' from his brilliant analysis of the swan image in Yeats as not relevant, 'because its subject is the cyclical theory of history, or the unforseen consequences of a moment of intense passion.'[1] Certainly Leda's swan is connected with the swan of 'Nineteen Hundred and Nineteen' as well as with those in the later poems, like 'Coole Park and Ballylee'. And on the psychological plane we may perhaps see the connection in the terms in which it was expressed by Prof. Kenneth Burke:

When Yeats writes of another swan [in 'Coole Park and Ballylee'], 'That stormy white But seems a concentration of the sky', is he not here covertly responding to the connotations that Leda's particular swan has for him? Indeed, we might trace a movement through his works thus: in his early poems, there are the white birds, which are 'seminal' aspects of himself; these become deified in taking the form of Zeus, as a swan; and in this form they again descend to earth.[2]

But even without going so far as to see a projection of the poet's personality in the swan, its connection with some kind of Divinity was already clear in some of the previous contexts where the image appeared, especially in *Calvary*. And there is a definite relation between the swan of 'Nineteen Hundred and Nineteen' and that of Leda, both at the imagistic and at the symbolic level. In the first poem 'The wings half spread for flight, The breast thrust out in pride' suggest the hovering position depicted in the sonnet, but the most striking prefiguration of 'Leda and the Swan' in 'Nineteen Hundred and Nineteen' is to be found a few lines later, when the poet says

[1] D. Stauffer, *op. cit.*, 71.

[2] K. Burke, 'On Motivation in Yeats' (1942), now in *The Permanence of Yeats,* selected criticism edited by J. Hall and M. Steinmann, N.Y., Macmillan, 1950, 257.

that the image of the swan 'can bring wildness, bring a rage To end all things'. This is exactly what the Leda myth implies (at least in Yeats's interpretation): the wild act of rape which is utterly destructive of a whole cycle of civilization ('The broken wall, the burning roof and tower'), though announcing a new one. In 'Nineteen Hundred and Nineteen' the image of the swan had already roused in the poet's mind that sense of a sudden, furious and prodigious destruction (and renewal) which was necessary to create *his* myth of Leda. The full symbolic implication of 'Leda and the Swan' is explained in the much-quoted passage at the beginning of the 'Dove or Swan' section of *A Vision*:

I imagine the annunciation that founded Greece as made to Leda, remembering that they showed in a Spartan temple, strung up to the roof as a holy relic, an unhatched egg of hers; and that from one of her eggs came Love and from the other War. But all things are from antithesis, and when in my ignorance I try to imagine what older civilization she refuted I can but see bird and woman blotting out some corner of the Babylonian mathematical starlight.

<div align="right">(*Vis. A.*, 181; *Vis. B.*, 268)</div>

We need not puzzle out what Yeats meant by the 'Babylonian mathematical starlight' (in a note to the 1937 edition he paraphrases the expression with the words 'Babylonian astrology'): he obviously intended by it whatever cycle of civilization preceded the classical one. The idea implicit in the statement is that any really profound change contains the seeds of love and conflict, and must be brought about by an act of violence, or rather, is necessarily an act of violence, a 'rage'. In the earlier poem he had treated this theme with reference to himself, to his own 'solitary soul' and 'laborious life'; in 'Leda and the Swan' he transferred it onto a universal plane. This seems to me characteristic: the constant tendency to attribute a universal value to his personal feelings and sensations and experiences, which induced him to build up his fantastic theories, continuously changing with the changes of his own sentiments.

It is not so much that he was given to generalizations: rather, his exceptionally sensitive nature dominated his mind to such an extent that, while he believed that he was considering and defining the nature of the universe, he was in reality only considering and defining his own personal nature. He projected his personal microcosmos into a macrocosmos, or, in other words, unconsciously made a universe out of his own personality.

The description of the swan in 'Nineteen Hundred and Nineteen', with its 'breast thrust out in pride', and the allusion in *The Player Queen* ('My breast feathers thrust out and my white wings buoyed up with divinity') find no parallel in the passage of Spenser's *The Ruines of Time* which suggested some of the elements which went into the Leda sonnet. It would not be unreasonable to think that Yeats may have fused together two separate Spenserian contexts, both dominated by a 'snowie swan'. A second such passage exists in Spenser's *Faerie Queene*, and it can offer more than one surprise. It is to be found in the description of the 'Tapets', or hangings decorating the House of Busyrane and depicting the loves of the gods in the best Aretinian or Giulio Romano fashion (*Faerie Queene*, III, xi, 32):

> Then was he turnd into a snowy Swan,
> To win faire *Leda* to his louely trade:
> O wondrous skill, and sweet wit of the man,
> That her in daffadillies sleeping made,
> From scorching heat her daintie limbes to shade:
> Whiles the proud Bird ruffing his fethers wyde,
> And brushing his faire brest, did her inuade;
> She slept, yet twixt her eyelids closely spyde,
> How towards her he rusht, and smiled at his pryde.

Here the pride of the swan is expressed by his 'brushing his faire brest'. There is no doubt that Yeats knew this passage. In his selections from Spenser he included the description of the House of Busyrane, though he reproduced only stanzas 21 to 30 and 47 to 55 of Canto XI, leaving out the description of

the 'Tapets'; at the time Yeats was still suffering from that peculiar and ambiguous form of prudery which appears clearly in his early poems and autobiographical writings—Busyrane's pictures were too daring for him. Now, after some fifteen years, one of the omitted stanzas re-emerged to provide an additional touch to his representation of the proud, solitary swan.

But the most striking fact is that here we have a picture of the Leda myth. A conventional renaissance picture, (it was most probably suggested by Michelangelo's lost painting of Leda), with none of the symbolic implications of Yeats's poem. I am not thinking of a direct influence of this stanza of the *Faerie Queene* on 'Leda and the Swan', but of a probable unconscious reminiscence when the idea of using the same myth became clear in the author's mind. Spenser's 'rusht' may be responsible for the 'white rush' of the sonnet, the bird's breast is as prominent, and (apart from the analogy between 'ruffing his fethers wyde' and 'the feathered glory', since feathers are necessarily common in bird descriptions) it is perhaps not unreasonable to think that Spenser's military metaphor ('inuade') may have confirmed Yeats in his idea of associating the Leda myth with war.

Yeats's reminiscences of the swan passage in Spenser ran together in his mind with recollections of another work which appeared in English in the same year as the *Faerie Queene*. This is the Elizabethan version of the *Hypnerotomachia Poliphili* by the Italian Francesco Colonna,[1] the Beardsley of his time, and is the model of *Under the Hill*. This masterpiece of early decadence has all the vagaries and aberrations which characterized the aesthetes of Yeats's own period, the toying with magic, the relish of decoration for decoration's sake.

Yeats not only knew the English version of this work, which was appropriately dedicated to Sir Philip Sidney, but he had good reason to remember it, having been engaged by a

[1] *Hypnerotomachia. The Strife of Loue in a Dreame.* At London, printed for Simon Waterson . . . 1592. It is regrettable that Yeats could not read the delightful Italian original, printed by Aldo Manuzio (Venice, 1499) and reproduced photographically in 1904 (London, Methuen).

publisher, Andrew Lang, who published it in 1890, to copy it whole from the Oxford volume, one of the few extant copies.[1] The *Hypnerotomachia* consists of numerous engravings and elaborate descriptions—one of those combinations of literary and figurative elements which so often left a lasting mark on Yeats's imagination. The descriptions and quaint engravings of triumphal cars illustrating the loves of Jove may have come back to him when he began to play, as he says, with the myth of Leda and the swan. So many things in these illustrations were already his own. They were fantastic, and full of emblems, such as dolphins, flames and spiral stairs, which he had already used as symbols, or was to use in the future. The treatment of Leda and the swan in the *Hypnerotomachia* I shall examine in the next chapter. I want here only to suggest that Colonna's description of a 'most white Swanne, in the amorous imbracing of a noble Nymph' [2] had joined for Yeats with the images of swans in Spenser.

We can conclude that the swan image developed in Yeats's mind by different stages, undergoing a number of influences especially from past reading. Among these his early familiarity with Spenser's poetry seems to have played the most important role. Finally the image blossomed into the sudden splendour of the Leda sonnet, where it fused with several other poetic elements.

While in the case of the swan image it has been possible to trace the development of its symbolic implications in an

[1] See *Aut.*, 154: 'I spent a few days at Oxford [in August 1889] copying out a seventeenth-century translation of Poggio's *Liber Facetiarum* or the *Hypneroto-machia* of Poliphilo for a publisher—I forget which, for I copied both. . . .' Cp. *L.*, 132. The copy at present in the British Museum is a recent acquisition, lacking several illustrations. The English version, copied by Yeats, appeared as *The Strife of Love in a Dream, being the Elizabethan Version of the First Book of the Hypnerotomachia of Francesco Colonna*. A new edition by Andrew Lang, London, David Nutt, 1890. This edition fortunately did not reproduce the illustrations in the badly produced and incomplete 1592 English edition, but borrowed them directly from the original Italian.

[2] *The Strife, etc., cit.*, London, 1890, p. 210.

unbroken line through Yeats's work, his treatment of the Helen figure appears much more inconsistent, confused, and at times purely casual. This may be due, perhaps, to the excessive wealth of references to Helen that Yeats must have found in the writings of his contemporaries: the image was not recondite enough to allow a personal interpretation. A tabulation of the associations that Helen had for Yeats at different times and in different works yields the following data:

(1) Destructive power of beauty (fall of Troy). This is in turn associated with Maud Gonne.

(2) Union of contraries: Love and War. This is of course strictly connected with 1.

(3) Physical decay, waning of beauty.

(4) Unity of all mythologies, religions and folk beliefs (especially the Irish and the Greek).

(5) Beauty as the bringer of madness and frenzy—which can be visionary frenzy or inspiration (like the swan image in 'Nineteen Hundred and Nineteen').

More than one of these associations may appear in a single context, and they alternate in his work in no particular order. Obviously the first two groups of associations, and even the third, are strictly connected with the Pre-Raphaelite and decadent conception of Helen which Yeats had found in a number of the works of his contemporaries.

The legend of the fall of Troy, with Helen, the fatal woman, as its heroine, was a favourite with the decadent writers and artists of the 'nineties. Professor Mario Praz has amply documented this in his *The Romantic Agony* with special reference to the painting *Hélène* by Gustave Moreau,[1] a painter who, as we shall see, was a favourite of Yeats. He must have read in the 1893 issue of *The Dial*, an early aesthetic periodical and forerunner of *The Savoy*, edited by his friends Shannon and Ricketts, the enthusiastic 'Note on Gustave Moreau' by Charles R. Sturt. In this note Moreau's Helen is celebrated in the most extravagant aesthetic prose ('samite sky' is a fair

[1] M. Praz, *The Romantic Agony*, O.U.P., 1933, especially chapters IV and V.

example).[1] Yeats did not escape the contagion: this prototype of the fatal woman is the first classical figure to appear in his poems, at a time when he was still steeped in Irish and oriental lore and mythology. Through the figure of Helen he absorbed the decadent idea of the fusion of love and death, of beauty and destruction, of (in the words of Ary Renan) 'le carnage et la volupté'.

Among the books and poems which he had certainly read where this Helen appears, were William Morris' *Earthly Paradise* (that third part of it which deals with the myth of Helen),[2] O'Shaughnessy's *An Epic of Women* (which must have attracted him also for its esoteric Blakian illustrations by J. T. Nettleship,[3] a friend of his father's, whom Yeats greatly admired), Rossetti's 'Troy Town', on which so much of the decadent interpretation of Helen as a fatal woman is based, Todhunter's *Helena in Troas*, which was derived from Morris, but also from Marlowe, as can be seen in lines like these:

> my face
> Gilding with glory the red woof of war,
> Shall shine for ever in the hearts of men;[4]

[1] Five issues of *The Dial*, edited by Charles H. Shannon and Charles Ricketts, were printed between 1889 and 1897; the 'Note on Gustave Moreau' (in n. 3, 1893, 10–16) says of *Hélène*: '. . . the artist does not tell . . . if this phantom knows herself to be more than woman, a symbol in some divine semblance, and would exult could she know laughter or tears . . .'

[2] See *Aut.*, 141: 'I had read as a boy, in books belonging to my father, the third volume of *The Earthly Paradise*.'

[3] A. W. E. O'Shaughnessy, *An Epic of Women and Other Poems*, London, 1870, contains also other poems on favourite Yeatsian subjects, such as 'Seraphitus', and 'Invocation to an Ivory Bird'. The authorship of the illustrations was pointed out to me by Mr. Ian Fletcher; Yeats published in the *Dublin University Review*, April 1886 a poem 'On Mr. Nettleship's Picture at the Royal Hibernian Academy, 1885', which was included also in the volume *The Wanderings of Oisin and Other Poems*, London, Kegan Paul, 1889, 126; but was rejected after 1892. Nettleship supplied an engraving of 'Cuchullin Fighting the Waves' as a frontispiece to Yeats's volume *The Countess Kathleen and Various Legends and Lyrics*, London, Fisher Unwin, 1892.

[4] John Todhunter, *Helena in Troas*, Kegan Paul, 1886, 7. For Yeats's opinion of this play see above, note 1 to pp. 96–97.

Oscar Wilde's 'The Burden of Itys' and 'The New Helen', and finally Flaubert's *Tentation de Saint Antoine*,[1] a book that inspired Yeats's stories 'Rosa Alchemica', 'The Tables of the Law' and 'The Adoration of the Magi' and where the figure of Helen-Ennoia, the immortal prostitute lover of Simon Magus, has all the esoteric connotations which appear in the description of Helen in Madame Blavatsky's *Secret Doctrine*, which had been the object of deep study by Yeats.[2]

Suggestions from all these may be found in Yeats's treatment of Helen. So Marlowe's famous lines:

> Was this the face that launch'd a thousand ships?
> And burnt the topless towers of Ilium?
> . . . for heaven is in these lips,

fuse with Flaubert's (and Madame Blavatsky's) Helen as Ennoia (or Epinoia) living thousands of years, in the figure of the fatal woman presented by Yeats in an early poem, 'The Sorrow of Love' (1891):

> And then you came with those red mournful lips,
> And with you came the whole of the world's tears,
> And all the sorrows of her labouring ships,
> And all the burden of her myriad years.
> (*C.K.,* 1892)

That the woman intended in these lines is Helen appears

[1] In the essay 'The Autumn of the Body' (1898) Yeats speaks of the *Tentation* as 'the last great dramatic invention of the old romanticism' (*I.G. & E.,* 297) and in *Aut.* (376) he tells how in the late 'nineties he was writing a novel (*The Speckled Bird,* unfinished and unpublished) in which 'my chief person was to see all the modern visionary sects pass before his bewildered eyes, as Flaubert's Saint Anthony saw the Christian sects'.

[2] H. P. Blavatsky, *op. cit.,* vol. III, published posthumously in 1897, speaks at length of the 'union of Simon with Helena, whom he called Epinoia (Thought)', and of the different reincarnations of Helen of Troy (pp. 113 and 471).

from the later and final version of the poem,[1] where this quatrain reads:

> A girl arose that had red mournful lips
> And seemed the greatness of the world in tears,
> Doomed like Odysseus and the labouring ships
> And proud as Priam murdered with his peers;
> (*C.P.*, 46)

At about the same time (1889–92) Yeats's poem 'The Rose of the World', the first to contain an open allusion to Helen and the fall of Troy, was written:

> For these red lips, with all their mournful pride,
>
> . . .
>
> Troy passed away in one high funeral gleam,

As Professor Agostino Lombardo has acutely remarked,[2] the typically decadent figure of Helen came at this stage to replace the Pre-Raphaelite emblem of the Rose which Yeats had amply used in the 'eighties and early 'nineties, and which in its turn was at one remove from his still more youthful ideal: the Platonic 'Intellectual Beauty' of Spenser and Shelley.[3] His aim

[1] The changes in the poem are discussed in: H. Read, 'The Later Yeats', *A Coat of Many Colours,* London, Routledge, 1945, 208–12; R. Stamm, 'The Sorrow of Love, a Poem by W. B. Yeats Revised by Himself', *English Studies,* XXIX, 3, June 1948, 78–87; R. Ellmann, *The Identity, cit.,* 121–3. They do not identify the 'girl' as Helen; besides the lines are connected with the description of Niamh at the beginning of 'The Wanderings of Oisin' (1889 version): 'And like a sunset were her lips, / A stormy sunset on doomed ships . . .', and with the Helen of 'Peace' (1910, see *post*); finally the words 'red mournful lips' connect this girl-Helen with the emblematic rose of Yeats's poems of the 'nineties: 'Red Rose, proud Rose, sad Rose of all my days!'(*C.P.*, 35).

[2] A. Lombardo, *op. cit.,* 269–70. See also Ellmann, *The Identity, cit.,* 71–9, 110–13.

[3] Cp. Yeats's note of 1925: 'The Rose differs from the Intellectual Beauty of Shelley and Spenser in that I have imagined it as suffering with man and not as something pursued and seen from afar' (*C.P.*, 524).

is now to suffuse a concrete present reality, a living woman with an aura of myth. Helen has not carried the 'burden of her myriad years', like Flaubert's Ennoia and Madame Blavatsky's Epinoia, she is not so much a reincarnation, as a contemporary paragon of proud beauty that can stand comparison with the ancient myth. As Mr. Ellmann puts it, 'the myth is reanimated by a subtle . . . identification of the actual and the legendary woman, of reality and the dream, and by making the counterpoint between them the dramatic situation with which the contemporary woman is faced'.[1] This can be seen in the group of poems written between 1908 and 1913 dominated by the figure of Helen, from which I shall quote the relevant lines together with their probable dating:

'No Second Troy' (December 1908):

> What could have made her peaceful with a mind
> That nobleness made simple as a fire,
>
> . . .
>
> Why, what could she have done being what she is?
> Was there another Troy for her to burn?
>
> > (*C.P.*, 101)

'A Woman Homer Sung' (5–15 April 1910):

> For she had fiery blood
> When I was young,
> And trod so sweetly proud
> As 'twere upon a cloud,
> A woman Homer sung,
>
> > (*C.P.*, 100)

'Peace' (May 1910):

> Ah, that Time could touch a form
> That could show what Homer's age
> Bred to be a hero's wage.
>
> > (*C.P.*, 103)

[1] R. Ellmann, *The Identity, cit.*, 112.

'When Helen Lived' (20–29 September 1913):

> Yet we, had we walked within
> Those topless towers
> Where Helen walked with her boy,
> Had given but as the rest
> Of the men and women of Troy,
> A word and a jest.
>
> (*C.P.*, 124)

Proud beauty and fire are the characteristics of this figure, in which a noble past clashes with a mediocre present. Yeats sees greatness in the destructive power of beauty. The last context is particularly significant as showing the poet's fidelity, at least on the verbal plane, to early literary influences: Marlowe ('those topless towers') goes hand in hand with Oscar Wilde who, in 'The Burden of Itys', had treated Paris in the same way, as 'an amorous red-lipped boy'. The conception of Helen is still decadent.

In the same years the figure of Helen appears in a completely different set of Yeatsian contexts. The quotations I have given up to the present have to do with beauty, love and conflict, and destruction. Those I shall introduce now are connected instead in the first place with the idea of physical decay. Flaubert's *Tentation* could well have provided a suggestion of Helen's old age, a sadistic description of the decay of her beauty, as well as of her reincarnation through 'a myriad years'. But it is somewhat surprising to find as an epigraph to the collection of stories *The Secret Rose*, published in 1897, and which should have included also the esoteric tales 'Rosa Alchemica', 'The Tables of the Law' and 'The Adoration of the Magi', the following Ovidian quotation:

Helen, when she looked in her mirror, seeing the withered wrinkles made in her face by old age, wept, and wondered why she had been twice carried away.

Yeats found this passage in the writings of the archdecadent of all time: Leonardo da Vinci. The age-old theme of *vanitas vanitatum* acquires a new poignancy through the associations that the mythical figure of Helen already possesses in our minds.[1] That is why the words quoted by Leonardo attracted Yeats: an ancient truth is repeated in a symbolic form, since Helen is a symbol, not an allegorical or metaphorical figure to which only one meaning can be attached, but a composite one, carrying in itself a number of implications. And when Yeats wants to explain the nature of 'The Symbolism of Poetry', in the essay with that title, he quotes some lines referring to Helen, to Helen's death:

> Brightness falls from the air,
> Queens have died young and fair,
> Dust hath closed Helen's eye;

and he adds, after another example of symbolic poetry:

or take some line that is quite simple, that gets its beauty from its place in a story, and see how it flickers with the light of the many symbols that have given the story its beauty as a sword-blade may flicker with the light of burning towers.

(*I.G. & E.*, 242–3)

The lines are from Thomas Nashe's famous song, 'Adieu, farewell earth's bliss',[2] another variation on the theme of vanity,

[1] Yeats may have been reminded of Helen's old age also by a passage in the already mentioned 'Note on Gustave Moreau' in *The Dial*, 3 (1893): 'Take the sonnet by Ronsard, whose subject at first sight would appear almost pictorial with its implied winter light and mirror gleam in which Helen, become old and wrinkled, muses sadly on her vanished beauty.' A translation by T. Sturge Moore of Ronsard's sonnet appears in the same issue of the periodical. Ronsard's Helen was not the classical one, but Hélène de Surgères, and the sonnet had been known to Yeats for some time, since he based on it his poem 'When You Are Old' written, according to R. Ellmann, on 21 Oct. 1891; see A. N. Jeffares, *op. cit.*, 78.

[2] It has been accepted today that the word 'air' in the first line is a traditional and suggestive misreading for 'hair'.

with its sad refrain: 'I am sick, I must die. / Lord, have mercy on us!' This is not the only place where Yeats quotes Nashe's lines, which must obviously have made a deep impression on him: we shall see two more Yeatsian passages where they occur, and it can safely be assumed that they were remembered together with the passage from Leonardo when Yeats wrote 'The Old Age of Queen Maeve' (1903):

> For there is no high story about queens
> In any ancient book but tells of you;
> And when I've heard how they grew old and died,
> Or fell into unhappiness, I've said,
> 'She will grow old and die, and she has wept!'
>
> (*C.P.*, 455)

But the most interesting fact is that Yeats must have learnt Nashe's poem when he was still a boy, before he wrote his early verse plays (later suppressed). In one of them, *The Island of Statues,* dating back to the time when the poet was only eighteen, we find some significant lines. The play, like all his other youthful productions, deals with magic. Two young people reach an enchanted arcadian isle where a witch has transformed into statues all those whom she had attracted there. The young people succeed in breaking the spell, but the sleepers, once awakened, prefer to remain in their Arcadia rather than return into the world. Here are a few lines from the scene of the awakening:

The Sleeper Ah! while I slumbered,
 How have the years in Troia flown away?
 Are still the Achaians' tented chiefs at bay?
 Where rise the walls majestical above,
 There dwells a little fair-haired maid I love.
The Sleepers all Together She is long ages dust.

> (*W. of O.*, 155)

It is easy to recognize in the fair-haired girl of Troy imagined

by the chastely idealistic adolescent Yeats, Nashe's Helen: 'Dust
hath closed Helen's eye'. The poet was to remain under the
spell of Nashe's lines for at least twenty more years. They re-
appear again in an essay of 1901, 'What is "Popular Poetry"?':

> . . . or take with you these lines in whose bare meaning also
> there is nothing to stumble over, and find out what men lose
> who are not in love with Helen:
> Brightness falls from the air . . .
>
> (*I.G. & E.*, 8–9)

This time the quotation comes to support the thesis that

> . . . there is only one kind of good poetry, for the poetry of the
> coteries, which presupposes the written tradition, does not
> differ in kind from the true poetry of the people, which pre-
> supposes the unwritten tradition. Both are alike strange and
> obscure, and unreal to all who have not understanding.
>
> (*I.G. & E.*, 10)

In this case Yeats not only recognizes the symbolic value of
the Helen figure, but sees in it something that could be con-
sidered both popular and literary. The example could not be
more apt and testifies to the greatness of Yeats's instinctive
though sporadic critical power. The choice of Nashe's poem
for his demonstration shows that Yeats had felt the true char-
acter of that Elizabethan song, which Professor C. S. Lewis
has admirably defined as a subtle mixture of the immemorially
popular and the extremely sophisticated.[1] At the turn of the
century Yeats was aiming at something very similar: the graft-
ing of Irish folklore and popular directness, with its immemorial
legends, on to the extremely sophisticated and thoroughly
decadent poetry and prose of the Rhymers, of the followers of
Swinburne and Pater and Beardsley. Helen was the most
sophisticated fatal woman, but in a poem like Nashe's she
could be thought of as one of the heroines that have taken root
in the popular imagination, proverbial figures known to the

[1] C. S. Lewis, *English Literature in the Sixteenth Century, Excluding Drama*,
O.U.P., 1954, 482.

most uncultured people. It seems natural that Yeats's next step
should have been the identification of Helen with an Irish
peasant beauty, whose story was still told in Galway, where
she had lived and died shortly before Yeats's time.

The story is told by Yeats in a prose piece, the first part of
which appeared in the periodical *The Dome* for October 1899,
under a title directly derived from Nashe's: 'Dust hath closed
Helen's eye'. Mary Hynes was a young peasant woman of such
beauty that the village boys would go mad for her, and one
was drowned one night while trying to reach her house. Her
early death made her legendary in the district:

She died young because the gods loved her . . . and it may
be that the old saying, which we forget to understand literally,
meant her manner of death in old times. These poor countrymen
and countrywomen in their beliefs, and in their emotions, are
many years nearer to that old Greek world, that set beauty
beside the fountain of things, than are our men of learning. She
'had seen too much of the world'; but these old men and
women, when they tell of her, blame another and not her, and
though they can be hard, they grow gentle as the old men of
Troy grew gentle when Helen passed by on the walls.

<div align="right">(E.P. & S., 166–7)</div>

It is curious to notice at this point how not Nashe but
another Elizabethan, Robert Greene, in his *Friar Bacon and
Friar Bungay*, identified another 'country slut', Margaret, the
fair maid of Fressingfield, with Helen of Troy, exactly in the
same spirit as Yeats's comparison of the country lass of Galway
with Helen. Moreover, since recent scholarly research seems to
establish that *Friar Bacon* pre-dated *Dr. Faustus*,[1] we can
assume that Marlowe's famous vision of Helen (a source of
inspiration for so many poets, including Yeats, as we have

[1] Cp. R. Greene, *Friar Bacon and Friar Bungay; John of Bordeaux*, ed. B. Cellini,
Firenze, La Nuova Italia, 1952; and B. Cellini, 'Echi di Greene nel Doctor
Faustus di Marlowe', *Rivista di Letterature Moderne*, aprile–giugno 1952, 124–9.

seen) was in its turn inspired by the lines that Greene had put
into the mouth of his country maid:

> Shall I be Helen in my forward fates,
> As I am Helen in my matchless hue,
> And set rich Suffolk with my face afire?
> <div align="right">(III, iii, 93–5)</div>

This digression on Greene is not put here to suggest that
Yeats was influenced by *Friar Bacon*; for all we know, he may
never have heard of it—though his interest in magic may have
led him to dip also into Greene's play.[1] What is more interest-
ing is that, at a distance of three hundred years, two poets of
very different temperament should have hit on the same
notion: any country girl can be a Helen, a paragon of beauty
bringing calamity.

But Yeats would not stop at this. The identification of
Helen with Mary Hynes was a confirmation of his belief that
all mythologies and folk tales, as well as all religions, are one.
This belief he had found in Blake, in Madame Blavatsky's and
the theosophists' books, and it was just then being propounded
on a more scientific basis in Frazer's *The Golden Bough*. He saw
this unity in terms of Irish folklore and Irish mythology, which
could incorporate all other mythologies, folk-beliefs and
religions, which could conciliate Paganism and Christianity,
as he stated in 1897, replying to a writer in *The Outlook* who
had criticized his articles on Irish folk-beliefs:

> . . . if your paragraphist . . . will wait until I have com-
> pleted the series of essays . . . he will find that the Irish peasant
> has invented, or that somebody has invented for him, a vague,
> though not altogether unphilosophical, reconciliation between
> his Paganism and his Christianity.[2]

[1] See Excursus IV: Yeats's Hunchback and Byron's Deformed Transformed.

[2] J. M. Hone, *op. cit.*, 152–3. For the connection between Irish and Greek
folk-beliefs see Yeats's note of 1899 to 'The Song of Wandering Aengus': 'The
poem was suggested to me by a Greek folk-song; but the folk-belief of Greece

In fact, the very first mention of Helen in a poem by Yeats, in the early 'nineties, carried the implication that a contemporary woman was at the same time Helen and Deirdre, that heroine of Irish lore: I must quote once again the opening of 'The Rose of the World', adding a fifth line:

Who dreamed that beauty passes like a dream?
For these red lips, with all their mournful pride,
Mournful that no new wonder may betide,
Troy passed away in one high funeral gleam,
And Usna's children died.

Usna's children died for Deirdre as Priam's race died for Helen. Helen is then associated for good, in Yeats's mind, with the Irish-Greek, Christian-Pagan equations. Her symbolism has acquired a new dimension; on the one side she represents the Love-War conflict, on the other the union of antithetical beliefs.

This connection is further emphasized in Yeats's later writings, when he evokes again the story of Mary Hynes.[1] The most important mention is the one in his lecture on *The Irish Dramatic Movement*, delivered at Stockholm to the Royal Academy of Sweden, in December 1923, when he went to receive his Nobel Prize. The lecture was necessarily prepared at a time when Yeats had just drafted his sonnet 'Leda and the Swan', though he may have used material already utilized during his American lecture tours. In an attempt to describe the Irish character, and how the Irish 'ignorance and violence can remember the noblest beauty', Yeats says:

I have in Galway a little old tower, and when I climb to the top of it I can see at no great distance a green field where stood once the thatched cottage of a famous country beauty, the

is very like that of Ireland and I certainly thought, when I wrote it, of Ireland, and of the spirits that are in Ireland' (*W.am.R.*, 88).

[1] As it appears from a letter (*L.*, 665), Yeats was reminded again by George Russell, in March 1921, of Nashe's 'Dust hath closed Helen's eye'.

mistress of a small local landed proprietor. I have spoken to old men and women who remembered her, though all are dead now, and they spoke of her as the old men upon the wall of Troy spoke of Helen, nor did man and woman differ in their praise.

(Aut., 561)

Yeats was in this way trying to demonstrate the suitability of Irish lore for dramatic purposes, the fact that Irish drama could be based on the same ground as Greek drama. At the same time these sentences (which in October 1925 were to be transformed into poetry in 'The Tower'),[1] reveal that Yeats identified himself, perhaps unconsciously, with the old men of Troy, watching from the tower the passage of Helen and saying that she was worth the bloodshed and the destruction. Thoor Ballylee, which he had bought thinking mainly of the lonely tower of the Platonist in Milton's 'Penseroso', of that of Shelley's 'Prince Athanase', and of the tower room in which Villiers de l'Isle Adam's *Axel* meditated on his magic practices; Thoor Ballylee, with its winding stair emblematic of the spiral movement of the aeons, acquires yet another symbolical meaning: it is also one of the 'topless towers of Ilium', from which beauty and strife can be contemplated. This symbol is a revelation of the nature of Yeats's poetry and of Yeats's vision: the poet, like the old men of Troy (or of County Galway), approves of destruction when brought about by beauty, and beauty by a simple law of contrast is necessarily destructive: what matters is only the achievement of beauty (a conception directly derived from the *fin de siècle* aesthetes which Yeats never completely forsook); the visionary is the wise man in an ivory tower, from which he can survey the landscape of human

[1] See Section II of 'The Tower' (*C.P.*, 219–20): 'I pace upon the battlements . . .', 'Some few remembered still when I was young / A peasant girl commended by a song, / Who'd lived somewhere upon that rocky place . . .'; 'Strange, but the man who made the song was blind, / Yet, now I have considered it, I find / That nothing strange; the tragedy began / With Homer that was a blind man, / And Helen has all living hearts betrayed.'

strife, see its inevitability and hence its nobility: the vision of beauty is a maddening experience, it fires the mind and reduces it to ashes, but though its effects are deadly, the essence of the vision is absolute, lofty serenity, 'nor did man and woman differ in their praise'.

We can see now why in the first version of 'Leda and the Swan' the word 'Tower' was capitalized: it was the polyvalent symbol of meditation, magic and vision, it was the actual Thoor Ballylee, and at the same time it was the tower of Ilium from which Yeats, the old man of Troy, the poet and seer,[1] was contemplating beauty, Mary Hynes and Helen, and destruction, the fall of Troy and the Irish troubles. The association of Helen and the 'topless towers' has undergone a deep transformation in Yeats's mind since he first met it in Marlowe: it has become an extremely complex symbolic cluster, which kept all its meaning at once when, in 'Leda and the Swan', the birth of Helen and its fateful consequences were suggested to the poet's imagination by the myth of Leda.

Helen is beauty and vision, and as such—like the other emblem of vision and inspiration, the swan—brought 'a rage' to the poet's mind and senses. And the fact that Helen represents vision and the power of vision to craze and fire the mind of man had already been expressed by Yeats in 1919, in 'The Double Vision of Michael Robartes', where a mysterious apparition, a girl, is seen by Robartes, who, as we know, is Yeats's *alter ego*:

> I knew that I had seen, had seen at last
> That girl my unremembering nights hold fast

[1] The seer is traditionally blind (cp. Tiresias); so was the poet Raftery (*C.P.*, note to 'The Tower', 532) who wrote the song about Mary Hynes, as well as Homer, the singer of Helen. Doubtless Yeats considered himself not only as a poet but also as a seer, identifying poetry and magic. Yeats's eyesight, never strong, was in the early 'twenties extremely weak: he had to dictate most of what he wrote. This may account for his insistence on the blindness of the poet at this time.

Or else my dreams that fly
If I should rub an eye,
And yet in flying fling into my meat
A crazy juice that makes the pulses beat
As though I had been undone
By Homer's Paragon
Who never gave the burning town a thought.

(C.P., 194)

The dream vanishes, the moment of vision passes, but it engenders a quickening of the pulse, what the ancients called the poetic *furor*, what is now called the poetic fire—like the beauty of Helen burning Troy. But she 'never gave the burning town a thought', in so much as the vision in itself is something aloof, unearthly, perfect and passionless, though generating passion. That is why in *A Vision*, when trying to visualize the kind of beauty appropriate to Helen with reference to the works of art with which he was most familiar, Yeats wrote:

One thinks too of the women of Burne-Jones, but not of Botticelli's women, who have too much curiosity, nor Rossetti's women, who have too much passion; and as we see before the mind's eye those pure faces gathered about the 'Sleep of Arthur', or crowded upon the 'Golden Stair', we wonder if they too would not have filled us with surprise, or dismay, because of some craze, some passion for mere excitement, or slavery to a drug.

(*Vis. A.*, 68; *Vis. B.*, 133)

Yeats remained faithful to the Pre-Raphaelites whom he had admired in his youth, and only through a deliberate effort to see with his eyes can we overcome the disappointment of an identification of Helen's beauty with the lifeless grace of Burne-Jones' figures. But if we succeed in adopting for a time his taste, we shall recognize that the women of Burne-Jones have the passionless aloof beauty, the air of detachment and abstraction that Yeats considered as a necessary characteristic of Helen, that is to say of vision.

But it is time to close our analysis of the treatment of the Helen figure in Yeats. We saw its development, under the suggestions provided not only by the Decadents of last century, but by the Elizabethans, like Marlowe and Thomas Nashe. We said at first that, because of the frequent recurrence of the figure of Helen in the writings of all times, and especially during the decadent period, such a figure was not recondite enough to allow to the last comer a personal interpretation. This statement should now be modified: though in Yeats's writings Helen is associated at different times with different and frequently derivative conceptions, by the early 'twenties the mind of the poet had succeeded once again in producing out of this elusive figure that miraculous synthesis which is a poetic symbol. A symbol is an indefinable poetic unit containing a whole wealth of meanings at once: it is felt, not rationally explicable. We cannot say, then, what exactly Helen 'stands for', Helen is an imaginative and emotional complex which should communicate directly and in its integrity (as a complex) with our sensuous and intellectual faculties. On the merely rational plane all that we can do is to point out some of the facets of the symbol. Helen is the essence of poetic vision, and at the same time is a reminder of the decay of the flesh; she is beauty and she is frenzy; she impersonates destruction and conflict, but also the union of opposites, the union of all beliefs; she lives at once in the past and in the present. But what matters is the poet's and the reader's capacity to feel and perceive all these fragmentary meanings as a whole.

The same is true of the other symbol which, though developed independently, had become at this stage strictly connected with Helen: the Tower. The tower, at first an emblem of meditation and magic, of the solitude of the poet and seer, then of the ascending and descending spiral of human and universal life—is now also the tower of Ilium, broken by Helen's beauty, 'the broken wall, the burning roof and Tower'.

Yeats's tower imagery and its sources has been amply

discussed by Mr. Henn and by Professor Jeffares.[1] I need only
point out that, apart from the poetic suggestions (the tower in
Shelley's 'Prince Athanase' and in Milton's 'Penseroso') the
tower had become associated, from a very early stage, with
mystical or occult meanings. Such meanings Yeats perceived
in Axel's tower, in the towers inhabited by the fabulous
personages of the *Chymical Marriage of Christian Rosencreutz*, or
even in the twenty-first trump of the Tarot pack which
MacGregor Mathers described in his *Fortune Telling Cards*:
'The Lightning-struck Tower: a Tower whose upper part is
like a crown, struck by a lightning-flash. (Two men fall head-
long from it, one of whom is in such an attitude as to form a
Hebrew letter *Ayin*.) Sparks and *débris* are falling. It shows
Ruin, Disruption.' [2]

The connection between this and the bookplate Yeats com-
missioned from Sturge Moore for his wife is clear: the lightning
struck tower from which a unicorn springs, the symbolism of
which I have already discussed. The tower was at that stage
already connected in Yeats's mind with his cyclic conception
of history, which was re-inforced when he associated the spiral
staircase (which actually existed in Thoor Ballylee) with the
spiral movement of history, the 'gyres' in his esoteric system.
This idea appears as early as March 1918 in the poem 'Under
the Round Tower' where (as he was later to explain in *A
Vision*)[3] the Sun and the Moon, governing this universal
motion, are figured in a golden King and a silver Queen
dancing up and down the stairs. As he wrote in a note to his
later collection of poems *The Winding Stair*: 'In this book and
elsewhere, I have used towers, and one tower in particular, as
symbols and have compared their winding stairs to the
philosophical gyres, but it is hardly necessary to interpret what

[1] T. R. Henn, *op. cit.*; A. N. Jeffares, 'Thoor, Ballylee', *English Studies*,
XXVIII, 6, Dec. 1947, 161–8.

[2] S. L. MacGregor Mathers, *Fortune-Telling Cards, cit.*, 21.

[3] *Vis. A*, 182; in the revised edition of his work (*Vis. B*, 270) Yeats adds a
direct quotation of four lines from 'Under the Round Tower' at this point.

comes from the main track of thought and expression' (*C.P.*, 535).

The presence of the tower symbol in 'Leda and the Swan', therefore, is more than a vivid metaphor for the invasion of the stronghold of Leda's chastity, 'the broken wall', it is more than a reference to the fall of Troy, it is an imaginative re-inforcement of the basic meaning of the poem (the advent of a new cycle of civilization) while at the same time bringing to bear on it a whole series of other significances.

If each symbol is a cluster of complex images and emotions, the poem as a whole is in its turn a cluster of such symbols, of such 'complexes'. Not only that, but each single symbol acquires and preserves new imaginative meanings from each symbolic cluster, that is to say from each poem or story, in which it has appeared, and in turn carries these new meanings into the next context in which it is included. This is what Yeats meant when, in his essay on the 'Symbolism of Poetry', he said that each line 'flickers with the light of many symbols . . . , as a sword-blade may flicker with the light of burning towers'.

By the early 'twenties, the swan, Helen and the tower had already grown for him into glittering symbols, which needed only to be included in a new 'story' to form that symbolic cluster which is a poem. The story was the myth of Leda.

IV

Images that yet fresh Images beget

THE myth of Leda was suggested most probably by the reading of Gogarty's *An Offering of Swans* in August 1923. A new symbolic cluster was formed with symbols (the swan, Helen, the tower) that had matured independently in Yeats's imagination. But this is not the whole of his mental process. Gogarty's mention of Leda was simply a reminder at the right moment. The myth of Leda would not have acquired its extraordinary ascendancy over the mind and the feelings of the poet if its mention had not suddenly evoked a new train of (probably unconscious) reminiscences. Some of these I shall now try to illustrate.

I have already discussed the stanza in the *Faerie Queene* where the story of Leda is figured, and I have little doubt that it must have been one of the first pictures in Yeats's mind when he was reminded of the myth. Spenser's is indeed a 'picture', the description of the scene in a tapestry. Its appeal is more visual than intellectual.

Also the *Hypnerotomachia Poliphili*, like Spenser, had an immediate visual attraction, not only in its elaborate descriptions but also for the accompanying engravings. And it appealed at the same time to Yeats's intellect, owing to its rich play with emblems and symbols.

One of the most elaborate sections of the book is the

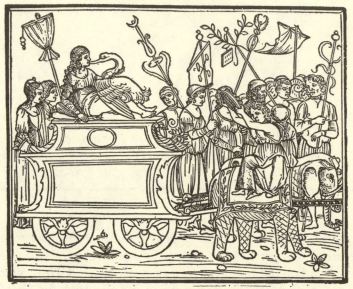

5. The Triumph of Leda in the *Hypnerotomachia Poliphili* (1499).

description of a procession of Renaissance triumphs representing the loves of Jupiter. Each of the four chariots drawn by fantastic animals, centaurs, white elephants, unicorns and 'spotted beasts', celebrates the conjunction of a mortal woman with Divinity, in a different shape; Europa and the Bull, Leda and the Swan, Danae and the shower of gold, Semele and lightning (in the form of 'a pyramidal flame'). The sensuousness of the description of the triumph of Leda (though somewhat attenuated in the English version that Yeats had been commissioned to copy out) must have impressed him:

Ouer this stately Chariot tryumphant, I behelde a most white Swanne, in the amorous imbracing of a noble Nymph, the daughter of *Theseus*, of an incredible beautie: and vpon her lappe sitting the same Swanne, over her white thighes. She sate vppon two cushines of cloth of golde, finely and softly wouen, with all the ornaments necessary for them.

Her selfe apparelled in a Nimphish sort, in cloth of siluer, heere and there powdered with golde, ouer one and vnder

three, without defect or want of anything, requisite to the adorning of so honorable a representation, which to the beholder, may occasion a pleasurable delight.

The significance of the myth disappears under the sumptuousness of the decoration. But the author had an eye for symbolism, and this is shown by the subtle way in which he suggests the fateful consequences of Leda's rape through a

6. Side decorations of the triumphal car of Leda in the *Hypnerotomachia Poliphili* (1499).

series of 'engraven tables' which he describes as adorning the sides of the car:

the Tables were of orient blewe Saphire, having in them, as small as motes in the Sunne, certaine glinces of golde, gratefull to the Magicke Arte, and of *Cupid* beloued in the left hande.

Vpon the Table on the right side, I behelde engrauen, a goodly Matron lying in a princely bed, beeing deliuered of two egges in a stately Pallace: her Midwyues and other Matrons and yonge women, beeing greatly astonished at the sight. Out of one of the which, spronge a flame of fire: and out of the other egge two bright starres.

Vpon the other side were engrauen, the curious Parents, ignorant of thys strange byrth, in the Temple of *Apollo*, before hys image, asking by Oracle the cause and ende heereof, having this darke aunswere. *Uni gratum Mare. Alterum gratum Mari.* And for thys ambiguous aunswere they were reserued by their Parents.

Vppon the fore-ende of the Charyot, there was represented most liuely the figure of *Cupid*, aloft in the skyes, with the sharpe heades of his golden arrowes, wounding and making bleede the bodyes of dyuers foure footed beastes, creeping Serpents, and flying Foules. And vppon the earth, stoode dyuers persons, vvondering at the force of such a little staue, and the effect of suche a vveake and slender Arrowe.

In the hynder ende, *Iupiter* appoynting in hys steade, a prvdent and svbtill Sheepehearde as a Iudge, awakened by hym, as hee lay sleeping neere a most fayre Fountaine, whether of the three most fayre Goddesses, hee esteemed best worthie. And he beeing sedvced by deuising *Cupid*, gaue the Apple to the pleasant working *Uenvs*.[1]

The allusion to the 'glinces of golde, gratefull to the Magicke arte' was apt to attract Yeats, interested as he was in 'the left hand way'. The symbolic treatment of Helen's birth, in the flame from the egg, stressing the element of destruction, must also have impressed him. There is no direct mention of the fall of Troy, but this too is implied in the fateful judgement of

[1] *The Strife of Love, etc., cit.,* 206–10.

Paris. Yeats wrote of Leda 'from one of her eggs came love and from the other war', and in Poliphilo, besides the element of destruction, there is the emblematic portrayal of the power of love.

Apart from the *Hypnerotomachia*, Yeats may have been reminded of the birth of Helen from Leda also by Goethe's *Faust*, part II (Laboratory scene, lines 6903–20, and Classical Walpurgis Night, lines 7271–313), where Faust has twice a vision of the meeting of Leda and the Swan, preparatory to the apparition of Helen.[1] The vision described by Goethe—who incidentally never mentions Leda by name—is closely modelled on Correggio's 'Leda' at the Kaiser Friedrich Museum in Berlin. But Yeats, though he stated in 1933 that 'perhaps *Faust, Louis Lambert, Seraphita* and *Axel* are our sacred books',[2] had no great admiration for Goethe, and imputed to him, as well as to Wordsworth and Browning, the fact that 'poetry gave up the right to consider all things in the world as a dictionary of types and symbols and began to call itself a critic of life and an interpreter of things as they are'.[3] He was influenced rather by Marlowe's *Doctor Faustus* than by Goethe's *Faust*.

Another writer was exercising a kind of intellectual dictatorship over the young poets, including Yeats, at the end of the last century. As he himself says in *The Trembling of the Veil*:

If Rossetti was a subconscious influence . . . we looked consciously to Pater for our philosophy.

(*Aut.*, 302)

And it was in the 'sacred book' itself of the aesthetic school, *The Renaissance*, that Pater spoke of the Leda myth, connecting it with the birth of Helen rather than with that of the Dioscuri.

[1] See Stuart Atkins, 'The Visions of Leda and the Swan in Goethe's Faust', *MLN*, LXVIII, 5, May 1953, 340–4. The connection with Yeats's poem was suggested by Professor Leo Spitzer, *loc. cit.*, 274.

[2] Letter to Olivia Shakespear, *L.*, 805.

[3] 'The Autumn of the Body', *I.G. & E.*, 302.

The relevant passages have already been quoted and acutely commented upon in connection with Yeats by Mr. Henn.[1] One is from the most famous page that Pater ever wrote, his description of 'La Gioconda'—a page that Yeats considered pure poetry and published in 1936 as verse at the beginning of his *Oxford Book of Modern Verse 1892–1935*, under the title 'Mona Lisa' [*sic*]:

> She is older than the rocks among which she sits;
> Like the Vampire,
> She has been dead many times,
> And learned the secrets of the grave;
>
> * * *
>
> And, as Leda,
> Was the mother of Helen of Troy,
> And, as St. Anne,
> Was the mother of Mary;[2]

Many readers of the famous passage out of its context in the essay on Leonardo fail to realize that the references to Leda and to St. Anne are by no means a casual flight of Pater's imagination: they are a precise reference to the fact that Leonardo used the same model with her 'mysterious smile', for 'La Gioconda', for the figure of St. Anne in the 'St. Anne, the Virgin and the Child' (Louvre), and for the lost painting of 'Leda', of which two excellent copies exist in Rome (Borghese Gallery and Spiridon Collection), and studies in Leonardo's hand at Windsor. Pater was wondering at Leonardo's identification of three women so distant from one another in time, one belonging to a fabulous mythological past, one to the Christian tradition, one alive in Leonardo's own time. It was this identification that suggested to Pater the idea of describing 'La Gioconda' in the same terms as Flaubert's Helen-Ennoia (and, as we have

[1] T. R. Henn, *op. cit.*, 199, 299.
[2] *Oxford Book of Modern Verse*, chosen by W. B. Yeats, O.U.P., 1936, 1.

seen, as Yeats's Helen), the immortal symbolic woman going through an infinite series of reincarnations.

When Yeats in 1923 was reminded of the Leda myth, Pater's purple passage, lurking for years in his mind, must have emerged, perhaps vaguely, suggesting a relation, or a parallel, between Leda and the birth of Helen on the one side, and the lineage of St. Anne-Mary-Christ, the birth of Christianity, on the other. Pater himself in the same essay had underlined the symbolic character of Leonardo's Leda and of the other women he painted, saying that

he found a vent for his thought in taking one of these languid women of Florence, and raising her, as Leda or Pomona, as Modesty or Vanity, to the seventh heaven of symbolic expression.

But another passage of Pater where Leda is mentioned is relevant to Yeats's sonnet. It occurs in the essay on 'The Poetry of Michelangelo', when Pater stresses some ideas that Yeats was later to share: the idea of a parallelism between Paganism and Christianity, and that of the 'creation of life' which, in Yeats's universalizing mind, could be identified with the birth of different cycles of civilization. Speaking of Michelangelo, Pater says:

This creation of life . . . is in various ways the motive of all his work, whether its immediate subject be Pagan or Christian, legend or allegory; . . . Not the Judgement but the Resurrection is the real subject of his last work in the Sistine Chapel; and his favourite Pagan subject is the legend of Leda, the delight of the world breaking from the egg of a bird.

This passage is important for several reasons: first of all, it mentions the painting of Leda by Michelangelo which, in the opinion of many critics, is the main figurative source of Yeats's sonnet on Leda. Michelangelo, in his turn, was to become a dominating figure in Yeats's later poetry, from this period onward. His mental process seems to have been the following: the thought of the Leda myth sent Yeats back to Pater's Leda; there he found the mythical girl connected not only with Leonardo (an artist for whom he shared the admiration of the

Decadents), but also with the more powerful—physically powerful—figure of Michelangelo, described by Pater as the greatest of the Florentine Platonists, whose doctrines, uniting Pagan, Christian and esoteric beliefs, fascinated Yeats. It was natural that Michelangelo should at this point have taken hold of his mind, so that, when not long after writing 'Leda', a group of young Irish poets asked him in June 1924 to write the editorial manifesto for the new review *To-Morrow*, he began it with the following sentences:

We are Catholics, but of the School of Pope Julius the Second and of the Medician Popes, who ordered Michelangelo and Raphael to paint upon the walls of the Vatican, and upon the ceiling of the Sistine Chapel, the doctrine of the Platonic Academy of Florence, the reconciliation of Galilee and Parnassus. We proclaim Michaelangelo the most orthodox of men, because he set upon the tomb of the Medici 'Dawn' and 'Night', vast forms shadowing the strength of ante-diluvian Patriarchs and the lust of the goat, the whole handiwork of God, even the abounding horn.[1]

It was in the same review (which was suppressed after its second issue) that 'Leda and the Swan', in its Version E form, was published. In the manifesto Yeats does not speak of Michelangelo's Leda, but of his Medici tombs; but the two figures of Leda and 'Night' in Michelangelo's work are strictly dependent on each other. Yeats had already referred to Michelangelo in 'The Tables of the Law' (1896) and in the poem 'Michael Robartes and the Dancer' (1918); but it was only after the writing of the 'Leda' sonnet that the great Italian artist acquired an extraordinary ascendancy over Yeats's imagination, in the two versions of *A Vision* and in several poems—till by 1938 Yeats in his old age seemed to identify himself with him:

> Grant me an old man's frenzy,
> Myself must I remake

[1] R. Ellmann, *Yeats, etc., cit.*, 250–1; cp. J. M. Hone, *op. cit.*, 361.

Till I am Timon and Lear
Or that William Blake
Who beat upon the wall
Till Truth obeyed his call;

A mind Michael Angelo knew
That can pierce the clouds,
Or inspired by frenzy
Shake the dead in their shrouds;
Forgotten else by mankind,
An old man's eagle mind.

<div align="center">(C.P., 347)</div>

The passage from Pater's essay on Michelangelo, besides
suggesting the importance of the Italian artist, provided Yeats
with another symbol which later acquired an ever-increasing
importance in his work. 'The delight of the world breaking
from the egg of the bird,' Pater said. This sentence must have
evoked in Yeats's mind the connection suggested in Madame
Blavatsky's *Secret Doctrine* between the Graeco-Latin Leda
myth and the doctrine of the Orphic and Oriental religions
according to which the world, or at least one of the Great
Races of the world (corresponding to different and successive
cycles of universal history), was born of an egg. The second
volume of *The Secret Doctrine*, first published in 1888 and con-
cerned with the 'Anthropogenesis', opens with the quotation
of an occult text, in which the evolution of mankind is
described as the generation out of each other of a series of
Races, produced by the whirling of a great Wheel (we must
remember that the Wheel is the basic symbol in the first version
of Yeats's *Vision*). Here is the passage referring to the birth of
the Third Race:

Then the Second evolved the Egg-born, the Third. The
Sweat grew, its Drops grew, and the Drops became hard and
round. The Sun warmed it, the Moon cooled and shaped it;
the Wind fed it until its ripeness. The White Swan from the

<div align="center">141</div>

Starry Vault [note: The moon] overshadowed the big Drop. The Egg of the Future Race, the Man-swan of the later Third. First male-female, then man and woman.[1]

The 'Egg' seems to enter naturally among Yeats's already established symbols: the wheel, the white swan, the notion of a succession of ages and races, each with its own Nativity. Already in the first volume (on 'Cosmogenesis') of her *magnum opus* Madame Blavatsky had dealt with the Egg, while commenting on another occult text, the *Book of Dzyan*:

The 'World Egg' is, perhaps, one of the most universally adopted symbols, highly suggestive as it is, equally in the spiritual, physiological, and cosmological sense. Therefore, it is found in every world theogony, where it is largely associated with the serpent symbol . . .[2]

But it is in the 'Anthropogenesis' section that she deals at some length with the Leda myth, saying among other things that

It relates to that group of cosmic allegories in which the world is described as born from an Egg. For Leda assumes in it the shape of a white swan, when uniting herself to the Divine Swan or Brahma-Kalahamsa. Leda is the mythical bird, then, to which, in the traditions of various peoples of the Arian race, are attributed various ornithological forms of birds which all lay golden Eggs. In the *Kalevala*, the Epic Poem of Finland, the beauteous daughter of the Ether, the 'Water-Mother', creates the world in conjunction with a 'Duck'—another form of the Swan or Goose, Kalahamsa—who lays six golden eggs, and the seventh, an 'egg of iron', in her lap.[3]

Madame Blavatsky goes on in the same vein for about two more pages (the passage quoted is typical of her style and of her method), till she makes her point:

Is this a poetical fiction only? . . . Indeed it is much more. Here we have an allusion to the 'Egg-born' Third Race . . .

[1] H. P. Blavatsky, *op. cit.*, II, 20.

[2] *Ibid.*, I, 94–5; for a more extensive treatment of the same subject see I, 384–93.

[3] *Ibid.*, II, 128–9.

The fact that I wish to note as of some importance in connection with Yeats's conceptions is that Madame Blavatsky insists on the relation between Leda's egg and the origin not so much of the world as *one* of the cosmic races or ages, and this suited Yeats's idea of the cyclic development of the universe.

In the late 'eighties and early 'nineties side by side with Madame Blavatsky's teachings, the symbolic doctrines of William Blake were running in Yeats's mind. There is, in Blake's prophetic books, a mysterious figure in an illustration which reminded the puzzled commentators, Yeats and Ellis, of the myth of Leda. The illustration occurs on page 11 of *Jerusalem* and it bears no apparent relation to the text. It represents a naked female figure, sitting or kneeling in a pond, with wings on her shoulders and a swan's long neck and head. Yeats and Ellis, obviously intrigued by it, commented:

This has been called Schofield as the man-drake on the Lake of Udan Adan. This has been suggested as the subject, but it has rather the appearance of an involuntary vision of the Feminine viewed as a combination of Air and Water, East and West, which do not meet as in the title-page of 'Heaven and Hell', but mingle as a Leda-Swan.[1]

At this early stage the Leda myth was, at least for a moment, connected in Yeats's mind with the idea of the union of opposites and with the conception of vision. For a fuller explanation of the meaning of the note quoted we must revert to Yeats's and Ellis's commentaries to the illustrations of Blake's *Marriage of Heaven and Hell*. The picture on the title-page to which they refer represents two naked human figures kissing in mid-air, and the note they appended to it runs:

Desire and Blood meeting and kissing. (Flame and cloud). Enthusiasm and instinct are equally to be understood, and all that is grouped symbolically under the points of the compass, East and West.[2]

[1] *The Works of William Blake, cit.,* II, 356–7. [2] *Ibid., cit.,* II, 351.

We get, then, the following set of correspondences for the figures of Leda and the Swan mysteriously fused in Blake's picture: Leda—Female—Water—West—Cloud—Desire—Instinct. Swan — Male — Air — East — Flame — Blood — Enthusiasm.

This accounts for the line that Yeats introduced in Version C of the Leda sonnet, 'So mastered by the brute blood of the air': the Swan is both Air and Blood. It relates to the ancient theory of the correspondences between the 'elements' and the 'humours', which Yeats and Ellis quote directly from Cornelius Agrippa, when commenting on Blake's visionary figure of Luvah:

This correspondence of the emotional life with air is a part of the occult system of Cornelius Agrippa. The 'Humours', he writes, 'partake of the elements, for yellow choller is instead of fire, *blood instead of air*, flegme instead of water, and black choller or melancholy instead of earth'. [The italics are Yeats's and Ellis's.][1]

These correspondences were well known to the Elizabethans, but Yeats seems to think that he is discovering them anew. And it must be said that the application of these correspondences by Blake as well as by his commentators is by no means consistent. As we saw in the comment to the title-page of *The Marriage of Heaven and Hell*, the male figure is equated not only with Air, but also with Fire (the meeting of Flame and Cloud). And this second equation is repeated in the comment to the third plate of the *Marriage*, at the top of which there is a naked reclining female figure being invested by flames (the attitude of the woman, lying back on a cloud, and the position of the flames, suggest the idea of a rape). Yeats and Ellis write of it:

The upper figure repeats the subject of the title-page, only the flame is not personified, and the cloud, as the Female, is. The picture may be called Orc embracing Enitharmon.[2]

[1] *The Works of William Blake, cit.,* I, 257. [2] *Ibid., cit.,* II, 351.

It should be taken into account that Blake's text on this page must have particularly struck Yeats, since it contains one of his basic beliefs:

Without Contraries is no progression. Attraction and Repulsion, Reason and Energy, Love and Hate, are necessary to Human existence. From these contraries spring what the religious call Good & Evil. Good is the passive that obeys Reason, Evil the active springing from Energy.

Here, in a nutshell, is the substance of Yeats's elaborate 'system', with its opposition and union of 'primary' and 'antithetical', of Man and Mask, of subjective and objective, of knowledge (Reason) and power (Energy)—a system which Yeats in his turn synthesizes in one line of his Leda sonnet: 'Did she put on his knowledge with his power?' The basic meaning of the line in the context of the sonnet seems to be 'Did Leda, overpowered by Godhead, share for a moment the divine knowledge of the future?' Did she see the tragic outcome of the present act? 'A shudder in the loins engenders there / The broken wall, the burning roof and tower, / And Agamemnon dead'. The early version of line 12, 'Did nothing pass before her in the air' supports this meaning. But once images are created they are polyvalent, andthis meaning co-exists with a number of others. The whole sonnet can also be read as a parable of the creative act of the artist. The swan, as Yeats writes elsewhere, is a symbol of inspiration. The line 'Did she put on his knowledge with his power?' can be read in the light of this passage in his 'Hodos Chameliontos' written shortly before the Leda sonnet:

When a man writes any work of genius, or invents some creative action, is it not because some knowledge or power has come into his mind from beyond his mind?

(*Aut.*, 272)

In any case, Blake's illustration seems relevant, and likely to have impressed Yeats: a woman raped by fire, as Leda was raped by the Swan—a woman whose posture recalls that of

Leda in some well-known paintings, like the one by Michelangelo.

And another woman raped or 'invaded', as Spenser would have said, by a fire from heaven, by the fire of the sun, may have been evoked for Yeats by the picture in Blake's book. This is Chrysogone, the mother of Belphoebe and Amoret in Canto VI of the third book of Spenser's *Faerie Queene*—the Canto which describes the garden of Adonis, included by Yeats in his Spenserian anthology. Chrysogone, after bathing in 'a fresh fountain',

> . . . faint through irkesome wearinesse, adowne
> Upon the grassie ground her self she layd
> To sleepe, the whiles a gentle slombring swowne
> Upon her fell all naked bare displayd;
> The sunne-beames bright vpon her body playd,
> Being through former bathing mollifide,
> And pierst into her wombe, where they embayd
> With so sweet sence and secret power vnspide,
> That in her pregnant flesh they shortly fructifide.

The offspring of this peculiar union are, as in the case of Leda, twins. The parallelism is so obvious that it seems probable that, in devising this odd new myth, Spenser must have had before his mind's eye some Renaissance picture of the Leda story, such as the one he was to describe in Canto XI of the same book, and which I have already quoted as one of the sources of the swan image and of the Leda sonnet for Yeats. It is reasonable to advance the opinion that, in some dim recess of Yeats's consciousness, the two Spenserian contexts (Leda and the Swan, and Chrysogone raped by the sun beam) became fused together, alongside Blake's Leda-Swan in *Jerusalem* and the woman raped by fire in *The Marriage of Heaven and Hell*; and with the help of Madame Blavatsky's teachings, of hints from Pater and from the *Hypnerotomachia*, and of the poet's other theosophic and occult notions, they formed a unique intel-

lectual accretion from which *his* conception of the Leda myth
was to spring. It is only a hypothesis, but it seems to me worth
entertaining. It would prove that poetry, for Yeats at least, was
the slow maturation of the seeds sown in his mind during his
youthful years: the authors I have mentioned had all been
read by him before he was thirty years old, and some con-
siderably earlier. Perhaps the strength and the beauty of his
mature poetry lies partly in the fact that it has such deep roots
in his own past intellectual experiences. This is what gives it
that tone of serene though passionate assurance—in spite of the
fact that, if we pass from his poetry to his abstract theorizing,
we find a hopeless muddle defying any effort towards rational-
ization. Yeats's nature was that of an artist: ideas in his mind
became clusters of poetic symbols, not philosophical counters:
he could present them transfigured into the glittering texture of
a poem, not rationalized into the scheme of a theoretical system.

Moving from the intellectual to the verbal level, we find that
also in this case reminiscences entered the Leda sonnet from
Yeats's early reading. In speaking of the swan image we have
already noticed his debt to Spenser (the white rush, the proud
breast); we have seen how the study of Blake and Cornelius
Agrippa suggested the 'brute blood of the air', and how instead
the 'broken wall' might have come from a very recent reading
of Gogarty's *Offering of Swans*, which however harked back
in its turn to some of Yeats's earlier poems. It would not be
surprising if further suggestions should have come from another
poet that Yeats had read and admired in his youth: Shelley.
Shelley mentions Leda only once, in his translation of the
'Homeric' Hymn to the Dioscuri (a poem mentioned also by
Madame Blavatsky in her discussion of the Leda myth). The
Hymn, after a brief reference to Leda as the mother of the
twins, celebrates them as the protectors of seafarers, saying that
when, during tempests, the sailors on an exposed ship

> sacrifice with snow-white lambs—the wind
> And the huge billow bursting close behind,

Even then beneath the weltering waters bear
The *staggering* ship—they [the Dioscuri] *suddenly* appear,
On yellow *wings rushing* athwart the sky.

The words *rush* and *suddenly* are in the first version of the
Leda sonnet, but *wings* (though very obvious in the context)
and *staggering* appear only in the final version. Is it too far-
fetched to suggest that while Yeats was polishing his poem
Shelley's lines connected with Leda confusedly emerged in his
mind, and the image of divinity rushing down from the sky
towards imperilled humanity was transposed into that of the
swan descending on the helpless girl?

Finally another line which invites speculation about its
sources is the first of the sestet, which Professor Kenneth Burke
has rightly defined as 'the most effective moment in the Leda
sonnet':[1]

A shudder in the loins engenders there

But in this case, as other critics have pointed out, the source is a
poem written by Yeats himself nine years before (May 1914),
'On Woman', where, speaking of Solomon and Sheba,[2] the
poet says:

Harshness of their *desire*
That made them *stretch* and yawn,
Pleasure that comes with sleep,
Shudder that made them one.
(*C.P.*, 165; *italics mine*)

Mr. Ian Fletcher remarks that shivers and shudders used as

[1] K. Burke, 'On Motivation in Yeats', *cit.*

[2] The symbolic figures of Solomon and Sheba, which appear also in Yeats's
'Solomon to Sheba' and 'Solomon and the Witch' (both written in 1918), seem
to have been suggested by Arthur Symons' dramatic poem 'The Lover of the
Queen of Sheba' published in the periodical *The Dome*, to which Yeats was
a contributor, in January 1900 (*The Dome*, n.s., V, 5–12).

euphemistic of the sexual act occur in the poetry of the eighteen-nineties, particularly in Symons.[1] But the words 'stretch and yawn' appear in a direct reference to Leda in Yeats's *The Player Queen* ('A passion for a swan / Made Queen Leda stretch and yawn'). It should be noticed that all versions of the Leda sonnet except the last one contain the line 'All the stretch'd body's laid in that white rush'.

On the purely verbal level there may be echoes from the poems of his contemporaries, his friends or acquaintances. The decadents, with their taste for the mythological, not infrequently treated the subject of Leda. Among others were 'Michael Field', in a poem included in *Underneath the Bough* (1893),[2] John Gray, who published in the 1897 issue of *The Dial* a poem entitled 'Leda', in which the only line that is even vaguely Yeatsian is

The sudden lightnings split the burning sky;[3]

and T. Sturge Moore—who stresses the birth of Helen from Leda in his poems 'Agathon to Lysis' ('A beautiful bird on a beautiful dame / Begat sweet Helen of Troy . . .') and 'The Home of Helen'.[4] But while I think Yeats took little on the verbal plane from his contemporaries, his repetition of the word

[1] Private communication.

[2] This too has been suggested to me by Ian Fletcher. I find that another work of 'Michael Field' (the pseudonym of Katherine Bradley and her niece Edith Cooper) may have had an influence on Yeats's later imagery; this is the one-act play in verse *Equal Love* dealing with Byzantium, published in the 1896 issue of the occasional magazine *The Pageant,* edited by Ch. H. Shannon and J. W. Gleeson White (pp. 189–224); Yeats contributed a story to the same issue.

[3] *The Dial,* V, 1897; 13–15.

[4] T. Sturge Moore, *The Sea Is Kind,* London, Grant Richards, 1914. The collection contains a poem dedicated to Yeats: 'The Phantom of a Rose', 'suggested by the dancing of M. Nijinsky and Mlle. Karsavina in *Le Spectre de la Rose*'; Sturge Moore must have seen the similarity of conception between the subject of the ballet, where a rose is transformed into a young man, its 'perfect emanation', and the rose-petals transformed into dancers in Yeats's earlier story 'Rosa Alchemica'.

'thigh' may be due to the picture and description in the *Hypnerotomachia*.[1]

Even in dealing with the literary influences which contributed to the formation of the Leda symbolic cluster in Yeats's mind, I have been unable to keep the merely poetical and intellectual firmly separated from the visual elements operating on the poet's imagination. Blake's illustrations, for instance, left nearly as great an impression on him as the text of Blake's prophetic books; the same is true of the *Hypnerotomachia Poliphili*, and Pater evoked to his mind's eye the works of Leonardo and Michelangelo. The visual and the intellectual are inseparable for him—and perhaps Yeats's early study of Blake is partly responsible for this mental attitude of the Irish poet. Also his study of magic, where visual symbols are amply used, and his addiction to visionary dreams in which obscure shapes appeared, may have contributed to establish this strict link between the visual and the intellectual. I have discussed this point more fully earlier, and at present I wish only to draw attention to the following facts: (*a*) Yeats's taste in the visual arts had been formed on Pre-Raphaelite paintings (the rediscovery of Blake was due to Rossetti) and on the art of the *fin de siècle* aesthetes like Aubrey Beardsley and Charles Ricketts:[2] all artists who based their work on strong intellectual

[1] On the verbal level I should mention the striking similarities in diction of Yeats's sonnet with Aldous Huxley's ambitious youthful poem, *Leda*, first published in 1920 (now in *Verses and a Comedy*, London, Chatto & Windus, 1946, 30–49). Apart from other words ('shudder', for instance, appears more than once) an expression like 'The folded glory of his wings' could well have suggested 'The feathered glory' of Yeats's swan. Besides Huxley says of Leda and the swan that their 'different grace in union is a birth / Of unimagined beauty on the earth'. But there is no evidence that Yeats had read Huxley's poem before 1923. If such evidence existed I should modify my previous statements on the 'catalyst' of the Leda sonnet, adding Huxley's poem to Gogarty's *An Offering of Swans*.

[2] In the early years of this century Yeats received his friends at Woburn Buildings, London, in 'a large room hung with Blake engravings, some Beardsleys, a Rossetti and other pictures of a pre-Raphaelite character' (Hone,

and literary stimuli rather than on strictly figurative ones, and who gave it a visionary or dreamy quality. (*b*) From the references to works of art in Yeats's writings it appears that what he appreciated most was not the quality of workmanship, but some symbolic meanings he read into them; Mr. Henn wrote that 'more important even than the influence of painting on Yeats was the influence of the criticism of that painting, and particularly of the work of Walter Pater' [1]—actually most important of all was not criticism but his personal interpretation (or other people's interpretations with which he agreed) of the symbolic value of the works of art. (*c*) What remained in his mind of the picture seen was not a precise recollection including the colours and general composition, but a few 'symbolic' details, and a vague outline of the main figure or figures, especially their attitudes and the sense of the actions they were performing (the case of Mrs. Yeats's bookplate mentioned above is typical—or, for a detail, the 'abounding horn' in Michelangelo's statue of Night, which in fact is a roughly hewn band twisting round the leg of the statue [2] and only by an effort of an imagination fascinated by symbols can be seen as a 'cornucopia').

Keeping these three points in mind we can proceed to examine the visual stimuli that contributed to the creation of the Leda sonnet. Seeing the prominence that Leonardo's *Leda* had

op. cit., 178). Charles Ricketts, 'certainly an heir of the great generation' (*Aut.*, 169), is referred to by Yeats in *Vis. A,* 208, as 'my education in so many things'. The photographic exhibition held at Reading University in 1957 was particularly valuable in collecting together reproductions of many of the figurative works which Yeats knew and which had affected his imagination, such as the symbolist paintings of Nettleship and Althea Gyles. An uncollected essay of Yeats on Althea Gyles, 'A Symbolic Artist and the Coming of Symbolic Art' (*The Dome*, n.s. I, 3, Dec. 1898, 233–7) is an even better record than 'Symbolism in Painting' of the poet's approach to figurative arts. On Ricketts' influence on Yeats see T. R. Henn, *op. cit.*, 237–9; and Gordon and Fletcher, *op. cit.*, 22–3.

[1] T. R. Henn, *op. cit.*, 251.

[2] Ch. De Tolnay, *Michelangelo,* vol. III, *The Medici Chapel,* Princeton U.P., 1948, 136, states that this band is 'usually interpreted as a garland of poppies, which were in the Renaissance an emblem of fertility'.

in Pater, we might expect that the surviving copies of that painting suggested something to Yeats. But Leonardo represents his Leda standing next to a large swan, lovingly looking at her children (two boys near an unhatched egg in the Borghese gallery version; two pairs of twins breaking from two eggs in the Spiridon collection version). The scene is idyllic, with none of the passion Yeats put into his sonnet. The fact is that by 1923, even if he had seen reproductions, Yeats had not seen the two extant copies of the painting, both in Rome, which he visited for the first time only in 1925. Leonardo's *Leda*, therefore, provided no visual suggestions for the poem.[1]

The same cannot certainly be said of Michelangelo's work mentioned by Pater. Michelangelo became a major influence on Yeats's poetry only *after* the writing of the Leda sonnet—and still more after he had seen the Sistine Chapel in Rome, in February 1925, whence he went back to Ireland

with great rolls of photographs of Michelangelo's 'fabulous' ceiling which, later, he spread out before the Minister of Justice as an argument against the Irish Censor's ban on Bernard Shaw's book *The Black Girl in Her Search for God*.[2]

Of that fabulous ceiling he had already spoken in his early story 'The Tables of the Law', contrasting the 'certitude of a fierce or gracious fervour' in 'the august faces of the sybils' in the Sistine Chapel with 'the uncertitude, as of souls trembling between the excitement of the spirit and the excitement of the flesh' in the faces painted by Sodoma or by 'the modern

[1] It is curious that in an essay of 1919, 'If I Were Four-and-Twenty', collected posthumously in the volume of the same title (Dublin, Cuala Press, 1940, 12) Yeats had written: 'When I close my eyes and pronounce the word "Christianity" and await its unconscious suggestion, I do not see Christ crucified, or the Good Shepherd from the catacombs, but a father and mother and their children, a picture by Leonardo da Vinci most often'. Since there is no painting by Leonardo with a 'father', it could be suggested that pictures like *The Virgin of the Rocks* and *St. Anne the Virgin and the Child* had fused in his mind with the *Leda*, so clearly a happy family scene.

[2] Hone, *op. cit.*, 368.

symbolists and Pre-Raphaelites'.[1] By 1918, when he mentioned
Michelangelo again in the poem 'Michael Robartes and the
Dancer', Yeats knew much better what to look for in the
Italian artist: the powerful union of flesh and spirit, the spiritual
energy expressed by the sheer physical power of the muscular
structure of Michelangelo's figures:

> . . . Michael Angelo's Sistine roof,
> His 'Morning' and his 'Night' disclose
> How sinew that has been pulled tight,
> Or it may be loosened in repose,
> Can rule by supernatural right
> Yet be but sinew.
>
> (*C.P.*, 198)

By this time Yeats, though he had not yet seen the 'Sistine
roof', had seen the statues in the Medici Chapel at Florence.
In 1907 he had made a short tour of Northern Italy, together
with Lady Gregory and her son. They visited Venice, Florence,
Milan, Urbino, Ferrara and Ravenna, and the poet was
deeply impressed by what he saw—his references to Urbino
are frequent from that date on. But in Venice he had also seen a
painting which, according to one biographer, had struck him
so much that he obtained a reproduction of it. Speaking of the
Leda sonnet, Professor Jeffares states:

The poem was founded upon Michelangelo's painting which
Yeats had seen in Venice and of which he had a large photo-
graphic coloured copy.[2]

Also Mr. Ellmann speaks of 'Michelangelo's painting in
Venice',[3] and Mr. Henn says:

Always before him, like the Michelangelo reproduction on
his desk, was the image of Leda and the Swan, and the two

[1] *The Savoy*, 7, Nov. 1896, 80. [2] A. N. Jeffares, *op. cit.*, 224.
[3] R. Ellmann, *The Identity, cit.*, 176.

eggs of Love and War that were the product of that fierce union.[1]

But Mr. Henn is not so sure that the painting is the one in Venice:

Yeats, who had a coloured reproduction of the picture, would have known the London National Gallery No. 1868, after Michelangelo.[2]

And M. Tschumi states:

The poem is inspired by Michael Angelo's sculpture now in Florence (Museo Nazionale).[3]

The apparent uncertainties about the location of Michelangelo's *Leda* (or over the fact whether it is a painting or a sculpture) are due to the disappearance of the original. This was a tempera painting done by the artist in 1529–30 and taken to France by his *garzone* Antonio Mini. It remained in Fontainebleau for over a century till (according to one report) the Superintendent to the Royal Palaces, Des Noyers, had it burnt or dismembered, considering it immoral (the same reason for which, reportedly, the son of the Duke of Orleans literally defaced Corrieggio's *Leda*).[4] In his exhaustive study of Michelangelo, Mr. De Tolnay lists four surviving copies in painting (at the National Gallery, London; at the Correr Museum, Venice; at the Schloss, Berlin; at the Gemäldegalerie, Dresden), a sculpture based on it by Bartolomeo Ammanati at the Museo Nazionale (Bargello), Florence, a cartoon, probably by Rosso Fiorentino but frequently attributed to Michelangelo himself, at the Royal Academy, London; and finally three different prints at the British Museum.[5]

[1] T. R. Henn, *op. cit.*, 32.　　　　　　　　[2] *Ibid.*, 243.

[3] R. Tschumi, *Thought in Twentieth Century English Poetry*, London, Routledge, 1951, 56.

[4] See Excursus V: Renaissance Paintings of Leda.

[5] Ch. De Tolnay, *op. cit.*, 106 ff., 191 ff., plates 279–85.

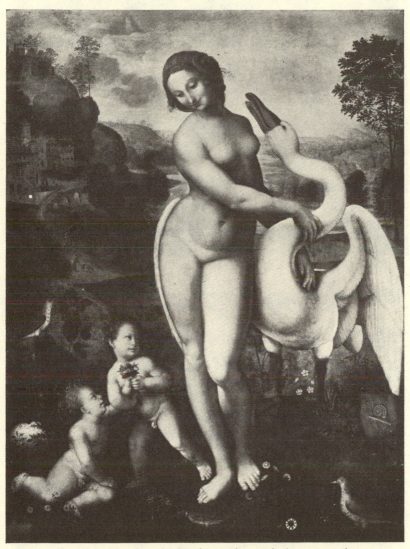

V. After Leonardo (Sodoma?): *Leda* (see p. 152).

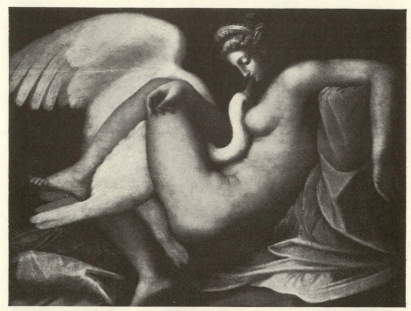

VI(*a*) After Michelangelo (XVIth cent. Venetian?): *Leda*

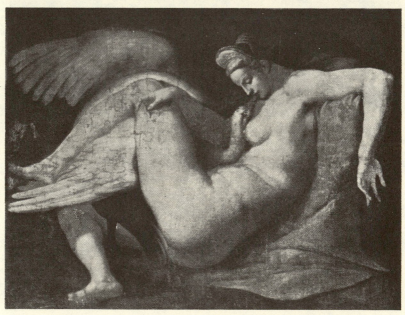

VI(*b*). After Michelangelo (Rosso Fiorentino?): *Leda*
(see p. 154).

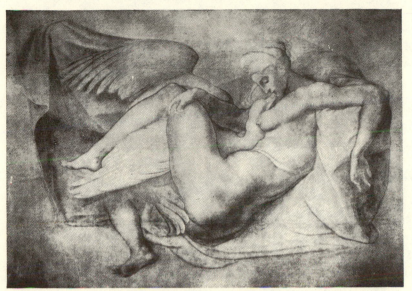

VII(*a*). After Michelangelo (Rosso Fiorentino?): *Leda*, cartoon

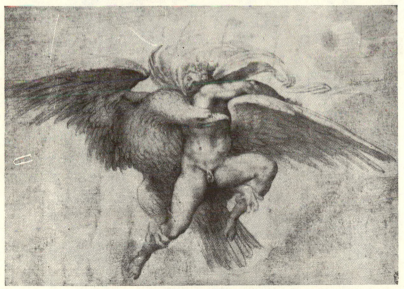

VII(*b*). Michelangelo (?): *Ganymede*, drawing
(see p. 155).

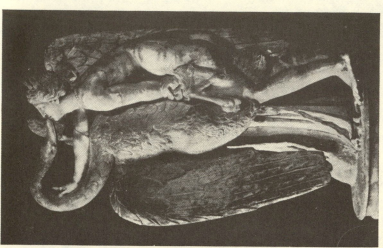

VIII(b). *Leda*, marble. Before removal of non-original parts (Hellenistic Roman, II cent. A.D.?) (see p. 157).

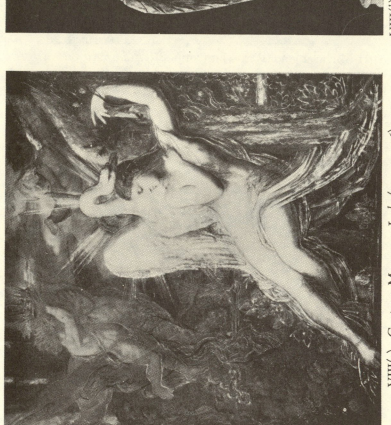

VIII(a). Gustave Moreau: *Leda* (see p. 156).

It is unlikely that Yeats knew the Berlin or Dresden copies, or was impressed by the diminutive group by Ammanati in Florence. His 'coloured reproduction' must have been of either the National Gallery or the Museo Correr copy. The second hypothesis is the most likely: the Correr painting is by a follower of Correggio or by an artist linked with the Venetian school, and his colour and figures are softer and at the same time more brilliant, than in the National Gallery copy (probably by Rosso Fiorentino); the whiteness of the swan is more emphasized ('That white rush' in the sonnet) and its left wing is more prominent and outstretched than in the other painting ('the great wings beating still' in the poem). Nevertheless, as Mr. Henn has rightly remarked, none of the copies of Michelangelo's painting 'fit the poem particularly well': hardly any of the details in Yeats's description agree with the scene painted by Michelangelo. Mr. Henn therefore adds:

It is possible, as Allt has suggested, that Yeats had also in mind the same painter's 'Ganymede and the Eagle'. In this Ganymede seems feminine and passive; there is in the bird a tremendous impression of force. The bird's head and neck press upon the breast of the boy, and the wings are beating at full strength.[1]

The picture referred to is a drawing sent by Michelangelo to Tommaso Cavalieri, and done at the same time as the *Leda*. There exists now a single copy of the drawing at Windsor,[2] and this Yeats might have seen, perhaps in reproduction. The suggestion cannot easily be dismissed, especially if we recall that in one of Gogarty's poems, Ganymede was mentioned in strict connection with the fall of Troy, and this could have fused the two images in Yeats's mind. Moreover there is one version of the Leda myth according to which the swan took refuge in Leda's lap because it was pursued by an eagle. This is the version

[1] T. R. Henn, *op. cit.*, 243.
[2] Ch. De Tolnay, *op. cit.*, 112, pl. 154.

adopted by Mr. Huxley in his poem *Leda*, where the scene is so described:

> A splendid swan, with outstretched neck and wing
> Spread fathom wide, and closely following
> An eagle, tawny and black. This god-like pair
> Circled and swooped through the calm of upper air,
> . . . Like a star unsphered, a stone
> Dropped from the vault of heaven, a javelin thrown,
> He [the eagle] swooped upon his prey . . .[1]

If Yeats had read this passage, the images of eagle and swan could well have fused into one in his poem (see for instance the beginning of Version A: 'Now can the swooping godhead have his will'); as they had fused for the Italian poet Gabriele D'Annunzio who, describing a sculpted group of Leda and the swan in Venice in his novel *La Leda senza cigno*, writes that the girl 'is seized by the great swan of Eurotas not with a webbed foot but with an eagle talon fretting her long voluptuous thigh' (translated from the 'Licenza' of the 1916 edition of the novel).

But if we grant that Yeats had in mind a composite picture, it need not have been made up only of the two Michelangelesque works. He had certainly seen other works of art on the subject of Leda, and one at least by an artist whose paintings, seen during his early visits to Paris in the 'nineties, had fascinated him. The painter, for whom Yeats had an unfailing admiration till the end of his life, was Gustave Moreau, to whom he referred frequently in his works, listing him among the great symbolists, 'the great myth-makers and mask-makers, the men of aristocratic mind', alongside Blake, Ingres in the *Perseus*, Puvis de Chavannes, Rossetti before 1870, Calvert and Charles Ricketts.[2] Moreau left several versions of his *Leda*,

[1] A. Huxley, *op. cit.*, 45–6; see *supra*, n. 1, p. 150.
[2] *The Bounty of Sweden* (1924), now in *Aut.*, 550.

now in the Musée Gustave Moreau, and provided as well a symbolic interpretation of the painting:

Le Dieu se manifeste, le foudre éclate: l'amour terrestre fuit au loin. Le cygne-roi, au regard sombre, pose sa tête sur celle de la blanche figure toute repliée en elle-même, dans la pose hiératique d'initiée, humble sous ce sacre divin. L'incantation se manifeste. Le Dieu pénètre, s'incarne en cette beauté pure. Le mystère s'accomplit, et devant ce groupe sacré et religieux se dressent deux génies accompagnés de l'aigle porteur des attributs divins, la tiare et la foudre. Ils tiennent devant Leda cette offrande divine, officiants de ce Dieu s'oubliant dans Son rêve. Et la Nature entière tremble et s'incline, les Faunes, les Dryades, les Satyres et les Nymphes se prosternent et adorent; tandis que le grand Pan, symbolisant toute la nature dans un geste de prêtre, appelle tout ce qui vit à la contemplation du mystère.[1]

Moreau actually left many of these symbols out of his canvas, but what *is* there is sufficient to emphasize the symbolical and visionary character of the painting, which must have endeared it to the young Yeats, with his fondness for esoteric lore. The attitude of the two figures in the picture does not agree with the scene described in Yeats's sonnet, though Leda's body is more stretched out across the painting than in the Michelangelesque work. But its posture strikingly recalls: (1) the woman raped by fire in Blake's *Marriage of Heaven and Hell*, and (2) another painting by Moreau, of which Yeats was so fond that by 1936 he still had a reproduction of it hanging on the wall of his room.[2] This painting, *Licornes*, has as its main figure a naked bejewelled woman in the foreground in exactly the same attitude as Moreau's *Leda*, except that her posture is slightly more reclined to the right of the picture, and her right arm rests on the neck of a white unicorn. For Yeats this picture, as I have already said in the chapter on the Unicorn, represented 'mystery'.

[1] P. Flat, *Le Musée Gustave Moreau—L'Artiste—Son Œuvre—Son Influence*, Paris [1899], 21–2 and plates 5 and 6.
[2] See letter of 8 Nov. 1936 to D. Wellesley, *L.*, 865.

It is reasonable to suggest that, when thinking of visual figurations of the Leda myth, Yeats had also this picture, so charged with mystery, before his mind's eye. Moreau's *Licornes* recalled at once the same painter's *Leda* and Blake's woman raped by fire—the three mixed with Michelangelo's painting of Leda in creating a complex mental vision, into which they carried the symbolic significances that Yeats had attached to each of them.

There is another graphic detail in the sonnet which finds no counterpart in the figurative works we have seen, in the words 'her helpless thighs are pressed / By the webbed toes' in the first version (which, through a series of slight changes, became in the final version 'her thighs caressed / By the dark webs'). For this realistic touch Yeats could have recalled the illustrations to the *Hypnerotomachia Poliphili*, or a reproduction of Veronese's *Leda* in Dresden Gemäldegalerie, although he certainly did not see the actual picture. A work of art which he most probably saw, and in which the swan's 'webbed toes' on Leda's thighs are prominent, is a Roman sculpture derived from a Hellenistic original, which is in the Museo Archeologico in Venice (the one alluded to by D'Annunzio in his *Leda senza cigno*). In this small group, we find a justification not only of the hint at the webbed feet of the swan, but also of the line (unchanged in all versions of the poem) 'How can those terrified vague fingers push . . .', since Leda seems to be struggling to hold back the swan's neck and body.[1] Yeats might well have been struck by this group, since it was kept in a separate room of the Museo, where the attendants, (presumably angling for tips) used to show it 'only to the gentlemen tourists'.[2] This experience may

[1] This detail is less clear after the recent restoration of the sculpture, from which the swan's neck and head and Leda's right arm (which were present when Yeats might have seen it) have been removed, since they were later additions. I am indebted to Professor Carlo Izzo for this information and for providing photographs of the Roman group before and after restoration.

[2] This detail has been provided by Professor Leo Spitzer. When I mentioned to him the Roman sculpture of Leda in Venice, he immediately recalled it though he had seen it some thirty years before. What had impressed it on his

have impressed some details of the sculpture in the mind of Yeats, when he visited Venice *en touriste* in 1907; and they were incorporated (so to speak) in the more famous Michelangelesque Leda picture which he saw in the same days in the Museo Correr nearby.

The description of Leda in the sonnet, therefore, does not derive from a single figurative source but, as is the case with the symbolic and verbal sources, from a number of them, which combined to form a unique whole out of the work of an unknown Roman sculptor, of the illustrator of the *Hypnerotomachia*, of an imitator of Michelangelo, of William Blake and of Gustave Moreau. And it is not possible to separate the literary from the visual reminiscences in his work, since both are inextricably woven together to create a symbolic whole.

The question to be asked now is, why did Yeats treasure Michelangelo's *Leda* as the main inspiration of his sonnet? Essentially, it seems to me, because Michelangelo was becoming for him a kind of spiritual hero or model, summarizing in his person and expressing in his work, many of the beliefs and symbols which Yeats had adopted.

First of all, Michelangelo's *Leda* corresponded to the earliest verbal picture of the Leda myth that Yeats had met as a young man, in Spenser's *Faerie Queene*; it is very likely that Spenser was himself describing in his lines a copy of the Michelangelo picture imported into England together with other representations of the loves of the Gods which were so popular at the

mind had been the behaviour of the museum attendant, who, whispering that there was an 'interesting' piece of sculpture, led him into the Leda room. Had it not been for this, the marble group would probably had left no trace on the memory of the visitor to the museum. The tricks of museum attendants vary little with the years, and if in 1907 Yeats had undergone a similar 'initiation' to the Leda group, that would have been enough to fix it in his mind. In any case, this seems to be one of the most sensual representations of the Leda myth, since it not only struck a decadent epicurean like D'Annunzio, but induced a hundred years earlier a Romantic like Chateaubriand to say that 'le Cygne est prodigieux d'étreinte et de volupté' (see M. Praz, *Gusto Neoclassico*, Napoli, 1959, 314).

time: both in the lines and in the picture Leda seems to be feigning sleep while the swan is 'ruffing his fethers wyde'—and Spenser comments on the 'wondrous skill and sweet wit' of the artist. A recollection of Spenser's lines would have automatically evoked in Yeats's mind Michelangelo's picture.

Secondly, the painstaking study of Blake in the early 'nineties must have accustomed Yeats to the appreciation of figurative elements directly derived from Michelangelo. The links between Blake and Michelangelo were extremely close not only on the aesthetic, but also on the spiritual plane; or at least Blake read symbolic meanings into Michelangelo's works, meanings which were insensibly absorbed by Yeats, even when in his study on Blake he does not seem to be aware of this process.[1]

In the third place, Moreau himself had derived his aesthetic principles from Michelangelo, or at least thought so when he stated them with reference to the prophets and the sybils of the Sistine Chapel and to the 'Night' and the other statues of the Medici Chapel:

Toutes ces figures semblent être figée dans un geste de somnambulisme idéal; elles sont inconscientes du mouvement qu'elles exécutent, absorbées dans la rêverie au point de paraître emportées vers d'autres mondes.[2]

To lose himself in reveries, in an 'ideal somnambulism', had been the aspiration of the youthful Yeats. He admired Moreau for having conveyed the sense of these symbolic visions in his paintings. But Moreau (like Spenser, Blake and Pater) was sending him back to Michelangelo. Or rather to the decadent and symbolist interpretation of Michelangelo, centring on the reclining figure of 'Night', and already expressed by Baudelaire in 'L'Ideal':

Ou bien toi, grande Nuit, fille de Michel-Ange,
Qui tors paisiblement dans une pose étrange
Tes appas façonnés aux bouches des Titans!

[1] For a fuller treatment of the influence of Michelangelo on Blake see my book, *Michelangelo nel Settecento inglese*, Roma, Ediz. Storia e Letteratura, 1950, 92–110.
[2] M. Praz, *The Romantic Agony, cit.*, chapter V.

In the wake of the symbolists, Yeats professed his admiration
for the statue of 'Night', to which he referred more than once.
But the Michelangelesque Leda painting is only a variant of
the figure of Night—and, what is more curious still, Michel-
angelo had directly derived the figure of Night from the bas-
relief on an ancient Roman sarcophagus representing Leda.[1]
For both Michelangelo and Yeats there was a secret identifica-
tion of Leda with Night: the one repeated the same figure, the
other was fascinated in the same way by statue and painting.
The connection between Leda and Night may have a further
significance, of which perhaps Yeats was unaware, but which
may have acted on his unconscious mind. According to the
Orphic cosmogenesis (of which, incidentally, the Florentine
Platonists had some knowledge—and Michelangelo's relation
to them is an acknowledged fact, stressed also by Walter Pater
in his essay on the Italian artist) Leda is identified with Night,
which, made pregnant by the wind, dropped on to Chaos the
egg of the Universe (or the Egg of Night). This leads us back
to the Egg of the World mentioned by Madame Blavatsky and
by the theosophists, which became, *via* Leda, a major symbol
in Yeats's later poetry and 'philosophy'. There is, then, already
in Michelangelo, through the peculiar and perhaps not wholly
casual connection between Leda and Night (most apparent in

[1] Ch. De Tolnay, *op. et loc. cit.* The myth of Leda with all the symbolic
meanings it acquired in Renaissance art mainly through the Neo-Platonic
tradition, has been thoroughly examined by E. Wind, *Pagan Mysteries in the
Renaissance,* London, Faber, 1958, 129–41. I note with interest that the findings
arrived at independently by Professor Wind fully coincide with my conclusions
as published in the article 'Leda and the Swan: The Genesis of Yeats' Poem'
in the *English Miscellany,* 7, 1956, which forms the basis of chapters II, III and IV
of the present book. In a note at p. 139 Professor Wind remarks on Yeats's
'mythographic accuracy', but he interprets the last tercet of Yeats's Leda sonnet
as leaving in doubt the birth of the Dioscuri from Leda's eggs. I do not agree
that the words 'Did she put on his knowledge with his power' refer to this (see
above, p. 145). As for the version of the myth that Yeats gives in *Stories of
Michael Robartes and his Friends,* Professor Wind refers to 'Gyraldus, "Castores
vel Dioscuri", *Historia deorum gentilium,* syntagma V, *Opera,* I, 184 ff., where
several variants are listed.'

the sleeping face of Leda in the cartoon at the Royal Academy, which is strikingly similar to the head of the statue in the Medici Chapel) a hint at those occult doctrines in which Yeats was steeped.

A further point should be made. The earliest biographers of Michelangelo, Vasari and Condivi, speaking of his *Leda*, say that the picture included also 'Castor and Pollux coming out of the egg'. The twins and the egg do not appear in the Royal Academy cartoon or in the four extant paintings. But they are clearly visible in the British Museum engravings—two by Cornelius Bos and one by Etienne Delaune. What is more, in one of the Cornelius Bos prints, the unhatched egg in the fore-ground is transparent and shows a human embryo, while an inscription under the picture reads:

> Formosa haec Laeda est, cignus fit Juppiter, illam
> Comprimit, hoc geminum quis credat parturit ovum,
> Ex illo gemini pollux, cum castore fratres
> Ex isto erumpens Helene pulcherrima prodit.

The presence of the egg and the mention of Helen would certainly have struck Yeats, had he seen the engraving. But this we cannot know.

What has been said is sufficient to explain why, although the Leda sonnet is a composite picture influenced by different works of art, Yeats preferred the Michelangelo painting. He felt, with the divining instinct of the visionary, that Michel-angelo summarized and concentrated on the symbolic plane images and ideas with which he had been familiar for many years, experiences dating back to his youth. This gave him a sense of the greatness of the Italian artist, so that in his later poetry Michelangelo became identified with himself as an un-wearied creative genius, 'an old man's eagle mind'.

The study of the genesis of the Leda poem has also shown how visual and literary reminiscences mingled inextricably in the poet's mind, to create a new work of art, and how important

for him were the impressions received and the taste formed in the early years of his life. Besides Michelangelo, the main sources of the poem are the *Hypnerotomachia*, Spenser, Shelley, Pater, Moreau, Blake and the Theosophists, all authors and artists known to Yeats before he was thirty. But the resulting poem is well beyond the atmosphere of the 'nineties to which its sources date back. The components have been transformed and utterly transfigured: a new symbolic unit has been created which in its turn opens the way to the great poetry of the last period of Yeats's activity.

V

The Mundane Egg

IN the previous chapters I have outlined on the one hand the evolution of a single image (the Unicorn) and the different connotations and associations it acquired over the whole development of Yeats's work, and, on the other hand, the accumulation and assimilation of different images within the narrow compass of a single sonnet ('Leda and the Swan'). In other words, we have seen from two different approaches the way in which Yeats's creative faculty worked. The Unicorn was chosen as a comparatively straightforward image, at times more allegorical than symbolic, and therefore easier to follow in its development than, for instance, the very complex and basically important symbol of the dancer, admirably expounded by Mr. Kermode in his *Romantic Image*.[1] These images grouped together in ever-shifting patterns: in perpetually changing and at the same time fundamentally constant 'figures'. The image of the dancer which Yeats loved so much might be applied to the working of his mind: his images move both on the level of poetry (the creation of ever-new poetic wholes) and on that of significance, in the same way as a dancer moves her limbs in an ever-changing variety of figures, but all subject to a constant pattern of rhythm and thought expressed through form and feeling.

[1] F. Kermode, *op. cit.,* 43–91.

Two marginal conclusions can already be drawn from this analysis: firstly Yeats remained faithful to the images that struck him in his youth, a fidelity which gives unity to a *corpus* of poetry which lends itself even too easily to a division into successive phases; and secondly each image, intellectualized and charged with esoteric meanings, has a strong and complex visual basis—is something *seen* by the poet essentially under the guise of a magic figure or work of art, and lodged and transformed in his mind. At times these figures are elaborate and richly ornamented, at times they approach the schematization of geometrical patterns.

In the 'eighties Yeats learnt from Madame Blavatsky that the Egg of Leda was connected with 'that group of cosmic allegories in which the world is described as 'born from an Egg', and more specifically with the Egg of Brahma, the Divine Swan, and the Auric Egg, which is treated at great length in the third volume of Madame Blavatsky's *Secret Doctrine*, and is shown in a most fascinating and complicated diagram, one of the very few in the book. Madame Blavatsky, with her typical syncretic method, is quick to relate the Egg-symbol to the primeval Egg of the Universe in the Orphic religion: the egg of Night impregnated by the wind and dropped on Chaos, from which Eros-Phanes[1] sprang out and gave origin to the existing world. Madame Blavatsky refers to the Orphic Egg just after giving the following account of the beliefs of Brahmanism:

In the beginnings, the 'First Cause' had no name. Later it was pictured in the fancy of thinkers as an ever invisible, mysterious Bird that dropped an Egg into Chaos, which Egg became the Universe. Hence Brahmâ was called Kâlahamsa, the 'Swan in [Space and] Time'. Becoming the Swan of Eternity, Brahmâ, at the beginning of each Mahâmanvantara,

[1] Eros, veiled with a faint torch in his hand, appears among the ritual dancers in Yeats's early esoteric story 'Rosa Alchemica' (1896).

lays a Golden Egg, which typifies the great Circle, or O, itself a symbol for the Universe and its spherical bodies.[1]

Not content with this, the founder of Theosophism, in connection with the references to the egg in the different religions, reminds us that the origin of the Universe or of any of its great periods is always connected with the presence of some sacred bird: Swan, Duck, Ibis, Golden Hawk, and 'even Christians have to this day their sacred birds, for instance, the Dove, the symbol of the Holy Ghost'.[2] Swan and Dove, the symbols of the two Annunciations used by Yeats in his treatment of the historical cycles in *A Vision*, are already to be found associated in the theosophical doctrines he studied in his youth.

The egg is not actually mentioned in the Leda sonnet: probably because 'bird and lady took such possession of the scene' that all conceptual structures went out of it. Fortunately the genuine native instinct of the artist overpowered the far-fetched intellectual structure, so that he gave us a passionate rather than an elaborately philosophical vision; but as soon as we consider the significance of the sonnet within the framework of Yeats's 'system' we realize that the egg—not mentioned but implied—is the key symbol, the symbol of the beginning of the new cycle, the origin of Greek civilization. As Yeats himself put it in a rejected draft for the first *Vision*:

In the midst or upon the edge of the Mediterranean Civilization all that world whose fall is symbolized by the burning of Troy, there occurred somewhere among the obscure northern tribes a multitudinous supernatural event which my poem 'Leda' represents as the begetting of Love and War, for from the eggs of Leda came no Helen only but Castor and Pollux.[3]

[1] H. P. Blavatsky, *op. cit.*, I, 384. [2] *Ibid.*, I, 388.

[3] Hazard Adams, *Blake and Yeats: The Contrary Vision*, N.Y., Cornell Univ. Press, 1955, 201. Mr. Adams's book is not only a detailed analysis of Yeats's relation to Blake, but also a precise and exhaustive treatment of the symbolic conceptions of the two authors; I am greatly indebted to this book, especially for what concerns the symbols of the Mundane Egg and of the Gyre or Vortex.

The egg is the beginning—and as such it contains already in itself all that is to come. It is not only important because of what will break from it, but also because it represents a universe closed in a single shell, a whole, a perfect unity. As such it was conceived by William Blake, who spoke of it as the Mundane Egg or Mundane Shell in his prophetic books: it was for Blake an all inclusive symbol, the shell within which his titanic mythology was enclosed, his Michelangelesque figures moved. Yeats studied and interpreted Blake in the years (1889–93) during which he was also deep in the study of theosophical doctrines. Coming upon the 'Mundane Shell' in Blake he was therefore quick to see the connection with the teachings of Madame Blavatsky; consequently he wrote in his commentary that Blake's Mundane Shell

is the microcosmic aspect of that 'circle pass not', so much talked of in Theosophical mysticism, and is identical with the egg of Bramah.[1]

That Yeats was right in associating Blake's Mundane Shell with the World Egg of ancient cults has been indirectly proved through the recent research of Sir Geoffrey Keynes, who pointed out that Blake must have got the idea of the egg of the world from J. Bryant's famous book, *New System, or An Analysis of Ancient Mythology* (1774–6), a book for which Blake, as an apprentice, had engraved some illustrations, including the one representing the world egg entwined by a serpent (*Ophis et Ovum Mundanum*).[2] But apart from this engraving, illustrating the egg-symbol conceived as basic for all mythologies (as Madame Blavatsky was to write a century later), young William Blake was made familiar with the same conception also by Erasmus Darwin's *Botanic Garden* (1789–91), to which he contributed illustrations.[3] Darwin refers to 'The Egg of Night, on Chaos hurl'd' which 'Burst, and disclosed

[1] *The Works of William Blake, cit.,* I, 317.
[2] G. Keynes, *Blake Studies,* London, 1949, 44.
[3] G. Keynes, *op. cit.,* 67.

The Mundane Egg

7. Detail from plate 4 of Jacob Bryant, *New System, or An Analysis of Ancient Mythology* (1774–6); engraved by Bazire's pupils, possibly William Blake.

the cradle of the world' in two places in his poem,[1] and to the second reference he appended the following note:

Alluding to the πϱοτον ωον, or first great egg of the antient philosophy, it had a serpent wrapped round it emblematical of divine wisdom, an image of it was afterwards preserved and worshipped in the temple of Dioscuri, and supposed to represent the egg of Leda. See a print of it in Bryant's mythology.[2]

[1] E. Darwin, *The Botanic Garden* (my references are to the first edition of Part I (London, Johnson, 1791) and to the second edition of Part II (London, Johnson, 1790)), Part I, Canto I, lines 413 ff.; Canto IV, lines 405–6.

[2] E. Darwin, *op. cit.,* I, 193. Darwin's poem is a mine of curious lore; there is even a conventional verbal picture (the book contains a 'Catalogue of the Poetic Exhibition' indexing such pictures) of the Leda myth, though she is not mentioned by name and the scene represents only one of the transformations of the 'Proteus-Lover', the *conserva polymorpha* (II, 182): 'And now a Swan, he spreads his plumy sails, / And proudly glides before the fanning gales; / Pleas'd on the flowery brink with graceful hand / She waves her floating lover to the land; / Bright shines his sinuous neck, with crimson beak / He prints fond kisses on her glowing cheek, / Spreads his broad wings, elates his ebon crest, / And clasps the beauty to his downy breast.'

The print referred to is precisely the one engraved by Blake. Here we find the Leda myth connected with the Orphic Egg of Night (perhaps the reason why Michelangelo used the same figure practically in the same posture to represent both 'Leda' and 'Night'). And we find in Darwin the 'Spartan temple' where the egg of Leda was preserved, to which Yeats referred in *A Vision*.[1] For the Orphic Egg, both Bryant and Darwin (whose poem Yeats probably never read) and also Madame Blavatsky, refer to Aristophanes' *Birds*. It may be a mere coincidence—but it is more than possible that Yeats had read in his childhood the relevant passage in Aristophanes. Certainly one fragment of the *Birds* had impressed him so much as a small boy that as late as 1920 he could write in *Four Years, Reminiscences 1887–1891*:

When I was a child and went daily to the sexton's daughter for writing lessons, I found one poem in her School Reader that delighted me beyond all others: a fragment of some metrical translation from Aristophanes wherein the birds sing scorn upon mankind.

(*Aut.*, 171)

It is impossible to trace the School Reader of the sexton's daughter. But in the best known metrical translation of Aristophanes' play current in the last century, that of J. Hookham Frere, the passage where the birds scorn mankind (incidentally, one is reminded of the scorning bird in 'Byzantium') reads like this:

Ye Children of Man! whose life is a span,
Protracted with sorrow from day to day,
Naked and featherless, feeble and querulous,
Sickly, calamitous creatures of clay!
Attend to the words of the Sovereign Birds
(Immortal, illustrious, lords of the air),

[1] *Vis. A*, 181; *Vis. B*, 268; see *supra*, p. 111.

Who survey from on high, with a merciful eye,
Your struggles of misery, labour and care.

* * *

Before the creation of Aether and Light,
Chaos and Night together were plight,

* * *

At length, in a dreary chaotical closet
Of Erebus old, was a privy deposit,
By Night the primaeval in secrecy laid—
A Mystical Egg, that in silence and shade
Was brooded and hatch'd, till time came about,
And Love, the delightful, in glory flew out,
In rapture and light, exulting and bright,

* * *

He soon, in the murky Tartarean recesses,
With a hurricane's might, in his fiery caresses
Impregnated Chaos, and hastily snatched
To being and life, begotten and hatch'd,
The primitive Birds . . .

It is questionable whether all this could have gone into a
school reader. But some part at least had been read, and re-
mained at the back of Yeats's mind till the time when he began
to realize the potency of the egg image.

And something else he must have read was connected with
Aristophanes—Plato's *Symposium*.[1] There the Greek play-
wright is made to tell a personal, ironical and deeply serious
story (the mixture of jocularity, self-irony and seriousness
which Yeats himself adopted both in his poems and in his
'philosophical' writings) on the origin of Love: man was at
first double, a nearly spherical shape, till the evil Gods decided

[1] R. Ellmann (*The Identity, etc., cit.,* 312) says that 'Lionel Johnson gave him
[Yeats] an edition of Plato early in the 'nineties and made him read it, Mrs.
Yeats heard from her husband.' He adds that 'the description of Eros in "Rosa
Alchemica" surely borrows from the *Symposium*'.

to divide him into two halves 'like an egg divided into two parts with a thread'; hence his constant desire to find his other half and be reunited to it, forming once again a whole, a perfect sphere—a desire which is called Love.

When in 1923 Yeats wrote 'Leda' he was not thinking of Leda's egg as the most significant feature of the myth: he was looking only for the equivalent, at the beginning of a pagan cycle of civilization, to the Christian Annunciation. In, or after writing the sonnet, the eggs of love and war, fruit of the union of woman and bird, began to take possession of his imagination and to evoke all that he had learned as a young man about the connection between the Leda myth and the world egg which figures at the origin of created things in different ancient cults. With the memory of Brahma's egg, about which he had learnt from the Theosophists, came Blake's Mundane Shell and the Orphic egg, which he knew, perhaps, not only through Madame Blavatsky's writings, but through the passage of Aristophanes' *Birds* which he had found as a child in the reader of the sexton's daughter. The cumulative effect of these memories was to show Yeats that here was a real symbol: it had the plurisignificance, the evasiveness, and therefore the independent life, characteristic of the images stored in the Great Memory, as opposed to the one-sidedness of allegorical emblems.

He was well acquainted, since his Golden Dawn days, with the Tattvas symbol of the black egg—the *Akasa*, or fifth element, the quintessence. Akasa represents the ideal condition, supreme unity of being—and its geometrical emblem (the contemplation of which may induce a trance state) is an oval. The association of this symbol with Blake's Mundane Egg was clear in Yeats's mind since the early 'nineties. Commenting on Blake's egg, he wrote: 'Students of the occult philosophy of the Tatwas will recognize in it a certain symbol associated with Akasa', and went on to identify it with 'the astral light of post-Paracelsian occultists'.[1] In her turn Madame Blavatsky

[1] *The Works of William Blake, cit.,* I, 317.

had taught him that the astral light, the impalpable shell that surrounds all things, was the equivalent of *anima mundi*, the world's great memory, the repository of all symbols.[1]

One of the influences of the Golden Dawn on Yeats was to rouse his interest in alchemical books and doctrines. In several treatises collected in Waite's edition of *The Hermetic Museum* the philosopher's stone, the highest secret of alchemy, is referred to as 'the egg of the sages'. Still more significantly in *The Chymical Marriage of Christian Rosencreutz*, a basic text for the Golden Dawn adepts, the egg symbol has a prominent place in a fantastic story alluding to the alchemical process. The molten bodies of two beheaded 'Royal Persons' are poured into a 'Golden Globe' where they undergo an alchemical treatment. The globe is broken and 'when we had thus opened the globe, there was no redness to be seen, but a lovely great snow-white egg . . . We stood around about this egg as jocund as if we ourselves had laid it'. Later the egg is placed in a 'great square copper kettle filled with silver sand' and eventually a 'pullus implumis' and 'jocund' breaks out of it. This bird grows at first black feathers, then snow white and finally feathers of many colours, but loses them all when put into a hot bath. He is painted with a stone made out of his bath water and becomes blue. The cycle of transformations is concluded when the bird, after drinking the blood of a white serpent, is beheaded and his blood poured into two moulds forms two children, fresh incarnations of the Royal Persons.[2]

The egg here is only one stage of a continuous process of the transformation of matter. This story is not directly relevant to Yeats's poetry. It is included here as an example which Yeats certainly knew, of the use of the egg in alchemical doctrines.

It was inevitable that having recognized the symbolic nature of the egg image Yeats should make use of it again and again

[1] I. Regardie (*The Tree of Life, cit.,* 68–9) remarks that the Astral Light of the occultists is a conception similar to Jung's collective unconscious.

[2] A. E. Waite, *The Real History, etc., cit.,* 176–82.

in ever new sets of mental associations. He mentions it first when explaining the meaning of the Leda myth at the beginning of the 'Dove or Swan' section of *A Vision* (1925):

I imagine the annunciation that founded Greece as made to Leda, remembering that they showed in a Spartan temple, strung up to the roof as a holy relic, an unhatched egg of hers; and that from one of her eggs came Love and from the other War.

(*Vis. A.*, 181; *Vis. B.*, 268)

The idea here expressed is basic for Yeats's whole system. Perhaps a short summary of the general lines of this system, as expounded in *A Vision*, is necessary at this point, bearing in mind the fact that it is extremely complex and evasive, as well as frequently muddled, so this will be only a bare schematical outline, leaving out that enormous mass of detail which made it for him so appealing a source of poetic images.

A Vision is based on the conception that all existence is conflict between opposed principles (hence each human being is both himself—Man—and his opposite—Mask). The characteristics both of individuals and of historical periods likewise belong to opposed principles: the principle of objectivity, which Yeats calls *primary* and that of subjectivity, which he calls *antithetical*. In between these two extreme conflicting poles there are a number of possible intermediate states. Considering individual or universal life *in time*, Yeats postulates a continuous movement of such life from a primary (objective) to an antithetical (subjective) state, and back again to primary. And he chooses to use, in order to represent this movement, the analogy of the 28 phases of the moon during the lunar month, so that phase one, the dark moon, represents complete objectivity (primary) and phase fifteen, the full moon, complete subjectivity (antithetical). The whole cycle can therefore be illustrated—like the moon phases in an astronomical atlas—by means of a circle, a 'great wheel'. The 'great wheel' is therefore the first symbol we meet with in the 'geometry' of *A Vision*.

Two basic points must, however, be taken into account:

(1) Each individual or each age will be particularly affected by one of the twenty-eight phases (this savours strongly of the astrological beliefs in 'influences' and 'correspondences'); we can therefore say that the character of a man belongs to a particular phase, or even that a certain historical age belongs to such or such a phase (in this case following a precise chronological cycle of development). This does not prevent each individual life, though dominated by one particular phase, from running through the whole cycle, and from having in itself—in conformity with the ever-existing pattern of conflict—its own opposite.

(2) The movement from phase to phase happens in time, so that examining past history we can trace in it the great cycles of development from primary to antithetical and back to primary. Yeats thought that each cycle lasted about two thousand years, but it contained in itself two smaller complete cycles of a thousand years each. In view of the doctrine of opposites, while the cycle was evolving in a certain direction (say from primary to antithetical) at the same time an opposite cycle was evolving in the opposite direction.

To express this conception, the diagram of the wheel was inadequate, and Yeats found (very tentatively in the first text of *A Vision*, much more clearly in the revised text) another 'geometrical' symbol: that of the 'gyre' or 'cone'. It is a movement along a spiral drawn on the surface of a cone—a circular movement starting at the base and narrowing till it reaches the point, or starting from the point and widening all the way to the base. At the end of the movement there is a sudden prodigious and terrifying change: the base becomes the point and the point the base. The union of Leda with the swan, and the annunciation of the Dove to the Virgin are for Yeats two such moments of complete change, the end of one gyre and the beginning of a new, prodigious destruction of the past and birth of the future.

I have been speaking of a gyre—which is an oversimplification: it is rather a double gyre. According to the doctrine of

opposites, each movement has its opposite, so that while one gyre is narrowing towards its point, another one, at the same time, is widening towards its base. The two gyres endowed with these opposite motions are represented as having each its apex exactly in the middle of the base of the other one; hence the well known *Vision* diagram representing two triangles (flat projections of cones) each with its apex in the middle of the base of the other.

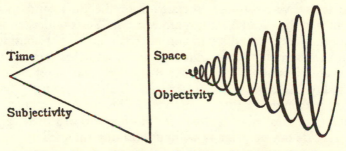

8. From the triangle to the 'gyre': diagram in *A Vision* (1937).

The gyres represent the movement in time and space of the life of the individual, but still more the movement of history. And on the historical plane Yeats has an even wider conception: in the same way as he used the analogy of the lunar month, he wanted to apply that of the solar year. So each complete cycle or gyre (historically two thousand years) is but a 'month' of a 'great year'. We reach in this way much larger cycles including twelve gyres each. The question he raises is: what kind of movement, what condition will exist after the twelfth gyre has been completed?

For the time being we must leave this question unanswered (as Yeats himself practically did, at least in the first version of *A Vision*); nor shall I try to point out the many more or less esoteric sources of these conceptions. I shall be content to explore the uses of the egg symbol by Yeats in the light of his system.

There is a peculiar reference in the introduction to the 1925

Vision. As is well known, Yeats pretended that the system there expounded had been adventurously discovered by his friend Michael Robartes among lost Arab tribes; Robartes had asked Yeats to put his notes in order, and the result was the text of *A Vision*. This text was later submitted to Owen Aherne, another imaginary scholarly friend both of Robartes and Yeats, who added all the prefatory matter to the volume. It is in the introduction that the fictitious Aherne writes:

> The twelve rotations associated with the lunar and solar months of the Great Year first arose, as Mr. Yeats understands, from the meeting and separation of certain spheres. I consider that the form should be called elliptoid, and that rotation as we know it is not the movement that corresponds most closely to reality. At any rate I can remember Robartes saying in one of his paradoxical figurative moods that he pictured reality as a number of great eggs, laid by the Phoenix and that these eggs turn inside out perpetually without breaking the shell.[1]
>
> (*Vis. A.,* xxiii)

Yeats delighted in such cryptic statements made in somebody else's person and throwing doubt on all that he had been saying. We could perhaps dismiss it as an ironical demonstration of Aherne's confusing and ineffectual pedantry. But no joke of Yeats's is meant to be meaningless. And the paradox of the egg turning inside out is certainly not completely casual—it is an imaginative rendering of a geometrical scheme which he felt to be too mechanical. It is another image for the revolving gyre. Furthermore it fulfils the important function of suggesting the origin and nature of the gyres: they are the expression in finite time of a more inclusive shape—that of the sphere, of which the elliptoid shape of the egg is another aspect. The egg-shape and the sphere begin, therefore, to be associated with something that precedes and transcends the temporal movement of the gyres, something like the all inclusive fifth element of the esoteric

[1] A further reference to the 'eggs', couched in similar language, is found in *Vis. A,* 175.

doctrines, the Akasa (which was symbolized by the egg). But Yeats's ideas on this point were not yet fully clear in 1925. In the first version of *A Vision* he says that at the end of the Great Year, after the twelfth cone, there will be a thirteenth cone, a fourteenth cone and a fifteenth cone—but these cones will not be real gyres but rather spheres. This, as Miss Virginia Moore points out, is contradictory: since the sphere obviously represents a condition beyond conflict and beyond time, there can be 'no degrees of wholeness, nor sequences in timelessness', and therefore there can be only one sphere.[1]

In 1925 Yeats's interest was still centred on the cyclic movement of history represented through the gyres; but the use of the myth of Leda had suggested already the importance of the symbol of the egg, while there was emerging the idea of the necessity of some form transcending the mere cycle of human life, and of history, an idea which could be represented only by that very ancient symbol of unity and perfection, the sphere.

It is not surprising, therefore, to find Leda, the sphere and the egg strictly associated in one of Yeats's greatest poems, 'Among School Children', written in 1926, not long after *A Vision*, and intended, as Yeats wrote to Olivia Shakespear, as a 'curse upon old age': 'It means that even the greatest men are owls, scarecrows, by the time their fame has come.' [2] The great man is Yeats himself, visiting, in his capacity as 'a sixty-year-old smiling public man', a model school. But at the sight of the

[1] V. Moore, *op. cit.*, 366–7; H. Adams (*op. cit.*, 175–6) publishes from 'a rejected typescript for *A Vision*' a note of Yeats with reference to the main symbol of his system: 'My instructors compare it to a work of art because in a work of art each separate line, colour or thought is related to the whole as if it were their multiplex. It is the sphere or multiple of all gyres. The gyres until this multiple is reached lead to new gyres like the overlapping members and so typify the suffering of man.' This is very likely a draft for the second edition of *A Vision* (1937), since in 1925 Yeats had been very careful never to mention the 'instructors', communicating with him through the mediumship of his wife.

[2] Letter of 24 Sept., *L.*, 719.

children he is suddenly reminded of something that Maud
Gonne told him once about her childhood:

> I dream of a Ledaean body, bent
> Above a sinking fire, a tale that she
> Told of a harsh reproof, or trivial event
> That changed some childish day to tragedy—
> Told, and it seemed that our two natures blent
> Into a sphere from youthful sympathy,
> Or else, to alter Plato's parable,
> Into the yolk and white of the one shell.
>
> <div align="right">(<i>C.P.</i>, 243)</div>

As in *A Vision*, Leda, the sphere and the egg are mentioned.
But a strange dislocation of reference has occurred. Maud
Gonne is not identified with Leda herself, but, as had hap-
pened many times before, with Helen—only in this case Yeats
is so full of the Leda myth that he mentions Helen only in-
directly, as the daughter of Leda. And the 'yolk and white of
the one shell' in the last line is not a reference to Leda's egg, but
to the egg mentioned in Plato's *Symposium*. The same applies
to the sphere, which refers to the Platonic parable instead of
the images in *A Vision*.[1] What has happened is clear: the
images had clustered together from the previous poem, but
the frame of reference had completely changed. Such is the
nature of poetic symbols: once established in the mind of the
author they may keep their associations with each other, while
changing their meaning. I do not need to comment further on
the poem, which has been most penetratingly analysed by
Professor Brooks, Mr. Wain, and more recently by Mr.
Kermode, who has written an extremely illuminating com-

[1] There is reference to the *Symposium* in that part of *A Vision* where Yeats
considered the work of previous thinkers who had used a similar symbolism
(*Vis. A*, Book II); there he states that at the beginning of the movement of the
gyres Sun and Moon were 'contained within each other—a single being like
man and woman in Plato's Myth' (*Vis. A*, 149).

ment on the dancer image in it, which he rightly considers as the culminating presentation of 'the image of the poetic Image'.[1]

In Plato the egg and the sphere symbolized the 'whole', the supreme aspiration of man split into two halves. The same idea can be found in another poem, 'Chosen', written shortly before, and much more strictly related to Yeats's system than 'Among School Children'.[2] The speaker is a woman, and the poem, like the Leda sonnet, is a celebration of the physical union of man and woman. The second of its two verses reads:

> I struggled with the horror of daybreak,
> I chose it for my lot! If questioned on
> My utmost pleasure with a man
> By some new-married bride, I take
> That stillness for a theme
> Where his heart my heart did seem
> And both adrift on the miraculous stream
> Where—wrote a learned astrologer—
> The Zodiac is changed into a sphere.
>
> <div align="right">(C.P., 311)</div>

The connection with the system is evident: the Zodiac represents the circular movement of the gyres, contrasted with the stillness of the sphere which is 'the multiple of all gyres', which contains and transcends them. Yeats thought it fit to add a note to the poem:

The 'learned astrologer' in 'Chosen' was Macrobius,[3] and

[1] Cleanth Brooks, 'Yeats's Great Rooted Blossomer', *The Well Wrought Urn*, N.Y., Reynal & Hitchcock, 1947, 163–75; John Wain, 'Yeats: Among School Children', *Interpretations,* ed. J. Wain, London, Routledge, 1955, 194–210; F. Kermode, *op. cit.,* 83–6.

[2] Plato's parable is alluded to also in another short poem, 'Summer and Spring', written at about the same time and to be considered as a preparation or a footnote to 'Among School Children': 'And when we talked of growing up / Knew that we'd halved a soul / And fell the one in t'other's arms / That we might make it whole.' (*C.P.*, 253).

[3] Not the imaginary Kusta ben Luka, as Mr. H. Adams (*op. cit.,* 284), unaware of the note, believes.

the particular passage was found for me by Dr. Sturm, that too little known poet and mystic.[1] It is from Macrobius's comment upon 'Scipio's Dream' (Lib. I, Cap. XII, Sec. 5): '. . . when the sun is in Aquarius, we sacrifice to the Shades, for it is in the sign inimical to human life; and from thence, the meetings place of Zodiac and Milky Way, the descending soul by its defluction is drawn out of the spherical, the sole divine form, into the cone.'[2]

(*C.P.*, 536)

The date of composition of 'Chosen' can be fixed with some accuracy. In a letter written on 21 February 1926 to Professor Grierson, Yeats stated:

I have been reading your Donne again . . . especially that intoxicating 'St. Lucies Day' which I consider always an expression of passion and proof that he was the Countess of Bedford's lover. I have used the arrangement of the rhymes in the stanzas for a poem of my own just finished.

(*L.*, 710)

The poem Yeats had just finished can only be 'Chosen',

[1] Dr. Frank Pearce Sturm was the only person who, in 1926, showed signs of having read *A Vision*; as Yeats wrote then to Olivia Shakespear (*L.*, 712), he was 'a very learned doctor in the North of England who sends me profound and curious extracts from ancient philosophies on the subject of gyres'. Yeats acknowledged his debt to Dr. Sturm in the second edition of *A Vision* (*Vis. B*, 69), and when the book was published he wrote in 1937 to Ethel Mannin that it was meant for nobody 'but a doctor in the North of England with whom I have corresponded for years' (*L.*, 899).

[2] There was a different note when the poem, under the title 'The Choice' (a title later transferred to a stanza taken out of 'Coole Park and Ballylee'), was first published in *The Winding Stair* (New York, Fountain Press, 1929): 'I have symbolized a woman's love as the struggle of the Darkness to keep the sun from rising from its earthly bed. In the last stanza of The Choice I change the symbol, to that of the souls of man and woman ascending through the Zodiac. In some Neoplatonist or Hermatist [*sic*]—whose name I forget—the whorl changes into a sphere at one of the points where the Milky Way crosses the Zodiac' (p. 26).

since it is the only one using that metre.[1] But the letter to
Grierson not only confirms the date of composition of 'Chosen',
but suggests also what has been the 'catalyst' assembling the
images in Yeats's mind to create this brief poem. The passionate
intensity of Donne's 'Nocturnall upon S. Lucies Day' and the
unmistakable sensuality mixed with a deep metaphysical long-
ing which informs especially its last stanza, found an exact
response in Yeats's state of mind at the time. With the Leda
sonnet Yeats realized that sexual consummation could be the
most effective expression of the achievement (in one supreme
moment) of final unity, of complete fulfilment, both on the
human and on the cosmic plane. In the last stanza of his poem,
Donne had said:

> But I am None; nor will my Sunne renew.
> You lovers, for whose sake, the lesser Sunne
> At this time to the Goat is runne
> To fetch new lust, and give it you,
> Enjoy your summer all;
> Since shee enjoyes her long nights festivall,
> Let mee prepare towards her, and let mee call
> This houre her Vigill, and her Eve, since this
> Both the yeares, and the dayes deep midnight is.

Yeats repeats both the invitation to sensual love and the
personal feeling of frustration of the speaker (in Yeats's later
poetry the strong sexual impulse is always contrasted and fused
with the consciousness of old age). And the mention in Donne
of the Zodiacal sign of the Goat (Capricorn) must have
appealed to Yeats, deep in the study of the extracts forwarded
to him by Dr. Sturm and supporting his system of planetary

[1] Mr. F. A. C. Wilson (*op. cit.*, 205–11) provides a very full and satisfactory
interpretation of 'Chosen', pointing out its Platonic and neo-Platonic founda-
tions in ample detail. He also remarks on its connection with Donne's poem
and points out that 'Chosen' is meant as an 'answer' to the 'Nocturnall'.

motions. He wrote in the first lines of 'Chosen':

> The lot of love is chosen. I learnt that much
> Struggling for an image on the track
> Of the whirling Zodiac.
>
> (*C.P.*, 311)

Donne's insistence on 'midnight' certainly suggested:

> On the maternal midnight of my breast

at line seven of Yeats's poem, while the mental fusion of 'S. Lucies Day' and the Macrobius quotation provided by Dr. Sturm must have unconsciously evoked other Donnian passages containing references to the Zodiac or the Sphere—for instance from 'An Anatomie of the World':

> We thinke the heavens enjoy their Sphericall (l. 251)

or

> They have impal'd within a Zodiake
> The free-borne Sun, and keepe twelve Signes awake
> To watch his steps; the Goat and Crab controule,
> And fright him backe . . . (ll. 263–6)

or still more probably another sensual poem of Donne's, 'The Sunne Rising', where the importunate sun is apostrophized (Yeats writes of 'the horror of daybreak'):

> Aske for those Kings whom thou saw'st yesterday,
> And thou shalt heare, All here in one bed lay.

(cp. the last line of the first verse of 'Chosen': 'And seemed to stand although in bed I lay'). So the last line of 'Chosen' in which the consummation of the sexual act is defined as the

point where 'the Zodiac is changed into a sphere', echoes the
last line of 'The Sunne Rising', referring to the union of the
two lovers:

This bed thy [the Sun's] center is, these walls, thy spheare.

The adoption by Yeats of Donne's metre was not casual,
though 'S. Lucies Day' remains a much better, more direct
and moving poem than 'Chosen'. The union of the lovers con-
ceived as a single whole, a world, a sphere, is close to Donne; it
can be seen for instance in 'The good-morrow', where the two
lovers are hemispheres, which, when joined together, can
suffer no change; 'A Valediction: of weeping', where the two
lovers are a single globe, a world, an 'All'; and finally 'S.
Lucies Day' itself, where the lovers, when separated, are 'two
Chaosses', but reunited are 'the whole world, us two'. This of
course leads us back to Plato's parable which was at the back
of Donne's mind when he spoke of his two lovers as a single
whole, as well as of Yeats's mention of the 'sphere'.

We have here the confluence of the stimuli provided by
Donne's poems, by Dr. Sturm's notes, and by the ideas behind
A Vision, especially that of the sphere (originating in Yeats's
early study of Theosophy, of Blake and, it should be added, of
Swedenborg and Boehme and other occult writers, as well as of
Plato) transcending the temporal movement of the 'gyres'. It is
a rather heavy burden for such a slight poem to carry—and
'Chosen' does not carry it well. The imagery is muddled, the
thought is at the same time too compressed and too drawn out,
and even the metre appears somewhat debased and gratuitous
when it is compared with the conceited dignity and the organic
relation of metrical pattern to development of thought in
Donne's original. In spite of this 'Chosen' lends itself to a
further remark of some importance in view of the evolution of
Yeats's poetry. It concerns the new emphasis on the sexual act
as a symbol of achieved unity and of evasion from the whirling
gyre of time into the sphere of timelessness. The lines describing
this consummation,

That stillness . . .
Where his heart my heart did seem
And both adrift on the miraculous stream,
<div align="center">(C.P., 311)</div>

are strangely reminiscent of his 'The Wild Swans at Coole',
written ten years earlier:

Unwearied still, lover by lover,
They paddle in the cold
Companionable streams or climb the air;
Their hearts have not grown old;

<div align="center">* * *</div>

But now they drift on the still water,
Mysterious, beautiful;
<div align="center">(C.P., 147)</div>

Here too we have an ageing person evoking an image of the
utmost miraculous perfection. And the words used are the
same: obviously Yeats was remembering them in 1926. But
by this time the moment of perfection was no longer represented
by the peaceful gliding of 'lover by lover', but by the violent
physical act of copulation. The twilight picture, softly
mysterious, had given place to a vigorous but crude sense of the
violence of miracle: the mythical swan-ravisher of Leda has
intervened, so that the lines describing the wild swans at Coole
are transformed by a sort of inner violence into the vivid
representation of the moment of sexual consummation.

It is important to notice two points: in the first place after
the Leda sonnet, the advent of either a new age or of the final
dispensation, timelessness (the sphere) is identified with the
physical violence of the sexual act; in the second, the *momentari-
ness* of such an advent or transition into timelessness is strongly
emphasized; in the case of Leda, as Professor Spitzer has

<div align="center">184</div>

acutely remarked,[1] the whole sonnet moves between the 'still' in the first and the 'before' in the last line, words suggesting the shortness of the act, 'an event offered without prehistory, itself creating history'; in 'Chosen' the 'stillness' taken as a theme is that of the instant of love. A 'theoretical' enunciation of this is to be found in *A Vision* (1937): 'I see in the union of man and woman a symbol of that eternal instant where the antinomy is resolved. It is not the resolution itself.'[2] In other words, the conflict can be resolved only momentarily. But when this eternal moment is considered in the abstract, as a mere conception, Yeats represents it as a geometrical figure: the Sphere.[3]

More than once Yeats called his system 'geometry', and the definition is revealing. Much as he tried to organize his thought in philosophical constructions, the impulse he needed to make poetry out of it was sensuous. The usefulness of *A Vision* lies in the fact that it is based on geometrical figures, on something that can be seen, that provides a visual pattern. Time and space are narrowing spirals. What shape could be given to the moment transcending them? There was no choice: a mere circle, like the traditional circle of eternity, was not enough— it was only the base of a cone; but a spherical body has no beginning or end, it can be conceived as containing all space (and therefore all time since time dimensions in Yeats's geometry have spacial consistency). Hence the sphere, or a spherical body, was the only possible representation of the moment beyond time, of the cycle beyond the twelve historical cycles. That is why Yeats can state that 'the Thirteenth Cycle is a Sphere and not a cone'.[4] As he said in an unpublished note for the first *Vision*, printed by Mr. Ellmann,[5] in the Thirteenth Cone all whirling is at an end and unity of being is perfectly

[1] L. Spitzer, *loc. cit.*, 273. [2] *Vis. B*, 214.
[3] See Excursus VI: The Moment of Moments.
[4] *Vis. A*, 170.
[5] R. Ellmann, *The Identity, etc., cit.*, 166.

attained. There,[1] as he himself wrote in the little poem of 1934:

> There all the barrel-hoops are knit,
> There all the serpent-tails are bit,
> There all the gyres converge in one,
> There all the planets drop in the Sun.
> (*C.P.*, 329)

'The Thirteenth Cycle is a sphere.' From this statement Yeats drew a long series of corollaries. The specific ground, the importance of the spherical thirteenth cycle in Yeats's later thought, has been so thoroughly mapped out by Mr. Ellmann, Miss Moore, and even more fully by Mr. Adams that I need do little more than summarize the evidence they have collected.[2]

The sphere is Unity of Being. But the web of associations has been cast wide. The most startling perhaps is the statement in Yeats's diary for 1930: 'I substitute for God the Thirteenth Cone.'[3] The meaning is plain: the Thirteenth Cone being the Absolute can be equated with the Christian conception of Godhead. In the 1937 *Vision* the Sphere is treated under the heading of 'The Completed Symbol', where the main principle of Yeats's system is summarized:

The whole system is founded upon the principle that the

[1] 'There' (the title of the little poem) is the Sphere: the equation is made in a note by Stephen Mackenna to his translation of Plotinus, which Yeats valued so highly. Dealing with 'Minor points of terminology', Mackenna writes: '"*There*"—"*In the Supreme*"—"*In the Beyond*" and other similar words or phrases translate at convenience the word "Ekei" used by Plotinus for the Divine Sphere, the Intelligible World' (Plotinus, *The Enneads,* translated . . . by Stephen Mackenna, London, The Medici Society, 1917–1930, I (1917), 125). See also the comment on 'There' in P. Ure, 'Yeats's Supernatural Songs', *RES*, n.s. VII, 25, Jan. 1956, 38–51.

[2] R. Ellmann, *The Identity, etc., cit.,* 158–62; V. Moore, *op. cit.,* 365–74; H. Adams, *op. cit.,* 281–4.

[3] *Pages from a Diary Written in Nineteen Hundred and Thirty,* Dublin, Cuala Press, 1944, 35.

ultimate reality, symbolized as the Sphere, falls in human consciousness, as Nicholas of Cusa was first to demonstrate, into a series of antinomies.

(Vis. B., 187)

The sphere is not only unity of Being, but also ultimate reality, what has always existed and will exist, though perceived by man only in the rare moments when the temporal antinomies are overcome. A further clarification comes a few pages later:

My instructors, keeping as far as possible to the phenomenal world, have spent little time upon the sphere, which can be symbolized but cannot be known. . . . The ultimate reality because neither one nor many, concord nor discord, is symbolized as a phaseless sphere, but as all things fall into a series of antinomies in human experience it becomes, the moment it is thought of, what I shall presently describe as the thirteenth cone.

(Vis. B., 193)

The distinction is noteworthy and subtle. Perfection, unity, true reality (as opposed to contingent reality which is merely phenomenal) does not exist in our world of time and space. Our knowledge of it is merely the intuition of a moment—but we cannot permanently grasp it. Hence the need of calling it by another name: the Thirteenth Cone, the cone beyond the twelve included in the temporal sequence. Yeats was acutely aware of the temporal limitations of man's knowledge, and therefore he was careful to repeat this distinction between the sphere seen as the Absolute and the same seen within the limitations of man's understanding:

The *Thirteenth Cone* is a sphere because sufficient to itself; but as seen by Man it is a cone. It becomes even conscious of itself as so seen, like some great dancer, the perfect flower of modern culture, dancing some primitive dance and conscious of his or her own life and of the dance.

(Vis. B., 240)

The image of the dancer, used to convey the difficult

conception of the perfect sphere's own consciousness of manifest-
ing itself to imperfect man, is already poetry. As Mr. Kermode
observed, the image of the dancer stands for the poetic image
itself, for art; and Mr. Adams commented on the above
passage from *A Vision*: 'The dancer whirling into a vortex,
consumed in equilibrium, is the image of momentary vision, the
image of truth.' [1] Poetry or art is the moment of vision, man's
only means of achieving that which the sphere symbolizes:
unity of being, ultimate reality, ultimate truth.

Here the decadent conception of art as the supreme achieve-
ment re-emerges—Yeats was never to abandon it. It is now
possible to understand why he writes that amid the whirling
motion of the historical cycles 'always at the critical moment the
Thirteenth Cone, the sphere, the unique intervenes'; [2] and why,
in the new ending of the 'Dove or Swan' section in the 1937
Vision (written presumably in 1936) he says that 'the *thirteenth
sphere* or cycle . . . is in every man and called by every man his
freedom'. [3] The sphere (God, Unity of Being, Ultimate
Reality, the absolute; or the Unique in the moment of vision,
Art, when referring to temporal human existence) is man's
freedom, in as much as it releases man from the rings of time
and space through the momentary ecstasy attained 'in the
creation or enjoyment of a work of art'.

As the sphere, ultimate reality, was unattainable by time-
bound man, for whom 'all things fall into a series of anti-
nomies', Yeats postulated a *Daimon*, that is to say the counter-
part of Man in Eternity, man projected outside time:

All things are present as an eternal instant to our *Daimon* (or
Ghostly Self as it is called, when it inhabits the sphere), but
that instant is of necessity unintelligible to all bound to the
antinomies. My instructors have therefore followed tradition by
substituting for it a *Record* where the images of all past events
remain for ever 'thinking the thought and doing the deed'.
They are in popular mysticism called 'the pictures in the astral

[1] H. Adams, *op. cit.*, 282. [2] *Vis. B*, 263. [3] *Vis. B*, 302.

light', a term that became current in the middle of the nineteenth century, and what Blake called 'the bright sculptures of Los's Halls'.

<div align="right">(Vis. B., 193)</div>

The 'Record' where images exist for ever can be easily recognized for what Yeats had defined as the Great Memory, or the Great Mind, in his essays of 1900, as *Anima Mundi* in 1917, and as *Spiritus Mundi* in 'The Second Coming'. The sphere or the thirteenth cone is, therefore, also the Great Memory, the reservoir of all those symbols which for him were the substance of poetry as well as of magic. The identification of the Great Memory with Blake's bright sculptures of Los's Halls dates back to 1900 when Yeats had written in his essay on 'Magic':

I have found it [the Great Memory] in the prophetic books of William Blake, who calls its images 'the bright sculptures of Los's Halls'; and says that all events, 'all love stories', renew themselves from those images.

<div align="right">(I.G. & E., 60)</div>

In order to realize the importance for Yeats of this identification it is necessary to go back a few more years in his career and see the passage of his commentary to Blake's works (1893) interpreting the meaning of Golgonooza, Blake's city of art:

Golgonooza is situated on the point where the translucent becomes the opaque, and is enclosed with the egg of Los, sometimes called the mundane egg, and again the halls of Los. The egg has one apex at the nadir and the other at the zenith, and is drawn in Blake's one diagram ('Milton', p. 32). It is the microcosmic aspect of that 'circle pass not', so much talked of in Theosophical mysticism, and is identical with the egg of Bramah. Students of the occult philosophy of the Tatwas will recognize in it a certain symbol associated with Akasa. It is also closely related to the 'sphere' of Swedenborg, and is the form of that many-coloured light which innumerable visionaries have seen encircling the bodies of men. Blake described it as created by Los to make men 'Live within their own energy', otherwise they would fall into the *non-Ens*. It is in its relation to

<div align="center">189</div>

9. William Blake's 'one diagram' of the Mundane Egg, from *Milton,*
plate 32.

the world in general the astral light of post-Paracelsian
occultists, and Blake has reflected their teaching that the images
of all things are contained within it, and may be read there,
whether they be of the future or the past, by the trained seer.
(See 'Jerusalem', p. 16, ll. 61, 69, where the past, present and
future are said to be sculptured in the Halls of Los.)[1]

There is no doubt that, not only when speaking of the Great
Memory, but also so many years later, when dealing in *A
Vision* with the 'sphere', Yeats remembered his own interpreta-
tion of Blake's spheroid form, the mundane egg—which had
for him the further appeal of being the *one* diagram in the
Prophetic Books. Hence the associations he had found for
Blake's mundane egg (the bright sculptures, eternal symbols in
the Great Memory, and the astral light of the occultists) are

[1] *The Works of William Blake, cit.,* I, 317.

transferred to his own 'sphere'. Seeing this association, we are no longer surprised at the cryptic hint in the introduction to the first *Vision* to the 'elliptoid' rather than the sphere, and to the eggs turning inside out perpetually. At the same time there was still some confusion: he used the plural and spoke of 'spheres' and 'eggs'. When he came to re-write his 'philosophical' work this plurality had disappeared, and as he had realized that there could only be *one* sphere (there can be no degrees of wholeness), so in the substitute prefatory material to the second *Vision* we hear of only one egg.

The new prefatory material was written after he had realized that he 'had misinterpreted the geometry' and was published first under the title of *Stories of Michael Robartes and his Friends* in 1931. It is a new version of what Yeats himself described as the 'unnatural story of an Arabian Traveller', invented because Mrs. Yeats 'was unwilling that her share [in the suprasensorial communication of *A Vision*] should be known', and is introduced again because he 'was fool enough to write half a dozen poems that are unintelligible without it'.[1] We are immediately told that 'Robartes called the universe a great egg that turns inside out perpetually without breaking its shell'; and we find that the new myth centres on a prodigious egg. The function of 'mother' to a new cycle of civilization destined to supersede our own, which in the early story 'The Adoration of the Magi' was attributed to a dying prostitute in Paris, is now given to a character out of one of Blake's minor poems, Mary Bell;[2] Robartes has entrusted her with a mysterious ivory box, and after his statement that our civilization 'is near its end', and that 'we are here to consider the terror that is to come', the following story unfolds:

Mary Bell then opened the ivory box and took from it an egg the size of a swan's egg, and standing between us and the dark window curtains, lifted it up that we might all see its

[1] *A Packet for Ezra Pound*, Dublin, Cuala Press, 1929, 25; all the material included in this book went into *Vis. B.*
[2] Cp. H. Adams, *op. cit.*, 196.

colour. 'Hyacinthine blue, according to the Greek lyric poet,' said Robartes. 'I bought it from an old man in a green turban at Teheran; it had come down from eldest son to eldest son for many generations.' 'No,' said Aherne, 'you never were in Teheran.' 'Perhaps Aherne is right,' said Robartes. 'Sometimes my dreams discover facts, and sometimes lose them, but it does not matter. I bought this egg from an old man in a green turban in Arabia, or Persia, or India. He told me its history, partly handed down by word of mouth, partly as he had discovered it in ancient manuscripts. It was for a time in the treasury of Harun Al-Rashid and had come there from Byzantium, as ransom for a prince of the imperial house. Its history before that is unimportant for some centuries. During the reign of the Antonines tourists saw it hanging by a golden chain from the roof of a Spartan temple. Those of you who are learned in the classics will have recognized the lost egg of Leda, its miraculous life still unquenched. I return to the desert in a few days with Owen Aherne and this lady chosen by divine wisdom for its guardian and bearer. When I have found the appointed place, Owen Aherne and I will dig a shallow hole where she must lay it and leave it to be hatched by the sun's heat.' He then spoke of the two eggs already hatched, how Castor and Clytaemnestra broke the one shell, Helen and Pollux the other, of the tragedy that followed, wondered what would break the third shell.

(*St. of M.R.*, 19 ff.; *Vis. B*, 50–1)

A fantastic story in the same tradition as those Yeats had written in the 'nineties; but perhaps he was right in believing that by the nineteen-tens he had rejected for good 'that extravagant style / He had learnt from Pater':[1] in the later tales there is less preoccupation with the formal harmony of words and instead a constant vein of irony and self-irony. In the present example Aherne's objection to Robartes' words anticipates the reader's objection to Yeats's whole fanciful construction of *A Vision*.

The passage, however, reveals a whole series of interesting

[1] 'The Phases of the Moon', *C.P.*, 184.

connections, not only with the Leda myth and with the re-
currence of the egg-symbols in oriental religions—pointed out
by Madame Blavatsky—but with other conceptions which had
established themselves in Yeats's mind. On its way from Sparta
to the further East (where it was worshipped in India as
the egg of Brahma) the third egg makes a detour through
Byzantium. An inevitable detour, since the historical
Byzantium, as seen in the first *Vision*, and the Byzantium of the
imagination in 'Sailing to Byzantium' (a poem written in the
same months of 1926 when Yeats was refurbishing 'Among
School Children' where the Leda-egg-sphere-dance cluster
was so prominent) represent the fullest possible poetic image
of Unity of Being, the state where all antinomies are reconciled
and time overcome. In Byzantium stood 'the church named
with so untheological a grace "The Holy Wisdom"',[1]
dedicated to that divine wisdom which, in the present passage,
guides the prodigious mission of Mary Bell. And in the hatch-
ing of the egg by the sun a faint echo of the Spenserian myth of
Chrysogone fecundated by the sun can be detected—an indirect
contributory reminiscence in Yeats's Leda sonnet. Finally not
only was the name of Mary Bell derived from Blake, but the
egg she carries is his Mundane Shell, as its colour reveals.
Robartes described the egg as 'Hyacinthine blue', and Blake in
Jerusalem had spoken of:

the Twenty-seven Heavens, numbered from Adam to Luther,
From the blue Mundane Shell, reaching to the Vegetative
 Earth.

The Mundane Shell is a blue egg, blue in so much as it is a
further all enclosing Heaven, beyond the other twenty-seven
(twenty-eight, the number of the phases of the moon, was a
very important figure in Yeats's as in Blake's mythology) and
in his commentary to Blake there is an elaborate diagram of the
twenty-seven heavens with the Mundane Shell.[2] Seen from

[1] *Vis. A*, 192. [2] *The Works of William Blake, cit.*, II, 301.

within, from 'the Vegetative Earth' the Mundane Egg is the starry vault of Heaven. Blake says:

> The Vegetative Universe . . .
> . . . expands in Stars to the Mundane Shell
> And there it meets Eternity again, both within and without.

Yeats's eternal egg 'turns inside out perpetually' and includes all the 'vegetative' historical gyres. Blake may have drawn his conception of the Mundane Shell as a further heaven including earth from one version of the oriental myth of the World Egg (well known to Yeats) according to which one half of it became the sky, the other the earth.

I have tried to sketch out the extremely complex associations of the egg image, which is the same as the geometric figure of the sphere. As with all other poetic symbols, it cannot be equated with any single conception, but must stay on its own, as an undefinable entity of the imagination, contributing to new imaginative clusters and absorbing ever new and varied significances. In the *Stories of Michael Robartes* the egg myth had assumed a new ironical and fantastic tone. And it became, in Yeats's own words, 'Rabelasian', like the strange poem of Blake's on Mary Bell which certainly was in Yeats's mind, in the play *The Herne's Egg*.[1] The play was begun in December 1935, under the influence of the Indian Swami, Shri Purohit, with whom Yeats, at Majorca, had undertaken the translation of the *Ten Principal Upanishads*. The nature of the play is described by Yeats in two ways; it is 'as wild a play as *Player Queen*, as amusing but more tragedy and philosophic depth', and 'the play is his [the Swami's] philosophy in a fable, or mine confirmed by him'.[2] Both definitions are eminently suitable. The play *is* the transposition into a highly stylized deliberately sham old Irish legendary setting of such oriental

[1] Letter to Ethel Mannin, 17 Feb. 1938, *L.,* 904–5.
[2] Letters to Dorothy Wellesley, 28 Nov. and 16 Dec. 1935, *L.,* 843–4.

doctrines as that of the World Egg dropped by a bird (the heron's egg) and of metempsychosis, rolled into one with the typically Yeatsian myth of Leda's egg and all its metaphysical and physical implications.[1] At the same time it is, like *The Player Queen*, a wild farce, at once summarizing and ironizing all the themes that had been so fertile for Yeats's poetry in his previous career. As *The Player Queen* juggles with the dominating images of the years 1910–20, *The Herne's Egg* plays with the images of 1920–35: the self-irony already apparent in several sections of *The Vision* acquires in *The Herne's Egg* a poignant Aristophanic quality which is curiously poetic. Yeats is right in calling it 'the strangest wildest thing I have ever written', and to write to Ethel Mannin: 'do not ask me what it means'.[2] Attracta, the priestess and wife of the mythical bird, the Great Herne, ravished by seven men, is at one and the same time Salome (the type of the dancer), Leda, the 'mother' of new civilizations, and the Queen coupling with the Unicorn in the earlier play. The idea of the new cycle of civilization is presented cryptically under the aspect of the Herne's egg, and again, following the doctrine of metempsychosis, in the transmigration of the spirit of a king into that of a donkey. This is the extreme irony: the beast of 'The Second Coming', the miraculous birth, the Unicorn, the stallion of Eternity, is reduced to a donkey, 'nothing to show for it, / Nothing but just another donkey'. Actually, even in *The Player Queen* this satirical motif was hinted at: there a prophet and half-wit predicted the advent of a new king by braying like a donkey.[3] *The Golden Ass* of Apuleius (a favourite book with the

[1] The materials that went into the play have been thoroughly pointed out and examined by Mr. F. A. C. Wilson (*op. cit.*, 95–136); his excellent treatment of the subject, revealing the range of Yeats's references, from *Julius Caesar* to Balzac's *Seraphita*, cannot be improved upon.

[2] Both in letters to E. Mannin, 19 Dec. 1935 and 17 Feb. 1938, *L.*, 845, 904.

[3] The association of the ass with the power of prophecy is traditional (cp. the Biblical Balaam's ass); A. De Gubernatis, *Zoological Mythology*, London, 1872, I, 397–8, deals at length with the belief that asses could announce extraordinary events with their braying.

decadents) provided the final touch; it is amusing to see how donkeys ran in Yeats's mind in 1936: when he had to comment on some poems submitted to him by Dorothy Wellesley, he could only speak of the sexlessness of the mule and of an episode in Apuleius' novel;[1] and in the broadcast on modern poetry of October 1936 he dwelt with pleasure on Edith Sitwell's 'Ass-Face'.[2]

Among the images ironically handled in *The Herne's Egg* there is also one that had become almost an obsession in the last years of his life: that of the dance of Salome, re-emerging from his early association with the decadents, in the wake of Oscar Wilde and Beardsley. Mr. Kermode has shown the importance of the figure of Salome equated at one time with that of Helen, and its significance as the type of the dancer. Yeats's plays, *The King of the Great Clock Tower* (1933-4), *A Full Moon in March* (1934), and the final play *The Death of Cuchulain* (1938) are dominated by the dance of the woman with, or in front of, a severed head. Yeats was probably referring to it when he wrote to Edmund Dulac, who had objected to his second play: 'I do not understand why this blood symbolism laid hold upon me but I must work it out.'[3] *The Herne's Egg* is on the whole a successful attempt to work it out of his system through satire. But one element of the original decadent Salome type he could not fully reject: the obsessive and unnatural virginity of the dancer. The famous 'Hérodiade' of Mallarmé, translated by Symons,[4] had left a very deep impression on him, and he still remembered the day Symons read it to him when, some twenty-five years later, he wrote *The Trembling of the Veil*; there Yeats transcribed the lines:

> The horror of my virginity
> Delights me, and I would envelop me

[1] Letter of 3 May 1936, *L.*, 854-5.
[2] Cp. *Ess. '31 to '36*, 20.
[3] Letter of probably 10 Dec. 1934, *L.*, 830.
[4] First published in the last issue of *The Savoy*, n. 8, Dec. 1896.

In the terror of my tresses, that, by night,
Inviolate reptile, I might feel the white
And glimmering radiance of thy frozen fire,
Thou that art chaste and diest of desire,
White night of ice and of the cruel snow!

(*Aut.*, 321)

The 'winter of virginity' occurs in *A Full Moon in March*,[1] but the echo from Symons' translation is most evident in *The Herne's Egg*:

Women thrown into despair
By the winter of their virginity
Take its abominable snow,
As boys take common snow, and make
An image of god or bird or beast
To feed their sensuality:
Ovid had a literal mind,
And though he sang it neither knew
What lonely lust dragged down the gold
That crept on Danae's lap, nor knew
What rose against the moony feathers
When Leda lay upon the grass.

(*C.Pl.*, 649)

There is no need to stress the appropriateness of the mention of Leda (or of Danae, an obvious equivalent of the Leda figure for Yeats).[2] Like passive Leda, Salome existed at the moment before revelation. Yeats said thus much in a passage of

[1] *C.Pl.*, 624.

[2] The equivalence of Danae and Leda is obvious for instance in Yeats's speech delivered in August 1924 (the time of the publication of 'Leda and the Swan') at the Tailteann Games, on the occasion of the conferring of the laurel of the Irish Academy on Stephen Mackenna for his translation of Plotinus; Yeats spoke then of the days 'when God came down to Danae in a Shower of Gold', an expression that shocked the conservative press (Hone, *op. cit.*, 363).

A Vision which followed closely the interpretation of the Leda myth as a new annunciation:

> When I think of the moment before revelation I think of Salome—she too, delicately tinted or maybe mahogany dark—dancing before Herod and receiving the Prophet's head in her indifferent hands, and wonder if what seems to us decadence was not in reality the exultation of the muscular flesh and of civilization perfectly achieved.
>
> (*Vis. A*, 185; *Vis. B*, 273)

The Yeatsian Leda-egg cluster has finally come into touch with one of those early symbols inherited like Helen from the writers and artists of the late nineteenth century—from Wilde and Symons as well as from Moreau and (here above all) Beardsley. But I need not go into the figurative sources of the image—this has been excellently done by Professor Gordon and Mr. Fletcher.[1] And in the present chapter I do not deal with the works of figurative art which found a place among the 'bright sculptures' in Yeats's mind, but with pure or geometrical forms: the egg, the sphere. What has been said about them is sufficient to illustrate the reason for the prominent place held in the end of the newly written introduction to the second *Vision* by what in the first version had been a stray allusion to Brancusi's eggs or ovoids.[2] They are now called 'stylistic arrangements of experience', they have found a place in Yeats's geometry of cones and spheres, they are symbols and therefore 'bright sculptures' themselves: symbols or spirits. Yeats referred to them as such, mentioning specifically Brancusi's ovoids in the mysterious little uncollected poem included in the introduction to *Words upon the Window-Pane* (1931):

> Let images of basalt, black, immovable,
> Chiselled in Egypt, or ovoids of bright steel

[1] In Gordon and Fletcher, *op. cit., passim.*
[2] The passage is quoted *supra*, p. 4; and compare Excursus I: Yeats and Abstract Art.

Hammered and polished by Brancusi's hand,
Represent spirits.

(W. & B., 35)

There was room in Yeats's imagination even for works of the 'abstract' art which he intensely disliked—always providing such works represented a symbolic form.

VI

The Dome of many-coloured Glass

~~~~~~~~~~~~~~~~~~~~~~~~~~~~~~~~~~~~~~~~~~~~~~~~~~~~~

BOTH the sphere and the egg represented for Yeats the abstract conception of Unity of Being. But being abstractions they were non-poetic. Unity of Being became poetry only when Yeats found another objective correlative for it, when he presented it as a city of the imagination, Byzantium. Three grades can be distinguished in the process towards the creation of poetry out of intellectual conceptions, all three sensuous in as much as they involve a visual, concrete, objective element. The first or sphere, though a visual image, is mere 'geometry', the nearest to absolute form and therefore to abstraction. The egg has wider associations, but it is still a simple form, emblem rather than symbol. Only with Byzantium have we a real, complex symbol, with infinite and indefinite associations—and only with Byzantium do we have poetry. Three degrees lead to the truly poetic image, three degrees marked by greater and greater sensuousness, from geometrical form to a whole inhabitable world of the imagination.

The Byzantium poems have been for many years the object of study by the most acute interpreters of Yeats's work; it is unnecessary to attempt yet another interpretation of their meaning or to list once again their literary sources. For an exhaustive interpretation the reader may be referred to that of Professor

Cleanth Brooks,[1] while the pages devoted to Byzantium in the catalogue of the Reading photographic exhibition concisely and clearly summarize the literary and visual stimuli acting on the poet's mind, adding some which had hitherto been unnoticed. The compilers of the Reading catalogue rightly remark that 'we are to see these poems as encyclopaedic in the sense that they represent a compendium of Yeats' system of images', and they consider them as the confluence of the decadent conception of Byzantium, of Yeats's historical studies for *A Vision*, and of the symbols derived from the rituals of the hermetic society to which he belonged.[2] One more fact should be kept in mind: the two poems were written at a distance of four years: 'Sailing to Byzantium' in August–September 1926, 'Byzantium' between April and September 1930. The first was written (concurrently with 'Among School Children') 'to recover *his* spirits', and the second to 'warm *him*self back into life' after an illness, and 'looking for a theme that might befit *his* years'.[3]

These points are not trivial, especially in view of the attempts of recent critics to demonstrate that the subject matter of the two poems is somewhat different and suggests a shift in the attitude of the author. 'Sailing', they find, describes the search for the 'country of the mind', while 'Byzantium' proper is a presentation of an ideal state beyond life. The distinction finds support in the fact that—as F. L. Gwynn pointed out[4]—the Byzantium of the first poem is that of about A.D. 550, the period mentioned in the famous description in *A Vision* 'a little

[1] Cleanth Brooks, 'Yeats: The Poet as Myth-Maker', *Modern Poetry and the Tradition*, Chapel Hill, Univ. of N. Carolina Press, 1939, 173–202.

[2] Gordon and Fletcher, *op. cit.*, 26–9. On the decadent conception of Byzantium see the chapter 'Byzantium' in M. Praz, *The Romantic Agony, cit.*

[3] The statement about 'Sailing to Byzantium' is in a letter to Olivia Shakespear of 5 Sept. 1926, *L.*, 718, that about 'Byzantium' in the dedication to Edmund Dulac of the English edition of *The Winding Stair and Other Poems*, London, Macmillan, 1933; now in *C.P.*, 537.

[4] F. L. Gwynn, 'Yeats's Byzantium and Its Sources', *Phil. Q.*, XXXII, 1, Jan. 1953, 9–21.

before Justinian opened St. Sophia and closed the Academy of Plato';[1] while in the second poem it is that of about A.D. 1000 'towards the end of the first Christian millenium', as Yeats stated in the note of 30 April 1930, his first mention of an idea for his second poem:

Subject for a poem. . . . Describe Byzantium as it is in the system towards the end of the first Christian millenium. A walking mummy, flames at the street corners where the soul is purified, birds of hammered gold singing in the golden trees, in the harbour offering their backs to the wailing dead that they may carry them to Paradise. These subjects have been in my head for some time, especially the last.

(*P.fr.D.*, 2)

Substantially, however, Byzantium remains an ideal image of unity of being, whether as an absolute state, or as a final achievement beyond human life. There is a shift of emphasis in the two poems, from movement to supreme stasis. But both were written as poems of 'recovery', as releases or escapes into serenity; and in both an old man speaks. The first draft of 'Sailing to Byzantium'[2] to which Yeats was able to refer as early as 5 September 1925, is substantially different in its first stanzas from the final form of the poem: the world of nature, of 'whatever is begotten, born and dies', is presented in terms of a Nativity picture: the wider generalization ('fish, flesh or fowl') comes in a later draft quoted by Mr. Ellmann[3] and was presumably written towards the end of the month. The same is true of the second stanza which was originally a description of the splendours of Byzantine art and architecture.

The strictly visual inspiration of the first draft should be noted: Yeats obviously began with two pictures in his mind's eye—a Renaissance Madonna expressing the humanization of

---

[1] *Vis. A,* 191; *Vis. B,* 280.

[2] The early drafts of 'Sailing to Byzantium' are published and amply discussed in A. N. Jeffares, 'The Byzantine Poems of W. B. Yeats', *RES*, XXII, 85, Jan. 1946, 44–52.

[3] R. Ellmann, *The Identity, etc., cit.,* 165.

the supernatural, the fullness of *earthly* life, and the stylized splendour of Byzantine mosaics and architectural forms which symbolize in a direct way the supernatural itself, the fullness of life beyond the boundaries of earth and flesh. The origin of 'Sailing to Byzantium' is visual, it is symbolic painting. But in revising it Yeats completely blotted out the two pictures as such, and was content to leave only indirect suggestions of them. This transformation shows how deeply he was conscious of his medium of expression: the sensuousness of poetry lies not in its descriptiveness but in the thought.

In the earliest draft the poem began:

> All in this land—my Maker that is play
> Or else asleep upon His Mother's knees,

and this was revised with a further stress on the Madonna painting:

> Here all is young; the chapel walls display
> An infant sleeping on his Mother's knees,

It is a far cry from this to the final form of the poem:

> That is no country for old men. The young
> In one another's arms, birds in the trees—
> (*C.P.*, 217)

the picture has gone, and the contrast between the youthfulness that it portrayed and the old age of the writer is firmly and straightforwardly stated. The first two lines of the revised second stanza are near quotations from 'Among School Children', Yeats's curse upon old age, upon which he was working at the same time:

> An aged man is but a paltry thing,
> A tattered coat upon a stick, . . .
> (*C.P.*, 217)

The 'old scarecrow' so effectively presented in 'Among School Children' has broken into the picture of Byzantium, ousting the 'pleasant dark-skinned mariners' who carried the poet 'towards the great Byzantium' in the corresponding lines of the second stanza of the earlier draft.

Though Professor Jeffares has already illustrated the significance of the changes introduced by Yeats in 'Sailing to Byzantium', it is useful to see them also from the point of view of what I should call the missing pictures in the final version. The more so since in the present chapter I propose to explore more exhaustively than has hitherto been done, the visual stimuli which contributed to the building of Byzantium in Yeats's imagination. The poet was in one of his years of grace: he had been writing the sensual and tragic poems which he was to collect in the two series *A Man Young and Old* and *A Woman Young and Old*—disturbing poems revealing a new perturbation in the poet's senses and feelings. 'Sailing to Byzantium' seems to have been written in the first place as an attempt to pacify this inner disturbance, to escape from the 'sensual music' of his recent poems by creating a poetic image of the place where all strife is at an end. Visual suggestions were at work at the beginning—but later, with the increasing consciousness of the sad reality of advancing age, the initial vivid 'pictures' were suppressed, the conceptions that they portended were generalized, and only the invocation to a superior wisdom (the sages) and the image of the golden bird representing the state 'out of nature' remained. In other words the metaphysical element came much more to the fore—metaphysical both in the sense of 'out of nature' and in the critical acceptation of the word as 'sensuous thinking'.

Four years later Yeats resumed the same theme, emerging from a period not of sensual and sentimental upheaval, but of physical illness. 'Byzantium' more than 'Sailing' is a contemplation of death—or rather of the ideal state after death. The metre adopted is significant from this point of view. While 'Sailing' was in the eight-line stanza form common to many

meditative poems of Yeats, 'Byzantium' adopts the metre that
Yeats used only in his most deeply felt poems of death and
birth, the stanza patterned on that of Cowley's funeral elegy for
Mr. William Hervey and used first in the poem for the death
of Major Gregory.[1] It is curious to observe that, in the imagery
of 'Byzantium', the process traceable in 'Sailing' is reversed.
There the most obvious visual images, though present in the
drafts, had disappeared from the final version: the reference to
the dome, so prominent in the drafts, had gone:

> That I may look in the great church's dome
> On gold-embedded saints and emperors

and so had the image of the dolphins (in the first version the
'saints' are asked to

> send the dolphins back and gather me
> Into the artifice of eternity,

while in the printed version the 'sages' invoked do not need the
intervention of the dolphins to carry the poet's soul to paradise).
In the first note made for 'Byzantium', instead, there is no
mention of either dome or dolphin, and even the draft of the
first stanza quoted by Mr. Ellmann speaks of a tower rather
than a dome. The poet saw himself as in the second part of the
poem 'The Tower', which opened:

> I pace upon the battlements and stare
> On the foundations of a house, or where
> Tree, like a sooty finger, starts from the earth;
> And send imagination forth
> Under the day's declining beam, and call
> Images and memories

[1] See the remarks on this metre in F. Kermode, *op. cit.*, 38 ff., and in a letter
of J. J. Cohane in *TLS.*, 10 May 1957.

From ruin or from ancient trees,
For I would ask a question of them all.
(C.P., 219)

'Byzantium' started from exactly the same point, and used the same metre:

> When the emperor's brawling soldiers are abed
> The last be nighted victims dead or fled—
> When silence falls on the cathedral gong
> And the drunken harlot's song
> A cloudy silence, or a silence lit
> Whether by star or moon
> I tread the emperor's tower
> All my intricacies grown clear and sweet.[1]

'I tread the emperor's tower'—but this time the 'images and memories' called forth, no longer come from the surrounding countryside of Thoor Ballylee, but from that city of the imagination which had become associated for him with the condition beyond mortality. At this stage, we should say, Yeats started from a metaphysical conception and tried to render it in visual images—in the process the images he had excluded from the first poem—the dome and the dolphins—came back to dominate the second. In this game of hide and seek there has, perhaps, been a transference of meaning: the word 'dome', though obviously suggested by the dominating feature of the historical Byzantium, the dome of Hagia Sophia, seems to have become here a metaphor for the sky. Or rather—through the subtle ambiguity characteristic of all poetry—it is at one and the same time both the church dome and the sky vault:

> The unpurged images of day recede;
> The Emperor's drunken soldiery are abed;
> Night resonance recedes, night-walkers' song
> After great cathedral gong;

[1] Published by R. Ellmann, *Yeats, etc., cit.*, 274.

## The Dome of many-coloured Glass

A starlit or a moonlit dome disdains
All that man is,
All mere complexities,
The fury and the mire of human veins.

<div align="right">(<i>C.P.</i>, 280)</div>

A recent controversy as to whether Yeats meant the last word in the fifth line to be *distains* or *disdains*, is worth recalling.[1] I am told that Mrs. Yeats is most positive in maintaining that *disdain* was meant,[2] and the confusion between the two words is common enough. A fairly early example can be found in Shakespeare's *Pericles*,[3] and with such a bad speller as Yeats even manuscript evidence does not mean much. The question of bad spelling is neatly stated also by Mr. Henn, with whose conclusion on the debated word I must concur:

The dome is the symbol of Byzantine achievement, the image of heaven, the only canopy of God. It disdains . . . not mankind, but the comparative simplification of his complexities. The Shelley memory is clear: but in the Cuala Press Edition (which often has misprints . . .) the word appears as

---

[1] See *TLS.*, from 11 Aug. to 3 Nov. 1950. The discussion originated from a letter of R. A. Auty, who noticed the spelling *distain* (the spelling of the first printing of the poem, in *Words for Music Perhaps and Other Poems,* Dublin, Cuala Press, 1932) in the anthology edited by Gwendolen Murphy, *The Modern Poet,* London, 1938. Mr. Auty and Miss Murphy maintained that the correct reading was *distain* in the sense of 'outshine', supported by Sir Herbert Read who suggested the meaning 'flood with light'; among the other correspondents, Richard Murphy, John Christopherson, Vernon Watkins and Bonamy Dobrée supported *disdain,* connecting it with *scorn* in the third verse of the poem. Mr. Arthur Mizener had noticed the two readings many years before, in the essay 'The Romanticism of W. B. Yeats' (1942; now in *The Permanence of Yeats, cit.,* 145) and, though accepting *disdain,* admitted *distain* as meaning 'free itself from the stain of and so be free to scorn all that man is . . .' See *infra* Mr. Henn's remarks on the subject.

[2] By Professor H. O. White, formerly of Trinity College, Dublin.

[3] In both Quartos of 1609 the reading at IV, iii, 31 is 'Shee did disdaine my childe, and stoode betweene her and her fortunes' (Q1, Sig. G2 r.). Practically all modern editors emend to *distain* in the sense of 'cast a slur upon'.

'distains'. In all four manuscript versions that I have seen it is spelt thus, though Yeats's spelling is at its best unreliable. That new image with its ambiguities is not without attractions: perhaps one day it may be an accepted variant.[1]

A more or less conscious ambiguity is suspected here; and the reading *distains* finds support in the lines of Shelley referred to by Mr. Henn:

> Life, like a dome of many coloured glass,
> Stains the white radiance of eternity.

Yeats himself had quoted these very lines in one of his most important essays, 'The Philosophy of Shelley's Poetry' (1900), and the context in which the quotation occurs is revealing. Yeats wrote, speaking of Shelley's conception of death:

This beauty, this divine order, whereof all things shall become a part in a kind of resurrection of the body, is already visible to the dead and to souls in ecstasy, for ecstasy is a kind of death . . .[2] And in the most famous passage in all his poetry [Shelley] sings of Death as of a mistress: 'Life, like a dome of many-coloured glass, stains the white radiance of eternity.' 'Die, if thou wouldst be with that which thou wouldst seek'; and he sees his own soon-coming death in a rapture of prophecy, for 'the fire for which all thirst' beams upon him, 'consuming the last clouds of cold mortality'.

<div align="right">(<em>I.G. & E.</em>, 101–2)</div>

[1] T. R. Henn, *op. cit.*, 217.

[2] Here Yeats inserted a passage from Shelley's 'Rosalind and Helen' (ll. 121–130): 'Heardst thou not sweet words among / That heaven-resounding minstrelsy? / Heardst thou not that those who die / Awake in a world of ecstasy? / How love, when limbs are interwoven, / And sleep, when the night of life is cloven, / And thought to the world's dim boundaries clinging, / And music when one beloved is singing, / Is death? Let us drain right joyously / The cup which the sweet bird fills for me.' The bird, the ecstasy, the lovers recall the imagery of 'Sailing to Byzantium'. And in the following quotations of sentences from *Adonais* one is reminded of the 'agony of flame' in 'Byzantium' and of the 'cloudy silence' which figures in the first draft of the poem, quoted above.

At this point Yeats quotes at some length Mrs. Shelley's statement about her husband's beliefs:

. . . the almost inexpressible idea, not that we die into another state . . . but that those who rise above the ordinary nature of man, fade from before our imperfect organs; they remain in their 'love, beauty, and delight', in a world congenial to them, and we, clogged by 'error, ignorance, and strife', see them not till we are fitted by purification and improvement to their higher state.

<div align="right">(<i>I.G. & E.,</i> 103–4)</div>

'Byzantium' deals with a condition very similar to that described here: it deals with death as the final achievement of an ideal state. Byzantium, as Yeats pointed out in his *Vision*, represented perfection: 'If I could be given a month of Antiquity and leave to spend it where I chose, I would spend it in Byzantium.'[1] Byzantium is the country where the spirits of men go—and is the world congenial to Yeats's spirit. This is very close to Shelley's idea that superior spirits passing beyond life 'remain in their love, beauty and delight in a world congenial to them'. Yeats, writing Byzantium, must have remembered Shelley's lines containing a similar conception: life compared to a dome of coloured glass staining the purity of eternity. But he inverted the terms: his dome was not earthly life but eternity, heaven, distaining, that is to say outshining or merging into a single radiance, the contrasting colours of human existence, all that man is, all mere complexities.

Shelley's lines not only tend to support the opinion that what Yeats wrote was *distains*, but they offer a key to the essential meaning of 'Byzantium': it is a meditation upon death. Yeats's conception of the ideal state beyond life is akin to that of the later Romantic poets. Eternity and beauty are identified. But there is one significant variation.

Keats, in the 'Ode to a Nightingale'—which, as Dr. Tillyard

---

[1] *Vis. A,* 190; *Vis. B,* 279.

has noticed, is echoed by Yeats in 'Sailing to Byzantium' [1]—
and Shelley in a passage of 'Rosalind and Helen' that Yeats
himself quoted at length in his essay on Shelley, evoke eternity
through the image of the nightingale. The solitary bird and its
song stand for aesthetic beauty, the beauty of art, but also for
that of nature. In Yeats the nightingale becomes an artificial
golden bird, as he says in 'Sailing':

> Once out of nature I shall never take
> My bodily form from any natural thing,
> But such a form as Grecian goldsmiths make
> Of hammered gold and gold enamelling
> To keep a drowsy Emperor awake;
> Or set upon a golden bough to sing
> To lords and ladies of Byzantium
> Of what is past, or passing, or to come.
>
> (*C.P.*, 218)

Nature is rejected, and the poet shows how faithful he has
remained to the doctrine of art for art's sake current in his
youth.[2] While in Keats and Shelley art was represented by
music, by the song of the bird, Yeats instead is thinking mainly
in terms of the visual arts. What matters is not so much the

---

[1] E. M. W. Tillyard, *Poetry: Direct and Oblique,* London, Chatto & Windus,
1934, 184. The claim is supported by a revised first draft of 'Sailing' quoted by
Jeffares (*loc. cit.*) where one finds the line 'After the mirroring waters and the
foam'. Keats' Ode is in turn obviously connected with the passage from 'Rosa-
lind and Helen' quoted above, n. 2, p. 208.

[2] Cp. Oscar Wilde, in *The Decay of Lying* (with an eye on Maeterlinck):
'Over our heads will float the Blue Bird singing of beautiful and impossible
things, of things that are lovely and that never happen, of things that are not and
that should be.' In *An Epic of Women* (*cit.*) W. E. O'Shaughnessy printed an
'Invocation to an Ivory Bird'. A corrective to the over-emphasis that recent
criticism has put on the aestheticism of the conception of the artificial bird is
provided by H. M. Campbell, 'Yeats's Sailing to Byzantium', *MLN*, LXX,
Dec. 1955, 585–9, which maintains that the 'bird' is to be seen as a primarily
religious symbol of the supernatural.

bird's song, but that the bird is artificial, an artefact. It is a work of plastic art which scorns 'aloud / In glory of changeless metal / Common bird or petal / And all complexities of mire or blood.'

In a letter of 4 October 1930 Yeats told Sturge Moore that he was led to write the second Byzantium poem to emphasize that the artificial bird was at the furthest remove from any natural thing:

> The poem originates from a criticism of yours. You objected to the last verse of 'Sailing to Byzantium' because a bird made by a goldsmith was just as natural as anything else. That showed me that the idea needed exposition . . .
>
> (*W.B.Y. & T.S.M.*, 164)

This defence of art against nature is very close to a passage in Plotinus' *V Ennead* in the section 'On the Intellectual Beauty'. Yeats was unquestionably familiar with Plotinus, which I am quoting in Mackenna's translation that he praised so highly:

> Still the arts are not to be slighted on the ground that they create by imitation of *natural* objects; for, to begin with, these *natural* objects are themselves imitations; then, we must recognize that they give no bare reproduction of the thing seen but go back to the Ideas from which Nature itself derived, and, furthermore, that much of their work is all their own; they are holders of beauty and add where nature is lacking. Thus Pheidias wrought the Zeus upon no model among *things of sense* but by apprehending what *form* Zeus must *take* if he chose to become manifest to sight.[1]

The verbal similarities are striking ('Once out of nature I shall never *take* / My bodily *form* from any *natural thing*') in view of the fact that this translation was published in 1926 at a time when Yeats was working at his poem. One feels that this section of the *V Ennead*, with its Shelleyan title, must especially

---

[1] Plotinus, *cit.*, IV, 74; italics mine. As far as I know, no one has drawn attention to this passage, though the Plotinian influence on Yeats has been exhaustively examined especially by Mr. F. A. C. Wilson.

have appealed to him. It is not surprising, then, that in poems celebrating the intellectual beauty of art as opposed to nature, the main images should have been derived from works of the visual arts. This is most clearly traceable in the images of the dome and the dolphin which, present in the first draft of 'Sailing', disappeared from the final version to re-emerge in the later poem, 'Byzantium'.

The symbolic significance of the dolphin was undoubtedly derived from Mrs. Strong's book *Apotheosis and After Life* where she referred to the ancient belief that dolphins were 'a mystic escort of the dead to the Islands of the Blest'.[1] But over and above Mrs. Strong there are two notes by the poet himself indicating that he had been particularly struck by sculptures representing human figures riding dolphins. First, as Mr. Ellmann tells us, Yeats, in an unpublished note to *A Vision*, mentioned 'a cast at the Victoria and Albert Museum which helped me to shape the image'.[2] The second reference is in a letter addressed by Yeats to Sturge Moore in October 1930, at the time Yeats was planning to call his next book of poems *Byzantium*. Moore was to design the cover containing the main symbols of the poem, and he enquired of Yeats: 'Is your dolphin to be so large that the whole of humanity can ride on its back?' Yeats replied 'One dolphin, one man. Do you know

[1] Mrs. Arthur Strong (Eugenie Sellers), *Apotheosis and After Life*, London, Constable, 1915, 215. The Reading University Exhibition Catalogue (*cit.*, 29) suggests as 'a more likely source' of the image A. De Gubernatis' *Zoological Mythology*, but in De Gubernatis there is only a passing hint; in Mrs. Strong's book instead the connection of dolphins with the after life is dealt with at some length in pages containing other references present in Yeats's mind at the time of writing 'Sailing'. Mrs. Strong mentions the use of cocks in sepulchral decorations (cp. Yeats's 'cock of Hades', an acknowledged source of the bird in 'Byzantium') and describes a monument at Trèves where the transit of the soul to the kingdom of death is represented by a boat 'manned by six lusty oarsmen' — compare Yeats's 'pleasant dark-skinned mariners' who carry him 'towards the great Byzantium, singing at the oars' in the early draft of 'Sailing' already referred to.

[2] R. Ellmann, *The Identity, etc.*, *cit.*, 284.

Raphael's statue of the Dolphin carrying one of the Holy Innocents to Heaven?'[1] It is understandable that Moore did not answer this question, for though there are plenty of classical and Renaissance groups of statuary representing children riding on dolphins to be found in galleries, no art historian attributed any of them to the Italian painter. (Shakespeare's confusion over Giulio Romano is somewhat similar.) There are dolphins drawing Galathea's sea-chariot in Raphael's fresco of the myth of Galathea at the Farnesina in Rome. To this Yeats seems to be referring in the early poem 'The Realists':

> Paintings of the dolphin-drawn
> Sea-nymphs in their pearly wagons
> (*C.P.*, 135)

And there are small representations in the fresco medallions of children and infant loves riding dolphins, in the grotesque decorations of Raphael's Loggia in the Vatican. These grotesques, however, were mainly the work of Giovanni da Udine.[2] I do not know what Yeats meant by Raphael's statue: what matters is that the image of the dolphin presented itself to his imagination as a piece of sculpture. And I want to suggest a third sculptured group which he had most probably seen and by which he must have been impressed: it is *Solglitter* (Sun sparkle), by the Swedish sculptor Carl Milles, and represents a naiad happily riding a dolphin. The buoyant vitality of the group—which was in Stockholm when Yeats was there at the end of 1923 to collect his Nobel prize—would have appealed to the poet. Certainly he was so taken with the works

---

[1] *W.B.Y. & T.S.M.*, 164–5.

[2] Mr. Henn has been of two minds about the visual origin of the dolphin: in *The Lonely Tower, cit.*, 235, he suggests a Roman mosaic in Ostia and refers in a note to the mysterious cast in the V. & A., to emblem books, and a picture in the Ashmolean Museum (this, I find, was acquired by the Museum after Yeats's time); in an essay of 1956 (*ESEA, cit.*, 66–7) he inclines to Titian's *Rape of Europa* in Boston.

of Milles which, as Hone tells us,[1] he had greatly admired in Stockholm, that three years later, when Yeats became chairman of the Advisory Committee for the new Irish coinage, he immediately recommended Milles and supported his designs.

Many of Milles' sculptures use the same symbols as Yeats's poems. For instance, the figure of the Archer in the Djurgarden, Stockholm (1919) and the Poseidon Fountain at Gothenburg, done in 1927–30 (the same years as the Byzantium poems) where there are human figures riding dolphins and unicorns in high relief along the basin.[2] A very successful exhibition of Milles' work was held in the winter 1926–7 at the Tate Gallery, and Milles is mentioned by Yeats in *A Vision* (1925).[3] *Sol-glitter* may well have helped to rouse his enthusiasm for Milles, and may have contributed later to the imagery of 'Byzantium'. Swedish art had made a great impression on Yeats during his 1923 visit to Stockholm, when he was in a peculiarly receptive state of mind. I suspect, strange though it may seem, that this visit served to centre his attention on Byzantium.

Before that date Byzantium had hardly ever been mentioned in Yeats's published work, and was far from being his ideal country of the mind. In the early 'twenties he was still saying, as appears in *The Trembling of the Veil*, that unity of being, supreme harmony, had been reached by the builders of the Gothic cathedrals, an idea obviously borrowed from Blake.[4] Byzantine art had been referred to only once, in a story written in the 'nineties. There was no further mention for nearly thirty years, in spite of his having seen the Ravenna mosaics in 1907, during his first visit to Italy. Suddenly, in early 1923, Byzantine thought is praised in the allusive poem 'The Gift to Harun Al-Rashid'—and shortly afterwards we find the enthusiastic section on Byzantium in *A Vision*, which is dated from Capri, February 1925: 'If I could be given a month of Antiquity and

---

[1] J. M. Hone, *op. cit.*, 385.

[2] See e.g., R. Rogers Meyric, *Carl Milles, An Interpretation of his Work,* New Haven, Yale Univ. Press, 1940.

[3] *Vis. A*, 211.

[4] See *Aut.*, 191.

leave to spend it where I chose, I would spend it in Byzantium.'
Was it the sight of the Byzantine mosaics in Sicily and Rome
in the winter of 1924-5 that had fired his imagination? It
rather appears that he went to see them because his mind had
already been captivated by the Byzantine myth. This was
obviously due to his historical reading at the time, to the
descriptions of Byzantine splendour in the books of Dalton and
Holmes, in Gibbon's *Decline and Fall*, and in the Cambridge
Mediaeval History,[1] joined to the reminiscence of the Byzantine
revival promoted by the asethetes of the 'nineties. But those
pages came alive to his physical as well as his mental eye only
through a later experience, through something he saw when he
went to collect his Nobel Prize: the new Town Hall of
Stockholm, completed only a few months before.

In *The Bounty of Sweden*, written upon his return from
Sweden as a 'bread and butter letter' to Stockholm,[2] he speaks
of the Stadshus as 'the greatest work of Swedish art',[3] and goes
on:

... this new magnificence, its narrow windows opening out
upon a formal garden, its tall tower rising from the quayside,
has taken ten years [to build]. It, too, has been an organizing
centre, but for an art more imaginative and amazing ... All
that has not come out of the necessities of site and material, no
matter in what school the artist studied, carries the mind back-
ward to Byzantium.

(*Aut.,* 554)

The decoration of the Stadshus, however, for all its stylized
mosaics, is in the *art nouveau* manner rather than in the Byzantine[4]

[1] Jeffares, 'The Byzantine Poems etc.', *cit.*; Gibbon and the Cambridge His-
tory were bought with the money of the Nobel Prize in early 1924 (*L.,* 701-2).

[2] See letters of 13 Jan. and 28 Jan. 1924 (*L.,* 701-3). Published first in Sept.
1924 in the *London Mercury*, the essay was printed the next year as a separate
volume by the Cuala Press.

[3] In 1926 Yeats entertained Ragnar Östberg, the 'great Swedish architect' of
the Stadshus, in his house in Dublin (*L.,* 719-20).

[4] See M. Wernstedt, 'The Stockholm City Hall', *The Studio*, XC, 1925,
203 ff.

—which is probably what attracted Yeats in the first place. His taste in the arts never went beyond the Pre-Raphaelites and the Decadents. The re-evaluation of Byzantine art had been due, after all, to the aesthetes of the Beardsley period. From the point of view of art criticism, Yeats's preferences in painting, sculpture and decoration are highly questionable; but what matters to us is the identification of the figurative works from which he drew his inspiration, whether Raphael or Gustave Moreau, Ravenna or Stockholm.

The idea of the re-creation of the art of the past, especially of a stylized art like the Byzantine, in a new form 'where all suggests history and yet is full of invention' was attractive to Yeats. In 1927 for the new edition of *Red Hanrahan* prefaced by 'Sailing to Byzantium' he commissioned Miss Norah McGuinness to produce 'archaic illustrations', writing to Lady Gregory:

I lent the artist a lot of Byzantine mosaic photographs and photographs of old Irish crucifixes and asked her to re-create such an art as might have been familiar to the first makers of the tales. The result is I think amusing and vivid.

(*L.*, 738)

It is neither, but what charmed Yeats seems to have been, as always, the ideas lying behind and exemplified in the figurative illustrations. We find the same preoccupation with ideas (whether those of the original architect and designers or those he himself read into it, is difficult to say) in his description of the Stadshus:

The Town Hall of Stockholm . . . is decorated by many artists working in harmony with one another and with the design of the building as a whole, and yet all in seeming perfect freedom . . . These myth-makers and mask-makers worked as if they belonged to one family, and the great walls where the roughened surface of the bricks, their carefully varied size and tint, takes away all sense of mechanical finish; the mosaic-covered walls of the Golden Room; the paintings hung upon

the walls of the committee rooms; the fresco paintings upon the greater surfaces with their subjects from Swedish mythology; the wrought iron and the furniture, where all suggests history and yet is full of invention; the statuary in marble and in bronze, now mythological in subject, now representations of great Swedes, modelled naked as if they had come down from some Roman heaven; all that suggestion of novelty and of an immeasurable past; all that multitude and unity, could hardly have been possible, had not love of Stockholm and belief in its future so filled men of different minds, classes and occupations, that they almost attained the supreme miracle, the dream that has haunted all religions, and loved one another.

*(Aut.,* 555-6)

This can be compared with what Yeats, less than a year *later*,[1] wrote in *A Vision* about Byzantium:

I think that in early Byzantium, and maybe never before or since in recorded history, religious, aesthetic and practical life were one, and that architects and artificers . . . spoke to the multitude and the few alike. The painter and the mosaic worker, the worker in gold and silver, the illuminator of

---

[1] This section of *A Vision* is dated Capri, February 1925. It might be argued that Yeats had been gathering material for it over a long period, so that the passage I am quoting could conceivably have been written earlier, could even have pre-dated *The Bounty of Sweden*. Yet that the parallel he drew between the Stadshus and Byzantium was more than a mere act of courtesy, a fanciful compliment to his ex-hosts, is borne out by Monk Gibbon's account of his first meeting with Yeats, which took place in the house at Merrion Square in December 1923, immediately after Yeats's return from his Nobel Prize visit to Stockholm: 'Yeats was full of the architectural beauties of Stockholm. He showed me a book of photographs that he had brought home and expatiated at some length on the dignity and fine proportions of the Town Hall' (M. Gibbon, *The Masterpiece and the Man: Yeats as I knew him,* London, Hart-Davis, 1959, 47). This recently published recollection seems to me a further confirmation of the evidence of Yeats's own writings: he did feel strongly about the Stadshus, and he was more directly moved and excited by Stockholm than he had originally been by either the sight of the Ravenna mosaics or those descriptions of Byzantium—the literary sources of the passage quoted in *A Vision* and of the Byzantium poems—that he had probably already read at this date.

Sacred Books were almost impersonal, almost perhaps without the consciousness of individual design, absorbed in their subject matter and that the vision of a whole people. They could copy out of old Gospel books those pictures that seemed as sacred as the text, and yet weave all into a vast design, the work of many that seemed the work of one, that made building, picture, pattern, metal work of rail and lamp, seem but a single image.

(*Vis. A*, 190–1; *Vis. B*, 279–80)

The similarity between the two descriptions, and still more between the conceptions implied in them, seems to confirm that it was in Stockholm that Yeats had first the intuition of what Byzantium could stand for: an ideal state, a condition of miraculous harmony manifested through art.

I wish here to look back at Yeats's one mention of Byzantine art in the 'nineties—at a time when the European decadents were fascinated by Byzantium, an age with many points in common with their own, the decadence of the greatest empire of antiquity. It occurs in the story 'Rosa Alchemica', which describes in a style obviously modelled on Pater (in *The Trembling of the Veil* Yeats wrote: 'Villiers de l'Isle Adam had shaped whatever in my "Rosa Alchemica" Pater had not shaped')[1] the occult rituals of an esoteric sect, such as the Golden Dawn, to which he himself belonged. The story appeared in *The Savoy* for April 1896 and was frequently reprinted with slight revisions—enough to prove that Yeats had many occasions to see it again, and to keep it alive in his imagination. This story has been overlooked for too long, as it is of the greatest importance to an understanding of the Byzantium poems.

Its central idea is, in Yeats's words, that:[2]

. . . the alchemists' doctrine was no merely chemical phantasy, but a philosophy they applied to the world, to the elements,

[1] *Aut.*, 320–1.

[2] All my quotations of 'Rosa Alchemica' are from *The Savoy*, 2, April 1896.

IX(*a*). Michelangelo: *Night* (see p. 161).

IX(*b*). Cornelius Bos: *Leda*, print after Michelangelo (see p. 162).

X(b). Michelangelo: Detail of *Night*, see Pl. IX(a).

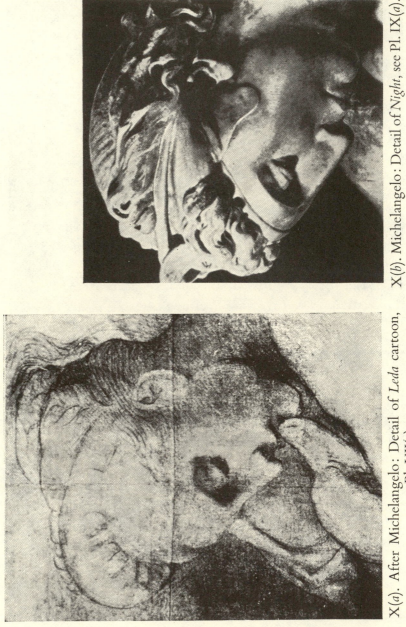

X(a). After Michelangelo: Detail of *Leda* cartoon, see Pl. VII(a).

XI. Stockholm Stadshus: the Golden Chamber, facing South. Designed by Einar Forseth (see p. 216).

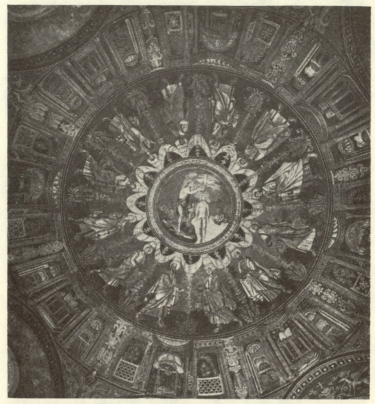

XII(*a*). Ravenna, Battistero degli Ortodossi: Mosaics in the dome

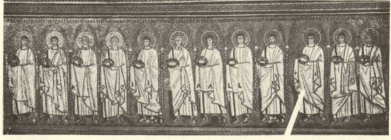

XII(*b*). Ravenna, S. Apollinare Nuovo: deta˙. of mosaic frieze on side wall
(see p. 221).

and to man himself; and that they sought to fashion gold out of common metals merely as part of a universal transmutation of all things into some divine and imperishable substance . . . the transmutation of the weary heart into a weariless spirit.

Also the Byzantium poems deal with the transition from the sensuous world to the world of the spirit, from nature to the golden bird:

> Miracle, bird or golden handiwork,
> More miracle than bird or handiwork,
> Planted on the star-lit golden bough,
> Can . . .
>
>     . . . scorn aloud
> In glory of changeless metal
> Common bird or petal
> And all complexities of mire or blood.
>
>             (*C.P.*, 280–1)

The alchemical gold, representing a divine and imperishable substance, or rather spirit as opposed to nature, reappears in the poems in the shape of the golden bird wrought by the smithies of the emperor. As a work of art, it represents another aspect of the alchemical transformation of which Yeats speaks in his early story: the transformation of life into art.

In the same way, God's holy fire which enshrines the 'sages' in 'Sailing to Byzantium' is a reflection of the fire of the alchemists of which Yeats speaks in 'Rosa Alchemica':

I repeated to myself the ninth key of Basilius Valentinus[1] in

---

[1] Perhaps Yeats had in mind the *Seventh* Key in Basilius Valentine's *The Golden Tract*, included in *The Hermetic Museum* (*cit.*, II, 339) where there is the following passage prophesying the Millennium: '. . . we shall be sons and heirs of God, and shall be able to do that which now seems impossible. But this can be effected only by the drying up of all water, and the purging of heaven and earth and all men with fire.' This may have fused with the following passage from the Ninth Key (*op. cit.*, 345–6) to suggest Yeats's reference: 'For the present state of things is passing away, and a new world is about to be created, and one Planet is devouring another spiritually, until only the strongest survive.'

which he compares the fire of the last day to the fire of an alchemist, and the world to an alchemist's furnace, and would have us know that all must be dissolved before the divine substance, material gold or immaterial ecstasy, awake. . . . As I thought of these things I drew aside the curtains and looked out into the darkness, and it seemed to my troubled fancy that all those little points of light filling the sky were the furnaces of innumerable divine alchemists, who labour continually, turning lead into gold, weariness into ecstasy, bodies into souls, the darkness into God; and at their perfect labour my mortality grew heavy, and I cried out, as so many dreamers and men of letters in our age have cried, for the birth of that elaborate spiritual beauty which could alone uplift souls weighted with so many dreams.

The Byzantium poems are the fulfilment of Yeats's dream. Byzantium is the materialization of that elaborate spiritual beauty Yeats was looking for.

The fire imagery (reminiscent of the alchemical fire) is prominent in both poems. To the holy fire of the first corresponds the mysterious fourth stanza of the second:

> At midnight on the Emperor's pavement flit
> Flames that no faggot feeds, nor steel has lit,
> Nor storm disturbs, flames begotten of flame,
> Where blood-begotten spirits come
> And all complexities of fury leave,
> Dying into a dance,
> An agony of trance,
> An agony of flame that cannot singe a sleeve.
>
> (*C.P.*, 281)

Whence do these flame-like figures come—figures of blood-begotten (that is nature-bound) spirits, who are purified through a dance? With these lines in mind it is interesting to turn to the description of the initiation into the esoteric order of the Alchemical Rose. The narrator is led through a passage decorated with impressive figures in mosaic, into

. . . a great circular room, and among men and women who were dancing slowly in crimson robes. Upon the ceiling was an immense rose, wrought in mosaic . . . The dance wound in and out, tracing upon the floor the shapes of petals that copied the petals in the rose overhead . . . and every moment the dance was more passionate . . . I stood under a pillar watching the coming and going of those *flame-like* figures, until gradually I sank into a half-dream.

This dance, like that of the blood-begotten spirits in 'Byzantium', ends in a trance. The fourth stanza of 'Byzantium', therefore, is reminiscent of the ritual dance in 'Rosa Alchemica'.

But there is more in the early story which went into the later poems. There is the *one* reference to the Byzantine mosaics. On his way to the circular room, the narrator of the story finds himself

. . . in a marvellous passage, along whose sides were many divinities wrought in a mosaic not less beautiful than the mosaic in the Baptistry at Ravenna, but of a less severe beauty.

The reference is precise: not to *any* mosaic of Ravenna, but to that of the Baptistry, the *Battistero degli Ortodossi*. Yeats in 1896 had not seen the actual building: he must have seen some illustration. This mosaic is not a procession of martyrs like that on the wall of *Sant'Apollinare Nuovo*, which is commonly thought to be what Yeats had in mind; it is instead inside the cupola, and the figures represented in it are those of the twelve Apostles. They stand on a golden background, in processional attitude, in the concavity of the dome. Arthur Symons has described this dome in the following words:

I remember . . . the lapis lazuli which makes a sky in the dome of the Baptistery, against which the twelve Apostles walk in gold and white robes with jewelled crowns in their hands, and the green grass, on which a shadow turns and darkens with their feet, as the circle goes round with the sun.[1]

This description in Symons' essay 'Ravenna' sounds a very

[1] A. Symons, *Cities of Italy*, London, Dent, 1907, 182.

likely source for Yeats, and is cited as such in the Reading catalogue, but it is dated Winter 1903, and appeared in the volume *Cities of Italy* in 1907, eleven years after Yeats had found the aesthetic suggestiveness of the Apostles in the dome for himself. Seen from the centre of the Baptistry below, the position from which photographs of the mosaic are generally taken (Yeats at the time had not seen the original), the inside of the cupola looks like a gigantic rose, of which the figures of the Apostles are the petals. So in 'Rosa Alchemica' the petals of the mosaic rose in the ceiling of the circular room float down to the floor, shapening into beautiful divine figures who join the dance:

[I saw] the petals of the great rose . . . falling slowly through the incense heavy air, and as they fell shapening into the likeness of living beings of an extraordinary beauty. Still faint and cloud-like, they began to dance, and as they danced took a more and more definite shape, so that I was able to distinguish beautiful Grecian faces and august Egyptian faces.

It was the mosaic in a dome, not that on a wall, that had struck Yeats in the first place. In the early draft of 'Sailing to Byzantium' he had written:

But now these pleasant dark-skinned mariners
Carry me towards the great Byzantium
Where all is ancient, singing at the oars
That I may look in that great church's dome
On gold-embedded saints and emperors.[1]

Here again the mosaics are in the dome. The dome he had in mind must have been the famous one of St. Sophia in Byzantium, of which he had read so much during his study, in the early 'twenties, of Byzantine history, and to which he refers in *A Vision*:

A building like St. Sophia where all, to judge by the contemporary description, pictured ecstasy.

(*Vis. A*, 193; *Vis. B*, 282)

[1] Quoted in A. N. Jeffares, 'The Byzantine Poems, etc.', *cit.*

The very name of the church must have appealed to him, especially if he remembered the strange equation made by Madame Blavatsky, who wrote that Simon Magus 'took about with him a woman whom he introduced as Helen of Troy who had passed through a hundred reincarnations, and who, still earlier, in the beginning of the aeons, was Sophia, Divine Wisdom'.[1]

The mosaics in the dome of St. Sophia 'named with so untheological a grace "The Holy Wisdom"' had, however, disappeared, removed or covered over by the Moslems. Yeats therefore, in a kind of mental double-exposure, had transferred into the dome of Santa Sophia those Byzantine mosaics of the Baptistry of Ravenna which had caught his imagination when he saw a reproduction of them in the early 'nineties. Only later on, when working over the same verse, he recollected other mosaics he had seen in Ravenna, perhaps S. Apollinare, and the lines became:

> O sages standing in God's holy fire
> As in the gold mosaic of a wall,
> Come from the holy fire, perne in a gyre . . .
> (*C.P.*, 217)

The sages, vague hieratical figures descending with a winding circular movement from a mosaic background, cannot help reminding us of those mysterious divinities coming down from the mosaic in the ceiling of the circular room in 'Rosa Alchemica'.

Yeats referred to the mysterious figures with which the Ravenna mosaics had inspired him as 'divinities' or 'gold-embedded saints and emperors', or finally 'sages'. He had seen them in the concavity of a dome. But at other times, in his peculiar moments of vision, he saw them in the concavity of the sky itself. (Symons had spoken of 'the lapis lazuli which makes

---

[1] H. P. Blavatsky, *op. cit.*, III, 113.

a sky in the Dome' of the Ravenna Baptistry. They appear in the poem 'The Magi' written in 1913:

> Now as at all times I can see in the mind's eye,
> In their stiff, painted clothes, the pale unsatisfied ones
> Appear and disappear in the blue depth of the sky
> With all their ancient faces like rain-beaten stones[1]
> 
> (*C.P.*, 141)

A note he appended to the poem says:

> I looked up one day into the blue of the sky, and suddenly imagined, as if lost in the blue of the sky, stiff figures in procession. I remembered that they were the habitual image suggested by blue sky.
> 
> (*C.P.*, 531)

The visionary procession in the sky and the procession of saints and emperors in the mosaics of the dome are obviously connected. That is why Yeats could write in *A Vision*:

> Could any visionary in [the days of Byzantium] passing through the church named with so untheological a grace 'The Holy Wisdom' [i.e. Hagia Sophia, Saint Sophia in Constantinople], can even a visionary of today wandering among the mosaics of Rome and Sicily, fail to recognize some one image seen under his closed eyelids?
> 
> (*Vis. A*, 191; *Vis. B*, 280)

It is not surprising to find that in the second Byzantium poem the dome referred to is a metaphor for the sky—the heavens inhabited by the Magi, the Saints or the Sages.

---

[1] The connections between this poem and both the earlier 'Rosa Alchemica' and the later 'Byzantium' do not end here. 'The Magi' closes with the memorable line referring to a supernatural birth (which Yeats quoted also in a crucial point of *A Vision*): 'The uncontrollable mystery on the bestial floor.' In 'Rosa Alchemica' the floor under the dancers is of green stone with 'a pale Christ on a pale cross wrought in the midst'; finally in 'Byzantium' there are 'marbles of the dancing floor' after an allusion to 'the Emperor's pavement'. Actually the 'pavement' (terrace) of the Imperial palace of Byzantium is not of marble, but wrought in coloured mosaic.

Yeats's road to Byzantium seems to have been the following: he was struck at first, in the 'nineties, by a reproduction of the mosaic in the dome of the Ravenna Baptistry. A part of the imagery of his esoteric tale 'Rosa Alchemica' sprang from it. He then seemed to lay this image aside, in spite of seeing the Ravenna mosaics themselves for the first time in 1907. But in 1923 the sight of the Stockholm Stadshus, with its decoration deliberately reminiscent of Byzantine art, evoked once again the memory of the splendour of that art and of that civilization, about which he had already been reading. This fused with the conception of an ideal state, where perfect beauty expressed in the arts corresponded to a perfect condition of life—natural and supernatural. The idea was developed in *A Vision*. It was then that Byzantium, about which he had read so much in the meantime, took possession of his imagination and established itself as one of his main symbols. And from it the poetry of 'Sailing to Byzantium' and 'Byzantium' was born.

The merely visual suggestion preceded the conceptual elaboration. Yeats is not the only poet whose imagination was nourished on what he saw as well as on what he heard and felt. In the last fifty years or so literary criticism has stressed more and more the fact that imagery is an essential element of poetic expression. The very word image has a visual implication. And images are not decorations superimposed on a pre-existing conceptual structure; in many cases they are the original sparks from which a poem is born.

The principle according to which an image, a shape or a visual suggestion precedes thought and the development of ideas has been convincingly expounded in Sir Herbert Read's lectures *Icon and Idea*. Read found a confirmation of it in the history of the development of the dome through the ages, as traced by Professor Baldwin Smith. He concludes:

As always, the further development of the primitive domical roof would have been dialectical—first the shape, then the idea, then the extension or elaboration of the shape to accommodate

the imaginative growth of the idea. As the shape developed (for constructive reasons) so symbolic values accrued to it. The dome acquired its cosmical significance: it became the very vault of Heaven, inhabited by Christ and his saints.[1]

The dome of the Ravenna Baptistry is an example of this last development. Yeats was struck in the first place by the dome in its most elaborate form, the dome with gold embedded saints and emperors. Later, in 'Byzantium' he returns to the more primitive idea of the dome as the sky:

A starlit or a moonlit dome
(C.P., 280)

He had gone back to the archetypal pattern of the dome which had been so prominent especially in romantic poetry. Miss Maud Bodkin has explored its significance from an essentially psychological point of view, along Jungian lines.[2] Yeats was unconscious of these overtones of the dome image, but was fully aware of its importance in the poetry of Coleridge and Shelley. 'Kubla Khan' is the highest and most open expression of a certain symbolic cluster which became nearly obsessive in the poems of the second romantic generation: the dome, the caves and the water. This cluster recurs in the poems of Shelley and Keats and its ascendency and influence has been examined by Wilson Knight who traces it back into Pope and Milton, and forward through Tennyson and Browning to Yeats.[3] But Yeats in his early work, in spite of his avowed admiration for Shelley and of the obvious echoes from 'Kubla Khan' in his poems, was fascinated by other symbols more closely related to his esoteric studies. In Shelley he preferred to see the poet-magician in his solitary tower, but eventually he realized that the poetry

[1] H. Read, *Icon and Idea: The Function of Art in the Development of Human Consciousness*, London, Faber, 1955, 67.

[2] M. Bodkin, *Archetypal Patterns, etc., cit.*

[3] G. Wilson Knight, *The Starlit Dome: Studies in the Poetry of Vision*, O.U.P., 1941.

of symbolism, the only poetry he valued, was the poetry of 'Kubla Khan'.[1] Yeats distinguished two main streams in poetry: on the one side he put Goethe, Wordsworth and Browning with whom 'poetry gave up the right to consider all things in the world as a dictionary of types and symbols and began to call itself a critic of life.[2] On the other there was the poetry that searched for perfection of thought and feeling united to perfection of form. In Spenser's description of the islands of Phaedria and of Acrasia

. . . certain qualities of beauty, certain forms of sensuous loveliness were separated from all the general purposes of life, as they had not been hitherto in European literature—and would not be again, for even the historical process has its ebb and flow, till Keats wrote his *Endymion*. I think that the movement of our thought has more and more so separated certain images and regions of the mind, and that these images grow in beauty as they grow in sterility. Shakespeare leaned, as it were, even as craftsman, upon the general fate of men and nations, had about him the excitement of the playhouse; and all poets, including Spenser in all but a few pages, until our age came, and when it came almost all, have had some propaganda or traditional doctrine to give companionship with their fellows. Had not Matthew Arnold his faith in what he described as the best thought of his generation, Browning his psychological curiosity, Tennyson, as before him Shelley and Wordsworth, moral values that were not aesthetic values? But Coleridge of the 'Ancient Mariner', and 'Kubla Khan', and Rossetti in all his writings, made what Arnold has called that 'morbid effort', that search for 'perfection of thought and feeling, and to unite this to perfection of form', sought this new, pure beauty, and suffered in their lives because of it.

(*Aut.*, 313)

The choice of authors and works is significant; the enchanted

---

[1] Imagery derived from Coleridge is particularly noticeable in the poem 'The Wanderings of Oisin', and not so much in its first version published in 1889, as in the form it acquired since its inclusion in the 1895 volume of *Poems*.

[2] 'The Autumn of the Body', *I.G. & E.*, 302.

islands of Spenser must have reminded Yeats of the enchanted islands of his own imagination and of Irish folklore where Oisin stopped in his wanderings. These islands were not only symbolic countries of the mind, they were also places of romantic escape like the Lake Isle of Innisfree.

The idea of taking refuge in a mythical land outside the world, where everything is beauty and harmony, recurs throughout Yeats's early work, whether prose or poetry. He had felt the fascination of T'yeer-na-n-Og, or Tir-na-n-Og, the country of the young or the land of eternal dancing in Irish folklore, which Oisin reached on his white horse; and he had included in the book he edited in 1893, *Irish Fairy and Folk Tales*, several descriptions of this country. One of them is a passage on 'The Phantom Isle' by the twelfth century writer Giraldus Cambrensis.[1] Yeats's whole poetical life was a pursuit of that phantom isle, and even when that mythical

---

[1] More than thirty years later, Yeats attributed to 'Giraldus' the authorship of the imaginary treatise *Speculum Angelorum et Hominum* on which he pretended to have based *A Vision*; he even commissioned Edmund Dulac to make an etching of Giraldus in the dress of an ancient sage, but with Yeats's own features. It has perhaps been too hastily assumed that the poet was in this way paying tribute to the earliest chronicler of Tir-na-n-Og. In *St. of M.R.* (1931) and in *Vis. B*, p. 40, he makes Michael Robartes say: 'I had made a fruitless attempt to identify my Giraldus with Giraldus of Bologna.' (This sentence is not to be found in *Vis. A.*) Yeats shows in this way that he had a knowledge of the works of the Italian humanist Giglio Gregorio Giraldi (latinized Giraldus or Gyraldus), 1479-1552. This Giraldus of Bologna was the author of *Historia deorum gentilium*, which was the fullest Renaissance exposition of classical mythology, reinterpreted along Neo-Platonic lines, a type of interpretation Yeats himself adopted, notably in his treatment of the Leda myth. Another point is that while Giraldus Cambrensis is a twelfth-century figure, Giraldus of Bologna lived in the sixteenth century, and Yeats gives 1594 as the date of publication of the *Speculum Angelorum et Hominum* of *his* Giraldus. This date, incidentally, is only two years removed from that of the actual publication of the English translation of the *Hypnerotomachia*, which Yeats had copied by hand; it is interesting to see by the description Yeats gives of the imaginary book by Giraldus, with its quaint symbolic engravings, that he was visualizing a book of much the same kind. Probably Yeats adopted the name 'Giraldus' because he met it in two very different contexts, both of which were of relevance to him.

country, detached from its original Irish folk setting, acquired different features in his imagination, the ritual dancing remained, as in 'Byzantium'.

In his very early long story 'Dhoya' Yeats evoked it as a lost paradise:

I have left my world far off. My people—on the floor of the lake they are dancing and singing, and on the islands of the lake; always happy, always young, always without change.

<div align="right">

(*J.Sh.,* 183)

</div>

And in the story 'The Heart of the Spring' an old man announces:

Tomorrow, a little before the close of the first hour after dawn, I shall find the moment, and then I will go away to a southern land and build myself a palace of white marble among orange trees, and gather the brave and the beautiful about me, and enter into the eternal kingdom of my youth.

<div align="right">

(*S.R.,* 86)

</div>

The next morning the old man was found dead. The land of eternity is found only through death. The same search for the eternal, the same need for an escape into serenity inspires the Byzantium poems. But Yeats's thought had matured in the meantime and the country beyond death is no longer represented as eternal youth or the dance of young lovers. In the Byzantium poems the dance is a purifying rite performed by spirits and youth is rejected, even if with regret. Eternity is art: Byzantium is the kingdom of art. With the passing of the years Yeats had abandoned the hazy escapism into vague imaginary worlds typical of the Irish twilight writers and had found that the ultimate reality was art. Also Coleridge in 'Kubla Khan', Keats in 'Endymion', and Shelley in a number of poems, had described imaginary exotic landscapes which were not mere opium dreams, but were the mental representations of the final aim of their life-long search, a search for beauty and art. The country of the mind, the country of art, was expressed by the three romantic poets through the same images. In all of them

it assumed an architectural consistency, culminating in the dome, which, with its roundness, its solidity, its imposing majesty, was a visual symbol of perfection of form.

Yeats recognized this achievement of the romantic poets: hence his praise for poems like 'Kubla Khan' and 'Endymion'. It is no coincidence that *his* city of art, Byzantium, should be dominated by the same crowning image: the dome. Yeats had reached it through a different, perhaps through a devious road —a road that runs through the wild and irregular landscape of thought of *A Vision*—but the final destination was the same and therefore it was expressed with the same images.

Also Shelley, a poet whom Yeats had always felt to be congenial, had been prompted to use the image of the dome by apparently unconscious suggestions. Mr. Neville Rogers's examination of Shelley's notebooks, with their curious sketches and doodles,[1] is revealing on this point: it suggests that Shelley's images—and the dome is prominent among them—presented themselves to his mind with imperious visual evidence. This is a further token of affinity between Shelley and Yeats. Their approach to the creative process of poetry was similar, and this may explain why, apart from the 'dome of many coloured glass' in *Adonais*, other passages in his work seem to prelude the Byzantium imagery.[2] The basic fact, however, is that the dome is an immemorial image which acquired in human consciousness through the centuries an extraordinary number of associations, some of which are closely connected with Yeats's interests and beliefs. Professor Baldwin Smith's book is very illuminating on the subject; I shall quote the paragraphs dealing with the dome as a figuration of an idea with which Yeats was familiar—that of the cosmic egg:

Since a conoid shape is also ovoid, it follows that the East

[1] N. Rogers, *Shelley at Work: A Critical Inquiry*, O.U.P., 1956; see especially pp. 105–20.

[2] One such passage from 'Epipsychidion' is pointed out by the reviewer of Mr. Rogers's book in *TLS*, 23 Nov. 1956, 696.

Christian's mystical interest in a gilded conoid dome as a celestial form must have been directly influenced by the pagan ideas of a cosmic egg, which not only figured so prominently in the early religions of India, Egypt, Persia and Greece, but by Roman times were essential to the heavenly symbolism of the two cults that had the greatest influence upon Christian imagery. Although the actual origins of the beliefs regarding a primordial egg and a god in the egg have little bearing upon the formation of domical ideology, it is to be noted that an egg-shaped baetyl in its rustic shrine upon an engraved gem from Minoan Crete suggests the very early importance of such concepts in the West and recalls the sacred stones of Syria. The appeal to the Christians of the ovoid shape and of the earlier beliefs in a golden egg came long after these beliefs had been combined with the mortuary cult of the Dioskouri, as dispensers of immortality, and had been taken over into the cosmogony of the popular Orphic cult which was preoccupied with the afterlife.

In the Orphic theogony the conception of the universe as the upper and lower halves of a vast egg, which were heaven and earth, recalls the Vedic beliefs of India which visualized the Divine One as residing in a primordial egg split into two parts, the lower, silver half being the earth and the upper, golden half resembling the gilded domes of Buddhistic and Christian sanctuaries, being the heavens. At the same time that this conception of a golden half egg was so prevalent in the late antique period, the egg itself was an emblem of resurrection and the belief in the universe as two halves of an egg had been taken over into the Cult of the Dioskouri, where the ovoid shape, as symbolizing heaven and earth, was identified with their helmet-like piloi.[1]

Professor Baldwin Smith mentions also the poem in praise of

---

[1] E. Baldwin Smith, *The Dome: A Study in the History of Ideas*, Princeton Univ. Press, 1950, 77. The book is indispensable to the study of the dome image: it gives a historical foundation to the ideas that Professor Wilson Knight and Miss Maud Bodkin had put forward and furnishes well-documented evidence to prove the dome one of the major archetypes in the imagination of the world.

Hagia Sophia at Constantinople, by Paul the Silentiary, where the dome is called 'the great helmet, which bending over, like the radiant heavens, embraces the church'.[1]

The domical shape is associated with the symbol of the cosmic egg which had become so important for Yeats after the writing of the Leda sonnet. The Leda myth itself is directly related to it and the dome of Santa Sophia which dominates Byzantium is found to be strictly connected with the world egg. Yeats, for all we know, may have never been aware of the connection; but a vague suggestion of it may have remained latent in his mind through a picture he saw before the beginning of this century. At that time, in the early 'nineties, he was a regular contributor to the periodical *The Dome* which was following in the steps of *The Savoy*. The editor in January 1899 invited readers to provide designs for a fantastic building, a memorial college of arts in 'a ruined town at the confluence of two great rivers, flowing for hundreds of miles through tropical deserts'. The three best designs were published and the most impressive of them had as its main feature a gigantic egg-shaped dome, on which the editor commented:

In the design by Mr. H. M. J. Close, the opportunities offered by the site have been recognized and used. If there were not so strong a suggestion of a Tower of Silence, towards which the boats bear corpses, while hungry birds hover above it on impatient wings, and if it provoked a less imperative longing to crack the dome with a colossal egg-spoon, to see if it is hard or soft boiled, the drawing would be as charming as it is striking.[2]

Whatever the impression this illustration had left on Yeats, a mental association between the dome and the cosmic egg must have been created through his familiarity with the work of William Blake. Yeats's Byzantium is the city of art, the equivalent of Blake's Golgonooza. In his interpretation of Blake's works Yeats had discussed at length the meaning of

[1] E. B. Smith, *op. cit.*, 79.    [2] *The Dome*, n.s. II, 3, March 1899, 246.

Golgonooza; he had pointed out that Golgonooza 'is enclosed with the egg of Los, sometimes called the mundane egg, and again the halls of Los', and is the only diagram in Blake's book.[1]

The mundane egg, besides being the egg of Brahma, from which all things were born, is also, according to Yeats, 'the form of that many coloured light which innumerable visionaries had seen encircling the bodies of men'. This corresponds to that light filtered through Shelley's dome of many-coloured glass, which, for Shelley, represented human life. Byzantium having taken the place of Golgonooza in Yeats's poetry, the dominating feature of the city, the dome of Santa Sophia, became the equivalent of Blake's mundane egg which is described elsewhere in Blake's work as blue, representing the outermost sky; and is associated as well with Shelley's dome of many-coloured glass. A further idea was present in Yeats's mind from the time when he wrote his commentary to Blake. In the note on Golgonooza and the mundane egg he had added that the many-coloured light:

. . . is in its relation to the world in general the astral light of post-Paracelsian occultists, and Blake has reflected their teaching that the images of all things are contained within it, and may be read there, whether they be of the future or the past, by the trained seer (see Jerusalem, page 16, line 61, 69, where the past, present and future are said to be sculptured in the halls of Los).

In other words the past, present and future are represented by the bright sculptures, that is to say the eternal symbols of poetry and magic, in the halls of Los (which Yeats identified with the mundane egg). There is a parallel in Yeats's conception of Byzantium: Byzantium is the place where all the future and the past is present, and the poet wishes to live eternally there,

---

[1] This and the following quotations are from a passage of the commentary to *The Works of William Blake* (*cit.*, I, 317) which I quoted in full in the V chapter of the present book; see *supra*, pp. 189–90.

transformed into the golden bird, the image of the seer, singing 'of what is past and passing and to come'.

The dome of Byzantium is like the many-coloured astral light encircling 'all that man is' all that is merely nature and in this way both distains it by projecting on it iridescent supernatural colours, and disdains it in so much as man and nature are mere complexities, 'the fury and the mire': like Byzantium itself it exists beyond nature, 'the images of all things are contained within it, and may be read there, whether they be of the future or the past'.

# VII

## *An Old Man's Eagle Mind*

━━━━━━━━━━━━━━━━━━━━━━━━━━━━━━━━━━━━

THE 'physical' impact of Yeats's later poetry—the feeling of concreteness it communicates in spite of its being based on the thin arbitrary ghosts that populate the phantasmagoria of *A Vision*, reveals Yeats's unique power not as myth-maker but as creative artist. The physical consistency is reached through a process of poetical organization: the 'geometry' of *A Vision* with its questionable patterns of cones, gyres, wheels, triangles etc. becomes a mental scaffolding, external and functional, the architectural understructure of some of Yeats's greatest poems of his last period. The imagination finds a habitation: Yeats erects the dome of Byzantium. And he creates the Hero who can own it and live there. A Hero who is imaginary and mythical (in a way he is imagination itself) but at the same time, in all his different impersonations, is the one full-blooded character to appear in Yeats's work. Oisin, Aengus, Baile and Aillinn, Forgael and Dectora, even Helen of Troy herself, were shadowy figures,[1] still enmeshed in the symbolism of the decadents or in Irish revival mythology: they had a twilight elegance, a noble

---

[1] Helen, however, acquired a crude physical existence in a later poem written in 1926: 'The first of all the tribe lay there / And did such pleasure take— / She who had brought great Hector down / And put all Troy to wreck— / That she cried into this ear, / "Strike me if I shriek."' From 'His Memories', first published in April 1926, *C.P.*, 251.

grace, or at best the grandeur of ritual gestures. Cuchulain too, who was to become one of the most impressive personifications of Yeats's later Hero, appears in the early poems as the ineffectual prisoner of an impersonal legend rather than of a myth. It is a far cry from Cuchulain's 'eyes more mournful than the depth of starry skies' [1] in an early poem to

A man that had six mortal wounds, a man
Violent and famous, strode among the dead;
Eyes stared out of the branches and were gone.

(*C.P.*, 395)

in Yeats's last poem, 'Cuchulain Comforted', written in January 1939.

The poet himself recognizes that Oisin, Countess Cathleen, and Cuchulain fighting the waves were dreams that had taken possession of his 'thought and love', independently from 'those things that they were emblems of.' [2] The figure of the Hero in Yeats's last poems and plays is more and at the same time less than the 'masterful images' appearing in his earlier poetry. More because it reached truly heroic stature, joyful, tragic and ironic; less because it renounced all elegance and grace, it was stained by the mire and blood of human passions: it came from 'the foul rag-and-bone shop of the heart'. Yeats's heart, since the new Hero, the wild old wicked man, was a projection of

[1] 'The Death of Cuchullin', in *Countess Kathleen, cit.*, 1892. These lines were modified in 1927, and the *C.P.* version, under the title 'Cuchulain's Fight with the Sea', reads: 'the mournful wonder of his eyes'. The transformation of the figure of Cuchulain has been traced with extraordinary perception by P. Ure, *Towards a Mythology, cit.*, 15–27; he sees the turning point in Yeats's play *At the Hawk's Well* (1916): 'Cuchulain, the Pre-Raphaelite dreamer of *The Rose*, the passionate Elizabethan or Jacobean stage-hero of *On Baile's Strand* . . . becomes a hero type and the play an exposition of the heroic nature.' For an exhaustive treatment of the subject see B. M. H. Bjersby, *The Interpretation of the Cuchulain Legend in the Works of W. B. Yeats*, Upsala, 1950; F. A. C. Wilson, *op. cit.*, has a chapter on Yeats's last play, *The Death of Cuchulain*.

[2] From 'The Circus Animals' Desertion' (1938?), *C.P.*, 391–2.

himself. Not literally a self-portrait, but the poetic image of Yeats's own mind:

> Grant me an old man's frenzy,
> Myself must I remake
> Till I am Timon and Lear
> Or that William Blake
> Who beat upon the wall
> Till Truth obeyed his call;
>
> A mind Michael Angelo knew
> That can pierce the clouds,
> Or inspired by frenzy
> Shake the dead in their shrouds;
> Forgotten else by mankind,
> An old man's eagle mind.
>
> (*C.P.*, 347)

Yeats evokes here some of the archetypal forms of his Hero. It is noteworthy that the mind presiding over them is Michelangelo's.

In Chapter IV I referred to Yeats's growing interest in Michelangelo, the painter of Leda, the Florentine Platonist who could well have identified Leda with the primeval Night dropping on chaos the Egg of the World, the creator in the 'Sistine roof' of a Mythical race which could 'rule by supernatural right yet be but sinew',[1] and finally the acknowledged master of the visionary William Blake. The mental ascendancy that Michelangelo acquired over Yeats is best illustrated by the first edition of *A Vision* (1925). Earlier Yeats seemed to prefer the more delicate and evanescent beauty of the Pre-Raphaelites or of such painters as Piero della Francesca or Carlo Crivelli. Even the muscular art of Blake was appreciated not as art but as symbol and philosophy. Characteristically in the 'Rosa Alchemica' group of stories the rooms inhabited by the new occultists (the imaginary Owen Aherne or Yeats himself) were

[1] 'Michael Robartes and the Dancer', already quoted in Chapter IV.

decorated with Crivelli's and Francesca's paintings,[1] though in fact Yeats's rooms at Woburn Buildings were hung with engravings of Blake, drawings of Beardsley and a painting of Rossetti's.[2] Only occasionally he had an intuition of another kind of beauty. Perhaps the passing reference to the 'august faces' of Michelangelo's sybils expressing a 'fierce fervour' in the story 'The Tables of the Law',[3] should be compared with the following passage (no doubt an implicit reference to Maud Gonne) in *The Celtic Twilight*:

One day a woman that I know came face to face with heroic beauty, that highest beauty which Blake says changes least from youth to age, a beauty which has been fading out of the arts, since that decadence we call progress set voluptuous beauty in its place.[4]

But it was only later, after his first visit to Italy, that Yeats, when thinking of Quattrocento painters, referred to the Ferrara school of Mantegna and Cosimo Tura with their hard metallic firmness, as well as to Crivelli or Piero della Francesca. In the historical survey of *A Vision*, based to such a large extent on the development of art styles, Yeats mentions Botticelli, Crivelli, Mantegna, da Vinci as representative of intellectual beauty.[5] Of course in the survey he had to take into account

---

[1] In 'Rosa Alchemica' Yeats described a solitary meditation in his room: 'when I looked at my Crivelli, and pondered on the rose in the hand of the Virgin, wherein the form was so delicate and precise that it seemed more like a thought than a flower, or at the grey dawn and rapturous faces of my Francesca. . . .' Also in 'The Tables of the Law' 'Aherne's' room is hung with reproductions of Crivelli and Francesca.

[2] Hone, *op. cit.*, 178. Cp. Henn, *op. cit.*, 231.

[3] *The Savoy*, n. 7, Nov. 1896, p. 80.

[4] 'And Fair, Fierce Women', included in *E.P. & S.*, 205.

[5] *Vis. A*, 202; *Vis. B*, 292. As for Cosimo Tura, in *A Packet for Ezra Pound* (1929) Yeats says that Pound showed him a symbolic painting of Tura to explain the meaning of his *Cantos*. Mr. Henn (*op. cit.*, 236) thinks that the picture Yeats had in mind when writing 'Michael Robartes and the Dancer' was not only the *Saint George* by Paris Bordone in Dublin, but also the painting of the same subject by Tura that Yeats had seen in Ferrara. The misprint 'Tuva' for

his pre-determined pattern of historical phases, so that, in the perpetual movement from periods of subjectivity to periods of objectivity, certain personalities had to be made to fit in with the characteristics of whichever phase they happened to have been living in. Since Yeats had postulated the beginning of a new cycle of a thousand years round the year 1000, the fifteenth-sixteenth century would represent the middle phase of the cycle itself—phase 15 of the lunar year—which was for him a phase of complete subjectivity, the highest human achievement, the moment when unity of being is reached. But it is a moment that exists only beyond the mind of man, not in reality. After the intellectual beauty of some Quattrocento painters reaching towards such humanly unattainable perfection, there comes therefore a kind of revelation and renewal. Significantly Yeats describes it with expressions closely reminiscent of those used in the Leda sonnet (which opens the historical section of *A Vision*):

Phase 15 past, . . . there is as it were a sudden rush and storm. In the mind of the artist a desire for power succeeds to that for knowledge, and this desire is communicated to the forms and to the onlooker.

(*Vis. A,* 203; *Vis. B,* 293)

Justinian's age, the greatest moment in the history of Byzantium, coincided with one of these turning points: hence the symbolic importance of Byzantium for Yeats. And the very words in the passage just quoted make it clear that Yeats felt these moments of perfection in history as closely akin to those other moments marking the beginning of another cycle, standing for revelation and revolution; moments to which he gave the most powerful artistic expression in the Leda sonnet.

It is at this point, just after phase fifteen, that Michelangelo's art appears. Yeats goes on in *A Vision*:

The eighth gyre, which corresponds to Phases 16, 17 and 18

Tura in Henn's book (and in its index) has been repeated by later commentators on Yeats.

and completes itself say between 1550 and 1650, begins with Raphael, Michael Angelo and Titian, and the forms, as in Titian, awaken sexual desire—we had not desired to touch the forms of Botticelli or even of Da Vinci—or they threaten us like those of Michael Angelo, and the painter himself handles his brush with a conscious facility or exultation. The subject matter may arise out of some propaganda, as when Raphael in the Camera della Segnatura, and Michael Angelo in the Sistine Chapel, put, by direction of the Pope, Greek Sages and Doctors of the Church, Roman Sybils and Hebrew Prophets, opposite one another in apparent equality. From this on, all is changed and where the Mother of God sat enthroned now that the Soul's unity has been found and lost, Nature seats herself, and the painter can paint what he desires in the flesh alone . . . I think Raphael almost of the earlier gyre—perhaps a transitional figure—but Michael Angelo, Rabelais, Aretino, Shakespeare . . . I associate with the mythopoeic and ungovernable beginning of the eighth gyre.

(*Vis. A*, 203–4; *Vis. B*, 293–4)

A shift of emphasis must be noted within this passage. Yeats seems to have begun by considering only figurative artists: Michelangelo, Raphael and Titian were the obvious choice since their life span fitted the period he was dealing with. But in the next few sentences he widened the range of reference to include writers as well; and immediately Raphael and Titian seemed less characteristic. As soon as historical periodization gives way to a more absolute conception, to a consideration of human types or rather of human archetypes of heroic dimensions, the only figurative artist who appears close to a personification of absolute objectivity is Michelangelo.

Probably his father's opinions were partly responsible for Yeats's change of taste in the arts—a change which was never complete since the poet never ceased to love the Pre-Raphaelites, Moreau and all art that he considered symbolic. But J. B. Yeats, after rejecting Rossetti and his school, tried to suggest to his son what great art was. In a letter of 1912 he wrote:

All art is *reaction from life* but never, when it is vital and

240

great, *an escape*. There is of course beautiful art which is an escape but it is languid amid all its beauty, Rossetti's for instance. In M. Angelo's time it was not possible to escape for life was there every minute as real as the tooth ache and as terrible and impressive as the judgement day.[1]

And two years later criticizing the figure of Victory in the monument to General Sherman in Central Park, New York, he wrote:

How Michael Angelo would have revelled in giving her the strong shoulders to support the heavy full-fledged wings, an athlete, a woman and an immortal. How Michael Angelo *loved* life is visible in his moulding and carving of the human body which palpitates with a too sentient life.[2]

Other passages from the same letter suggest that Michelangelo was a recluse (W. B. would have said a subjective nature) with an aristocratic mind—characteristics that would certainly have appealed to the poet. How they fitted in with Yeats's conception of the men of the sixteenth phase, taken no longer as representatives of historical periods, but as absolute human types, can be seen from what Yeats wrote in the part of *A Vision* where he classifies such types according to the sequence of the lunar phases. In them the 'excitement' of life supersedes the 'still trance of Phase 15':

At one moment they are full of hate . . . and their hate is always close to madness; and at the next they produce the comedy of Aretino and of Rabelais or the mythology of Blake, and discover symbolism to express the overflowing and bursting of the mind. There is always an element of frenzy, and almost always a delight in certain glowing or shining images of concentrated force: in the smith's forge; in the heart; in the human form in its most vigorous development; in the solar disc; in

[1] J. B. Yeats, *Letters to his Son W. B. Yeats and Others, 1869–1922*, ed. J. Hone, London, Faber, 1944, 144.

[2] J. B. Yeats, *op. cit.*, 190; letter of 30 Aug. 1914.

some symbolical representation of the sexual organs; for the being must brag of its triumph over its own incoherence.

(*Vis. A.,* 78; *Vis. B.,* 138–9)

This definition is very important. Though written in 1925 or earlier still, it is the best description of the characteristics and of the imagery of Yeats's later poetry:

> You think it horrible that lust and rage
> Should dance attention upon my old age;
> They were not such a plague when I was young;
> What else have I to spur me into song?

('The Spur', *C.P.,* 359)

Images such as the smithies of 'Byzantium', the sexual imagery of 'The Wild Old Wicked Man' or 'The Three Bushes', the heart mysteries of 'The Circus Animals' Desertion', and the discovery of symbolism, the irresistible impression of power and delight in creation we receive reading his later poems, are all contained in Yeats's definition of the men of the sixteenth phase. It is a definition of the Hero into which Yeats was to 'remake' himself in the last twenty years of his life, Rabelaisian in a play like *The Herne's Egg*, Aretinian in his sharp satirical moods and in the outspokenness of his sexual allusions.

Michelangelo became the archetype of this hero, the presiding mind. Yeats's earlier inspirations, Blake and Nietzsche, who had fused together in his mind at the beginning of the century ('Nietzsche completes Blake and has the same roots', he had said in 1902),[1] became at this point the direct descendants of Michelangelo. Speaking of the nineteenth century, a time of increasing rationalism and 'objectivity', Yeats picks out the men who reacted to the trend, trying to express a 'new emotion':

Certain men have sought to express the new emotion through the *Creative Mind*, though fit instruments of expression do not yet exist, and so to establish, in the midst of our ever more abundant *primary* [i.e. objective, impersonal] information,

[1] See letter to Lady Gregory quoted above, p. 41.

*antithetical* [i.e. subjective] wisdom; but such men, Blake, Coventry Patmore at moments, Nietzsche, are full of morbid excitement and few in number . . . They were begotten in the Sistine Chapel and still dream that all can be transformed if they be but emphatic.

(*Vis. A.*, 209; *Vis. B.*, 299)

It is outside my scope to enter a discussion of the meaning of *Creative Mind* within the framework of Yeats's system; substantially, it is the reasoning faculty, and the allusion here is to the 'philosophical' character of Blake's and Nietzsche's works. But it is also the mind itself capable of penetrating either in words or through the creation of works of art, to the core of the mystery of the universe. It is the 'mind Michael Angelo knew'.

Michelangelo became for Yeats the embodiment of the creative mind, as a poem of 1937 underlines:

> That girls at puberty may find
> The first Adam in their thought,
> Shut the door of the Pope's chapel,
> Keep those children out.
> There on that scaffolding reclines
> Michael Angelo.
> With no more sound than the mice make
> His hand moves to and fro.
> *Like a long-legged fly upon the stream*
> *His mind moves upon silence.*
>
> ('Long-legged Fly', *C.P.*, 382)

And in one of his very last poems, 'Under Ben Bulben', which he corrected on his death-bed and whose formal imperfection is partly redeemed by the feeling it communicates that this is truly the poet's death duel, Michelangelo's 'secret working mind' is evoked once more; this time it expresses not so much the will to penetrate the ultimate mystery, to find the key to the ordering of the universe—it expresses rather the concrete aspiration of

Yeats's own creative mind, the aim of his greatest poetry in a world of men and human passions:

> Michael Angelo left a proof
> On the Sistine Chapel roof,
> Where but half-awakened Adam
> Can disturb globe-trotting Madam
> Till her bowels are in heat,
> Proof that there's a purpose set
> Before the secret working mind:
> Profane perfection of mankind.
>
> (*C.P.,* 399)

In spite of the exaggerated gesture, the high rhetoric of the last line—a definitive statement of faith and purpose—goes farther than the previous belief, that the mind attaining perfection is made like 'a perfectly proportioned human body'.[1] It places man squarely in the foreground. It is the last step along the road pointed out by Blake and Nietzsche: Yeats no longer thinks of Blake's 'Divine Humanity' or of Nietzsche's Superman, but sees man himself, in his 'profane' physical individuality, as the object of his art, of his creative effort.

Once again it must be stated that Yeats's pronouncements purporting to illustrate a comprehensive view of the universe are always 'metaphors for poetry', statements about the nature and purpose of his art. The extraordinary quality of Yeats's later poetry lies in the fact that, while it claimed to be based on an absurdly complicated abstract system of thought, it achieved a powerful human concreteness. Perhaps the example of Michelangelo's art, with its constant emphasis on man, may

---

[1] A favourite phrase of Yeats's, who derived it from Dante and repeated it in a number of places. See, e.g., *The Trembling of the Veil*: 'I thought that in man and race alike there is something called Unity of Being, using that term as Dante used it when he compared beauty in the *Convito* to a perfectly proportioned human body'; cp. *Vis. A,* 202, and cp. in the present book p. 13, n. 1.

have helped Yeats towards this ultimate achievement. In his first attempt to describe in verse the state of perfection of Phase 15, Yeats had written that in it

> All thought becomes an image and the soul
> Becomes a body . . .
> > > All dreams of the soul
> End in a beautiful man's or woman's body.
> > ('The Phases of the Moon', *C.P.*, 185–6)

At fifty-three, when he wrote these lines, the beauty Yeats was thinking of as representing perfection was still that of youthful human bodies. With the consciousness of old age Yeats's conception of human beauty changed. His was an extreme example of a subjective nature and his theorizing is always bound up with his personal condition. The private problem of advancing age together with a growing consciousness of his assurance, of his control over language and power of expression, modified his view of what beauty was or should be. No longer refinement but vigour of speech; no longer delicate colours and elaborate outlines, but muscular, solid, powerful figures. The Adam in the ceiling of the Sistine Chapel is somewhat languid, but full of restrained energy, beautiful but virile; and next to him there is the figure of the Creator—stormy old age which Blake had tried to reproduce in many of his engravings. In Woburn Buildings Yeats had one of them, 'The Ancient of Days' from the illustrations to the Book of Job.[1] But Michelangelo's old men had an energy, communicated a sense of movement, both interior and physical, that Blake could never equal. They may well stand as the figurative counterparts of the old men in Yeats's late poetry (Yeats himself was one of them) which in 'An Acre of Grass' are typified in Timon and Lear.

---

[1] See Henn, *op. cit.*, 231. Yeats had also two of the seven prints that Blake made out of his many illustrations to the *Divine Comedy*: 'The Whirlwind of Lovers' (The Circle of the Lustful), and 'Dante striking Bocca degli Abbati' (The Circle of the Traitors).

These formidable old men, possessed by a superhuman frenzy, had long been part of that mental gallery of archetypal forms which Yeats variously called the Great Memory, *Spiritus* or *Anima Mundi*, or, following Blake, the bright sculptures of Los's Halls. Forms conceived as quite independent of the authors that gave them life (Shakespeare, though historically belonging to the same phase as Michelangelo, as a man was assigned by Yeats to a much less 'subjective' phase). Such forms or personages are thought of as mythical, like the figure of Helen. In his early period Yeats had called them directly 'Gods':

The more a man lives in imagination and in a refined understanding, the more gods does he meet with and talk with, and the more does he come under the power of Lear and Hamlet, and Lancelot and Faust, and Beatrice, and Quixote, divinities who took upon themselves spiritual bodies in the minds of the modern poets and romance-writers.[1]

I have little doubt that the inclusion of Timon among such prepossessive archetypes many years after the time of 'Rosa Alchemica' was suggested not so much by Shakespeare as by a remark of Ezra Pound's, who was referring to a series of drawings of Wyndham Lewis done in the second decade of this century. In his 'Memoir' on the sculptor Gaudier-Brzeska, published in 1916 (a book containing the Manifesto of the Vorticist Movement, which, as Mr. Ellmann has shown[2] must have had some part in the development of Yeats's conception of the 'gyres'), Pound wrote:

I believe that Mr. Wyndham Lewis is a very great master of design; that he has brought into our art new units of design and new manners of organization. I think that his series 'Timon' is

---

[1] 'Rosa Alchemica', *The Savoy*, 2, April 1896, 60–1. A few lines later Yeats again mentions Lear: 'There is Lear, his beard still wet with the thunderstorm, and he laughs because you thought yourself an existence who are but a shadow, and him a shadow who is an eternal god.' This conception of Lear's joy was to be returned to by Yeats exactly forty years later in the poem 'Lapis Lazuli' (see below).

[2] R. Ellmann, *The Identity, etc., cit.,* 156.

a great work. I think he is the most articulate expression of my own decade. If you ask me what his 'Timon' means, I can reply by asking you what the old play means. For me his designs are a creation on the same *motif*. That *motif* is the fury of intelligence baffled and shut in by circumjacent stupidity. It is an emotional *motif*.[1]

The fury of intelligence: that is the 'old man's frenzy' that Yeats was pursuing—including also that element of intellectual aristocratic pride which is the least appealing trait of Yeats's character as a man, and which, one suspects, he may partly have acquired through his frequentation of that arch-scorner, Ezra Pound.

Lear, as can be seen from the 'Rosa Alchemica' passage quoted before, was a 'mental form' of longer standing for Yeats. In this case it is apparent that the play itself had made a deep impression on him, with its wealth of obviously symbolic characters: the Fool and the blind man are so effective as dramatic foils to the hero that Yeats did not hesitate to appropriate them in order to increase the suggestiveness of his own plays. *The Hour Glass* is the play where the figure of the Fool, endowed with the inspired wisdom that the old 'wise man' lacks, most fully reveals its significance. But the Shakespearean pattern is perhaps best approximated in *On Baile's Strand*,

[1] E. Pound, *Gaudier-Brzeska, A Memoir*, London, Lane, 1916, 107. Pound's words correspond with what Yeats was to say later in *A Vision* about Wyndham Lewis, when he considers him as the exact expression in art of the time in which he lives. Yeats certainly knew Pound's monograph on Gaudier-Brzeska, since the book contains several references, friendly and critical at the same time, to Yeats himself. Pound says of him: 'The man among my friends who is loudest in his sighs for Urbino, and for lost beauty in general, has a habit of abusing modern art. . . .' Yeats replied in the same tone: 'Ezra Pound, whose art is the opposite of mine, whose criticism commends what I most condemn, a man with whom I should quarrel more than with anyone else if we were not united by affection' (*P.f.E.P.*, 5). See also H. W. Häusermann, 'W. B. Yeats's Criticism of Ezra Pound', *English Studies*, XXIX, 4, Aug. 1948, 97–109; and T. Parkinson, 'Yeats and Pound: the Illusion of Influence', *Comp. Lit.*, VI, 3, Summer, 1954, 256–64.

where the Fool and Blind Man with their earthy wisdom are the counterpoint of the madness of Cuchulain fighting the waves. That Lear himself remained for Yeats all the time one of the 'images out of *Spiritus Mundi*', which Shakespeare simply evoked rather than created, is made clear by a letter he wrote in 1928 to Sean O'Casey:

> Do you suppose for one moment that Shakespeare educated Hamlet and King Lear by telling them what he thought and believed? As I see it, Hamlet and Lear educated Shakespeare, and I have no doubt that in the process of that education he found out that he was an altogether different man to what he thought himself, and had altogether different beliefs.
>
> (*L.*, 741)

It is their knowledge of being eternal and unchangeable images, mental archetypes outside the round of worldly mutability, that gives these supreme tragic figures the gaiety of which Yeats speaks in 'Lapis Lazuli' (1936): Hamlet and Lear are gay, though 'Hamlet rambles and Lear rages' (*C.P.*, 338). Rage, frenzy, *histerica passio*, were the passions that Yeats conceived as essential to his 'hero as an old man'. Can the irrational rage of Lear be said to have 'educated' Yeats? Certainly his mind was possessed by it when turning to poetry in the last years of his life. His sense of the importance of what we may call the Lear myth is revealed by the curious suggestion made in 1930 in a letter written to Lady Gregory after having seen a bad performance of the Shakespearean tragedy:

> If I dared I would put *King Lear* into modern English and play it in full light throughout—leaving the words to suggest the storm—and invite an audience of Connaught farmers, or sailors before the mast.
>
> (*L.*, 778)

But Yeats had actually done something of the kind shortly before that time:[1] he had provided in 1926–7 versions for the

---

[1] In a note in the *New York Times* of 15 July 1933 Yeats stated that his purpose in translating *Oedipus* had been that of making it understood to the most

modern stage of Sophocles' *King Oedipus* and *Oedipus at Colonus*—the two Greek tragedies which (as has frequently been noticed) have so many affinities in theme, characterization and even imagery, with *King Lear*. Significantly, the Oedipus plays were written exactly at the same time as 'Sailing to Byzantium', 'Among School Children', the poems in the two series 'A Man Young and Old' and 'A Woman Young and Old'—all poems concerned with old age, establishing it as Yeats's last new basic theme.

The only other work written concurrently with the Oedipus plays was *The Resurrection*,[1] so markedly different both from the play that had preceded it, *The Cat and the Moon* (1924), and from the one that followed it, *Words upon the Window Pane* (1931). There is a reason for the contemporaneous presence in Yeats's mind of both the Pagan and the Christian myths. Oedipus, it will be remembered, in Sophocles' second play, does not die: he disappears prodigiously into the womb of earth, and this portent acquires an obscure universal significance that Yeats did not fail to underline in his rendering of the words of the chorus towards the close of *Oedipus at Colonus*:

> What is this portent? What does it shadow forth?
> Have Heaven and Earth in dreadful marriage lain?
> What shall the allotted season bring to birth?
> This blind old ragged, rambling beggar-man
> Calls curses upon cities, upon the great,
> And scatters at his pleasure rich estate.
>
> (*C.Pl.*, 567)

uncultivated audience: his is 'a plain man's *Oedipus*'. He had begun to translate *Oedipus the King* in 1909 for the Abbey Theatre, as a protest against the English censor who had forbidden the performance of Sophocles' play in London. But he completed the translation only seventeen years later (see *L.*, 537).

[1] *The Resurrection* was completely rewritten (except the lyrics) in 1930–1, when Yeats called the first version of it 'a chaotic dialogue' (letter to Olivia Shakespear of 27 Dec. 1930; *L.*, 780).

And again:

> Thunder has stirred the hair upon my head.
> What horror comes to birth? What shall be found,
> That travail finished, on the lowly bed?
>
> (*C.Pl.*, 568)

There is no possibility of missing the echoes of a poem like
'The Second Coming' in these passages. Here, then, is another
prophecy of a new era, born of prodigy and terror. In the same
way the resurrection of Christ is portent and prophecy: in the
opening song of Yeats's *The Resurrection* we are immediately
confronted with it:

> And then did all the Muses sing
> Of Magnus Annus at the spring
> As though God's death were but a play.
>
> Another Troy must rise and set
> Another lineage feed the crow
> Another Argo's painted prow
> Drive to a flashier bauble yet.[1]
>
> (*C.Pl.*, 580)

This time the prophecy evoked in connection with the death of
Christ is that of Virgil's Fourth Eclogue, which Yeats used
more than once in his previous work, notably in the early
story 'The Adoration of the Magi',[2] and implicitly in his treat-
ment of the Leda myth. But as, when following up the develop-
ment of the Unicorn and 'rough beast' symbol, I pointed out a
change of stress, from the conception of *re*birth, a return of the
past, to the more absolute one of just birth and the sexual act
preceding it (a change taking place round 1916 and culminat-
ing in the 'Leda' sonnet of 1924), so we can now see a further

---

[1] These lines remained unchanged since their first publication in *The Adelphi*,
June 1927.

[2] See above, Chapter I, p. 64.

change in the work of Yeats written from 1926 onwards, notably in the Yeatsian mythical interpretation of the Oedipus story and of the Christian Resurrection: the stress—in expressing the symbolic event bringing about the new Advent—is no longer on birth, but on death. For the old poet death is now a continuous presence.

As for the universal symbolic value with which Yeats endowed the Oedipus legend, he may well have adopted a hint from Hegel, since he told Lady Gregory[1] that 'as he had learned from Hegel', European civilization began when 'Oedipus had destroyed the Asiatic Sphinx[2] which kept personality in bondage, and now the tables were to be turned, Oedipus himself to be destroyed'. This conception matured further as Yeats revised the text of *A Vision*, and when in 1929, in *A Packet for Ezra Pound*, he decided to publish the preliminary matter to the new edition of *A Vision* (which eventually came out eight years later), Oedipus had acquired a tremendous symbolic significance. It is here that Yeats makes the surprising statement:

I send you the introduction of a book which will, when finished, proclaim a new divinity. Oedipus lay upon the earth at the middle point between four sacred objects, was there washed as the dead are washed, and thereupon passed with Theseus to the wood's heart until amidst the sound of thunder earth opened, 'riven by love' said the messenger, and there sank

[1] Cp. Ellmann, *The Identity, etc., cit.,* 187.

[2] The riddle of the Sphinx and its solution by Oedipus had for Yeats all the appeal of a symbolic mythological event. The Sphinx entered early into Yeats's symbolic bestiary (see above, Chapter I, p. 36), as nineteenth century artists had been very fond of representing the scene of her questioning of Oedipus. Mr. Henn (*op. cit.,* 237) believes that Yeats had been particularly struck by Ingres' painting of this subject. I think it more likely that two other artists who were among his favourites and had dealt with the same subject had impressed him even more. *The Pageant,* edited by C. H. Shannon and J. W. Gleeson White, to which Yeats contributed, published a print representing 'Oedipus and the Sphinx' by Ricketts in the 1896 issue, and in 1897 the reproduction of a painting on the same subject by Gustave Moreau. Both artists were greatly admired by Yeats, who celebrated the symbolic quality of their work.

down into the earth soul and body. I would have him balance
Christ who, crucified standing up, went into the abstract sky
soul and body, and I see him altogether separated from Plato's
Athens, from all that talk of the Good and the One, from all
that cabinet of perfection, an image from Homer's age . . . He
raged against his sons, and this rage was noble not from some
general idea, some sense of public law upheld, but because it
seemed to contain all life, and the daughter who served him as
did Cordelia Lear—he too a man of Homer's kind—seemed
less attendant upon an old railing rambler than upon genius
itself. He knew nothing but his mind, and yet because he spoke
that mind fate possessed it and kingdoms changed according
to his blessing and cursing.

<div align="right">(<em>P.f.E.P.</em>, 35–6; cp. <em>Vis. B</em>, 27–8)</div>

Oedipus now balances Christ: he is the symbolic hero and
originator of a violent subjective irrational age, the opposite
of the Christian abstract objectivity. This time Yeats is not
speaking in historical terms, of ages succeeding each other, but
stresses merely the opposition of two kinds of civilizations.
Lear re-emerges in this context, to be rightly equated with
Oedipus—both obscurely representing 'genius itself'. On the
rational plane it is difficult to see how an old man raging
against his sons (since Yeats chooses to underline this aspect
of Oedipus' frenzy) can be the hero of a civilization—but the
fact remains that the figure of the god or hero or king slayer or
would be slayer of his children is a recurrent one in all cultures,
as much as that of the murdered god illustrated by Frazer.
Psychologists have come to the conclusion that it represents one
of the basic situations in the human psyche, whether as an
aspect of the Oedipus complex, or as a pattern in the collective
unconscious. The Biblical example is provided by the story
of Abraham and Isaac (which incidentally suggests a solution
to the complex); and Isaac in his turn has been taken as a type
of Christ, ready to be sacrificed for the good of his people.[1] It

[1] See E. Wellisch, *Isaac and Oedipus,* London, Routledge & K. Paul, 1954.
Wellisch suggests the connection between the Oedipus and the Lear stories

would be out of place to enter a discussion of psychological implications of which Yeats seems to have been completely unaware. What must be pointed out is instead his instinctive and unconscious capacity to identify and express in their complex structure these basic images of man's inner and most secret nature. The interpretations he gave of them may have been muddled or ostensibly false, even perverse (perhaps this is the case with the interpretation quoted above of the Oedipus myth); in his theoretical approach to them he may have been misled or deceived by the prodigious and haphazard collection of more or less esoteric literature he had accumulated in his brain. But he possessed the essential gift of being able to express 'the mystery of things', to use Lear's phrase.

So in *Purgatory* Yeats wrote his own *Oedipus at Colonus*: the old man killing his son under an obscure compulsion that no amount of reference to Yeats's own theories and principles can clarify.[1] It would be absurd to compare *Purgatory* with Sophocles' tragedy or with *King Lear*,[2] but there is no doubt that the theme is treated in it with a suggestive power which succeeds in conveying all its haunting mysteriousness: it remains a 'heart's mystery', or perhaps a secret of the mind, because the poet has been able to maintain the two basic qualities of the archetypal story: irrationality and tragic power. When Mr. Eliot (who selected *Purgatory* for special praise, mainly on the basis of its use of poetic dramatic language) approaches the theme of Oedipus at Colonus with the intent

(p. 50). Also Cuchulain, another personification of the Hero in Yeats's mature poetry, right to his last play, *The Death of Cuchulain* (1938), had killed his son: the theme obviously fascinated Yeats.

[1] *Purgatory* is to be related to the after-death condition of the 'Dreaming Back', described by Yeats in *Vis. B*, 224.

[2] The affinities between *Purgatory* and *King Lear* are pointed out by F. A. C. Wilson, *op. cit.*, 159–60; e.g., compare *Purgatory*: 'I am a wretched foul old man', with *King Lear*, IV, vii: 'I am a very foolish fond old man.' The echo is deliberate.

of providing a Christian rationalization of it, he produces only a drawing-room melodrama like *The Elder Statesman*.

Yeats's *Packet for Ezra Pound* develops further the motif of the opposition between the Oedipus and the Christ myths, in order to suggest more fully the basic structure of his system; and in so doing he established an extremely significant equation between Oedipus and Michelangelo (while Christ is equated with a Christian militant mystic who lived in Michelangelo's time). Once again the 'images out of *Spiritus Mundi*' coalesce: the raging, rambling old men, Oedipus and Lear, fuse into the supreme artist-figure, Michelangelo, the myth-maker hero of Yeats's old age—the projection of his own personality in the world of his mental creations:

What if Christ and Oedipus or, to shift the names, Saint Catherine of Genoa[1] and Michael Angelo, are the two scales of a balance, the two butt-ends of a see-saw? What if every two thousand and odd years something happens in the world to make one sacred the other secular, one wise the other foolish, one fair the other foul, one divine the other devilish? What if there is some arithmetic or geometry that can exactly measure the slope of the balance, the dip of the scale, and so date the coming of that something?

(*P.f.E.P.*, 37; cp. *Vis. B.*, 28–9)

While confirming the archetypal quality that the figure of Michelangelo had acquired for him, the passage stresses both the principle of opposition fundamental to all life, and the possibility of finding a geometrical pattern expressing the secret ordering of life itself. The need for such ordering and the idea that it could be symbolized (I am using the verb in its mathe-

---

[1] The reference to this Italian mystic (lived 1447–1510) was obviously suggested to Yeats by the fact that Baron F. von Hügel made her the subject of his fundamental study of Christian mysticism, *The Mystical Element of Religion as Studied in Saint Catherine of Genoa and her Friends*, first English edition 1908, second 1927. Yeats addresses von Hügel ironically in the last section of 'Vacillation' (1931–2; *C.P.*, 285–6).

matical acceptation) by geometrical signs have been maturing for a long time in Yeats's mind. Before ever receiving the supernatural communications on which he founded *A Vision*, Yeats, in 1916–17, had already written in *Per Amica Silentia Lunae*:

I think that we who are poets and artists, not being permitted to shoot beyond the tangible, must go from desire to weariness and so to desire again, and live but for the moment when vision comes to our weariness like terrible lightning, in the humility of the brutes. I do not doubt those heaving circles, those winding arcs, whether in one man's life or in that of an age, are mathematical, and that some in the world, or beyond the world, have foreknown the event and pricked upon the calendar the life-span of a Christ, a Buddha, a Napoleon.

<div align="right">(<em>P.A.S.L.,</em> 38)</div>

The principle here expounded is, for better or worse, the very basis on which *A Vision* is built. That cosmological or philosophical principles could be expressed—or rather revealed—through mathematical or geometrical forms must have been a familiar conception to a man who in his youth had studied Boehme and the occultists. From Symons' book, for instance, he may have learnt that Gerard de Nerval, a typical example of a symbolist poet, had left papers containing 'a demonstration of the Immaculate Conception by geometry';[1] and Yeats when preparing his edition of Blake certainly saw the curious symbolic plates of William Law illustrating 'the Deep Principles of Jacob Behmen, the Teutonic Theosopher',[2] which he

---

[1] A. Symons, *The Symbolist Movement in Literature*, 1899, 28.

[2] Jeffares (*op. cit.*) and Henn (*op. cit.*) refer to William Law, *An Illustration of the Deep Principles . . . in Thirteen Figures*, 1763. But the allusion in *A Packet for Ezra Pound* is not to the *Thirteen Figures*, all diagrammatic and later attached to the second volume of the 1764–81 edition of Boehme's work, but to the three plates with human figures added to the third volume of the same work. See *The Works of Jacob Behmen The Teutonic Theosopher . . . with Figures, illustrating his Principles, left by the Reverend William Law, M.A.*, vol. III, London, M. Richardson, 1772. The earliest reference of Yeats's to Law is in a review on 'William Blake' in *The Bookman*, April 1896; cp. Ellmann, *The Identity, etc., cit.*, 326.

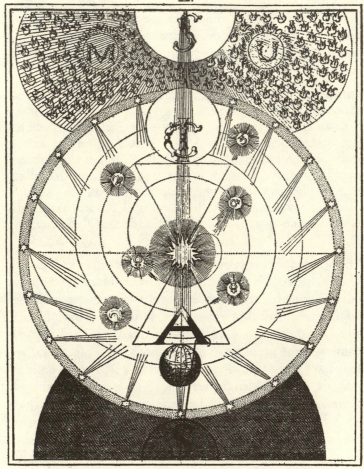

10. Figure X: one of the *Thirteen Figures* left by William Law, illustrating Boehme's 'Deep Principles'; from vol. II of Boehme's *Works*, London, 1764–81. Notice the spiral and the 'hourglass' figures.

mentioned in the 'nineties, and mentioned again when, in *A Packet for Ezra Pound*, looking back to the peculiar 'figures' in his own book, he felt he owed a justification, or an apology, to his own readers:

Some, perhaps all, of those readers I most value, those who have read me many years, will be repelled by what must seem an arbitrary, harsh, difficult symbolism. Yet such has almost always accompanied expression that unites the sleeping and waking mind. One remembers the six wings of Daniel's angels, the Pythagorean numbers, a venerated book of the Cabala where the beard of God winds in and out among the stars, its hairs all numbered, those complicated mathematical tables that Kelly saw in Dr. Dee's black scrying-stone, the diagrams in Law's Boehme, where one lifts a flap of paper to discover both the human entrails and the starry heavens. William Blake thought those diagrams worthy of Michael Angelo, but remains himself almost unintelligible because he never drew the like.

<div align="right">(*Vis. B.*, 23; cp. *P.f.E.P.*, 31)</div>

The name of Michelangelo is dragged in rather surprisingly in this display of esoteric lore—was it meant to lend authority to questionable examples? In any case the passage makes clear the visionary character of such mathematics or geometry as Yeats developed in his later work, and perhaps suggests their real imaginative sources. It seems true that visionary conditions, by whatever means they are induced, result in the sight of resplendent objects, blurred perhaps in their outlines while some minutiae may be extremely luminous and clear;[1] but the first and basic objects 'seen' in this way are architectonic structures and geometrical figures fixed or moving. Aldous

---

[1] Cp. Yeats's description of a vision of his own in that section of his Introduction to W. H. Horton's *Book of Images* (1898) which he later suppressed: 'I closed my eyes a moment ago, and a company of people in blue robes swept by me in a blinding light, and had gone before I had done more than see little roses embroidered on the hems of their robes . . .' W. H. Horton, *A Book of Images, cit.*, 13.

Huxley has related experiments of this kind in *The Doors of Perception*, and a very recent case is that of an eighteen year old American University student who died of an overdose of a sedative drug he was experimenting on himself. According to a press report the student's diary described the effect of the drug in the following way: 'I see a spiral-shaped structure emerging from a black background, like a nebula. The spiral slowly dissolved, and its substance was projected forward, forming a circle. Coloured cubes and oblongs appeared; the spiral formed again caving in at the centre so as to appear tridimensional . . .' This may seem beside the point: Yeats in his youth induced visions simply by concentrating his mind on certain symbols, and certainly never used drugs. But surely all conditions which approximate to the trance state have something in common. The emergence of geometrical figures is an automatic response of the mind to the stimuli which tend to loosen its grip on objective reality. And the spiral is, among geometrical figures, the one that implies movement.

The spiral—or, as he called it, the 'gyre' or vortex—became Yeats's principal symbol in a system which, though finally apprehended through mediumistic revelations, had its origin in the visions he tried to induce in his mind, under the guidance of MacGregor Mathers and other occultists. Two interpenetrating conical spirals, each one with its point in the centre of the other's base, and perpetually whirling, are Yeats's expression, visionary and geometrical at the same time, of the movement of the universe. Yeats says that when, after writing the first version of *A Vision*, he read for four years only philosophical treatises, he 'found neither the geometrical symbolism nor anything that could have inspired it except the vortex of Empedocles'.[1] His inspiration did not come from philosophical texts but, in the first place, from those symbols for evocation he had handled in the 'nineties. The figure of two equilateral triangles (which he later interpreted as flat projections of 'gyres'), either interpenetrating or joined at their apices

[1] *P.f.E.P.*, 27; *Vis. B*, 30.

so as to form an hourglass shape, recurs insistently among MacGregor Mathers' symbols for evocation, and it was reproduced also in a signet ring of Madame Blavatsky's:[1] it was basically a variant of that archsymbol of all magic, Solomon's seal, where the two triangles form a six-pointed star, and the contemporary upward and downward movement implied in the figure makes it—in one interpretation—symbolic of the supreme 'truth' expressed in the Hermetic writings: *quod superius sicud quod inferius*, what is above is like that which is below, the basic enunciation of that doctrine of 'correspondences' by which Yeats was for ever fascinated.

He was thoroughly familiar with all this, and his passion for emblematic geometry found vent in the Yeats and Ellis edition of Blake, where they supplied the diagrams illustrating the organization of Blake's thought (Yeats was later to complain because Blake had not provided them himself). And, in those charts, circles and spirals express a cyclical conception of the development of religions and civilizations to which Yeats was to remain substantially faithful to the end of his life.[2] It is probable that Yeats's adoption of the 'gyre' as the main geometrical symbol of his system was largely conditioned by the fact that the spiral is the geometric pattern that best conveys the feeling of movement, and more precisely of circular movement. The idea of cycles of civilization on the one hand, and of the symbolic meaning of the circular and serpentine motion characteristic of ritual dances in different cultures, on the other, may have more or less consciously contributed to enhance for him the suggestiveness of the spiral movement. The circular dance in 'Rosa Alchemica' (which was to become later the dance and trance of the spirit-flames in 'Byzantium')[3] is one

[1] See *The Key of Solomon the King, cit.*; and T. R. Henn, 'The Accent of Yeats's "Last Poems"', *cit.*

[2] In *The Works of William Blake, ed. cit.*, see especially the 'Chart of the Twenty-seven Heavens and of the Mundane Shell' (I, 301) and the 'Chart of the Descending & Ascending Reason' (I, 305).

[3] See Chapter VI above.

11. 'Chart of the Descending and Ascending Reason' in Blake's *Works*
(1893).

expression of this movement, and is certainly linked with the
Druidic 'serpent dance' mentioned in a story of *The Secret Rose*
(1897),[1] and with the 'circular dance which is so ancient that
the gods, long dwindled to be but fairies, dance no other in
their secret places', mentioned in another story of the same
collection.[2]

But apart from these elements of folklore, there was much in
Yeats's reading which may have contributed to suggest the

[1] 'The Twisting of the Rope and Hanrahan the Red', in *S.R.*, 148.
[2] 'Of Costello the Proud, of Oona the daughter of Dermott and of the Bitter
Tongue', first published in *The Pageant*, 1896, then in *S.R.*, 103.

significance of a motion which was at once circular and serpentine, and to build up that polyvalency of meanings, that immense suggestiveness, that would make Yeats recognize that figure as a highly relevant symbol. Professor Jeffares has pointed out many of the literary sources that went into the making of Yeats's conception of the 'gyres',[1] besides those mentioned by the poet himself. There is no need to go over the same ground again: doubtless, Boehme's conceptions and Law's diagrams illustrating them made a deep impression on Yeats, and underlie in part his symbolism; Dante too may have suggested the same visual pattern, though not so much through Doré's illustrations of the Gerion episode, as Professor Jeffares suggests (Yeats in the 'nineties had expressed his contempt for Doré's *Illustrations to the Divine Comedy*),[2] as through Dante's general conception: Hell is in the shape of a funnel (the name which Yeats's spirit-instructors had originally given to the gyres) with narrowing circles—and the mount of Purgatory is conical with an ascending spiral path round it which Blake represented very effectively in those illustrations to the *Divine Comedy* that Yeats loved so well. Perhaps Yeats's attention was further concentrated on the spiral form at a crucial moment in the development of his system, as Mr. Ellmann suggests,[3] by the founding by Ezra Pound, Wyndham Lewis, Epstein, Brancusi and others of the Vorticist movement in 1916: Ezra Pound's suggestion that 'the image is not an idea. It is a radiant node or cluster', fairly coincides with Yeats's conception of the nature of symbolism in poetry and the arts; and when Pound calls that image a 'vortex', and defines it as 'a whirlwind of force and emotion',[4] he emphasizes just those qualities in poetic expression that Yeats had then begun to appreciate.

[1] A. N. Jeffares, '"Gyres" in the Poetry of W. B. Yeats', *English Studies*, XXVII, 3, June 1946, 65–74.

[2] In the third article of the series 'William Blake and His Illustrations to the Divine Comedy' Yeats says that Doré's art is a 'noisy and demagogic art, an art heavy with the rank breath of the mob' (*The Savoy*, 5, Sept. 1896, p. 31).

[3] *The Identity, etc., cit.*, 156.

[4] Cp. E. Pound, *Gaudier-Brzeska, cit.*, 106, and Ellmann, *loc. cit.*

If the Vorticist doctrine can be considered as the final stimulus leading Yeats's imagination to adopt the gyre symbol, its very first inception, I think, was even earlier than the time when he read Boehme. He was still under twenty when he read the recently published volume of the theosophist A. P. Sinnett (later a prominent member of the Golden Dawn in London); *Esoteric Buddhism* (1883) was the book that first awakened his interest in esoteric doctrines. There, in the chapter on 'The World Periods' Yeats found the distinction, so important in his own later system, between 'objective' and 'subjective' lives; and, in the chapter on 'The Planetary Chain' he was certainly struck by what Sinnett called 'The Spiral Advance', that is to say 'the spiral character of the progress accomplished by the life impulses that develope [*sic*] the various kingdoms of nature'.[1] Here then the spiral was connected with the very sources of life itself. During his contacts with Madame Blavatsky he read the first volume of her *Secret Doctrine*, published in 1888; and there in one and the same page two remarkable references occur in the course of her discussion of a passage from the esoteric 'Book of Dzyan'. The passage deals with the symbol of the 'Wheels' representing, as Madame Blavatsky explains, 'the centres of force round which primordial cosmic matter expands and . . . becomes spheroidal and ends by being transformed into globes and spheres'.[2] (In Yeats's *Vision* the Wheel, with its spiral movement, was finally transformed into a sphere: see Chapter V above.) She goes on to

---

[1] A. P. Sinnett, *Esoteric Buddhism*, London, 1883, 45 ff., and 35. Here is a typical passage containing images which Yeats was to use later: 'Many times does it [the spiritual monad] circle, in this way, right round the system, but its passage round must not be thought of merely as a circular revolution in an orbit. In the scale of spiritual perfection it is constantly ascending. Thus, if we compare the system of worlds to a system of towers standing on a plain—towers each of many stories symbolizing the scale of perfection—the spiritual monad performs a spiral progress round and round the series, passing through each tower, every time it comes round to it, at a higher level than before' (p. 34).

[2] H. P. Blavatsky, *The Secret Doctrine, cit.,* I, 143.

discuss the movement of these wheels, representing primaeval life force, and quotes Swedenborg on the subject:

The most perfect figure of the motion above described must be the perpetually circular; that is to say, it must proceed from the centre to the periphery and from the periphery to the centre.

In other words, this motion—the first and original motion of the universe—is spiral (like that of the 'life impulses' described in Sinnett's book). And Madame Blavatsky adds, since the text she is interpreting says at this point that the Wheels were placed 'in the Six Directions of Space':

By the 'Six Directions of Space' is here meant the 'Double Triangle', the junction and blending together of pure Spirit and Matter, of the Arûpa and the Rûpa, of which the Triangles are a Symbol. This Double Triangle is a sign of Vishnu; it is Solomon's Seal . . .

We have in this page, then, both the spiral motion and the double triangle: Yeats's gyres are the union of these two. I am not saying that Yeats based his 'gyres' on this page of Madame Blavatsky's, but it might have remained in some corner of his mind while his thought matured, to re-emerge completely transformed in *A Vision*.

The spiral and the double triangle likewise figured very prominently in the doctrines and rituals of the secret society of the Golden Dawn to which Yeats belonged for over twenty years. Miss Virginia Moore, in her exhaustive and revealing study of Yeats's esoteric affiliations, connects the 'gyre' with the 'Spiral Path of the Serpent of Wisdom', which was the symbol of the road followed by the adept to reach full initiation into the secret science of the sect.[1] But among these occult doctrines the most striking point in connection with the spiral symbol seems to me the one made by Israel Regardie, a fellow member of the Golden Dawn: Regardie is defining the Astral Light of the occultists, which, as we saw, Yeats identified with Blake's

---

[1] V. Moore, *op. cit.*, 274.

Halls of Los, the Great Memory, *Spiritus Mundi,* or (to use the language of *A Vision*) the Thirteenth Cone, which is a sphere, the condition of perfection beyond the world and at the same time the seat and source of all existence. Regardie prefers here to call it 'the Formative World', and explains:

All the forces and 'ideas' from the Creative and the Archetypal realms are represented and focussed in this plastic agent, the Formative World. It is at once substance and motion, the movement being one which is 'simultaneous and perpetual in spiral lines of opposite motion'.[1]

The basic suggestion for the symbol of the gyres, it seems to me, lies here: the two opposed moving spirals included in the single sphere of the astral light.

But the poet never derives his symbols mechanically from a single specific doctrine. He must be attracted by the sensuous appeal of a certain image, or figure, or motion. Even before starting his study of magic or theosophy, Yeats was attracted by the mere notion of the whirling movement of things. Otherwise why, when he was twenty-two, should he have chosen for quotation these lines from a mediocre poem of William Watson?

> In mid whirl of the dance of Time ye start,
> Start at the cold touch of Eternity,
> And cast your cloaks about you and depart.
> The minstrels pause not in their minstrelsy.[2]

The verb 'whirl' was a favourite one of the earlier Yeats; witness

> all the many changing things
> In dreary dancing past us whirled

---

[1] I. Regardie, *The Tree of Life, cit.,* 61. See above, Chapter VI.
[2] In a letter to Kath. Tynan, June 25, 1887; *L.,* 40.

264

and

<div align="center">

The whirling ways of stars that pass[1]

(*C.P.*, 7–8)

</div>

from the first of his poems which he thought worth preserving. Time was a whirling dance that brought about change.

It appears, at any rate, that Yeats was in the first place interested in the motion itself, and only later he attributed to it a symbolic meaning. As Professor Jeffares remarks when listing some of the possible literary reminiscences which may have contributed to suggest the gyres symbol, 'Yeats's interest in some of these other sources depends upon a visual concept of a mere movement'.[2]

The attraction of the gyre is visual before being intellectual. For years Yeats had before his eyes Blake's illustration to the V Canto of the *Inferno*, 'The Whirlwind of Lovers':[3] may not that ample spiral formed of human bodies whirled about by a cease-less wind have suggested to him the vision of the perpetual motion of all mankind, all earthly things along the same circular sinuous line? Also another work of Blake's had struck him: 'Jacob's Ladder', that Blake had represented as an infinite spiral staircase.[4] As late as 1930 Yeats defined it 'a mere

---

[1] This poem, 'The Song of the Happy Shepherd', had appeared first, with comparatively few variants, as part of the play *The Island of Statues* in the *Dublin University Review* in 1885. It is difficult to decide which way the influence lies in the case of the poems of an older man, E. J. Ellis, published under the title of *Fate in Arcadia* in 1892, when he and Yeats had been collaborating for three years on their edition of Blake. The title piece, a verse play, seems a weak imita-tion of *The Island of Statues*, but the other poems are more definitely esoteric in their symbolism than those of Yeats at this time; in 'Change', change itself is seen as the whirling movement of all things, 'the circling of the days and of the years', 'that whirling sea'; more interesting still is 'Sphinx and Sekhet' where 'change' is seen as brought about by the union of a woman and a lion: here a typical myth of the later Yeats seems foreshadowed.

[2] Jeffares, '"Gyres" in the Poetry of W. B. Yeats', *cit.*, 71.

[3] i.e. 'The Circle of the Lustful: Paolo and Francesca'; see above, p. 245, n. 1.

[4] Yeats had referred to this watercolour of Blake's in a note added in 1924 to a story in *The Celtic Twilight* describing a spirit ascending to the sky 'as if it was a winding stairs'; see *E.P. & S.*, 293, and Jeffares, *art. cit.*, 71.

gyre' and asked T. Sturge Moore to use it as a model for the
cover design he commissioned from him for his volume *The
Winding Stair*—another emblem of the 'philosophical' gyre:

The Winding Stair, as you will see by one of the poems, is
the winding stone stair of Ballylee enlarged in a symbol, but
you may not think the stair, even when a mere symbol,
pictorial. It might be a mere gyre—Blake's design of Jacob's
ladder—with figures, little figures.

(*W.B.Y. & T.S.M.,* 163)

'A mere gyre': substantially what fascinated Yeats was a
graphic pattern, a particular line projected into space. Is it
accidental that the artists contemporary with Yeats were
pursuing exactly the same pattern in their own figurative work?
Beardsley's and Ricketts' drawings develop along serpentine
lines: they find in the spiral their basic pattern and rhythm.
With his sensitivity to visual suggestions Yeats became ob-
scurely aware of it in the 'nineties and, with a mind ever
thirsty for intellectual adventure, associated it with his expecta-
tion of a change in life and art. This he expressed in an un-
collected essay published in *The Dome* for December 1898
under the title 'A Symbolic Artist and the Coming of
Symbolic Art'. Yeats later rejected this essay, probably because
he felt he had too narrowly conceived it as a 'puff' for his fellow
member of the Golden Dawn, Althea Gyles, who had done
the cover design for *The Secret Rose*; but in its directness the
essay is perhaps more valuable than the much quoted 'Sym-
bolism in Painting'. Yeats states that he sees in Althea Gyles's
paintings

a beginning of what may become a new manner in the arts of
the modern world; for there are tides in the imagination of the
world, and a motion in one or two minds may show a change
of tide.

Pattern and rhythm are the road to open symbolism, and the
arts have already become full of pattern and rhythm. Subject
pictures no longer interest us, while pictures with patterns and

XIII. H. M. J. Close: *A Memorial College*. From 'The Dome", n.s. II, n.3, March, 1899 (see p. 232).

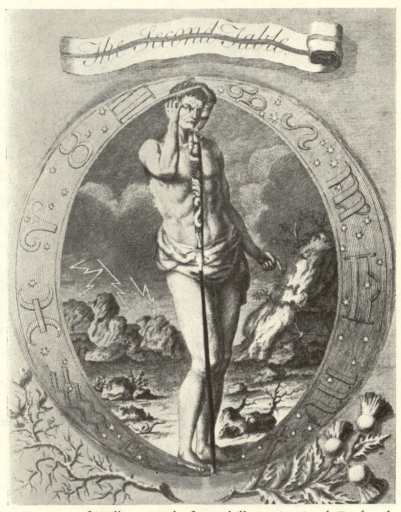

XIV. One of William Law's 'figures' illustrating Jacob Boehme's
*Works*, Vol. III, London, 1772 (see p. 257).

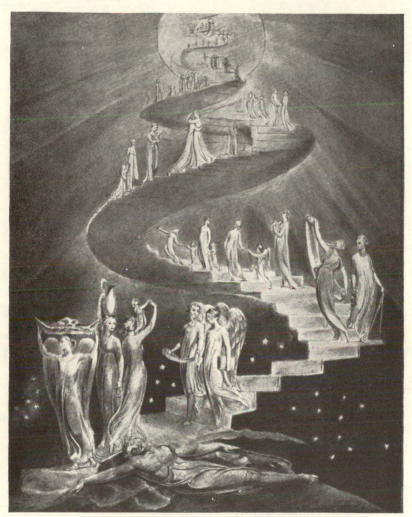

XV. William Blake: *Jacob's Ladder* (see p. 265).

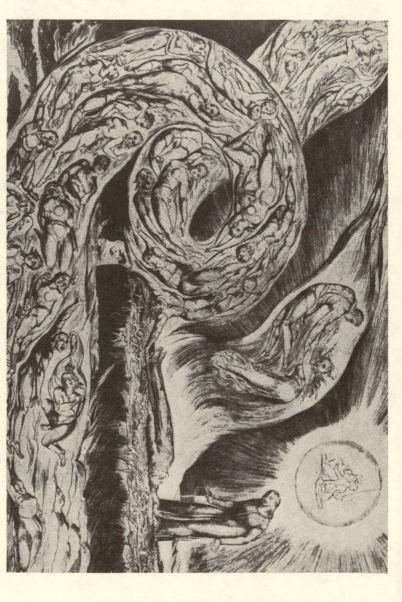

XVI. William Blake: *The Whirlwind of Lovers* (*Inferno*, canto V). From *The Savoy*, n.3, July, 1896, illustrating Yeats's article (see p. 265).

rhythms of colour, like Mr. Whistler's, and drawings with patterns and rhythms of line, like Mr. Beardsley's in his middle period, interest us extremely. Mr. Whistler and Mr. Beardsley have sometimes thought so greatly of these patterns and rhythms, that the images of human life have faded almost perfectly; and yet we have not lost our interest.[1]

The gyre, or spiral, is the rhythmical pattern that Yeats had learnt to recognize as characteristic of the change in the arts in his own time. That serpentine twist in the figures, that linear movement characteristic of the *art nouveau*, seemed to indicate a deeper change in the feeling of the age. It is a question worth considering whether the changes in stylistic patterns which occur in the course of art history are not always external intimations of more profound changes in the attitude of man towards creation. Ultimately, art is the expression through the senses of man's apprehension of his surroundings and of his feelings towards them. Social, moral, and sentimental values are implicit in such attitudes. The formal pattern, therefore, embraces them all, being the graphic manifestation of the mode of their ordering—since art is also order, the affirmation of man's personality sorting out the apparently chaotic accumulation of data provided by everyday experience. Stylistic arrangements grow of their own accord out of man's consciousness, and only afterwards they may be rationalized into aesthetic theories. So at one time we find an aesthetics of the visual arts emphasizing the importance of symmetry, regularity, straight lines and exact perspective, at other times an aesthetics stressing the dramatic appeal of irregularity, curved lines and distorted perspective. Figurative patterns move between these two extremes, and the predominance of the one or the other in individual artists as well as in historical periods or in different countries, is no mere decorative whim; it corresponds to a difference of approach to the subject matter treated, a difference in the mode of apprehension. As the straight line prevailed in those forms of classical art which set themselves the task of reaching an ideal of lofty

[1] *The Dome*, n.s. I, n. 3, December 1898, 233–4.

serenity, so when the curved line predominated the feeling expressed was one of wavering uncertainty or of dramatic conflict. The 'line of beauty' changed with the age, and the spiral line, the exasperation of the curved line, became the dominating feature of art in ages when the urgency of change was most strongly felt: at the end of the Renaissance, at the time of the Romantic revolution, at the beginning of this century. For Hogarth, whose frequently despised *Analysis of Beauty* contains the earliest seeds of Romantic aesthetics, the line of beauty was the Serpentine; and the most perfect expression of it was the cornucopia of the ancients, since it was a cone 'twisted and

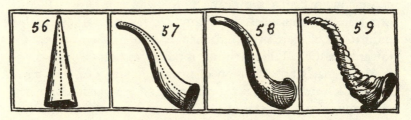

12. The 'Line of Beauty' from the cone to the cornucopia: detail of plate 2 of William Hogarth's *Analysis of Beauty* (1753).

bent', but 'more ornamented, and with a greater number of other lines of the same twisted kind, winding round it with as quick returns as those of a screw'.[1] He purported to have taken this principle from Michelangelo, and quoted a passage from the *Treatise on Painting* by Lomazzo, a mannerist of the sixteenth century:

And because in this place there falleth out a certaine precept of *Michael Angelo* much to our purpose, I wil not conceale it, leaving the farther interpretation and vnderstanding thereof to the iudicious reader. It is reported then that *Michael Angelo*

[1] W. Hogarth, *The Analysis of Beauty Written with a view of fixing the fluctuating Ideas of Taste*, London, 1753, 53. See also the excellent critical edition edited with an introduction by J. Burke, Oxford, Clarendon Press, 1955. Cp. Yeats's mention of a cornucopia in connection with Michelangelo's *Night*, above, p. 151 and note.

vpon a time gaue this observation to the Painter *Marcus de Sciena* his scholler; *that he should alwaies make a figure Pyramidall, Serpentlike, and multiplied by one two and three.* In which precept (in mine opinion) the whole mysterie of the arte consisteth. For the greatest grace and life that a picture can haue, is, that it expresse *Motion*: which the Painters call the *spirite* of a picture: Nowe there is no forme so fitte to expresse this *motion*, as that of the flame of fire, which according to *Aristotle* and the other Philosophers, is an elemente most actiue of all others: because the forme of the flame thereof is most apt for motion: for it hath a *Conus* or sharpe pointe wherewith it seemeth to divide the aire, that so it may ascende to his proper sphere. So that a picture hauing this forme will bee most beautifull.[1]

Whether or not Michelangelo actually gave this definition, it fits in with his position in art history, as the man who saw the end of the Renaissance and who, in the formidable and contorted creations of his art, anticipated the conflicts and the soul-searching of the next age.

Yeats, though most probably completely unaware of this definition, had had an intuition of the archetypal nature of this visual pattern. He found it resumed and repeated by the artists of his own time,[2] so that it grew in his imagination acquiring, through his own constant hankering after the symbolic, more and more meaning. When he felt that his poetry needed the support of a personal structure of thought, he found it in a visual pattern, which he charged with a metaphysical significance. He deceived himself into believing that what was merely the instinctive knowledge of the aesthetic 'rightness' of that pattern, was instead the obscure communication of a cosmological structure. But the deception was fortunate in so much as the primitive sensuous instinct was right. Stripped of all its confused and confusing occult and 'philosophical'

[1] The translation of Lomazzo's treatise, by Haydocke, was published at Oxford in 1598. It is quoted in Hogarth, *op. cit.*, V–VI.

[2] In the introduction to his edition of Hogarth's treatise (p. xlix) Professor Burke rightly remarks that 'the serpentine line comes again into prominence during the Victorian rococo revival'.

superstructures, *A Vision* is a personal mythology which, like ancient mythology, provides poetic images. But when we inquire into the prime mover, the original seed of this mythology, we find 'a mere gyre', simply a visual pattern.

At least in the case of Yeats, the first impulse towards the creation of poetry is visual rather than intellectual—that is to say it comes from the senses; and only later the poet's mind erects round this seminal impulse an elaborate structure of thought. Perhaps Lomazzo's phrase and Michelangelo's precept are right: the 'whole mystery of art' is the gift of possessing the basic pattern—only in this way do those 'stylistic arrangements of experience' (I am now quoting Yeats) which *are* art and poetry become possible.

# Excursus I: Yeats and Abstract Art

YEATS, with his partiality for symbolism, could not appreciate cubism or abstract art, though he was very fond of marked stylization of the figurative forms. In the 'nineties he had lavished praise on such minor and at times rough draughtsmen as William Horton and Althea Gyles, who shared his interest in the world of praeternatural visions and symbols; and, though later he saw his mistake and suppressed all references to their art, he tried, at first, to defend them also on aesthetic grounds, by pointing out that they were inaugurating a new style, dominated by rhythmical linear patterns. He was in fact applying the 'aesthetic' principle of style as an end in itself to belated and weak followers of the sentimental allegorism of the Pre-Raphaelites, and complicated it all with his personal doctrine of symbolism based on magic. As early as 1898 he had realized that 'subject pictures no longer interest us' ('A Symbolic Artist and the Coming of Symbolic Art', cit.), but would not grant that the 'symbols' introduced by these artists in their work were as much 'subject' as the historical or domestic scenes painted by the Victorian artists. He reacted against Impressionist art as being too crude and raw a representation of nature, without any attempt at stylization; at the same time he could not feel in sympathy with such an austere conception of stylization as that of the cubists, who, polemically, made no concession to subject matter. There is a very interesting letter on the subject, written to his father J. B. Yeats in 1916 (L., 608): 'I feel in Wyndham Lewis's Cubist pictures an element corresponding to rhetoric arising from his confusion of the abstract with the rhythmical. Rhythm implies a living body, a breast to rise and fall, or limbs that dance, while the abstract is incompatible with life. The Cubist is abstract.' He proceeds to attack the Impressionists because, by leaving out rhythm (meaning the sinuous fluency of the outlines) they 'brought all this rhetoric of the abstract on us': instead of arranging 'consciously and deliberately' (Yeats's italics) their figurative patterns, they adopted an unconscious and instinctive arrangement. Art, then, for Yeats, should be conscious ordering of materials, an 'artifice' like that produced by the 'smithies of Byzantium' in Yeats's great later poem: 'the smithies break the flood', he says there, and the flood, we learn from his essay on Althea Gyles already quoted, is always 'the

271

flesh, the flood of the five senses' or (to return to 'Byzantium') nature, the 'mire and blood of human veins'. As an example of rhythmical and non-imitative art he mentions, in his letter of 1916, Japanese paintings: 'Everywhere there is delight in form, repeated yet varied, in curious patterns of lines, but these lines are all an ordering of natural objects though they are certainly not imitation.' But the ordering of natural objects through pattern and rhythm, though conscious should not be mechanical: the rhythm should be the rhythm of life, and the Cubists have been 'wrong in substituting abstract scientific thought for conscious feeling'. Applying this principle to poetry Yeats finds that real poetry is rhythmical while music-hall verses are abstract, because their cadence is not a living rhythm, 'it is but the noise of a machine and not the coming and going of the breath'. (Curiously enough, just at this time T. S. Eliot was expressing the opposite opinion, that the music hall artist was the only one capable of communicating poetry to an audience; see his essay on 'The Possibility of Poetic Drama', in *The Sacred Wood*. But Eliot was trying to make the rhythm of his poems sound as lifeless as possible in order to express the emptiness of contemporary life.) Yeats's letter is particularly interesting because 1916 marks the high point of the Vorticist movement in art, a confluence of Imagism and Cubism promoted by his friend Ezra Pound together with Wyndham Lewis, Gaudier-Brzeska, Epstein and Brancusi (see Pound's book, *Gaudier-Brzeska, A Memoir, cit.*, containing the Manifesto of Vorticism and a complaint against Yeats who 'has a habit of abusing modern art for its "want of culture"').

Later Yeats modified his attitude towards the different expressions of abstraction in art, not because he approved of them, but because, when his theory of historical cycles matured, he considered inevitable the advent of an era of abstraction. So W. Lewis and Brancusi were considered the purest expression of the historical phase in which they were living. Already in *Vis. A* (1925), at the end of the historical section of the book, he wrote, in a page which was not included in the 1937 edition, about certain friends of his and 'the writers, poets and sculptors admired by these friends' (p. 211): 'It is with them a matter of conscience to live in their own exact instant of time, and they defend their conscience like theologians. They are all absorbed in some technical research to the entire exclusion of the personal dream. It is as though the forms in the stone or in their reverie began to move with an energy which is not that of the human mind. Very often these forms are mechanical, are as it were the mathematical forms that sustain the *physical primary*—I think of the work of Mr. Wyndham Lewis, his powerful "cacophony of sardine tins", and of those marble eggs, or objects of burnished steel too drawn up or tapered out to be called eggs, of M. Brancussi [*sic*], who has gone further than Mr. Wyndham Lewis from recognizable subject matter, and so from personality.' At this stage he prefers a compromise, he prefers 'those sculptors who would certainly be rejected as impure by a true sectary of this moment, the Scandinavian Milles, Meštrović perhaps, masters of a geometrical pattern or rhythm which seems to impose itself wholly

from beyond the mind.' Yeats preferred stylization to abstraction in art. In later years, while his own mind seemed more and more absorbed by the 'geometry' of his 'system' of thought, he was more ready to accept non-representational forms in art—though they still represented impersonality, objectivity, lack of humanity. In the additional book IV of *Vis. B* (1937), referring to a book that had greatly impressed him, J. Strzygowski, *Origin of Christian Church Art*, Oxford, 1923, he writes (p. 258): 'He finds amid the nomad Aryans of northern Europe and Asia the source of all geometrical ornament, of all non-representative art. It is only when he comes to describe such art as a subordination of all detail to the decoration of some given surface, and to associate it with domed and arched buildings where nothing interferes with the effect of the building as a whole, and with a theology which so exalts the Deity that every human trait disappears, that I begin to wonder whether the non-representative art of our own time may not be but a first symptom of our return to the *primary tincture*.' (The *primary tincture*, in the terminology of *A Vision*, is the condition of objectivity and impersonality.) Was not Yeats himself, when adopting geometrical patterns as supporting structures for his thought and indirectly for his poetry, conforming with the trend of his own time, becoming 'abstract'? The passage at the end of the new introduction to *Vis. B*, where he regards his 'system' as a 'stylistic arrangement of experience comparable to the cubes in the drawing of Wyndham Lewis and to the ovoids in the sculpture of Brancusi', implies this attitude. And this time, for once, these two artists (the only two artists classifiable as 'abstract' that Yeats ever mentioned) are accepted without reservation. But we should take into account that in the meantime their cubes and ovoids (see in this book the chapter on 'The Mundane Egg') had become symbolic. Yeats accepted abstraction only when he could interpret it as symbolism.

# Excursus II: The Enchanted Garden

IT is not impossible that the idea of seeing *Anima Mundi* as the luxuriant growth of an exotic water plant or garden came to Yeats from Nathaniel Hawthorne's famous story 'Rappaccini's Daughter'. Yeats probably never read it, but saw and reviewed twice for American newspapers (*The Boston Pilot* of 1 Aug. 1891, and the *Providence Sunday Journal* of 26 July 1891) the stage adaptation of the story made by his admired friend and fellow poet-dramatist, John Todhunter. The adaptation, with the title *The Poison Flower*, presented Rappaccini as a Cabbalist, and this greatly impressed Yeats, who just then was deep in his esoteric studies. This passage from one of Yeats's reviews, containing a defence of the figure of Rappaccini, is extremely significant (*L. to N.I.*, 135): 'One finds it quite easy to believe that this worn-looking Kabalist, who crosses the stage with cat-like tread, has in his mind some wild dream for the regeneration of men, and that he is bringing up in the garden, whose strange and exotic flowers rise before one, a new Eve to be mother of a new race to whom the poisons of the world—its diseases and crimes—shall do no hurt, for they will carry within themselves "the poison that drives out poison". The copy of the Kabala that lies upon my own desk pleads for him, and tells us that such men lived, and may well have dreamed just such a dream, in the mystic Middle Ages.' There is no need to underline the importance that this conception of a new Eve, the mother of a new race, was to acquire in the development of Yeats's cyclical view of the universe, from the story 'The Adoration of the Magi' (1896) onward. As was the case with *Axel* (see *supra*, pp. 22–3), also in *The Poison Flower* we have a stage set that made a lasting impression on Yeats for its symbolic quality, so that the visual image remained in his mind.

Actually the Enchanted Garden can be considered an archetypal image: not *Anima Mundi* itself but certainly one of the images out of the Great Memory, as Yeats called them. From the Garden of Eden and the *hortus conclusus* of the Song of Solomon, to the stylized walled-in rose-gardens of primitive painters like Stefano da Zevio, to the rose garden in Eliot's *Family Reunion* and *Four Quartets*, it runs through all cultures and ages. Yeats devoted a section of his Spenserian anthology to 'Gardens of Delight' (*Poems of Spenser, cit.*), and certainly liked

# The Enchanted Garden

Marvell's 'Garden' if, as Mr. Gwynn convincingly suggests, lines 51–4 of this poem contributed to the image of the bird in 'Sailing to Byzantium' (F. L. Gwynn, 'Yeats's Byzantium and Its Sources', *cit.*, 21). It is worth pointing out that also another 'silvan scene' of Marvell's was in Yeats's imagination from a very early time: some lines of the poem which now bears the title 'The Song of the Happy Shepherd' (*C.P.*, 7–8) and which was originally the epilogue of the plays *The Island of Statues* and *The Seeker* (first published in the *Dublin University Review*, I, 9, Oct. 1885, 230–1, and reprinted under the title 'The Song of the Last Arcadian' in *W. of O.*, 74–6) echo Marvell's 'The Nymph complaining for the death of her Faun':

> I must be gone—there is a grave
> Where daffodil and lily wave,
>
> Farewell; I must be gone I wis,
> That I may soothe that hapless faun
> (Who's buried in the sleepy ground),
> With mirthful songs till rise the dawn.

I have quoted the earliest printed version, where 'faun' could be taken to mean 'fawn', recalling the tomb of the fawn in Marvell's poem (in Marvell's poems the word is spelt with a 'u', and Yeats constantly confused the two words—see an example in a letter to T. Sturge Moore quoted *supra*, p. 59).

# Excursus III: The Swan Emblem

THE swan is a constant and traditional member of the bestiary of emblem books, from Alciati onwards. But a very curious and interesting coincidence in the interpretation of the swan emblem as portending a supernatural birth (as in Yeats's 'Leda and the Swan', where it announces an advent parallel to the birth of Christianity) has been pointed out to me by Professor Mario Praz, to whom I am indebted for the following information. It occurs in the widely known repertory of emblems intended for preachers, compiled by the Abate Filippo Picinelli, *Mondo Simbolico*, Milan, 1653 (I am quoting and translating from the enlarged edition, *Mondo simbolico ampliato*, Milan, 1669). In the chapter on swan emblems (libro I, cap. XVIII, par. 216, p. 127), among a number of interpretations of such emblems, Picinelli writes: 'If Lucarino wrote over the flying swan the motto *Laetificat Accessu*, the same impresa could well be applied to the nativity of St. John, of which the Archangel Gabriel, according to Luke i. 14, said, *Erit gaudium tibi, et exultatio, et multi in nativitate eius gaudebant*; to that of the Virgin Mary, of which is sung: *Nativitas tua Dei Genetrix Virgo gaudium annuntiavit universo mundo*; and especially to the Nativity of Christ, of which Luke, ii. 10, writes: *Ecce enim evangelizo vobis gaudium magnum, quod erit omni populo.*' This interpretation, Professor Praz suggests, seems to be a personal one of Picinelli's, who was trying to attach a religious or 'metaphysical' meaning to the 'profane' emblems he knew. In fact, the emblem of Lucarini referred to, representing a solitary swan flying over a deserted expanse of water (*Imprese dell'Offitioso Accademico Intronato raccolte de lo Sconosciuto Accademico Unito*, Siena, 1629, I, 172), is only used as a good omen for the return of a son to his father after a long absence.

# Excursus IV: Yeats's Hunchback and Byron's Deformed Transformed

‡‡‡‡‡‡‡‡‡‡‡‡‡‡‡‡‡‡‡‡‡‡‡‡‡‡‡‡‡‡‡‡‡‡‡‡‡‡‡‡‡‡‡‡‡‡‡‡

A CURIOUS example of the fascination that any work dealing with magic held for Yeats is the fact that, of all Byron's poetry, what struck him most was his last, incomplete and forgotten play, *The Deformed Transformed*, dealing with a Faustian theme of magic transformation and reincarnation. *The Deformed Transformed*, based on a mediocre Gothic novel from which also 'Monk' Lewis had taken a play, presents a certain Arnold, a hunchback (the play begins with the words 'Out, hunchback!'), who makes a pact with an evil spirit in order to assume the shape of a great man of the past. Evoked by magic, there appear to him in succession the shades of Caesar, Alcibiades, Socrates, Antony and Demetrius Poliorcetes, but Arnold finally chooses the most handsome of all, Achilles, a figure 'animated out of the ideal marble'. In his turn the evil spirit takes Arnold's deformed shape but assumes the name of Caesar. Now when Yeats in 1918 began to classify according to his system the different human types, in a series modelled on the phases of the moon, he assigned to the twenty-sixth phase (a phase very nearly approximating total objectivity, absence of personality), the type of the man with a physical imperfection—and called it 'The Hunchback' (the next phase, even more impersonal, was that of 'The Saint'—then came 'the dark of the moon', utter impersonality). To illustrate this he wrote in the same year the little poem 'The Saint and the Hunchback', collected in *W.S. at C., 1919,* in which he makes the Hunchback say:

> A Roman Caesar is held down
> Under this hump.

The resentment of the Hunchback is contrasted with the deliberate renunciation of the Saint, who consciously wants to abolish his personality, and replies:

> I shall not cease to bless because
> I lay about me with the taws

277

> That night and morning I may thrash
> Greek Alexander from my flesh,
> Augustus Caesar, and after these
> That great rogue Alcibiades.

The Hunchback ironically rejoins:

> To all that in your flesh have stood
> And blessed, I give my gratitude,
> Honoured by all in their degrees,
> But most to Alcibiades.

The mention of Caesar and Alcibiades suggests that the hunchback Yeats had in mind was Byron's; in the play also Alexander is mentioned as the first of the spirits of the past to be evoked, though he actually does not appear: 'the shape of each victor / From Macedon's boy'. This evocation could have attracted Yeats's attention also for another reason: it asks the 'shadows of beauty and of power' to

> Walk lovely and pliant
> From the depth of this fountain,
> As the cloud-shapen giant
> Bestrides the Hartz Mountain.

A note of Byron's (*Poetical Works*, O.U.P., 1911, 894) explains here that 'this is a well-known German superstition—a gigantic shadow produced by reflection on the Brocken'. It is indeed the 'man on a hill-top . . . amazed at his own shadow cast gigantically on a mountain mist', that George Russell had drawn and Yeats had seen as a young man and was deeply impressed by it; the episode is told by Russell, and I have already quoted it (see *supra*, Chapter I, note to p. 67) with Russell's comment that the image adumbrated Yeats's 'central idea' of 'a duality in self, of being and shadow'. Yeats developed this idea into his theory of man and mask, the mask being the opposite of the man's character, towards which man continually aspires. Byron's hunchback, selling his soul in order to become his own opposite, the most handsome of men, is another example of it, and his relevance for Yeats is obvious. This may well have been the reason that attracted Yeats to Byron's curious and uncouth fragmentary play, and led him to adopt the figure of the Hunchback as the type of the men of phase twenty-six. Describing this type in *Vis. A*, 115–16 (*Vis. B.*, 177–8) Yeats wrote: 'without personality he is forced to create its personal [*Vis. B*: artificial] semblance . . . The deformity may be of any kind, great or little, for it is but symbolised in the hump that thwarts what seems the ambition of a Caesar or of an Achilles. He commits crimes, not because he wants to, or . . . because he can, but because he wants to feel certain that he can . . .' The mention of Achilles at this point, added to those of Caesar, Alcibiades and Alexander, is

conclusive evidence that Yeats was thinking of Byron's *Deformed Transformed*. Achilles is the shape, the 'mask', that the Hunchback (both in Byron and in Yeats) wants to assume.

As a man, Yeats assigns Byron, together with Gabriele D'Annunzio and Oscar Wilde, to phase nineteen which, after the fuller subjectivity of the three preceding phases, marks 'the beginning of the artificial, the abstract, the fragmentary, and the dramatic. Unity of being is no longer possible, for the being is compelled to live in a fragment of itself and to dramatize that fragment . . . He is now governed by conviction, instead of by a ruling mood, and is effective only in so far as he can find this conviction. His aim is so to use an intellect which turns easily to declamation, emotional emphasis, that it serves conviction in a life where effort, just in so far as its object is passionately desired, comes to nothing. He desires to be strong and stable, but as Unity of Being and self-knowledge are both gone, . . . he passes from emphasis to emphasis.' It is, for once, a fair intuition of Byron's personality. But Byron too, as every man for Yeats, aspires to his own opposite; significantly Yeats assigns to phase five, the exact opposite of phase nineteen, 'Byron's Don Juan or his Giaour': Byron the man reaches his 'mask' as an artist, in the creations of his imagination (see *Vis. B.*, 148 and 113).

# Excursus V: Renaissance Paintings of Leda

BESIDES the painting of Correggio and the copies from those of Leonardo and Michelangelo, mentioned in the present book, the subject of 'Leda and the Swan' was a favourite with a number of other Renaissance and Mannerist artists. Typical of the treatment used by the latter, all elegant sensuality that was to lead to the rococo *bravura* pieces of a Boucher, is a drawing done *c.* 1580 by the Austrian mannerist Bartholomeus Spranger, a distant follower of Michelangelo (see it reproduced in Th. Muchall-Viebrook, *Deutsche Barockzeignungen*, Munich, pl. I). But the painters of the Venetian school, whom Yeats liked for their sensuous appeal, have more remarkable works on the theme. A *Leda* by Titian's workshop is, significantly, merely a variant of his *Venus with a Looking Glass* (Leningrad, Hermitage); Tintoretto treated the subject more than once: a painting in the Uffizi shows the bird released from a cage in Leda's alcove, and another in the Contini Bonacossi collection in Florence (sold to Goering in 1941 and returned in 1948) is also a bedroom scene. So is Paolo Veronese's *Leda* in Leipzig, perhaps the most sensual of all. (One is reminded of Yeats's lines in 'Michael Robartes and the Dancer', *C.P.*, 198:

> Paul Veronese
> And all his sacred company
> Imagined bodies all their days
> By the lagoon you love so much,
> For proud, soft, ceremonious proof
> That all must come to sight and touch;

in the next line Yeats mentions 'Michael Angelo's Sistine roof'). Giuseppe Portigliotti ('Le Lede', in *Porpore pugnali etère*, Milano, 1929, 217–18) attributes the popularity of the subject in the sixteenth century and the fact that it is mostly treated as an interior alcove scene, to the spreading of morbid sexual tendencies at the time. This seems excessive, though the sexual appeal of the subject is

280

undeniable: such representations of Leda as the one described by Spenser in *The Faerie Queene* (see *supra*, p. 212) were sure to be among the pictures imported into England at the time to decorate the bed-chambers of Italianate Englishmen; they are frequently referred to in Elizabethan literature under the name of 'Aretine pictures' because Aretine had written the licentious verses accompanying a very popular series of them done by Giulio Romano and representing the loves of the gods. Professor Wind (*Pagan Mysteries in the Renaissance, cit.*) has shown that cultivated painters like Michelangelo (and, much later, this was the case also with Moreau) attached a deep metaphysical meaning to the myth of Leda. But the taint of wantonness remained: Guy de Maupassant chose a picture of Leda and the Swan to decorate the 'room upstairs' in the too hospitable house of Madame Tellier (in the story 'La Maison Tellier'); and today, as a supreme indignity, Miss Pamela Hansford Johnson uses Leda as the subject of a pornographic 'living picture' in her novel *The Unspeakable Skipton* (1959), and, worse still, has the hero quote Yeats's sonnet in this connection. In view of the reputation of immorality acquired at an early date by the subject, it is not surprising that zealous moralists tried to destroy Correggio's *Leda* and apparently succeeded in destroying Michelangelo's painting.

As for Leonardo's *Leda*, the original was taken by Leonardo to France in 1516, and it was still in Fontainebleau (but in a bad state of repair) in 1625; after that all trace was lost. The Borghese copy is generally attributed to the Sodoma school, while the Spiridon copy (which was sold by Countess Gallotti Spiridon to Hitler in 1941 and restored to Italy in 1948) may be by Francesco Melzi, who followed Leonardo to France, or by Leonardo himself and completed by Melzi (see *Catalogo della seconda mostra nazionale delle opere d'arte recuperate in Germania,* a cura di R. Siviero, Rome, 1950, 28–30). An extraordinary confusion about this painting was made by J. Davidson Reid in an article where she set out to discuss the sonnets by Yeats and by Rilke on Leda in the light of the works of figurative art on the same subject ('Leda Twice Assaulted', *Journal of Aesthetics and Art Criticism,* XI, 4, June 1953, 378–9). The article begins: 'Ghirlandaio painted his Leda and the Swan (Rome: Galleria Borghese) in an easy, familial mood, Leda watching her children playing around a momentuous egg, the swan blissful in domesticity.' The description corresponds exactly to the Leonardesque copy in the Borghese. Why then Ghirlandaio? The fact is that in the same gallery there is another painting of the same title: it is only a woman's head next to the head of a swan, a work obviously of the sixteenth century. It has had various attribution in the Florentine Mannerist school—in the popular Spanish encyclopedia Espasa-Calpe (vol. XXIX) it is reproduced under the article 'Leda' and attributed to Giorgio Vasari; others (e.g. A. De Rinaldis, *La R. Galleria Borghese in Roma,* 2nd edition, Rome, 1937, 31) attribute it to a member of the Ghirlandaio family, Michele di Ridolfo del Ghirlandaio, the grandson of *the* Ghirlandaio whose name was Domenico. Obviously Miss Reid saw a reference to a *Leda* by a Ghirlandaio in the Borghese Gallery, but neither

took into account that this was Michele and not Domenico, nor, when confronted with the other *Leda* in the Gallery, realized the impossibility on stylistic grounds of assigning to 'Ghirlandaio' a work so obviously belonging to the Leonardo school. Indeed, in a note to her article (*loc. cit.*, 386–7), Miss Reid quotes a passage from C. F. MacIntyre's book, *Fifty Selected Poems of Rainer Maria Rilke*, describing Leonardo's *Leda*, and candidly remarks: 'Ghirlandaio has a similar conception (Rome: Galleria Borghese) with upright swan and Leda. . . .' This is hardly surprising, since what she calls Ghirlandaio is actually a Leonardo, while the one by Michele del Ghirlandaio is a completely different picture. Finally, speaking of the 'innumerable' copies of Michelangelo's *Leda*, she appends to her reference to the one in the National Gallery the following note (*loc. cit.*, 385): 'one may compare the lighter conception in Bartolomeo Ammanati after a lost Michelangelo, Il Bargello; Florence'. In this way the reader is misled into thinking that also Ammanati's copy is a painting and not, as in reality, a sculpture.

# Excursus VI: The Moment
# of Moments

THE idea that perfection, complete fulfilment, can be reached and held only for a moment is not only Yeats's. He merely found a new image for it, he called it the point where the gyre (the movement of human life) becomes a sphere—in the same way as for Eliot it is the point of intersection of the temporal with the timeless. Yeats made this point clearer in some notes for the revised version of *A Vision* which he wrote, Mr. Ellmann says (*The Identity etc., cit.,* 221), in 1928: 'At first we are subject to Destiny . . . but the point in the Zodiac where the whirl becomes a sphere once reached, we may escape from the constraint of our nature and from that of external things, entering upon a state where all fuel has become flame, where there is nothing but the state itself, nothing to constrain it or end it. We attain it always in the creation or enjoyment of a work of art, but that moment though eternal in the Daimon [man's projection in Eternity] passes from us because it is not an attainment of our whole being. Philosophy has always explained its moment of moments in much the same way; nothing can be added to it, nothing taken away; that all progressions are full of illusion, that everything is born there like a ship in full sail.'

The passage is pregnant with ideas which were of the utmost importance to Yeats, and which are still relevant to a better understanding not only of his un-systematic system of thought, but of his never enunciated poetics, and therefore of his poetry. The statement that 'all progressions are full of illusion' and that everything is born in the 'moment of moments', seems to contradict Yeats's whole theory of existence as a continual conflict, a theory which he had found so concisely and strikingly expressed in Blake's one sentence: 'Without Con-traries is no progression.' In fact Yeats (as, in his own way, Blake) recognizes that, though temporal existence is constant conflict, the final aim and achieve-ment is to transcend such existence, to transcend the dimensions of time and space, to 'stretch out' the moment (the expression comes from 'The Double Vision of Michael Robartes', *cit.*: 'In contemplation had those three so wrought / Upon a moment, and so stretched it out / That they, time overthrown, / Were dead yet flesh and bone'). And this sense of transcendence was realized at certain

isolated moments of human existence, it was the sudden revelation or vision perceived 'in the creation or enjoyment of a work of art'. Here Yeats was repeating a conception common to poets and mystics of all times. Blake had put it, in a famous passage, in this way:

> Every Time less than a pulsation of the artery
> Is equal in its period & value to Six Thousand Years,
> For in this Period the Poet's Work is Done, and all the Great
> Events of Time start forth & are conceiv'd in such a Period,
> Within a Moment, a Pulsation of the Artery.

Yeats alludes directly to 'what Blake called "the pulsaters [*sic*] of an artery"' in the already quoted additional final passage of the introduction to *Vis. B* (see *supra*, pp. 3–4). Among Yeats's contemporaries, T. S. Eliot had called it the moment of incarnation 'at the still point of the turning world' (*Four Quartets*); for Virginia Woolf it was 'the moment of being', and, curiously enough, she described it in geometrical terms, in a famous passage of *The Waves*, the only novel of hers that Yeats read (see *L.*, 799 and 853); Joyce's *Ulysses* was a long series of such moments of intensity, which he called 'epiphanies', and Yeats was fully aware of this (see *L.*, 651); finally D. H. Lawrence, an author that Yeats admired, expressed, e.g. in the preface to the American edition of his *New Poems* (1920), his idea of the moment of vision in violent sexual terms: it appears most strikingly in his poem 'Swan', a companion piece to his 'Leda' in the collection *Pansies*:

> Far off
> at the core of space
> at the quick
> of time
> beats
> and goes still
> the great swan upon the waters of all endings
> the swan within vast chaos, within the electron.

(The poem ends in a way which is vaguely reminiscent of Yeats's Leda sonnet: 'the vast white bird / furrows our featherless women / with unknown shocks / and stamps his black marsh-feet on their white and marshy flesh').

I have treated elsewhere at some length the central position that this conception of 'the moment' has acquired in modern literature, in its different connotations: eminently aesthetic in Joyce and Virginia Woolf, religious in Eliot, physical in Lawrence (see the chapter 'The Moment as a Time Unit in Fiction' in my book *The Tightrope Walkers*, London, Routledge & K. Paul, 1956). In the intuition of this supreme moment of fulfilment all experience is unified and rolled into one—the artist, the mystic and the sensualist share the same feeling of

fullness of life and achievement, beyond the temporal and spacial boundaries, reaching the condition that Yeats called Unity of Being. All Yeats's life had been a pursuit of this Unity of Being, to realize at this point that it can be achieved only momentarily.

In the note for the revised version of *A Vision* quoted before Yeats said that the 'moment of moments' is attained 'in the creation and enjoyment of a work of art'. The true nature of Yeats was that of the artist, and for such natures all problems, intuitions and sensations are seen under the species of aesthetic experience—the experience that they naturally feel as the highest possible for man. This attitude was strengthened in Yeats by his youthful contacts with the aesthetic movement of the end of last century. Ultimately, then, Unity of Being is just the artistic creation, and his pursuit of such unity is the pursuit of art. As several critics have noted, in Yeats's late poetry unity of Being is frequently symbolized by physical union. In his early writings love, especially in its physical manifestations, was treated very warily. Eros presides over the mystical ecstatic dance in 'Rosa Alchemica'—but he is merely an abstraction, a symbol of that fusion of Paganism and Christianity and the Orphic mysteries which occupied Yeats's thoughts at the time; if there is a sensual element in the story it has to be looked for in the dance itself. A clearer hint at the possibility of identifying religion, and therefore the supernatural, with sexual love, is contained in the unpublished novel written in the 'nineties, *The Speckled Bird*, the hero of which '... was going to the East now to Arabia and Persia, where he would find among the common people so soon as he had learnt their language some lost doctrine of reconciliation; the philosophic poets have made sexual love their principal symbol of a divine love and he had seen somewhere in a list of untranslated Egyptian MSS. that certain of them dealt with love as a polthugic power ... All the arts sprang from sexual love and there they could only come again, the garb of the religion when that reconciliation had taken place' (R. Ellmann, *The Identity etc., cit.*, 52).

Here we still have Yeats the magician and the occultist, exploring the meaning he has given to religion and associating it naturally with art (his real religion). Love is mentioned only as equivalent to earthiness, in accordance with Yeats's belief in a total religious experience which included the senses as well as the brain (a conception derived directly from Blake). It is only with the poems on Solomon and Sheba ('On Woman', 1914: 'Solomon to Sheba', 1918; 'Solomon and the Witch', 1918) that sexual love becomes the symbol of the reconciliation of opposites, or at least of an attempt at such reconciliation, at transcending the conflict in a superior unity. But the final association of the sexual act with a supernatural event occurs in *The Player Queen*: just because this play is an unsuccessful work of art, it stayed longer with Yeats, who kept pouring into it all his new thoughts and conceptions as they came into his mind, so that now it can be considered a very revealing seminal work. There the conjunction of the Queen with the Unicorn is described as a 'New Dispensation', the advent

of a new historical cycle (see *infra*, chapter one of the present book). This idea informs also the Leda sonnet, but as yet does not represent an escape from the wheel of time. It is a momentary suspension, miraculous and of cosmic import, but still a new beginning, not the final peace and stillness when, as the poet says in 'Chosen', 'the Zodiac is changed into a sphere'. The latter conception, that of a final escape from the wheel of time, was reached by Yeats only slowly and laboriously. For a long period, practically until the first version of *A Vision* was completed, he was bound to the idea of an unending series of cycles and there are only vague hints at the possibility of permanently transcending them. 'Chosen' is perhaps the first open statement in poetry of such a possibility, which became clearer to his mind at that time (1926). This year was one of the richest for his poetic production (see *infra*, p. 204)—and his poems were all based on the twin themes of old age and sexual love. He felt physically the intensity that informs his work of this period: on May 25 of that year he wrote to Olivia Shakespear: 'One feels at moments as if one could with a touch convey a vision—that the mystic way and sexual love use the same means' (*L.*, 715).

This attitude must have become even firmer in later years when, studying Oriental religions with the Indian Swami, Shri Purohit, he learnt of those cults in which physical intercourse is a major element in the mystic experience. The attribution of a metaphysical meaning to the sexual act (as in 'Chosen') was certainly important for Yeats. But if we forget for a moment this meaning we realize that his insistence on it is only the full affirmation of the sensual element which is inevitable in all art—since art communicates through the senses.

# Bibliography

## (A) WORKS BY W. B. YEATS

(1) Books and abbreviations used:

*The Variorum Edition of the Poems of W. B. Yeats,* ed. P. Allt and R. K. Alspach; New York, Macmillan, 1957.

*Aut.: Autobiographies,* London, Macmillan, 1955.

*The Bounty of Sweden,* Dublin, Cuala Press, 1925.

*C. & M.: The Cat and the Moon and Certain Poems,* Dublin, Cuala Press, 1924.

*The Celtic Twilight, Men and Women, Dhouls and Faeries,* London, Lawrence and Bullen, 1893; rev. ed., Bullen, 1902.

*C.Pl.: Collected Plays,* London, Macmillan, 1952.

*C.P.: Collected Poems,* London, Macmillan, 1950 (one vol. edition).

*C.W.: The Collected Works in Verse and Prose,* 8 vols., Stratford-on-Avon, Shakespeare Head Press, 1908.

*C.K.: The Countess Kathleen and Various Legends and Lyrics,* London, Fisher Unwin, 1892.

*C. of A.: The Cutting of an Agate,* London, Macmillan, 1919.

*E.P. & S.: Early Poems and Stories,* London, Macmillan, 1925.

*Ess.: Essays,* London, Macmillan, 1924.

*Ess. '31 to '36: Essays 1931 to 1936,* Dublin, Cuala Press, 1937.

*Fairy and Folk Tales of the Irish Peasantry,* London, W. Scott, 1888.

*F.Pl. for D.: Four Plays for Dancers,* London, Macmillan, 1921.

*The Green Helmet and Other Poems,* Churchtown, Cuala Press, 1910.

*The Herne's Egg,* London, Macmillan, 1938.

*The Hour Glass, A Morality,* London, Heinemann, 1903.

*The Hour Glass,* Stratford-on-Avon, Shakespeare Head Press, 1911.

*I.G. & E.:Ideas of Good and Evil,* London, Bullen, 1902.

*If I Were Four-and-Twenty,* Dublin, Cuala Press, 1940.

*In the Seven Woods,* Dundrum, Dun Emer Press, 1903.

*Irish Fairy Tales,* London, Fisher Unwin, 1892.

*J.Sh.:* Ganconagh, *John Sherman and Dhoya,* London, Fisher Unwin, 1891.

287

# Bibliography

*L.: Letters,* ed. A. Wade, London, Hart-Davis, 1954.

*Letters on Poetry from W. B. Yeats to D. Wellesley,* O.U.P., 1940.

*Letters to Katharine Tynan,* Dublin, Clonmore & Reynolds, 1953.

*L. to N.I.: Letters to the New Island,* ed. with an introduction by H. Reynolds, Cambridge (Mass.), Harvard U.P., 1934.

*Michael Robartes and the Dancer,* Churchtown, Cuala Press, 1920.

*Mosada: A Dramatic Poem,* Dublin, Sealy, Bryers & Walker, 1886.

*Mythologies,* London, Macmillan, 1959.

*October Blast,* Dublin, Cuala Press, 1927.

*On the Boiler,* Dublin, Cuala Press, 1939.

*P.f.E.P.: A Packet for Ezra Pound,* Dublin, Cuala Press, 1929.

*P.fr.D.: Pages from a Diary Written in Nineteen Hundred and Thirty,* Dublin, Cuala Press, 1944.

*P.A.S.L.: Per Amica Silentia Lunae,* London, Macmillan, 1918.

*Pl.: Plays in Prose and Verse, Written for an Irish Theatre and generally with the help of a Friend,* London, Macmillan, 1922.

*Pl. & C.: Plays and Controversies,* London, Macmillan, 1923.

*Pl.Q.: The Player Queen,* London, Macmillan, 1922.

*Poems,* London, Fisher Unwin, 1895.

*Responsibilities: Poems and a Play,* Churchtown, Cuala Press, 1914.

*Responsibilities,* London, Macmillan, 1916.

*Reveries over Childhood and Youth,* Churchtown, Cuala Press, 1915.

*S.R.: The Secret Rose,* London, Lawrence and Bullen, 1897.

*S.P. & F.: Seven Poems and a Fragment,* Dundrum, Cuala Press, 1922.

*St. of M.R.: Stories of Michael Robartes and his Friends: an extract made by his pupils: and a play in prose,* Dublin, Cuala Press, 1931.

*Stories of Red Hanrahan and the Secret Rose,* illustrated and decorated by Norah McGuinness, London, Macmillan, 1927.

*T. of L. 1897: The Tables of the Law. The Adoration of the Magi,* London, priv. printed (Bullen), 1897.

*T. of L. 1902: The Tables of the Law. The Adoration of the Magi,* London, Bullen, 1902.

*T. of L. 1904: The Tables of the Law and The Adoration of the Magi,* London, Mathews, 1904.

*T. of L. 1914: The Tables of the Law and The Adoration of the Magi,* Stratford-on-Avon, Shakespeare Head Press, 1914.

*The Trembling of the Veil,* London, Werner Laurie, 1922.

*Two Plays for Dancers,* Dublin, Cuala Press, 1919.

*Vis. A: A Vision: an Explanation of Life founded upon the Writings of Giraldus and upon Certain Doctrines attributed to Kusta Ben Luka,* London, Werner Laurie, 1925.

*Vis. B: A Vision,* London, Macmillan, 1937.

*W. of O.: The Wanderings of Oisin and Other Poems,* London, K. Paul, 1889.

*W. & B.: Wheels and Butterflies*, London, Macmillan, 1934.

*W.T. Is N.: Where There Is Nothing, being vol. I of Plays for an Irish Theatre*, London, Bullen, 1903.

*W.S. at C. 1917: The Wild Swans at Coole, Other Verses and a Play*, Dundrum, Cuala Press, 1917.

*W.S. at C. 1919: The Wild Swans at Coole*, London, Macmillan, 1919.

*W.am.R.: The Wind among the Reeds*, London, Mathews, 1899.

*The Winding Stair*, New York, Fountain Press, 1929.

*The Winding Stair and Other Poems*, London, Macmillan, 1933.

*Words for Music Perhaps and Other Poems*, Dublin, Cuala Press, 1932.

*W.B.Y. & T.S.M.: W. B. Yeats and T. Sturge Moore: Their Correspondence 1901–1937*, ed. U. Bridge, London, Routledge & K. Paul, 1953.

(2) In Periodical Publications and Pamphlets:

'A Biographical Fragment', *The Criterion*, I, 4, July 1923, 315–21.

'Dust Hath Closed Helen's Eye', *The Dome*, Oct. 1899.

*Is the Order of the R.R. & A.C. to Remain a Magical Order?*, London, priv. printed, 1901.

'The Island of Statues' and 'The Seeker', *Dublin University Review*, I, nn. 3, 56–8; 4, 82–4; 5, 110–12; 6, 136–40; 8, 120–3; 9, 230–1; April–Oct. 1885.

'Of Costello the Proud, of Oona the Daughter of Dermott and of the Bitter Tongue', *The Pageant*, 1896.

'On Mr. Nettleship's Picture at the Royal Hibernian Academy, 1885', *Dublin University Review*, II, 4, April 1886.

'Rosa Alchemica', *The Savoy*, n. 2, April 1896, 56–70.

'A Symbolic Artist and the Coming of Symbolic Art', *The Dome*, n.s. I, 3, Dec. 1898, 233–7.

'The Tables of the Law', *The Savoy*, n. 7, Nov. 1896, 79–87.

'William Blake and His Illustrations to the Divine Comedy', *The Savoy*, nn. 3, July 1896, 41–57; 4, Aug. 1896, 25–41; 5, Sept. 1896, 31–6.

(3) Introductions, Editions, etc.

*A Book of Irish Verse selected from the Modern Writers by W. B. Yeats*, London, Methuen, 1895.

*The Works of William Blake, Poetic, Symbolic, and Critical*, edited with lithographs of the illustrated 'Prophetic Books' and a Memoir and Interpretation by E. J. Ellis and W. B. Yeats, 3 vols., London, Quaritch, 1893.

W. Blake, *Poems*, selected by W. B. Yeats, London, Lawrence & Bullen, 1893; 2nd edition, London, Routledge, 1905.

Gogarty, O. St. J., *An Offering of Swans*, Preface by W. B. Yeats, Dublin, Cuala Press, 1923.

Horton, W. T., *A Book of Images*, drawn by W. T. Horton and introduced by W. B. Yeats, London, Unicorn Press, 1898.

# Bibliography

*Oxford Book of Modern Verse 1892–1935,* chosen by W. B. Yeats, O.U.P., 1936.

Shri Purohit Swami, *An Indian Monk,* Introduction by W. B. Yeats, London, Faber, 1932.

*Poems of Spenser selected by W. B. Yeats,* Edinburgh, T. O. & E. C. Jack [1906].

Tagore, R., *Gitanjali,* Introd. W. B. Yeats, London, Chiswick Press, 1912.

*The Ten Principal Upanishads,* put into English by Shri Purohit Swami and W. B. Yeats, London, Faber, 1937.

Villiers de l'Isle Adam, J. M., *Axel,* translated . . . by H. P. R. Finberg, preface by W. B. Yeats, illustrations by T. Sturge Moore, London, Jarrolds, 1925.

(B) CRITICISM AND BIOGRAPHY

(1) Books.

Adams, H., *Blake and Yeats: The Contrary Vision,* N.Y., Cornell U.P., 1955.

Alvarez, A., *The Shaping Spirit,* London, Chatto & Windus, 1958.

Bjersby, B. M. H., *The Interpretation of the Cuchulain Legend in the Works of W. B. Yeats,* n. 1 of 'Upsala Irish Studies', Upsala, 1950.

Blackmur, R. P., *Language as Gesture,* N.Y., Harcourt Brace, 1952.

Bodkin, M., *Archetypal Patterns in Poetry,* O.U.P., 1934.

Bodkin, M., *Studies of Type Images in Poetry, Religion, and Philosophy,* O.U.P., 1951.

Bowra, M., *The Heritage of Symbolism,* London, Macmillan, 1943.

Bradbrook, M. C., *Shakespeare and Elizabethan Poetry,* London, Chatto & Windus, 1951.

Bronowski, J., *The Poet's Defence,* Cambridge U.P., 1939.

Brooks, C., *Modern Poetry and the Tradition,* Chapel Hill, Univ. of N. Carolina Press, 1939.

Brooks, C., *The Well Wrought Urn,* N.Y., Reynal and Hitchcock, 1947.

Daiches, D., *Poetry and the Modern World,* Univ. of Chicago Press, 1940.

Ellis-Fermor, U., *The Irish Dramatic Movement,* London, Methuen, 1939.

Ellmann, R., *Yeats: The Man and the Masks,* London, Macmillan, 1949.

Ellmann, R., *The Identity of Yeats,* London, Macmillan, 1954.

Gibbon, M., *The Masterpiece and the Man: Yeats as I knew him,* London, Hart-Davis, 1959.

Gogarty, O. St. J., *As I was going down Sackville Street,* London, Rich & Cowan, 1937.

Gordon, D. J., and Fletcher, I., *I, the poet William Yeats,* Descriptive Guide to the University of Reading 1957 Yeats Photographic Exhibition (mimeographed), Reading, 1957.

Graves, R., *The Common Asphodel,* London, H. Hamilton, 1949.

Gwynn, St., ed., *Scattering Branches,* London, Macmillan, 1940.

# Bibliography

Hall, J., and Steinmann, M., eds., *The Permanence of Yeats: Select Criticism*, N.Y., Macmillan, 1930.

Henn, T. R., *The Lonely Tower*, London, Methuen, 1950.

Henn, T. R., *The Harvest of Tragedy*, London, Methuen, 1956.

Hoare, D. M., *The Works of Morris and Yeats in relation to early Saga Literature*, Cambridge U.P., 1937.

Hone, J. M., *W. B. Yeats, 1865–1939*, London, Macmillan, 1942.

Hough, G., *The Last Romantics*, London, Duckworth, 1949.

Jeffares, A. N., *W. B. Yeats, Man and Poet*, London, Routledge & K. Paul, 1949.

Kermode, F., *Romantic Image*, London, Routledge & K. Paul, 1957.

Knight, G. Wilson, *The Starlit Dome: Studies in the Poetry of Vision*, O.U.P., 1941.

Knights, L. C., *Explorations*, London, Chatto & Windus, 1946.

Koch, V., *W. B. Yeats: The Tragic Phase*, London, Routledge & K. Paul, 1951.

Leavis, F. R., *New Bearings in English Poetry*, new edition, London, Chatto & Windus, 1950.

Lombardo, A., *La poesia inglese dall'estetismo al simbolismo*, Roma, Edizioni di Storia e Letteratura, 1950.

MacNeice, L., *The Poetry of W. B. Yeats*, O.U.P., 1941.

Martz, L. L., *The Poetry of Meditation*, New Haven, Yale U.P., 1954.

Matthiessen, F. O., *The Responsibilities of the Critic*, N.Y., O.U.P., 1952.

Menon, V. K. N., *The Development of W. B. Yeats*, Edinburgh, Oliver & Boyd, 1942.

Moore, V., *The Unicorn: William Butler Yeats' Search for Reality*, N.Y., Macmillan, 1954.

Murphy, G., *The Modern Poet*, London, Sidgwick & Jackson, 1938.

O'Donnell, J. P., *Sailing to Byzantium*, Harvard Thesis in English, n. 11, Harvard U.P., 1939.

Parkinson, Th., *W. B. Yeats, Self-Critic: A Study of His Early Verse*, Berkeley, Univ. of California Press, 1951.

Press, J., *The Fire and the Fountain*, O.U.P., 1955.

Read, H., *A Coat of Many Colours*, London, Routledge & K. Paul, 1945.

Rudd, M., *Divided Image: A Study of William Blake and W. B. Yeats*, London, Routledge & K. Paul, 1953.

[Russell, G. W.] A.E., *Imagination and Reveries*, Dublin, Maunsel, 1915.

[Russell, G. W.] A.E., *Song and Its Fountains*, London, Macmillan, 1932.

Savage, D. S., *The Personal Principle*, London, Routledge & K. Paul, 1944.

Skelton, R., *The Poetic Pattern*, London, Routledge & K. Paul, 1956.

Spender, S., *The Creative Element*, London, H. Hamilton, 1953.

Stauffer, D., *The Golden Nightingale: Essays on Some Principles of Poetry in the Lyrics of W. B. Yeats*, N.Y., Macmillan, 1949.

Tate, A., *On the Limits of Poetry*, N.Y., Swallow Press, 1948.

Tillyard, E. M. W., *Poetry: Direct and Oblique*, London, Chatto & Windus, 1934.

Tschumi, R., *Thought in Twentieth Century English Poetry*, London, Routledge & K. Paul, 1951.

Tuve, R., *Elizabethan and Metaphysical Imagery*, Univ. of Chicago P., 1947.

Ure, P., *Towards a Mythology: Studies in the Poetry of W. B. Yeats*, Liverpool U.P., 1946.

Ussher, A., *Three Great Irishmen*, London, Gollancz, 1952.

Wade, A., *A Bibliography of the Writings of W. B. Yeats*, 2nd edition, London, Hart-Davis, 1957.

Wellek, R. and Warren, A., *Theory of Literature*, N.Y., Harcourt Brace, 1949.

Whalley, G., *Poetic Process*, London, Routledge & K. Paul, 1953.

Wilson, E., *Axel's Castle*, London, Scribner, 1931.

Wilson, F. A. C., *W. B. Yeats and the Tradition*, London, Gollancz, 1958.

Yeats, J. B., *Letters to His Son W. B. Yeats and Others, 1869–1922*, edited with a memoir by J. Hone and a preface by O. Elton, London, Faber, 1944.

(2) Essays, articles, etc.

Allt, G. D. P., 'Yeats and the Revision of his Early Verse', *Hermathena*, LXIV, Nov. 1944, 90–101; LXV, May 1945, 40–57.

Becker, W., 'The Mask Mocked: or, Farce and the Dialectic of Self', *Sewanee Review*, LXI, 1, Winter 1953, 82–108.

Benson, C., 'Yeats and Balzac's *Louis Lambert*', *Modern Philology*, XLIX, 4, May 1952.

Campbell, H. M., 'Yeats's Sailing to Byzantium', *MLN*, LXX, Dec. 1955, 585–9.

D'Agostino, N., 'W. B. Yeats: il periodo del sole', *English Miscellany*, 5, 1954.

Davenport, A., 'W. B. Yeats and the Upanishads', *RES*, n.s. III, 9, Jan. 1952, 55–62.

Donaldson, A., 'A Note on W. B. Yeats' "Sailing to Byzantium"', *N. & Q.*, CXCIX, n.s. I, 1, Jan. 1954, 34–5.

Dume, T. L., 'Yeats' Golden Tree and Birds', *MLN*, LXVII, 6, June 1952, 404–7.

Ellmann, R., 'Joyce and Yeats', *Kenyon Review*, XII, Autumn 1950.

Fraser, G. S., 'W. B. Yeats and T. S. Eliot', in N. Braybrooke (ed.), *T. S. Eliot: A Symposium for his Seventieth Birthday*, London, Hart-Davis, 1958, 196–216.

Frye, N., 'Yeats and the Language of Symbolism', *Univ. of Toronto Quarterly*, 17, Oct. 1947, 1–17.

Greene, D. J., 'Yeats's Byzantium and Johnson's Lichfield', *Philological Quarterly*, XXXIII, 4, Oct. 1954, 433–5.

Gwynn, F. L., 'Yeats's Byzantium and Its Sources', *Philological Quarterly*, XXXII, 1, Jan. 1953, 9–21.

# Bibliography

Häusermann, H. W., 'W. B. Yeats's Criticism of Ezra Pound', *English Studies*, XXIX, 4, Aug. 1948, 97–109.

Henn, T. R., 'The Accent of Yeats's "Last Poems"', *ESEA*, IX, 1956, 56–72.

Jeffares, A. N., 'The Byzantine Poems of W. B. Yeats', *RES*, XXII, 85, Jan. 1946, 44–52.

Jeffares, A. N., '"Gyres" in the Poetry of W. B. Yeats', *English Studies*, XXVII, 3, June 1946, 65–74.

Jeffares, A. N., 'Thoor, Ballylee', *English Studies*, XXVIII, 6, Dec. 1947, 161–8.

Jeffares, A. N., 'An Account of Recent Yeatsiana', *Hermathena*, LXXII, 1948, 21–43.

Jeffares, A. N., 'Notes on Yeats's "Lapis Lazuli"', *MLN*, LXV, 1950, 488.

Jeffares, A. N., 'Yeats's "The Gyres": Sources and Symbolism', *The Huntington Library Quarterly*, XV, 1, Nov. 1951, 87–97.

Newton, N., 'Yeats as Dramatist: *The Player Queen*', *Essays in Criticism*, VIII, 3, July 1958, 269–84.

Parkinson, T., 'The Sun and the Moon in Yeats's Early Poetry', *Modern Philology*, L, 1, Aug. 1952, 50–8.

Parkinson, T., 'Yeats and Pound: The Illusion of Influence', *Comparative Literature*, VI, 3, Summer 1954, 256–64.

Pearce, D. R., 'Yeats' Last Plays: An Interpretation', *ELH*, XVIII, 1, March 1951, 67–76.

Reid, B. L., 'Yeats and Tragedy', *Hudson Review*, XI, 3, Autumn 1958, 391–410.

Saul, G. B., 'The Winged Image: A Note on Birds in Yeats's Poems', *Bulletin of the New York Public Library*, LVIII, 6, June 1954, 267–73.

Spitzer, L., 'On Yeats' Poem "Leda and the Swan"', *Modern Philology*, LI, 4, May 1954, 271–6.

Stamm, R., 'The Sorrow of Love, A Poem by W. B. Yeats Revised by Himself', *English Studies*, XXIX, 3, June 1948, 78–87.

*Times Literary Supplement*, Correspondence from 11 Aug. to 3 Nov. 1950, on a variant in 'Byzantium'.

Trowbridge, H., 'Leda and the Swan: A Longinian Analysis', *Modern Philology*, LI, 2, Nov. 1953, 118–29.

Ure, P., '"The Statues": A Note on the Meaning of Yeats's Poem', *RES*, XV, 99, July 1949, 254–7.

Ure, P., 'The Integrity of Yeats', *The Cambridge Journal*, III, 2, Nov. 1949, 80–93.

Ure, P., 'Yeats's Supernatural Songs', *RES*, n.s. VII, 25, Jan. 1956, 38–51.

Victor, P., 'Magie et sociétés secrètes: L'Ordre Hermétique de la Golden Dawn', *La Tour Saint-Jacques*, 2–3, Janvier–Avril 1956.

Wain, J., 'Yeats: Among School Children', in *Interpretations*, ed. J. Wain, London, Routledge & K. Paul, 1955, 194–210.

Warren, A., 'W. B. Yeats, The Religion of a Poet', in *Rage for Order*, Univ. of Chicago Press, 1948.

Weeks, D., 'Image and Idea in Yeats's "Second Coming"', *PMLA*, LXIII, 1, March 1948, 281–92.

Witt, M., 'A Competition for Eternity: Yeats's Revision of his Later Poems', *PMLA*, LXIV, 1, March 1949, 40–58.

(C) MISCELLANEOUS

(1) Books.

Aristophanes, *The Birds*, trans. J. Hookham Frere (first pub. 1840, many nineteenth-century editions; included in 'World's Classics', 1907).

Balzac, H. de, *Séraphita, Louis Lambert*, vol. XXXIV of *La Comédie Humaine*, ed. G. Saintsbury, London, Dent, 1895–8.

Blake, W., *All his woodcuts photographically reproduced in facsimile*, ed. L. Binyon, London, Unicorn Press, 1902.

Blake, W., *The Illustrations to the Divine Comedy of Dante*, London, printed privately for the National Art Collection Fund, 1922.

Blavatsky, H. P., *Isis Unveiled: A Master-Key to the Mysteries of Ancient and Modern Science and Theology*, 2 vols., 2nd edition, N.Y., Bouton, 1877.

Blavatsky, H. P., *The Secret Doctrine: The Synthesis of Science, Religion, and Philosophy*, 3 vols., 3rd revised edition, with a preface by A. Besant and G. R. S. Mead, London, Theosophical Publishing Soc., 1893–7.

Boehme, J., *The Works of Jacob Behmen The Teutonic Theosopher . . . with Figures, illustrating his Principles, left by the Reverend William Law, M.A.*, 4 vols., London, M. Richardson, 1764–81.

Byron, Lord, *The Poetical Works*, O.U.P., 1904.

[Colonna, F.], *Hypnerotomachia Poliphili*, Venetiis, in aedibus Aldi Manutii, 1499.

[Colonna, F.], *Hypnerotomachia Poliphili*, photographically reproduced, London, Methuen, 1904.

[Colonna, F.], *Hypnerotomachia. The Strife of Loue in a Dreame*, London, printed for Simon Waterson, 1592.

[Colonna, F.], *The Strife of Love in a Dream, being the Elizabethan Version of the First Book of the Hypnerotomachia of Francesco Colonna*. A new edition by A. Lang, London, D. Nutt, 1890.

Dalton, O. M., *Byzantine Art and Archeology*, Oxford, Clarendon Press, 1923.

D'Annunzio, G., *La Leda senza cigno*, Milano, Treves, 1916.

Darwin, E., *The Botanic Garden*, London, Johnson, 1790–1.

De Gubernatis, A., *Zoological Mythology, or, the legends of animals*, 2 vols., London, 1872.

De Rinaldis, A., *La R. Galleria Borghese in Roma*, 2nd edition, Roma, Libreria dello Stato, 1937.

# Bibliography

Digby, G. W., *Symbol and Image in William Blake*, O.U.P., 1957.

Donne, J., *Poems*, ed. H. Grierson, O.U.P., 1912, 2 vols.

Eliot, T. S., *Collected Poems 1909–1935*, London, Faber, 1936.

Eliot, T. S., *The Sacred Wood*, London, Methuen, 1920.

Eliot, T. S., *Selected Essays*, London, Faber, 1932.

Eliot, T. S., *The Family Reunion*, London, Faber, 1939.

Eliot, T. S., *Four Quartets*, London, Faber, 1944.

Eliot, T. S., *The Elder Statesman*, London, Faber, 1959.

Ellis, E. J., *Fate in Arcadia*, with illustrations by the Author, London, Ward & Downey, 1892.

Ellis, E. J., *Seen in Three Days*, written, drawn and tinted by E. J. E., London, Quaritch, 1893.

Flat, P., *Le Musée Gustave Moreau—L'Artiste—Son Oeuvre—Son Influence*, Paris [1899].

Flaubert, G., *La tentation de Saint Antoine*, Paris, 1874.

Frazer, J. G., *The Golden Bough*, one vol. edition, London, Macmillan, 1922.

Frye, N., *Fearful Symmetry*, Princeton U.P., 1947.

Goblet d'Alviella, E., *The Migration of Symbols*, London, Constable, 1894.

Goethe, W., *Faust*.

Gogarty, O. St. J., *Wild Apples*, Dublin, Cuala Press, 1928.

Gogarty, O. St. J., *Others to Adorn*, preface by W. B. Yeats, forewords by A. E. and H. Reynolds, London, Rich & Cowan, 1938.

Gogarty, O. St. J., *Perennial*, London, Constable, 1946.

Gogarty, O. St. J., *The Collected Poems*, London, Constable, 1951.

Greene, R., *Friar Bacon and Friar Bungay; John of Bordeaux*, ed. B. Cellini, Firenze, La Nuova Italia, 1952.

Hansford Johnson, P., *The Unspeakable Skipton*, London, Macmillan, 1959.

*The Hermetic Museum restored and enlarged: Most faithfully instructing all Disciples of the Sopho-Spagyric Art how that Greatest and Truest Medicine of the Philosopher's Stone may be found and held*. Now first done into English from the Latin Originals, ed. A. E. Waite, 2 vols., London, Elliott, 1893.

*The Hermetick Romance or The Chymical Wedding*, written in high Dutch by Christian Rosencreutz, translated by E. Foxcroft, late Fellow of Kings College in Cambridge, London, 1690.

Hogarth, W., *The Analysis of Beauty*, written with a view of fixing the fluctuating Ideas of Taste, London, 1753.

Hogarth, W., *The Analysis of Beauty*, with the rejected passages . . . ed. J. Burke, Oxford, Clarendon Press, 1955.

Holmes, W. G., *The Age of Justinian and Theodora*, London, Bell, 1905.

Horton, W. T., *The Way of the Soul: A Legend in Line and Verse*, London, Rider, 1910.

Hügel, F. von, *The Mystical Element of Religion as studied in Saint Catherina of Genoa and Her Friends*, 2 vols., London, Dent, 1908.

# Bibliography

Huxley, A., *Verses and a Comedy*, London, Chatto & Windus, 1946.

Huxley, A., *The Doors of Perception*, London, Chatto & Windus, 1954.

Keynes, G., *Blake Studies*, London, Hart-Davis, 1949.

Laran, J., *Gustave Moreau*, 48 planches hors-texte . . . intr. L. Deshairs; Paris [1912].

Lawrence, D. H., *The Complete Poems*, 3 vols., London, Heinemann, 1957.

Lawrence, D. H., *Selected Essays*, intr. A. Huxley, Harmondsworth, Penguin Books, 1950.

Lewis, C. S., *English Literature in the Sixteenth Century, Excluding Drama*, O.U.P., 1954.

Lucarini, *Imprese dell'Offitioso Accademico Intronato raccolte da lo Sconosciuto Accademico Unito*, Siena, 1629.

Mathers, S. L. MacG., *Kabbala Denudata, the Kabbala Unveiled*, trans. S. L. MacG. M., London, Redway, 1887.

Mathers, S. L. MacG., *Fortune-Telling Cards. The Tarot, Its Occult Signification, Use in Fortune-Telling and Method of Play, etc.*, London, Redway, 1888.

Mathers, S. L. MacG., *The Key of Solomon the King* . . . Now first translated and edited from Ancient MSS. in the Brit. Mus. London, Redway, 1889.

Maupassant, G. de, *La Maison Tellier*, Paris, 1886.

Melchiori, G., *Michelangelo nel Settecento inglese*, Roma, Edizioni di Storia e Letteratura, 1950.

Melchiori, G., *The Tightrope Walkers*, London, Routledge & K. Paul, 1956.

'Michael Field' (K. Bradley and A. Cooper), *Underneath the Bough*, London, Bell, 1893.

Moore, T. Sturge, *Danae*, London, Hacon & Ricketts, 1903.

Moore, T. Sturge, *The Sea Is Kind*, London, G. Richards, 1914.

Morris, W., *The Earthly Paradise*, 4 vols., London, F. S. Ellis, 1870.

Muchall-Viebrook, T., *Deutsche Barockzeichnungen*, Munich, n.d.

*Musaeum Hermeticum reformatum et amplificatum*, Frankfurt, 1678.

O'Shaughnessy, A. W. E., *An Epic of Women*, London, 1870.

Östberg, R., *Das Stadthaus*, Stockholm, 1953.

Pater, W., *The Renaissance: Studies in Art and Poetry*, London, Macmillan, 1877.

Picinelli, F., *Mondo Simbolico Ampliato*, Milano, 1669.

Plato, *Symposium*.

Plotinus, *The Enneads* . . . trans. by St. MacKenna, 5 vols., The Medici Society, 1917–30.

Portigliotti, G., *Porpore pugnali etère*, Milano, Treves, 1929.

Pound, E., *Gaudier-Brzeska, a memoir* . . . Including the published writings of the sculptor, and a selection from his letters, London, Lane, 1916.

Praz, M., *The Romantic Agony*, O.U.P., 1933.

Praz, M., *Gusto Neoclassico*, 2nd edition, Napoli, ESI, 1959.

Read, H., *Icon and Idea: The Function of Art in the Development of Human Consciousness*, London, Faber, 1955.

# Bibliography

Regardie, I., *The Tree of Life: A Study in Magic,* London, Rider, 1932.

Regardie, I., *My Rosicrucian Adventure,* Chicago, Aries Press, 1936.

Regardie, I., *The Golden Dawn: An Account of the Teachings, Rites and Ceremonies of the Order,* 4 vols., Chicago, Aries Press, 1937–40.

Regardie, I., *The Philosopher's Stone: A modern comparative approach to alchemy from the psychological and magical points of view,* London, Rider, 1938.

Ricketts, Ch. de S., *Self-Portrait,* taken from the Letters and Journals . . . compiled by T. Sturge Moore, ed. C. Lewis, London, 1939.

Rilke, R. M., *Fifty Selected Poems* with English Translations by C. F. MacIntyre, Berkeley, Univ. of California Press, 1940.

Rogers, Meyric R., *Carl Milles, An Interpretation of His Work,* New Haven, Yale U.P., 1940.

Rogers, N., *Shelley at Work, A Critical Inquiry,* O.U.P., 1956.

Shelley, P. B., *Poetical Works,* O.U.P.

Sinnett, A. P., *Esoteric Buddhism,* London, Redway, 1883.

Siviero, R., *Catalogo della seconda mostra nazionale delle opere d'arte recuperate dalla Germania,* Roma, 1950.

Smith, E. Baldwin, *The Dome: A Study in the History of Ideas,* Princeton U.P., 1950.

Spenser, E., *Poetical Works,* ed. J. C. Smith and E. de Selincourt, O.U.P., 1912.

Strong, E., *Apotheosis and After Life: Three Lectures on Certain Phases of Art and Religion in the Roman Empire,* London, Constable, 1915.

Strzygowski, J., *Origin of Christian Church Art,* trans. O. M. Dalton, Oxford, Clarendon Press, 1923.

Strzygowski, J., *Early Church Art in Northern Europe,* London, Batsford, 1928.

Symons, A., *The Symbolist Movement in Literature,* London, Heinemann, 1899.

Symons, A., *Cities,* London, Dent, 1903.

Symons, A., *Cities of Italy,* London, Dent, 1907.

Symons, A., *William Blake,* London, Secker, 1924.

Symons, A., *From Toulouse-Lautrec to Rodin,* London, Lane, 1929.

Todhunter, J., *Helena in Troas,* London, K. Paul, 1886.

Tolnay, Ch. de, *Michelangelo. III: The Medici Chapel,* Princeton U.P., 1948.

Virgil, *Eclogues.*

Waite, A. E., *The Real History of the Rosicrucians,* London, Redway, 1887.

Waite, A. E., *The Brotherhood of the Rosy Cross,* London, Rider, 1924.

[Walton, C.], *Notes and Materials for an adequate biography of W. Law. Comprising an elucidation of the scope and contents of the writings of J. Böhme,* London, priv. printed, 1854.

Wellisch, E., *Isaac and Oedipus,* London, Routledge & K. Paul, 1954.

Westholm, A., *Milles: En bok om Carl Milles konst,* Stockholm, 1950.

Wilde, O., *The Sphinx,* decoration by C. Ricketts, London, Mathews & Lane, 1894.

# Bibliography

Wilde, O., *Selected Works,* ed. R. Aldington, London, Heinemann, 1946.

Wind, E., *Pagan Mysteries in the Renaissance,* London, Faber, 1958.

Wollin, N. G., *Modern Swedish Decorative Art,* London, The Architectural Press [1931].

Woolf, V., *The Waves,* London, Hogarth Press, 1931.

(2) Periodical Publications.

*The Dial,* ed. Ch. H. Shannon and Ch. Ricketts, 5 issues, 1889–97.

*The Dome: A Quarterly containing Examples of All the Arts,* ed. E. J. Oldmeadow, London, Unicorn Press, from 1897 to 1900.

*The Pageant,* ed. Ch. H. Shannon and J. W. Gleeson White, only two issues, 1896, 1897.

*The Savoy,* ed. A. Symons, only 8 issues, 1896.

Atkins, S., 'The Visions of Leda and the Swan in Goethe's Faust', *MLN,* LXVIII, 5, May 1953, 340–4.

Beardsley, A., 'Under the Hill', *The Savoy,* nn. 1, 2, Jan., April 1896.

Cellini, B., 'Echi di Greene nel Doctor Faustus di Marlowe', *Rivista di Lettera-ture Moderne,* Aprile–Giugno 1952.

Gogarty, O. St. J., 'Leda and the Swan', *The Atlantic Monthly,* CXLIX, March 1932, 325–6.

Gray, J., 'Leda', a poem, *The Dial,* V, 1897, 13–15.

Mallarmé, S., 'Hérodiade', trans. A. Symons, *The Savoy,* 8, Dec. 1896.

'Michael Field', 'Equal Love', a play in one act, *The Pageant,* 1896, 189–224.

Reid, J. D., 'Leda Twice Assaulted', *Journal of Aesthetics and Art Criticism,* XI, 4, June 1953, 378–89.

Sturt, Ch. R., 'A Note on Gustave Moreau', *The Dial,* 3, 1893, 10–16.

Symons, A., 'Ballet, Pantomime and Poetic Drama', *The Dome,* n.s. I, Oct.–Dec. 1898.

Symons, A., 'The Lover of the Queen of Sheba', *The Dome,* n.s. V, Jan. 1900.

Wernstedt, M., 'The Stockholm City Hall', *The Studio,* XC, 1925, 203 ff.

# Index

# Index

# Index

# Index

Pope, Alexander, 226
Portigliotti, Giuseppe, 280
Pound, Ezra, 65, 238n., 246–7, 261
Praz, Mario, 115, 159n., 160n., 201n., 276
Pre-Raphaelites, 5, 9, 12, 14, 18, 26, 32, 115, 118, 129, 150, 153, 216, 236n., 237, 240, 271
Press, John, 8–9n.
Purohit Swami, 13, 194, 286
Puvis de Chavannes, Pierre, 14, 156

Quinn, John, 92

Rabelais, François, 240–2
Raftery, 128n.
Raphael, 140, 203, 216, 240; *Galathea*, 203
Ravenna mosaics, 153, 214–15, 221–6; XII
Read, Herbert, 118n., 207n., *225–6*
Regardie, Israel, 20n., 24n., 25, 172n., 263–4; *The Golden Dawn*, 24n.; *My Rosicrucian Adventure*, 25n.; *The Philosopher's Stone*, 25n.; *The Tree of Life*, *20n.*, *25*, 172n., *264*
Reid, J. Davidson, 281–2
Renan, Ary, 116
Rhymers' Club, 12, 32, 123
Ricketts, Charles, 17n., 36n., 69, 115, 116n., 150, 151n., 156, 251n., 266
Rilke, Rainer Maria, *281–2*
Rogers, Neville, 230
Romano, see Giulio Romano
Ronsard, Pierre de, 121n.
Rosencreutz, Christian, see *Chymical Marriage*, etc.
Rossetti, D. G., 12, 13, 17n., 18, 21, 116, 129, 137, 150, 156, 227, 238, 240–1
Rosso Fiorentino, 154–5; VI(*b*), VII (*a*)
Russell, G. W. ('A.E.'), 12, 26, *67n.*, 77, 90, 103, 126n., *278*

St. Sophia (in Constantinople), 193, 202, 206, 222–4, 232–3
Salome (Yeats's conception), 195–8; see also 'dance'
Saul, G. Brandon, 101n.
*Savoy, The* (periodical), 15, 16, 21, 61n., 72n., 115, 153n., 196n., 218, 232, 238n., 246n., 261n.; XVI
serpentine line, 259–61, 263, 266–70
Shakespear, Olivia, 137n., 177, 180n., 201n., 249n., 286
Shakespeare, William, 20, 141, 195, 207, 213, 227, 240, 246–8, 253; *Hamlet*, 246, 248; *Julius Caesar*, 195n.; *King Lear*, 141, 237, 245–9,

252–3; *Pericles*, 207; *Timon*, 141, 237, 245–6
Shannon, Charles H., 17n., 115–16n., 149n., 251n.
Shaw, G. B., 152
Shelley, P. B., 5, 12, 14, 18, 20–1, 26, 30, 32, 42n., *62n.*, 104–8, 118, 127, 131, 147–8, 163, 207–11, 226–7, 229–30, 233; *Adonais*, *208*, 230; *Alastor*, *105–8*; *Epipsychidion*, 230; *Hellas*, 42n., 62n.; *Hymn to the Dioscuri*, *147–8*; *Prince Athanase*, 105, 127, 131; *Revolt of Islam*, 5, 18; *Rosalind and Helen*, *208n.*, 210
Sidney, Sir Philip, 113
Sinnett, A. P., 19, *262–3*
Sitwell, Edith, 196
Siviero, R., 281
Skelton, Robin, 90n.
Smith, E. Baldwin, 225, *230–2*
Sodoma (Antonio Bazzi), 152, 281; V
*Song of Solomon*, 274
Solomon's seal (emblem), 259, 263
Sophocles, 248–9, 253; *Oedipus* plays, 249–51, 253
Southwell, Robert, 20n.
Spenser, Edmund, 12, 30, 32, 86–7, 100, 107–9, 112–14, 118, 133, 146–7, 159–60, 163, 193, 227–8, 274, 281; *Faerie Queene*, *112–13*, 133, *146*, 159, 227; *Prothalamion*, *86–7*, 100, 107; *Ruines of Time*, *107–8*, 109, 112
sphere (symbol), 166, 170–1, 176–80, *182–91*, 194, 198, 200, 262, 264, 283, 286
Sphinx, 36, 42, 58–9, 79, 251, 265n.
spiral (winding stair emblem), 127, 130–1, 174, 185, 258–9, 261–7; XV, XVI
*Spiritus Mundi*, see *Anima Mundi*
Spitzer, Leo, 77n., 137n., 158–9n., 184–5
Spranger, Bartholomeus, 280
Stamm, Rudolf, 118n.
Stauffer, Donald, *5–6*, 9, 42n., 110
Stefano da Zevio, 274
Stockholm Town Hall, 215–18, 225; XI
Strindberg, A., 17n.
Strong, Mrs. A. (Eugenie Sellers), 212
Strong, L. A. G., 76
Strzygowski, J., 273
Sturm, Frank Pearce, 180–4
Sturt, Charles R., *115–16*, *121n.*
stylization, 13, 271–3
swan (symbol), 77, 79, 89, 93, 95–7, *99–115*, 128, 132, 141–2, 144–5, 165–6, 184, 276, 284; see also *Leda* (works of art)